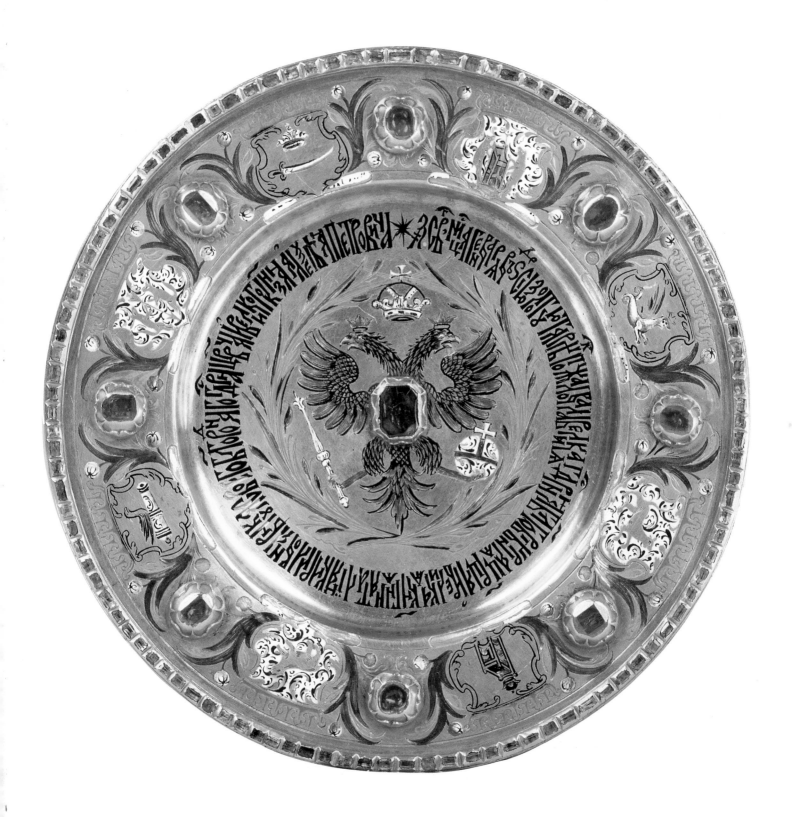

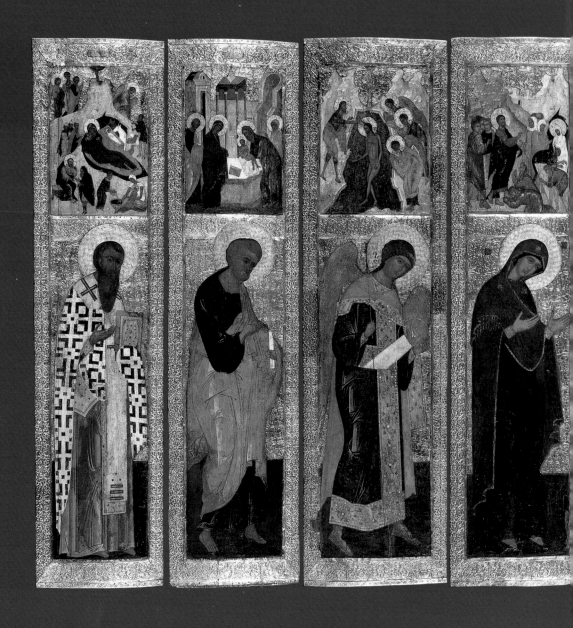

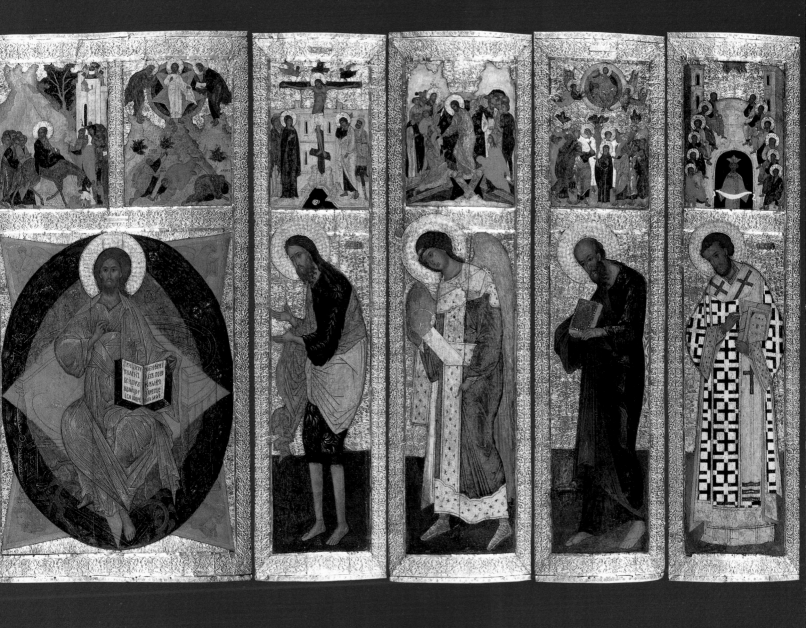

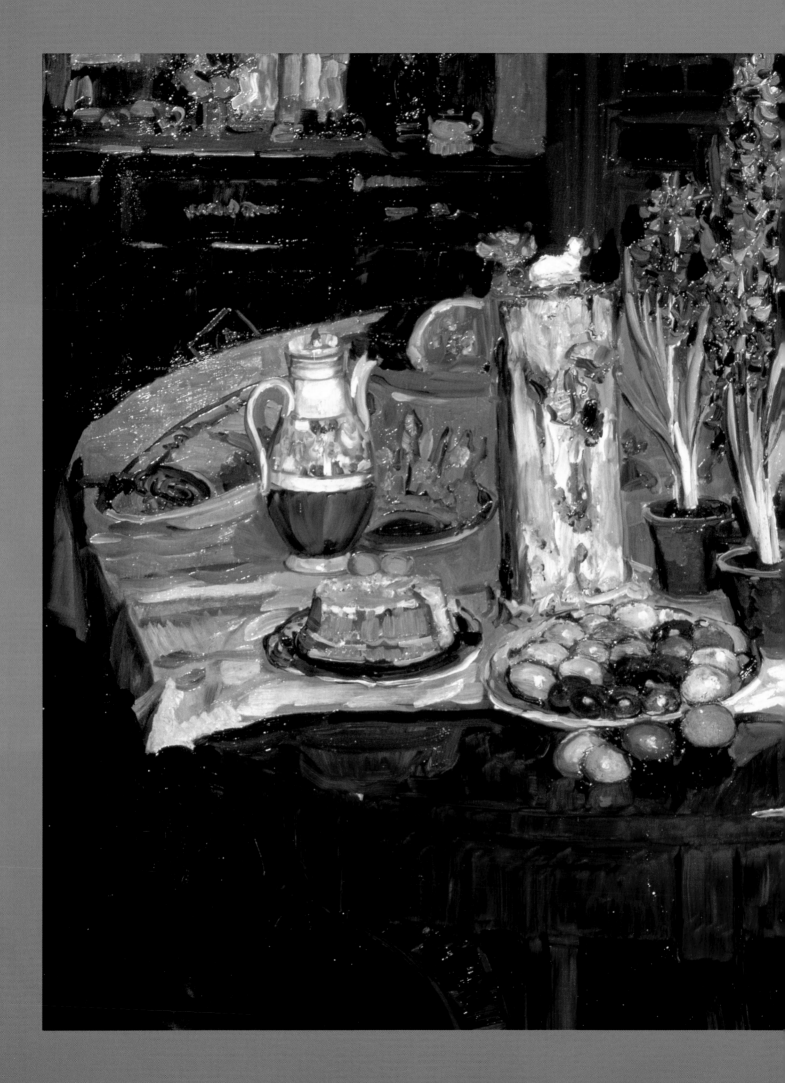

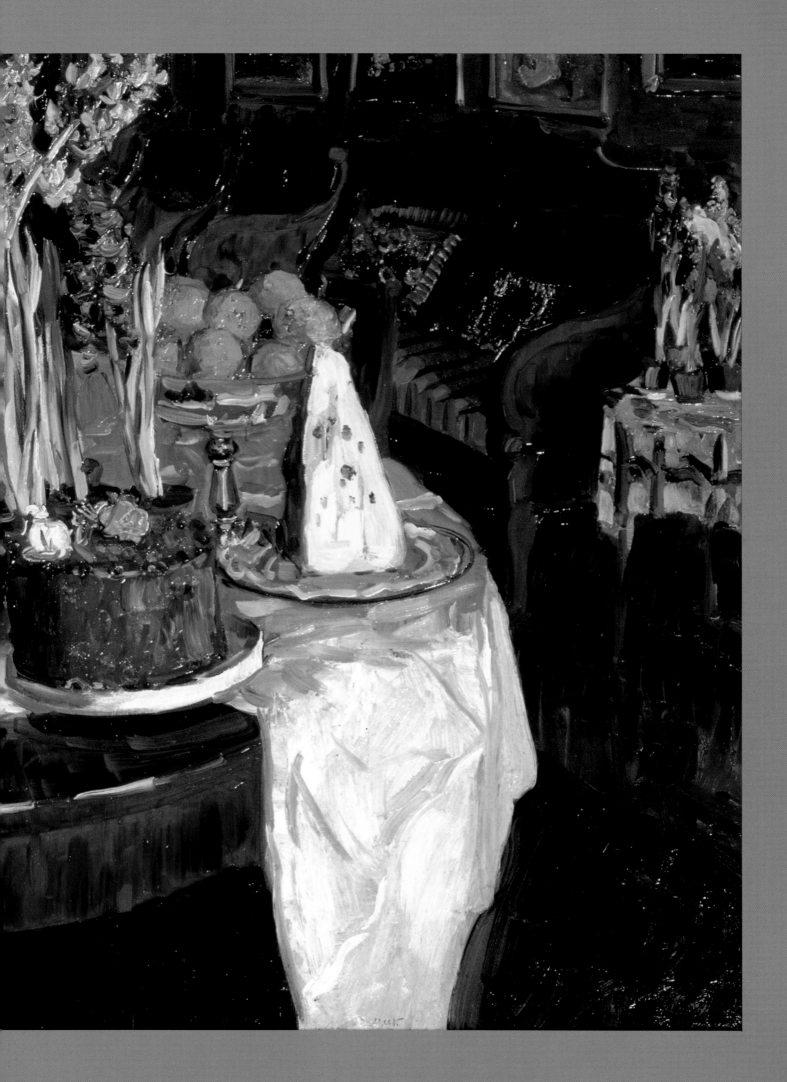

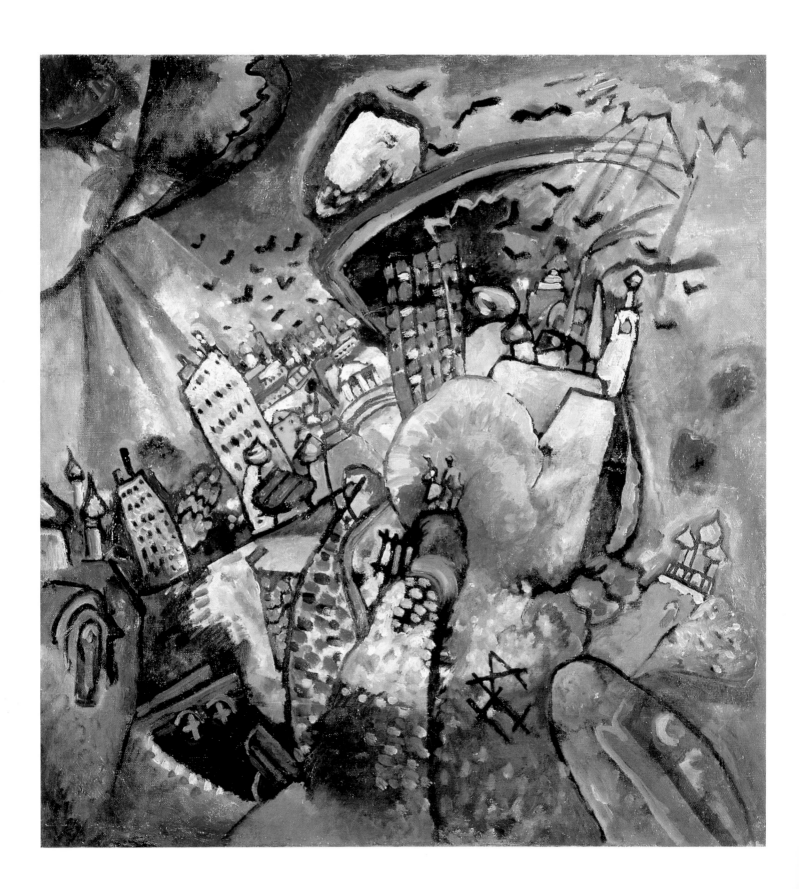

MOSCOW
TREASURES AND TRADITIONS

Mikhail M. Allenov
Irina A. Bobrovnitskaya
John E. Bowlt
Julie Emerson
Olga G. Gordeeva
Alexey K. Levykin
Valentina M. Nikitina
Galina G. Smorodinova
Katrina V. H. Taylor
Tatyana V. Tolstaya
Inna I. Vishnevskaya

Introduction by
W. Bruce Lincoln

Smithsonian Institution Traveling Exhibition Service
Washington, D.C.

in association with
University of Washington Press
Seattle and London

Published on the occasion of an exhibition organized by the Smithsonian Institution Traveling Exhibition Service and the USSR Ministry of Culture in association with the Seattle Organizing Committee of the 1990 Goodwill Games and the Seattle Art Museum. Made possible by a grant from The Boeing Company.

Distributed by University of Washington Press
P.O. Box 50096
Seattle, Washington 98145-5096

Library of Congress Cataloging-in-Publication Data
Moscow: treasures and traditions/introduction by W. Bruce Lincoln; [contributors] Mikhail M. Allenov . . . [et al.]

ISBN 0-295-96994-6
ISBN 0-295-96995-4 (pbk.)
 1. Art, Russian—Russian S.F.S.R.—Moscow—Exhibitions. 2. Art and society—Russian S.F.S.R.—Moscow—Exhibitions. I. Lincoln, W. Bruce. II. Allenov, Mikhail Mikhaïlovich. III. Smithsonian Institution. Traveling Exhibition Service. IV. Soviet Union, Ministerstvo Kul'tury.
N6997.M7M65 1990
709'.47'074753—dc20 90-30271
 CIP

Printed and bound in Japan

Cover: The festivities celebrating the mid-point of winter, before the Lenten season, are depicted by Boris Kustodiev in *Shrovetide*. This was a joyful time of traditions—of blini, dancing bears, and puppet shows (1919, cat. 199, detail).

Back cover: Kovsh, Sixth Moscow Jewelers' Artel (1908-17, cat. 62, see p. 107).

Frontis 1: Plate (1694, cat. 37, see p. 88).

Frontis 2: The Entry into Jerusalem iconostasis (cats. 6-14).

Frontis 3: The rich interiors of Zhukovsky's paintings revel in beauty and quiet elegance. The joyous midnight Mass of Easter, fireworks, and the family dinner were traditionally followed on Easter day by the ringing of church bells and visits from friends. *The Easter Table* welcomes with its spring flowers from the hothouse, colored eggs, ham, and holiday bread and sweet cheese—*kulich* and *paska* that have been blessed at church (1903, cat. 196).

Title page: Red Square, Vasily Kandinsky (1916, cat. 208, see p. 219).

Opposite: Icon lamp from the workshop of Ivan Alekseyev (1895, cat. 54).

CONTENTS

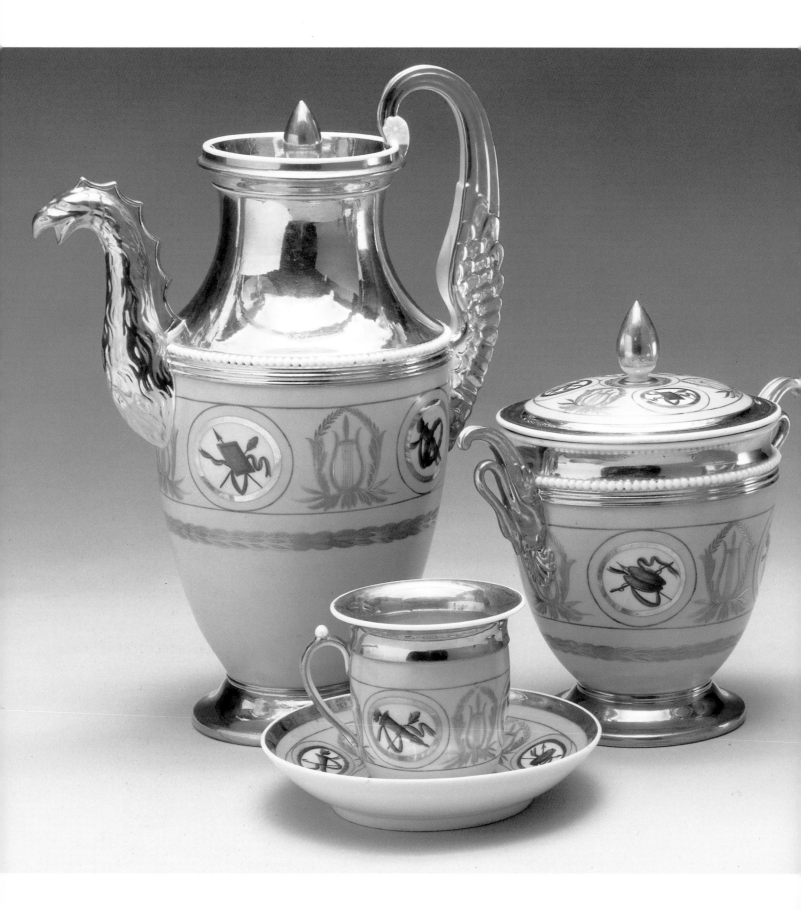

FOREWORD

"And now at last the goal is in sight: in the shimmer
Of the white walls gleaming near,
In the glory of the golden domes,
Moscow lies great and splendid before us!

.

Moscow—how deeply the name resounds in the Russian heart!"

Alexander Pushkin

Pushkin's words serve as a distinctive epigraph for the exhibition *Moscow: Treasures and Traditions,* which presents to the American public a wondrous survey of the art of Moscow from the fifteenth century to the present day.

The museums of the USSR, renowned for their artistic treasures, have made their collections available for this special presentation. Represented in this exhibition are selections from the State Museums of the Moscow Kremlin, State Tretyakov Gallery, State Historical Museum, State Russian Museum, State Museum of Ceramics and 18th-Century Estate of Kuscovo, Museum of History of Moscow, Ostankino Palace-Museum, the Apartment-Museum of I.I. Brodsky in Leningrad, Museum of Graphic Arts of the Tatar People in Kazan, State Art Museum of Belorussia in Minsk, and Saratov State Museum named after Radishchev. In addition, private individuals have kindly agreed to place works from their collections in the exhibition.

Visitors to *Moscow: Treasures and Traditions* and readers of this book have the unique opportunity to view icons from the city's celebrated cathedrals and monasteries. The secular and sacred objects created by the gifted masters of the silver and gold workshops in the Kremlin Armory include arms and armor, firearms, ceremonial vessels, clerical vestments, orders, and heroic medals—the majority of which belonged at one time to Russian tsars, patriarchs, and important historical figures. The porcelain of the Moscow-area firms of Gardner, Popov, and Kuznetsov—and in the post-Revolution years, the Dmitrov and Dulevo state porcelain

factories—is distinguished by its remarkable perfection and subtlety of execution. The world-renowned Moscow firms of Khlebnikov, Ovchinnikov, and Fabergé, as well as others that sprang up from the second half of the nineteenth century to the beginning of the twentieth, created beautiful works in silver and gold reflecting the traditions of native Russia. The clothing of village folk, urban dwellers, and the military provide insight into the wearer as well as the manufacturer. And, finally, the paintings, graphics, and sculpture of Moscow's artists attest to a brilliant range of talent little known to American audiences.

Through this selection, we have endeavored to recreate the phenomenon of Moscow art, life, and events in diverse historical periods. We offer you a fascinating journey far into the past centuries, an opportunity to encounter not only the masterworks of Russian art, but also the virtuoso artists who made them.

We hope that this exhibition, organized by the Ministry of Culture of the USSR in association with the Smithsonian Institution Traveling Exhibition Service, will strengthen cultural ties between our countries. Its showing in the United States, through the efforts of the Smithsonian Institution and the Goodwill Games, will surely promote a greater mutual understanding of the peoples of our two great nations.

Genrikh P. Popov
Head of the Main Administration of Art
Ministry of Culture, USSR

Empire-style porcelain tea and coffee service from the Popov Factory (1820s, cat. 110).

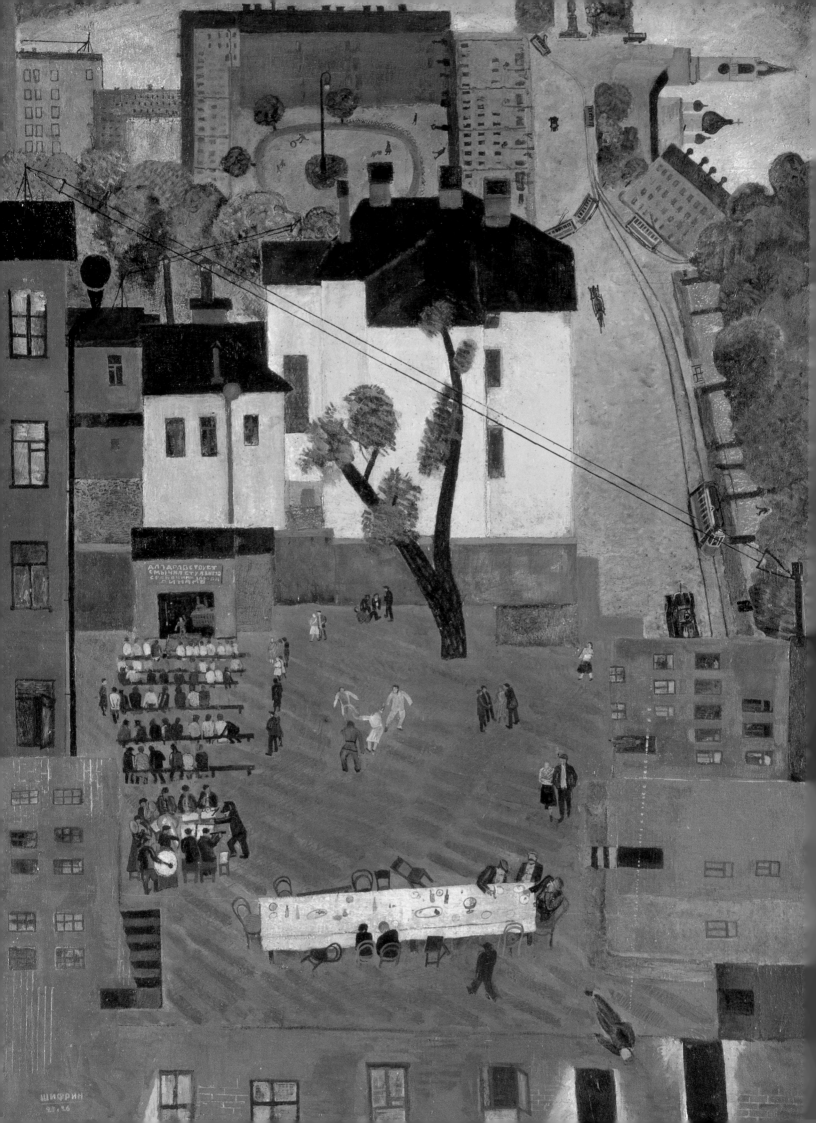

PREFACE

Little dramas within the apartment courtyards attract painter and set designer Nisson Shiffrin in *Strastnoy Boulevard*. Even in this novel perspective, streetcars still run along the boulevard leading to the pink tower and domes of Strastnoy (Holy) Monastery (founded in the 17th century and now the site of the movie theater Rossiya), while beyond the statue of Pushkin lies a tree-filled park promenade beloved from the early 18th century (1926, cat. 213).

It is a great honor for the Smithsonian Institution to collaborate again with the Ministry of Culture of the USSR and the museums of the Soviet Union. With a brilliant array of precious objects and works of art, *Moscow: Treasures and Traditions* traces five centuries of Moscow's culture, following the development of its unique character. The Smithsonian, with its own vast collections of art and artifacts, fully appreciates the value of presenting original artifacts such as these treasures to recreate a panorama of historical events and to interpret the hopes and values of society.

From my own professional research in reconstructing the patterns of life and cities in the ancient Near East, and my experience in living in two quite different major American cities, Washington, D.C., and Chicago, I am particularly aware of the distinctive styles, behaviors, and worldviews that develop in urban cultures. Cities are shaped by the events of their history and the decisions of their inhabitants; and perhaps the corollary to this is that people are shaped by their cities. When that city is also the capital of a world power we welcome a window into its past to inform the present. There are few modern-day capitals that have experienced such dramatic changes and varied roles as has Moscow—provincial city in Kievan Rus, vassal city to Mongol overlords, capital city of a fledgling Russian state, seat of Eastern Orthodoxy, ex-capital for two centuries, and renewed capital of the Soviet Union.

There are also few places where the arts have assumed such a prominent role in defining critical social and political questions in addition to continuing their age-old role of nourishing the soul and pleasing the eye. Through the efforts of the Ministry of Culture of the USSR, the Smithsonian Institution offers here works of art and artifacts of historic significance, preserved through turbulent centuries in the treasuries of the tsars and patriarchs, by individuals and museums. Such an undertaking would not be possible without the generous financial support of The Boeing Company and the commitment of the Seattle Organizing Committee of the 1990 Goodwill Games and the Seattle Art Museum. The exhibition itself reflects negotiations, research, and curatorial efforts of international collegial relationships, which, for the Smithsonian, have opened yet another window for increasing mutual understanding with the Soviet Union.

Robert McC. Adams
Secretary
Smithsonian Institution

IMPRESSIONS OF MOSCOW

I first visited Moscow as a university student in 1960, but my fascination with the great city really started when I was a young boy and began to read Leo Tolstoy's *War and Peace.* For myself and for many Americans, the siege of Moscow during the Second World War seemed like an eerie refrain from that powerful and emotional tale. It was only later that I learned the true depth of Tolstoy's world and art, which has struck such a resonant chord in the hearts of his fellow Muscovites. Tolstoy, like his compatriot Rimsky-Korsakov, evoked mythic themes that had been played out for centuries in the epic chronicles of the ancient capital, and thus were ingrained in the fabric of the Russian character. Over nearly a millennium, Moscow—great crossroads of culture and conflict—had become a place where fact and legend were almost as one, just as it remains to this day.

But one fact was clear on that visit in 1960, as I drove the long road that Napoleon's armies had trod years before: the vastness of the land and the fierce storms from the north are formidable allies indeed. And so they have been for hundreds of years. Since the days of ancient Rus, the forces of nature have saved Moscow again and again from annihilation at the hands of invaders. Winter, it may come as no surprise, is a time of great joy in Moscow. But the land and the climate have also played the part of antagonist to the city, and one sees this imprint as well on its rich cultural heritage.

Through the paintings and decorative objects in this exhibition, we can see the unfolding of Moscow's turbulent and splendid cultural development. To Moscow has fallen a special role in the minds and hearts of the Soviet citizens, a role forged by its history of celebrated and sobering events—the coronations of the tsars, the October Revolution, the great victory parade of 1945. These works of art, from warrior icons to Sergey Ivanov's *Arrival of the Foreigners,* reflect both the troubled history and unique genius of the city, a

genius that even today continues to inspire Moscow's many-faceted art scene.

If we look closely at a map of European Russia we can observe a vast state with few natural borders; nor do its political boundaries, now as in the past, follow ethnic or linguistic demarcation. This may give a clue to some of the characteristics of the artistic styles that have been associated with Moscow.

Since its birth, the city has enjoyed a somewhat protected geographical location—not on a major north-south route by river, such as Kiev, but between Russia's two great avenues of invasion and trade, the Dnepr and the Volga. Even the northern east-west caravan route, which passed near Moscow between these two great rivers, was less favored than the southern route across the steppe and to the Ukraine. Moscow was buffered and protected as well by endless forests of fir and birch.

It was this geographical isolation, then, that gave the young state of Muscovy a chance to discover its own character. The insulation provided the people and their craftsmen with the time to adapt themselves to the land, which led to the birth of the folklore and culture of the region. Ultimately, Muscovy accepted the inevitable intervention of outside forces and the influx of new ideas, but it held tenaciously to roots sunk deep in the early years of its life. These traditions were tempered in each generation by the fates—usually by how long each wave of new peoples stayed in the precincts.

A bewildering procession of tribes must have crossed the Moskva River and its tributary, the Neglinnaya, in order to camp on the protected height of Borovitsky Hill, the site of Moscow's first settlement. The early Muscovites were menaced in the north by the Vikings and in the southwest by the Kievan state and the Byzantine Empire. In the southeast, the Kazans annually ravaged the country around Moscow and in the east the descendants of the Huns marched across

Isaak Levitan was an undisputed master of Russian landscape painting. In the wondrous play of *Moonlit Night. The Big Road* he uncovers the subtle rhythms of silver tree trunks and black shadows that vanish quietly into a mysterious blue-violet night (1890, cat. 183).

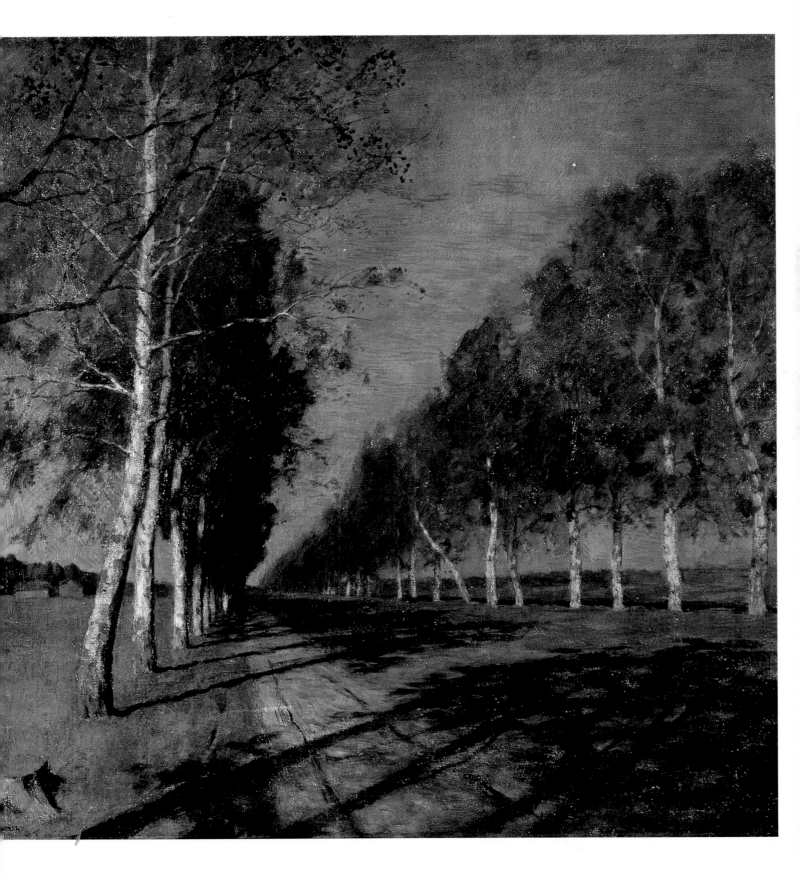

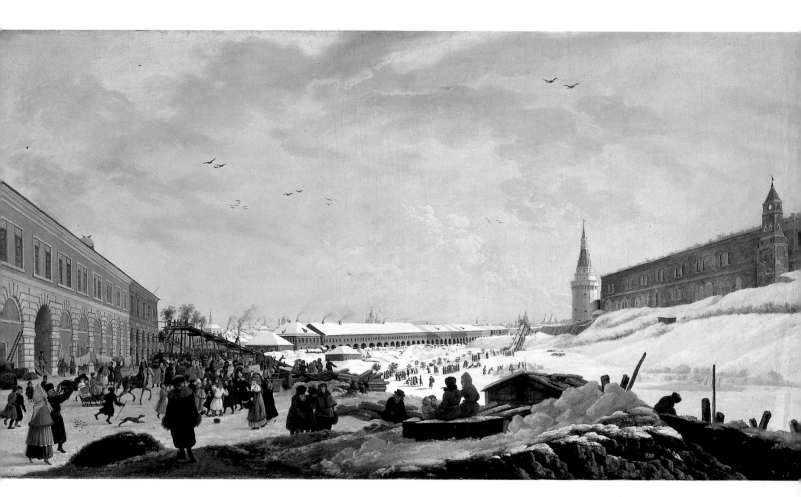

The French-born painter Gerard de la Barthe worked in Russia for twenty-five years. His many scenes of Moscow life painted between 1794-98 enjoyed wide popularity as engravings in Europe and Russia. *Ice Slides on Neglinnaya Street in Moscow During the Week Before Lent* depicts Muscovites enjoying Shrovetide amusements outside the Kremlin walls— a particular favorite the high wooden slide glazed with ice in the background (1795, cat. 160).

the steppe and into Europe in the fourth and fifth century, achieving under Attila a still-astonishing reputation for ferocity. Epic oral poems called *byliny* chronicled these fabled days; a few lines from *Song of Igor* (ca. 1187) capture the vivid mingling of myth and reality that in a way came to define the early character of Moscow:

From dawn till dusk, from dusk till dawn the tempered arrows flew, sabres clanged against helmets, lances of Frankish steel clashed in the unknown steppe amid the Polovetsian land. The black earth beneath the hooves was sown with bones and watered with blood, and a harvest of sorrow came onto the land of Russia.

Even today, the force of oral tradition and legend continues to shape the culture of the city, perhaps nearly as much as the undeniable tumult of its long and eventful history.

Moscow was sacked by the Mongols in 1237. In part, the invaders were lured to the region by their need for the highly skilled craftsmen, artists, and poets found in such settlements. Eventually, Russia freed itself from the grip of the Mongols, and in the latter fifteenth century inherited the traditions of Orthodoxy from fallen Byzantium. Now, Byzantine culture merged forcefully with the heritage of Moscow. As with other influences thus absorbed in the workshops of the grand princes and later the tsars, the inevitable result was something new and quite distinct.

An icon portrait of Tsar Fedor I (1584-98), painted in the 1630s or 1640s, captures this blending of the Byzantine and Moscow styles. The icon, a transitional type called a *parsuna,* speaks movingly of the struggle of the age. The artists of the time were coming to grips with the new secular aesthetic demands, even as they held to Byzantine dictums that art should express the eternal truths of Orthodox belief.

Such portraits of individuals were usually commemorative, and this one appears at first to be completely within the traditions of icon painting. But upon closer inspection, one senses a greater simplification of the figure and the style, as well as a more naturalistic use of color and of motifs that draw on the art of both past and present.

It was during Fedor's reign that the head of the Russian church was upgraded to the rank of patriarch, on equal terms with the ancient patriarchates of Rome, Constantinople, Antioch, and Jerusalem. Thus, yet another myth was born that would nurture the culture of the city—Moscow as "the Third Rome."

In architecture, there was a search for forms to convey the new status of the city. This led to the creation of the splendid ensemble of the Moscow Kremlin—itself destined to become a legendary symbol of the glory and might of the Russian lands. The period also produced intensely lyrical painting. This synthesis of the heroic and the lyrical—fostered by an influx of artists from northern Italy—engendered the so-called "Russian Renaissance."

The unification of the Russian land into a single centralized state, led by Moscow, produced an upsurge of national consciousness and an unprecedented flowering of culture. In the tsar's workshops, influences from north, south, east, and west were wed with Russia's richest folk arts, to beget styles unlike any the world had ever seen.

Yet it was a process to be repeated again and again in coming centuries. Moscow experienced many cycles of reviving its great breadth of traditions, to be enriched each time with an array of new influences. Certainly as we stand on the brink of this era of *glasnost,* Moscow will once again see its heritage in a new light, and in the process help preserve the glories of its past as well as shape the challenges of its future.

Donald R. McClelland
Exhibition Coordinator and Curator

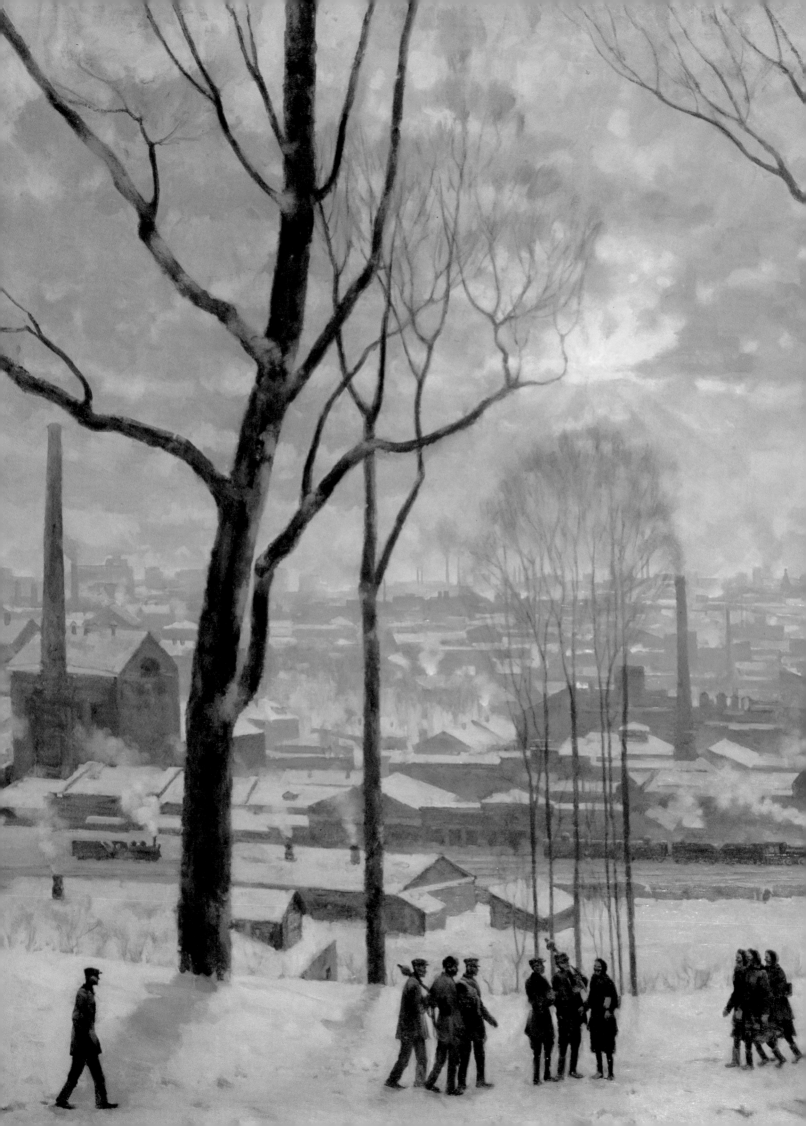

By his seventy-fourth year, Konstantin Yuon had lived through many changes in Moscow and the arts when he chose to paint *Morning of Industrial Moscow* in 1949. At that moment, when the arts were subject to rigid political orthodoxy, Yuon found quiet beauty in the blue haze of a frosty morning—in the ordinary passage of workers set against the extraordinary Brueghel-like vista of Moscow beyond (cat. 218).

W. BRUCE LINCOLN

MOSCOW, THE CULTURAL HEARTLAND OF RUSSIA

At the confluence of the Neglinnaya and Moskva rivers, the Borovitsky Hill juts upward from the Russian plain. Neither known nor commented upon by chroniclers during Europe's Middle Ages, it was an out-of-the-way place, far from the great trading centers that exchanged the goods of Asia with the West. Novgorod, Russia's link with the Hanseatic League and lord of a vast fur empire that swept across the far north of Eurasia, stood more than three hundred miles to its northwest; Kiev, the bastion that guarded Christian Europe against the pagan horsemen of the steppes, lay five hundred miles to the southwest.

Sometime around the eleventh century, life in the region overlooked by the Borovitsky Hill began to change as settlers replaced the herders and hunters of earlier times. Smiths, potters, cobblers, and jewelers lived among these new-comers and produced wares for trade with others who lived within the reach of central Russia's rivers. Located near the headwaters of the Oka, Volga, Don, and Dnepr—four of the greatest rivers in European Russia—the region around the Borovitsky Hill thus gained the wherewithall to attract wealth and influence just as the centers of political and economic power in the Russian land began to shift away from Novgorod and Kiev.

The settlement near the Borovitsky Hill took on military significance just after the middle of the twelfth century. In the year 1156 according to the ancient Tver chronicle (others dispute the exact date and speak in more general terms) Prince Yuri Dolgoruky of Suzdal built a forti-fied outpost there as a link in the chain of de-fenses that guarded the southwestern frontier of his small domains. With scarcely enough room for a man to walk a hundred paces in any direc-tion from its center, Dolgoruky's rough log forti-fication marked the beginning of Moscow's Kremlin. Among the flourishing centers from which a score of richer, more powerful princes ruled the principalities into which the Russian land was fragmenting in those days, it was the poorest of second cousins. Over a hundred years elapsed before a significant town took shape around it, and another century before Moscow took on much political significance. It began to grow stronger in the fourteenth century and during the next three hundred years would spread its power across six thousand miles of Eurasia to the Pacific. Yet, no matter how far Moscow reached or how much its power in-creased, the Kremlin that crowned the Borovit-sky Hill remained the center of its life. "There is nothing above Moscow except the Kremlin," an

Edward Gartner's 1839 *Ivanov Square in the Moscow Kremlin* shows Assumption Cathedral and the Hall of Facets on the left and Ivan the Great's Bell Tower in the center, with the tsar's bell on a pedestal. Por-trayed are members of the family of Count Vasily Olsufev, Mos-cow's civil governor (cat. 165).

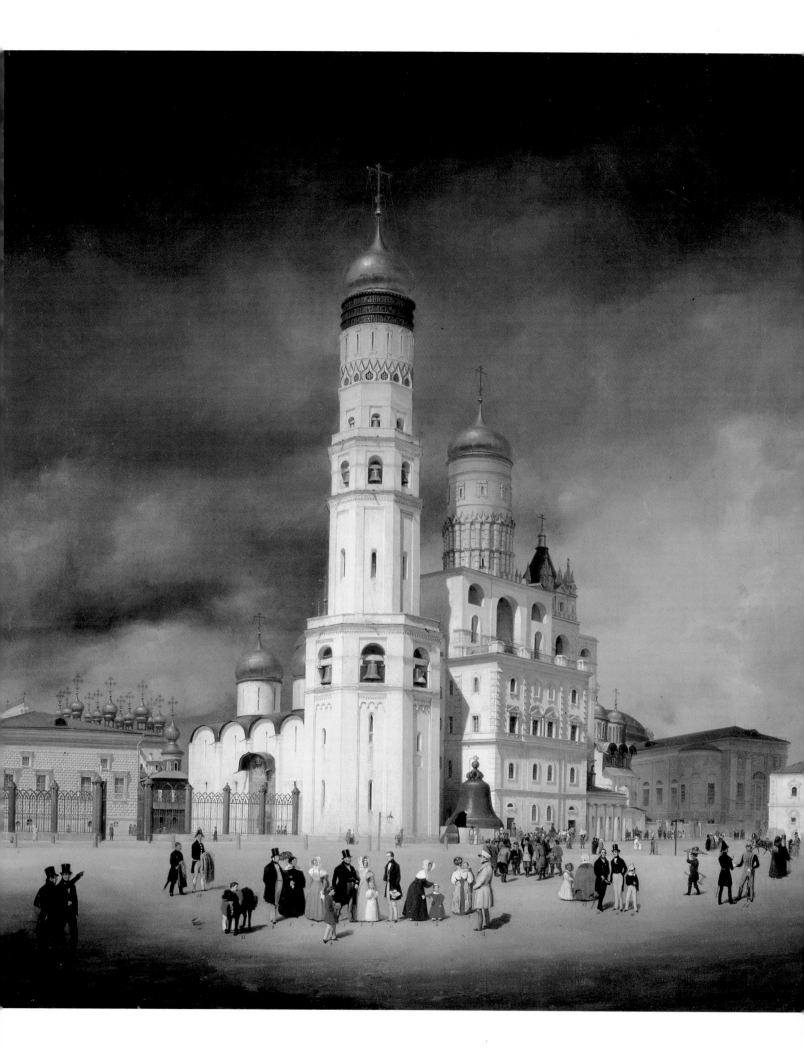

Sent to Russia twice as Charles V's ambassador, Sigismund Herberstein published, thirty years later, his illustrated comments on life within and beyond the Kremlin, including the bison and aurochs of the forest and the first known Moscow city plan, here reprinted in Braun's atlas of 1577, *The Most Famous Cities of the World*. In it, Moscow was said to be twice as large as Prague (cat. 142).

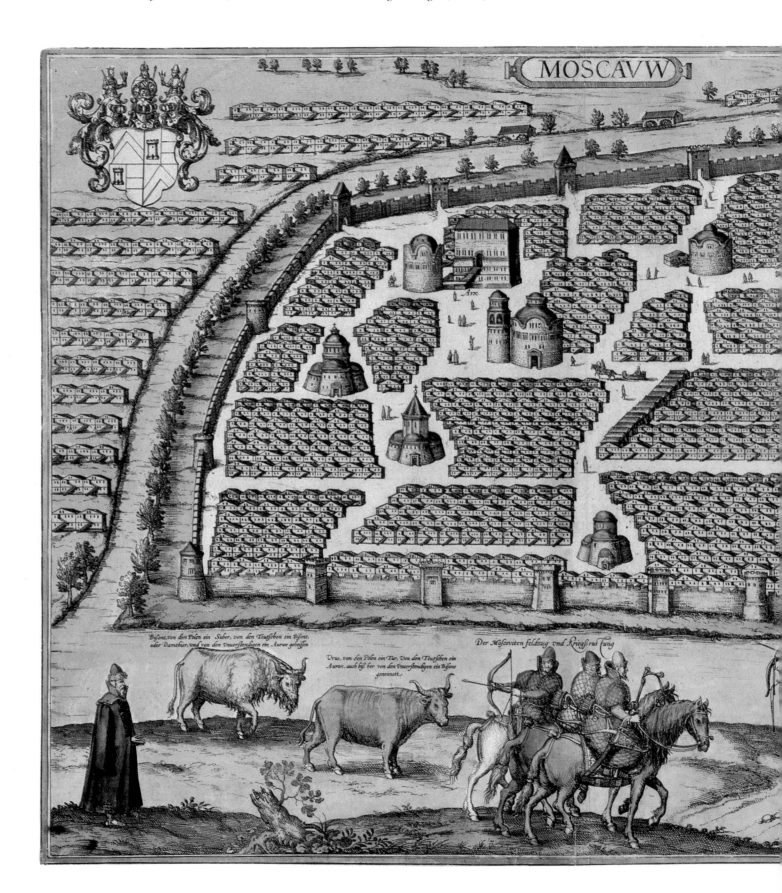

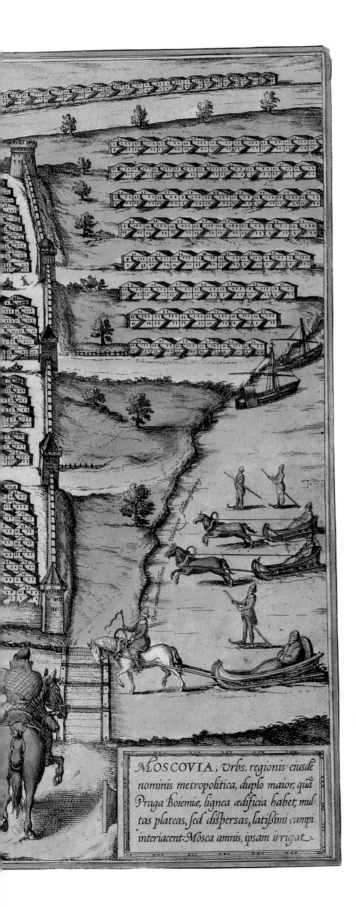

MOSCOVIA, urbs, regionis eiusdē nominis metropolitica, duplo maior, quā Praga Boiemiæ, lignea ædificia habet, multas plateas, sed dispersas, latißimi campi interiacent: Mosca amnis, ipsam irrigat.

old Russian proverb said, "and there is nothing above the Kremlin except Heaven."

As Moscow's power increased, the Kremlin grew. At the end of the 1330s, Ivan I, known as Ivan Kalita (the moneybag) in recognition of his reluctance to part with the wealth he collected from his subjects, doubled the area that lay within its walls. Ivan rebuilt Dolgoruky's rough palisade with stout oak logs laid horizontally and joined so cleverly that they appeared seamless from the front and offered no handhold to attackers who might try to scale them. A quarter-century later, Grand Prince Dmitry, later called Donskoy to commemorate his victory over the Mongols at Kulikovo on the banks of the Don River, replaced Ivan's oaken defenses with walls of stone and expanded them to bring the Kremlin nearly to its present dimensions.

From the Kremlin's gates, Moscow's rulers went forth to unite the Russian lands. Ivan Kalita had ruled a kingdom that covered less than six hundred square miles, but a long line of able successors built impressively upon those humble beginnings. As Moscow's princes became Grand Princes of All Russia, then Tsars and Autocrats of All the Russias, and, beginning with Peter the Great in 1721, Emperors and Empresses of All the Russias, they spread their dominion across more than eight and a half million square miles of Eurasia. Great Novgorod bowed before them at the end of the fifteenth century and Kiev entered their domains in the seventeenth. Reval and Riga, the two easternmost Hansa towns, whose wealth at one time had surpassed the wildest imaginings of Moscow's princes, came under the sway of Russia's emperors in the eighteenth century. By then Russia's lands had reached the Pacific and soon crossed its waters to the shores of Alaska and California. Eleven time zones lay within Russia's Eurasian domains. In those days, the sun never set upon the lands of Imperial Russia.

There was a Russian church before there was a Russian state, and one of the great strengths of Moscow's princes was their ability to enlist its

support in their effort to gather the Russian lands. In 1325, Metropolitan Peter had died in Moscow and, three years later, his successor had moved the center of the Russian church from Vladimir to the city of Peter's death. After that, church and prince had worked hand in hand to unite Russia. Because Moscow's princes were doing the work of Christ, the church fathers insisted, any who resisted them must be branded enemies of Christ and punished by excommunication. This blunted many challenges to Moscow's hegemony in Russia, for none of her rivals enjoyed the same unique combination of political power and church support. By the end of the fifteenth century, Moscow had become the center of the Russian land and the capital of the first Russian state.

To symbolize the centralization of political power in Moscow, her princes uprooted works of art closely identified with formerly independent principalities and placed them in an all-Russian pantheon in the Kremlin. The most precious of these early monuments of Russian art was the icon *The Virgin of Vladimir,* which had been painted in Byzantium for a church built by one of Kiev's princes and moved to Vladimir before the end of the twelfth century. Perhaps no other icon portrays such clear affection between mother and child or radiates so much tenderness. Although painted by an unknown artist, *The Virgin of Vladimir* soon came to stand as one of the truest symbols of Russian Orthodoxy. For that reason Grand Prince Vasily I ordered it moved to Moscow in 1395 as a symbol of his capital's new status as the center of Russian Christianity.

Other regional treasures followed *The Virgin of Vladimir* to Moscow. One of the last to make the journey was a twelfth-century icon of St. George that had been painted by a Greek artist working in Novgorod and stood as an impressive monument to that city's patronage of the fine arts. Novgorod's masterpiece came to Moscow on the orders of Ivan the Terrible when the tsar was trying to rebuild the Kremlin's cathedrals as national symbols of piety after the great fire of 1547 destroyed some of their best icons. Yet politics as well as piety underlay his order, for the terrible tsar probably also had in mind that the transfer of this icon, which portrayed St. George bearing the sword of sovereignty in true Russian fashion, would symbolize the subjugation of the once proud Novgorod by Moscow.

Moscow's princes adorned their Kremlin with brilliant new works as well as transported masterpieces. Feofan Grek (Theophanes the Greek), an artist who had settled in Novgorod around 1370 and painted frescoes for some of its greatest churches, came to Moscow soon after 1400 at the invitation of Grand Prince Vasily I. Feofan established a workshop in Moscow—probably the first in which Greeks and Russians worked closely together—which produced icons that remain among the greatest of Russia's early fifteenth-century masterpieces. Profuse in his use of highlights and noted for his sweeping brush strokes, Feofan produced somber, dramatic, elongated images that imparted a vivid ascetic character to his work. His decoration of the Kremlin's Cathedral of the Annunciation in the early 1400s easily stands as one of the greatest monuments of his age. Probably the creator of the full-length deesis tier in the cathedral's iconostasis, Feofan increased its height dramatically and gave it an entirely new significance. Icon painters who followed him preserved his new emphasis upon height in their work, and painted Russia's saints full-length and life-sized. Yet the artist who first surpassed Feofan's brilliance concentrated not on boldness and height but on line and shading. Perhaps for that reason, Andrey Rublev became the greatest of Russia's icon painters.

Rublev's biography is shrouded in mystery.

Medallion portrait of Peter I by Armory painter Gregory Mussikisky; on the reverse is the insignia of tsarist Russia—the double-headed eagle of Byzantium—adopted by Ivan III 200 years earlier. St. George, protector of the poor and slayer of the dragon of paganism, is emblazoned on the crest (cat. 85).

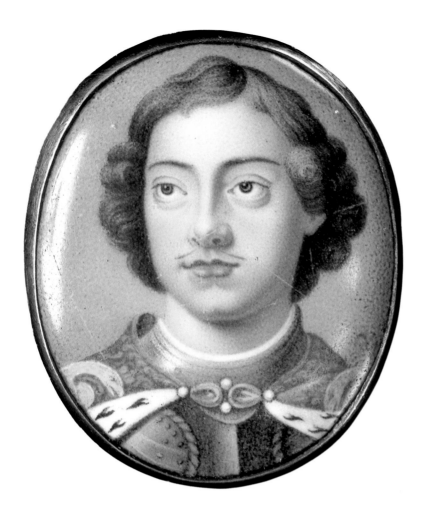

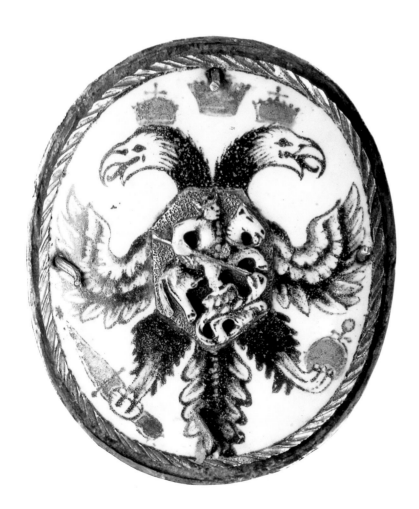

We know only that he probably was born around 1370, that he became a monk in his youth, and that he came to Moscow from the Troitse-Sergeyev Monastery in Zagorsk at about the time Feofan established his workshop. A young man when Feofan already was well along in years, Rublev combined brilliant delicacy of shading with superb harmony of color in his painting. His icons had neither the ascetic tension nor somber drama of Feofan's work but instead evoked a great serenity that emphasized the otherworldly character of his saintly subjects. Several great fires destroyed most of what Rublev painted in Moscow, and the best surviving examples of his work are the icons and murals he did in Zagorsk and Vladimir on commissions from his royal patron in Moscow. Yet even these few remains of what must have been a very large corpus are more than sufficient to establish Rublev as one of the world's greatest artists in the opinion of many art historians. The profound spirituality and grace in Rublev's work set a new standard for Moscow painting at the beginning of the fifteenth century.

Moscow's princes grew powerful because they were careful to seek favor with the Mongols, the fierce Asiatic warriors who spread their empire from China to the Danube during the first half of the thirteenth century. Fighting as some of the most effective light cavalry that the world has ever seen, the Mongols had moved quickly through the Russian land between 1237 and 1240, striking without warning and killing without mercy any who opposed them. "Even the earth began to moan,"one chronicler wrote as he told of their attack against Ryazan, a city that lay a little more than a hundred miles southeast of Moscow, at the end of December 1237. A month later, Moscow's turn came. When the Mongol armies moved on to take greater prizes in Vladimir at the beginning of February 1238, they left the Kremlin's wooden defenses in ruins.

Drawn by Russian cartographers for Tsar Boris Godunov, this map accurately depicts the Kremlin in the early 17th century. Merchants and artisans no longer lived within the Kremlin, which had truly become the residence of the tsar, the patriarch, and select boyar elite (cat. 144).

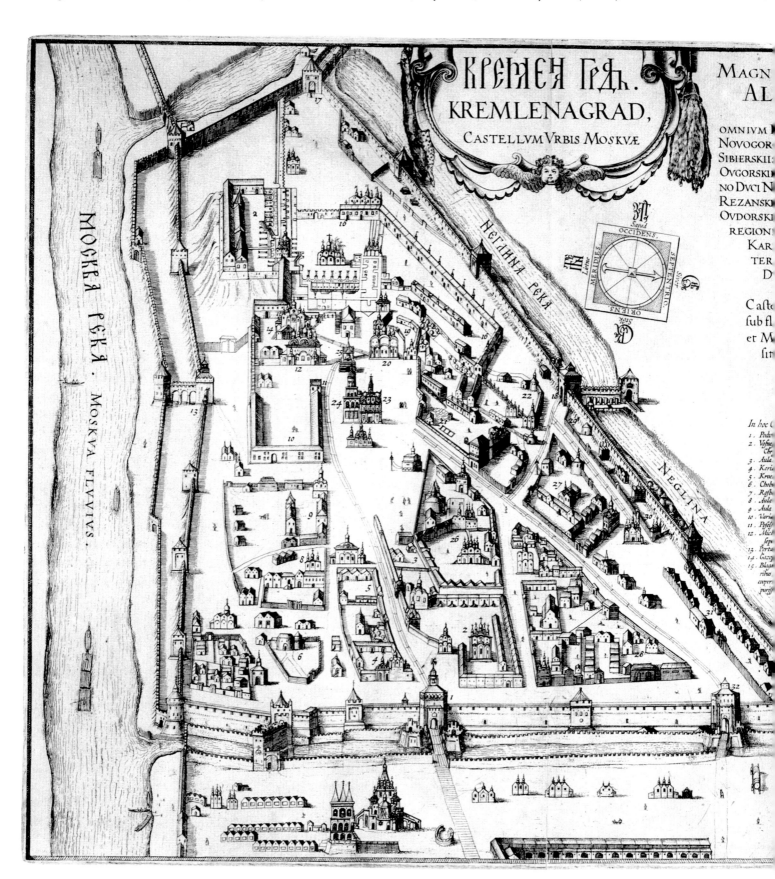

DOMINO CÆSARI, ET MAGNO DVCI
IO. MICHAELOVITS.
· DEI GRATIA,
RVM AVTOKRATORI, VLADIMERSKII, MOSKOFSKII
: TZAR KAZANSKII, TZAR ASTOROCHANSKII, TZAR
NO PLESKOFSKII: MAGNO DVCI SMOLENSKII, IVERSKII
ASKII, VEATSKII, BOLGARSKII: ETIAM DOMINO, ET MAG
RODI IN TERRIS INFERIORIBVS, TZERNIGOFSKII,
YTZKII, ROSTOFSKII, IAROSLAFSKII, BELOZERSKII,
ORSKII, KONDINSKII ET TOTIVS SEPTENTRIONALIS
NDATORI; ET DOMINO TERRARVM IVERSKYE,
SKICHI, ET GRVZINSKICH CÆSARVM ET
KABARDINSKIES, TZERKASKICHI, IGORSKICH
ET MVLTARVM DITIONVM DOMINO
ET MODERATORI
cum tribus contiguis Vrbibus Moſkuæ, prout
Imperio, piæ memoriæ, Magni Domini Cæſaris,
Ducis Boriſſi Fœdorovits, omnium Ruſſorum, &c.
imenſu fuit; ſummâ ac debitâ obſervantiâ,
offertur. dicatur. conſecratur.

ᵣbis Moſkuæ · Typo hæc ſubſequentia ſuis numeris notata deſignantur ordine.

Porta Frolofſkie · 16. Aula Cæſaris . a. Nova Aulæ ſtructura .
ter. Monaſterium Aſcenſionis 17. Boerowinſkeuerod . Porta alta ſylvæ .
ᵣatrices ſepeliuntur . 18. Cammenemoſt, Porta iuxta pontem lapideum .
novits Selemeyteff . 19. Aula Patriarche .
rie, hoſpitium Kerilofſkiorum . 20. Pretziſki. Beatæ Mariæ Virginis, Soborno tzerke,
rie, hoſpitium Kroeciſkiorum . templum Synodale, quo Eccleſiaſtici omnes conveniunt .
mamentarium . 21. Vetus Aula Domini, ſcilicet Boriſſi Fœdorovits Godunoff
Tribunal aut Ius grasſatorum . qui poſtea Cæſar fuit .
Vaciliovits Sſetſkie . 22. Troyſke podvorie; hoſpitium Troytſkorum .
ᵣu Ivanovits Meſſeſloffske . 23. Reskſtova Chriſtova; Templum in quo Cæſar feſto
Peregrinæ Iuris præfecture . Nativitatis ſacrum audit .
gel; Templum in quo omnes Cæſares 24. Ivan velikoy; magnum Divi Ioanis templum, cuius
 turris tegimen deauratum eſt, campaniſque abundat .
 25. Campana magna, pendens penè 2200. podas, quæ
 valeret ponderum noſtratium 66000. libris .
umen. Meſkua . 26. Iſnoulena Monaſtir; Monaſterium miraculorum .
Cæſaris, et Magni Ducis . 27. Aula Bogdani Iaclovits Belſkoy .
ᵣntiatie. Marie; templum novum tur 28. Aula Andreæ Petrovits Kleſhin .
ta, ut et totius templi, ære deaurate 29. Aula Simeonis Nikitovits Godunoff .
et Crux altiſſime turris ex auro 30. Aula Dimetri Ivanovits Godunoff .
ta eſt-. 31. Aula Gregorij Vaciliovits Godineſſ; poſtea fuit
 Granarium .
 32. Nicoolſke vored; Porta Sancti Nicolai .

FLVVIVS.

Privilegio Nobilis-
simorum et Præpotentum
D. D. Ordinum Generalium
Confœderatarum Regionum
cautum eſt, ne quis has
Tabulas Civitatis et Caſtelli
Moſkuæ aliquo modo im-
primat, aut alibi im-
preſſas divendat .

While more illustrious princes continued to struggle against the Mongols' domination, Moscow's rulers learned the value of capitulation. It was no quirk of fate that the Mongol khan had confirmed Ivan Kalita's claim to the title of Grand Prince and had received his commission to collect the Mongols' yearly tribute. Nor was it accidental that Ivan's successors followed his example. Accommodation with the Mongols thus formed the keystone of Moscow's policy while its princes increased their wealth and strengthened their authority over other Russians. Not until the Mongols had ruled Russia for nearly a century and a half did a Moscow prince challenge their authority. Then the Grand Prince Dmitry had marched against the armies of the Mongol khan Mamai and had defeated them on Kulikovo field in September 1380. This victory did not immediately lift the Mongols' yoke from Russia, but it shattered the myth of their invincibility and marked the beginning of their decline. A hundred years later, Dmitry's great-grandson Ivan III fought the Mongol armies once again, this time on the Ugra River, to mark the formal end of their hold upon Russia. For defeating the Mongols and for his success in gathering the Russian lands, Russians would remember this tsar as Ivan the Great.

Ivan's victory enabled him to replace the Mongol khan as master of the Russian land. Yet there was more behind Moscow's mastery of Russia than a single victory. In 1453, the last Byzantine emperor, Constantine XI, had perished upon the walls of Constantinople just before his city had fallen to its Moslem attackers. As ruler of the only Orthodox state not yet under infidel domination, Ivan therefore claimed the legacy of Byzantium, and this strengthened his authority fully as much as did his victory on the Ugra. In 1472, he married Sofia Paleologus, niece of the last Byzantine emperor. About a decade later, he began to use the double-headed Byzantine eagle as a state crest and claimed the titles of tsar and autocrat, both of which carried imperial meaning. Before the end of the century, the head of the Russian church proclaimed Moscow the Third Rome, the successor to Rome and Byzantium, and the last hope of salvation for mankind.

In the 1470s, Ivan began to rebuild the Kremlin to reflect his new grandeur. Brought into contact with the influences of the Italian Renaissance by his marriage to Sofia Paleologus, who had been educated in Rome as a ward of the Pope, he turned to the builders of northern Italy to transform his vision of a new Kremlin into stone and mortar when it proved beyond the skills of Russian architects to do so. Cathedrals formed its center; new brick and stone fortifications shaped the perimeter.

To rebuild Moscow's Kremlin, Ivan turned first to the architect Rudolfo Fioravanti. Called Aristotele by the Russians out of respect for his wide learning, Fioravanti had once been the chief engineer of Bologna and had built a bridge across the Danube for Hungary's Matthias

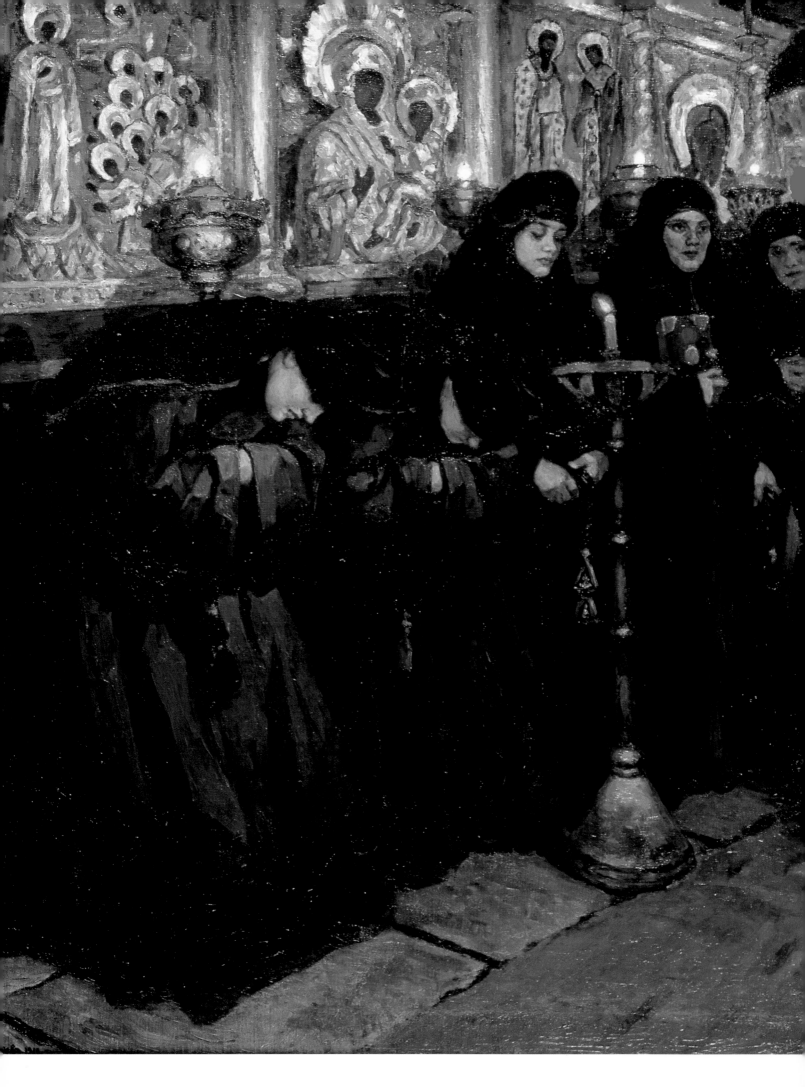

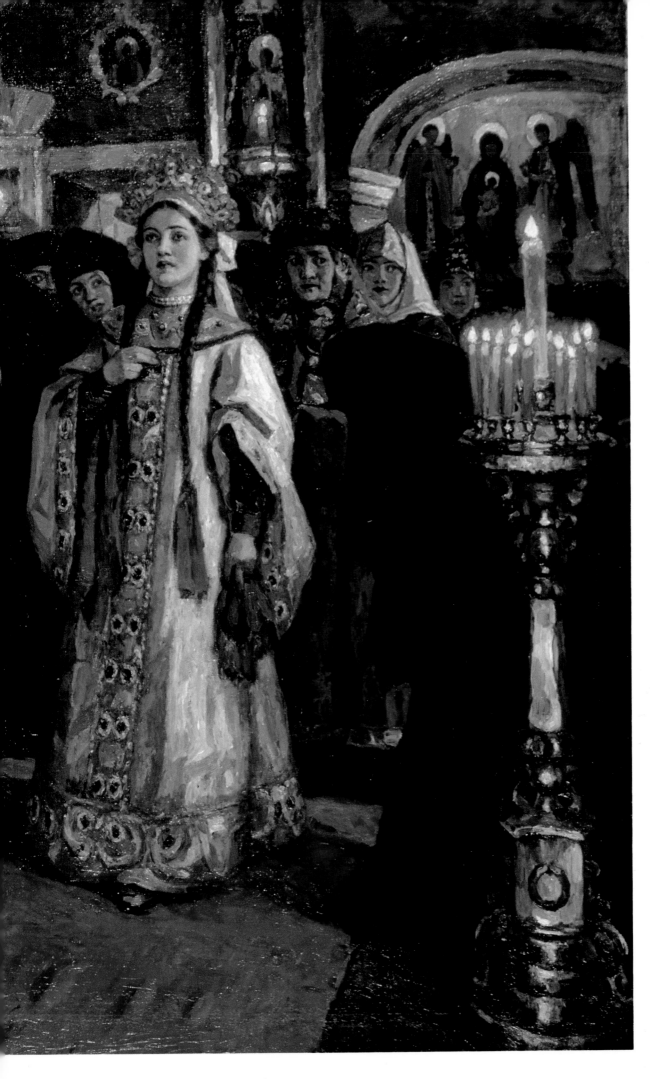

Historical painter
Vasily Surikov dramat-
ically recreates medie-
val life in *The Visit of
the Tsarevna to the Con-
vent*. Flickering icon
lamps illuminate the
gold-clad icons and
richly ornamented
robes of the royal prin-
cess as she enters the
convent, the predeter-
mined life of many
daughters of tsars
(cat. 186).

Corvinus before he came to Russia in 1475. Using the Cathedral of the Assumption in Vladimir as his model, Fioravanti built the Kremlin's cathedral of the same name on a larger scale in the space of four years. Yet his was no mere copy of the masterpiece that had graced Vladimir since the end of the twelfth century. Fioravanti combined his own innovations with Novgorodian and Italian Renaissance elements to produce a cathedral of unprecedented spaciousness by Russian standards. At the same time, his workshops in the Kremlin provided Russians with rare training in architecture and engineering that they would apply elsewhere in Moscow as the city began to grow beyond the Kremlin's walls.

Completed in 1479, Fioravanti's Cathedral of the Assumption immediately occupied a position of precedence among the Kremlin's churches. There, Russia crowned her tsars, and there they were wed. From its altars, metropolitans and patriarchs offered up solemn prayers for Russia's salvation in times of danger and celebrated masses of thanksgiving for victories won in days of triumph. Yet Fioravanti's creation marked only the beginning of Ivan's rebuilding program. Using architects from Novgorod's recently conquered sister city of Pskov, this dynamic tsar rebuilt the Cathedral of the Annunciation in the 1480s to be the family church of Russia's sovereigns.

Before work on the Cathedral of the Annunciation was finished, Ivan set other builders to work on a ceremonial hall and royal audience chamber. This time, he turned to Marco Ruffo and Pietro Antonio Solario, who built the fa-

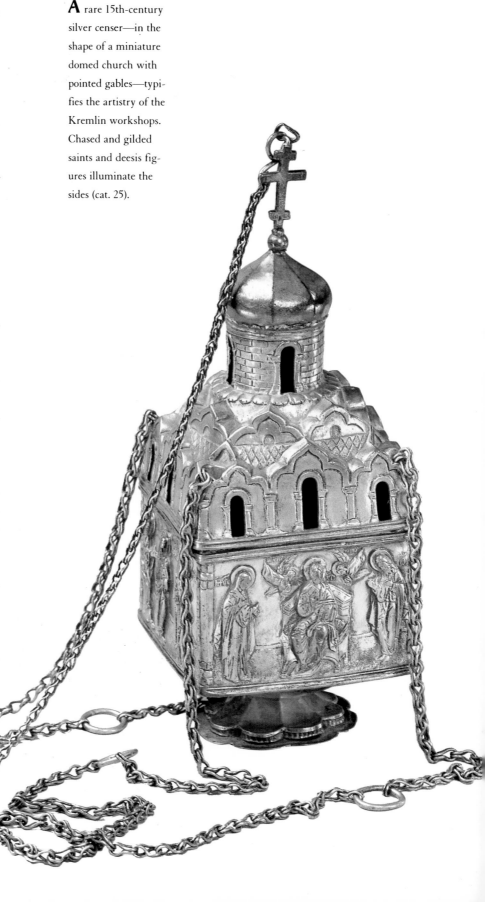

A rare 15th-century silver censer—in the shape of a miniature domed church with pointed gables—typifies the artistry of the Kremlin workshops. Chased and gilded saints and deesis figures illuminate the sides (cat. 25).

mous Palace of Facets very much in the style of the early Renaissance Italian palaces they had known in Ferrara and Bologna. The most striking feature of the palace was the vaulted ceiling in its second-floor ceremonial hall. Supported by a single central pillar, this was entirely in the Russian tradition and reminded foreign dignitaries of the different world into which they had arrived. Ruffo's and Solario's vaulted ceiling would look upon the making of Russia's history in centuries to come: the coronation feasts of tsars and emperors, the reception of foreign ambassadors, and the celebration of her greatest victories. As a young prince, Ivan the Terrible would celebrate the Russians' capture of Kazan in 1552 in this great hall. In the same place, a century and a half later, a thirty-seven-year-old imperial giant named Peter the Great would toast Russia's first triumph over the armies of modern Europe after he had defeated the forces of Sweden's Charles XII at Poltava during the summer of 1709.

Like Ivan the Terrible and Peter the Great who came after him, Ivan the Great wanted to bring the latest military technology to Russia. To defend his Kremlin, he therefore built new walls of stone and brick. Sixty-five feet high and surmounted by nineteen towers, Ivan's walls stretched for a mile and a quarter and encompassed seventy acres, their massive facades broken only by five large gates. Costly, imposing, and supposedly impregnable because they incorporated the best defense technology of the time, these transformed Moscow's Kremlin into a fortress similar to the castles of Ferrara and Milan.

Ivan the Great turned his attention to the last of the great Kremlin churches, the Cathedral of Michael the Archangel, in 1505, the year of his death. This time he employed Alevisio Novi, an Italian architect who lacked Fioravanti's daring but created a masterpiece nonetheless. Novi utilized such northern Italian devices as ornate portals, bold horizontal cornices placed beneath scallop shells, rosettes, Venetian windows, and garlands to ornament the red brick and white

stone structure that would serve as the necropolis of Russia's tsars until Peter the Great moved Russia's capital to St. Petersburg at the beginning of the eighteenth century.

Although the Cathedral of Michael the Archangel was completed soon after the death of Ivan the Great, the last feature of his prodigious reconstruction program was not finished until almost a hundred years later. The original three stories of the Bell Tower of Ivan the Great were built by the Italian Marco Bono during the first years of Vasily III's reign. Ivan the Terrible added a bell tower of the Novgorod-Pskov type next to Bono's structure some thirty years later, but it was not until 1600 that Tsar Boris Godunov, elected to the Russian throne after the dynasty of Rurik had reached its end, added the final stories that raised the Bell Tower of Ivan the Great to a height of two hundred sixty-five feet, making it the tallest structure in Russia.

The newly gathered Russian lands over which Russia's sixteenth- and seventeenth-century tsars ruled from Ivan the Great's reconstructed Kremlin were by no means secure. Nor had they ever been. Situated in an irregular arc that began with the Novodevichy Convent to Moscow's southwest and swung to the east and north to include the Donskoy, Danilov, Simonov, and Novospassky monasteries before reaching the Andronnikov Monastery, where Rublev had lived much of his life, six fortress monasteries and convents had risen in Moscow's outskirts during the fourteenth and fifteenth centuries. Between these outlying defenses and the Kremlin's walls, Russia's tsars built two more rings of defenses, an inner one of stone and an outer one of earth, before the end of the sixteenth century. Within them lay Moscow's many churches and a handful of stone buildings. The combination of towers, walls, gates, and church domes made Moscow an exotic and impressive sight from afar, although it remained much less so from within. "It shines like Jerusalem from without," the Holstein diplomat Adam Olearius wrote, "but is like Bethlehem inside."

Of all the natural treasures to be found in Russia, none was more favored by sixteenth- and seventeenth-century Europeans than its furs. More foreigners came to Moscow in the sixteenth and seventeenth centuries in search of furs than ever before, and their accounts of their travels provide us with new and valuable sources about the city's life and culture. The Moscow that these foreigners visited was growing rapidly. Mattias Miechowski, a physician from Krakow who visited Russia's capital in 1517, estimated it to be twice as large as Florence or Prague. At the end of the century, England's Giles Fletcher judged Moscow to be larger than London.

Life in Moscow was uncertain at best. Ivan the Great had transformed the Kremlin into a fortress of brick and stone, but the city that spread around it continued to be built of wood. In Moscow, as in Fletcher's London and Miechowski's Krakow, fires took a continuing and terrible toll. In 1547 and again in 1571, all of the city that lay outside the Kremlin walls burned to the ground. By the seventeenth century, Muscovites had grown so accustomed to rebuilding their homes that a prefabricated house market flourished on the city's eastern side. There, Adam Olearius tells us, an entire pre-cut wooden house could be purchased, delivered to any place in the city, and erected in two or three days.

Ivan the Terrible's invitation for Russia's best icon painters to work in the Kremlin's Armory—the Oruzheynaya Palata—to replace the many treasures that had perished in the great fire of 1547 marked the beginning of the famed Kremlin workshops that produced art for Russia's royalty and the church. As their numbers increased—and as they were joined by Italian, Dutch, German, Greek, Turkish, and even Armenian, Persian, and Indian craftsmen in the seventeenth century—the artists of the Kremlin workshops produced works of high quality in considerable quantity. Skilled in filigree, niello, and enamel, they shaped exquisitely orna-

Europeans were welcome in Moscow as early as the 16th century, but were required to live in a separate district. Sergey Ivanov recreates the cultural contrasts in *The Arrival of Foreigners. Seventeenth Century*, 1901 (cat. 193).

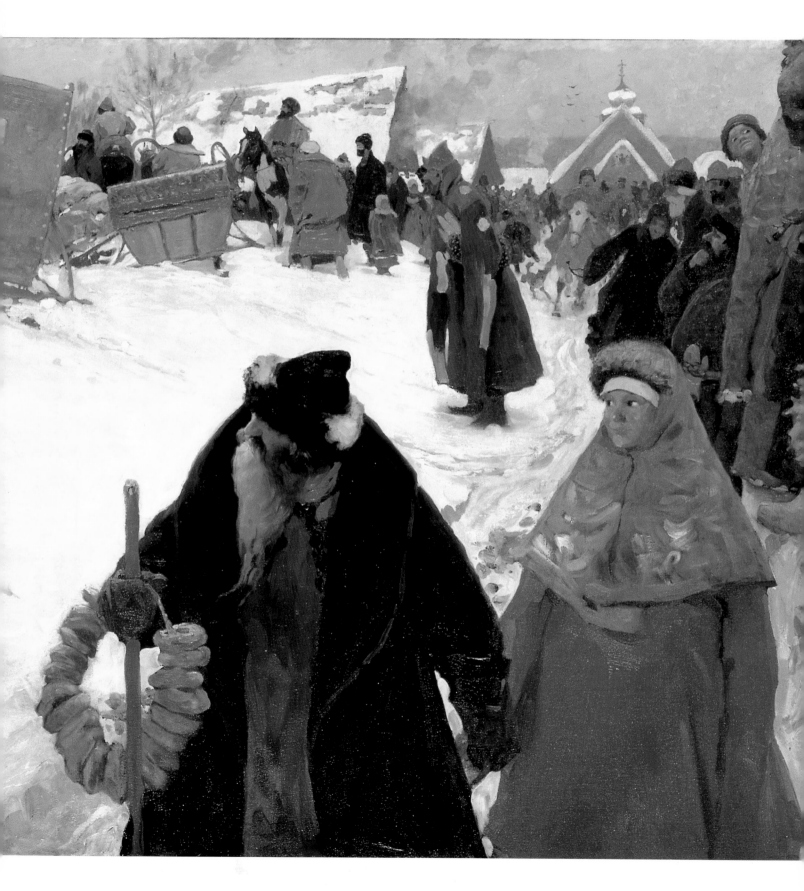

mented chalices, bindings for Gospels, censers, *kovshi,* and other objects to adorn the churches and homes of wealthy Russians. Foreigners were astounded by the quantities of silver and gold plate on Russians' tables in those days—and they were appalled by the dirt that encrusted it. In the sixteenth century, as in the eighteenth and the twentieth, Russia was an enigma to Europeans, a land of contradictions and mysteries that seemed very difficult to understand.

Gold dishes covered with dirt were but one of the many contradictions of an era when Ivan the Terrible put men to death without a thought and begged forgiveness for his sins. Perhaps nothing personified this era of contrasts more vividly than the Cathedral of St. Basil the Blessed, which Ivan built to commemorate his first great victory at Kazan in 1552. Built by the Russian architects Barma and Posnik, the latter of whom came from Pskov, St. Basil's drew upon a Russian architectural heritage whose best examples are the Church of the Ascension in Kolomenskoe (where Russia's tsars had built a rural retreat) and the Church of the Beheading of St. John the Baptist at nearby Diakovo. Incorporating the tall octagonal tower of the Kolomenskoe church in the center of their cathedral, Barma and Posnik surrounded it with eight chapels, each of which commemorated an important event in the seige of Kazan. The result has been called a monstrosity, an inexplicable curiosity, and a church of great beauty. Legend has it that Ivan thought the newly completed St. Basil's so wondrous that he ordered its architects blinded so that they could never build another. Certainly, there are none exactly like it anywhere else in Russia. St. Basil's Cathedral continues to sit at the end of Red Square, a unique monument to the tumult and contradictions that dominated the reign of the tsar who built it.

Ivan the Terrible's readiness to use terror as an instrument of political control combined with his unbridled temper to end his dynasty (the scene of him holding the son he had killed in a fit of rage is the subject of one of Ilya Repin's greatest paintings) and open an era of turmoil such as Russia had not seen since the coming of the Mongols. Called the "Time of Troubles," these years of upheaval began with the death of Ivan's feebleminded son Tsar Fedor Ivanovich in 1598 and continued until the election of Mikhail Romanov to the throne in 1613. The Time of Troubles brought famine, plague, rebellion, and foreign invasion. Peasants and Cossacks led by Ivan Bolotnikov raged across Russia's south during those years. The Swedes seized Novgorod in the northwest, and the motley forces of a half-dozen pretenders ravaged the areas of the Russian land that lay in between. Then in 1611 the armies of Poland occupied Moscow's Kremlin, and Russia lay prostrate beneath a new conqueror's heel. The next year, three very different men—Prince Dmitry Pozharsky, Moscow's Patriarch Germogen, and a village butcher from the Volga river trading center of Nizhny-Novgorod by the name of Kuzma Minin—raised an army, drove the Polish conquerors from the Kremlin, and rescued Russia from her days of peril. Together with five hundred delegates to the Assembly of the Land that gathered in Moscow in February 1613, they chose Mikhail Romanov, the sixteen-year-old grandnephew of Ivan the Terrible's first wife, to be Russia's new tsar. Sickly, timid, and completely unassuming, Mikhail was to found the dynasty that would rule Russia until 1917.

The rise of the Romanov dynasty began a new era in the history and culture of Moscow. When he came to Moscow to be crowned with the Crown of Monomakh—the bejeweled, fur-rimmed crown that, according to legend, had

A rare and intimate chamber portrait of Tsar Fedor Iannovich, son of Ivan IV. Devoid of ceremonial details, this very early secular portrait, or *parsuna,* still follows the conventions of icon painting, portraying the devout tsar as "an ascetic imbued with humility" (cat. 152).

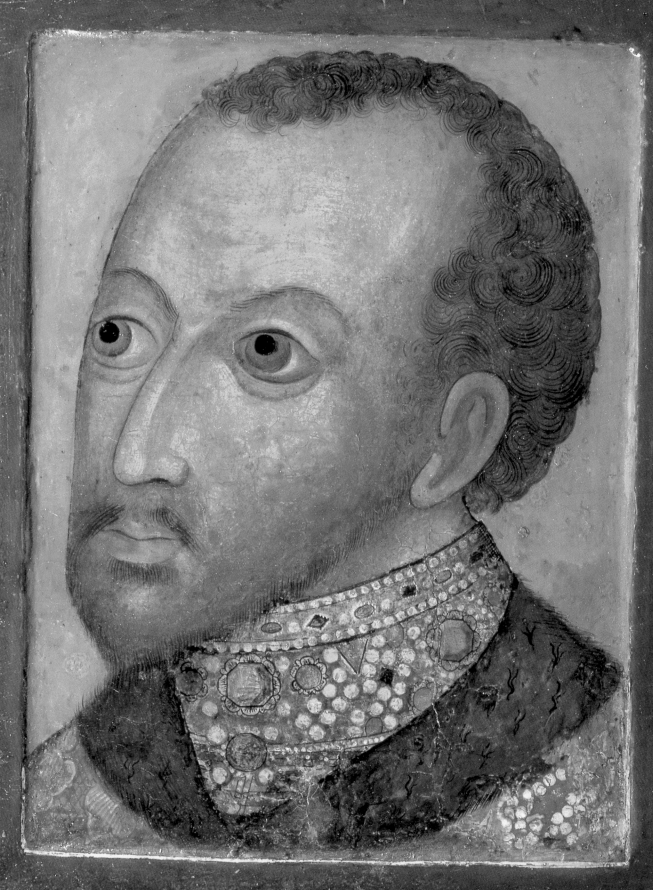

БЛГОВѢ́РНЫИ КНЗЬ ѲЕОДОРЪ IШАННОВIЧ

been bequeathed to Russia's rulers by the Byzantine Emperor Constantine Monomakh—Mikhail Romanov entered a badly damaged Kremlin that stood in the center of a city that had been burned to the ground by the retreating Poles. The breakdown of old Muscovite values and the dislocations caused by nearly two decades of war had cut Russians adrift from the world in which they had lived in the fifteenth and sixteenth centuries. Anxious to anchor their new order in the certainty of the tried and true, Mikhail and the men around him turned to the *Domostroy*, the book of rules in which Ivan the Terrible's onetime adviser the monk Silvester had counseled absolute obedience to a chain of authority that began with fathers and husbands and extended upward to the tsar before it rose to the throne of God Himself.

In a society in which tsar and church always had been the chief patrons of art, such unbending injunctions to bow to authority forced Moscow's icon painters into a rigid framework in which they made up for their inability to experiment with new forms (as had Feofan Grek and Rublev) by concentrating upon detail. This was characteristic of the best icons of the seventeenth century, which frequently appear crowded with exquisitely painted figures. Often the work of painters who received their early training in workshops that the great merchant princes of the Stroganov family had established in the remote Ural mountain centers of Perm and Solvychegodsk before they began to work in the Kremlin, these icons formed the last glorious chapter in the story of Muscovite icon painting. Icons of high quality would be painted well into modern times, but the dynamism of icon painting faded as the Muscovite Age came to a close at the end of the seventeenth century. As Peter the Great pushed his nation across the great chasm that separated the medieval world from the modern, the thoughts of Russians turned from

the hereafter to the here-and-now. For the first time, Russia's best artists began to celebrate the achievements of man as well as the glory of God.

The rigid precepts upon which the Romanovs had tried to rebuild Russia during the second and third decades of the seventeenth century could not keep out new foreign influences or eradicate those that already had crossed the frontier. Although repeatedly denounced by the church, foreign portraits and possibly even foreign portrait painters had appeared in Moscow during the Time of Troubles, and these marked the beginning of new influences that would alter forever the course of Moscow's (and Russia's) history. For a time, the proscriptions of the patriarchs Yosif and Nikon suppressed foreign influence in Moscow's art and life, but even Nikon eventually succumbed to the vanity of having his likeness captured on a canvas that preserved all of his arrogant self-righteousness for posterity. Russia's contact with the West, especially through Poland, was becoming too broad to mute the sharp contrasts between their two cultures. At the beginning of the eighteenth century, Peter the Great would push Old Russia and the West onto a collision course where sharp political and cultural conflict would become inevitable.

Yet, it was not the example of Europe but a campaign to make Moscow into the spiritual and political center of the Orthodox East that posed the greatest danger to Russia's traditionalists. Nikon, a huge, raw-boned priest of compelling religiosity and powerful intellect who towered over friend and foe, had become Russia's patriarch in 1652, and, within a decade, his effort to make Moscow the center of religious purity unleashed a storm of protest. With the xenophobic archpriest Avvakum leading those who defended the old ways, the men and women whom history would remember as the Old Believers rejected the tsar, church, and gov-

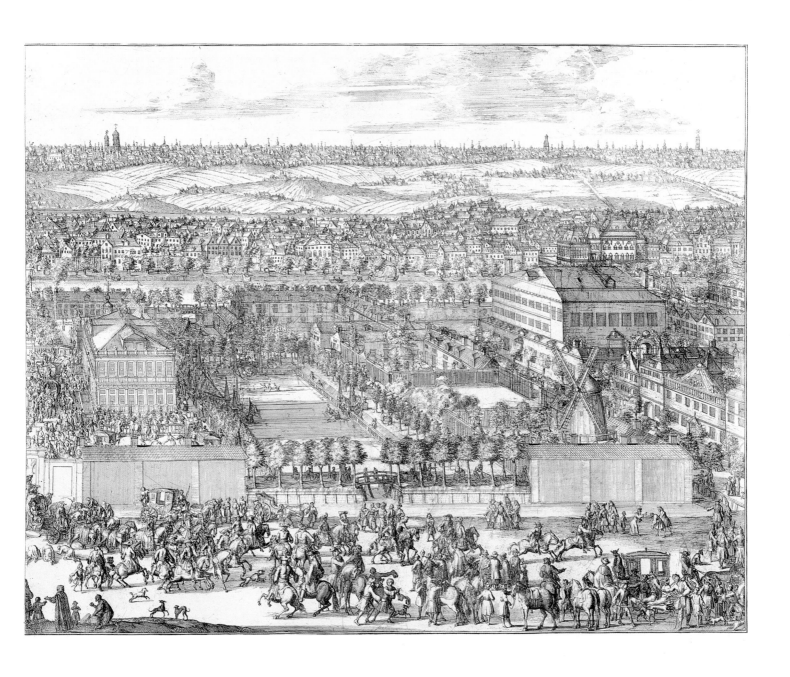

ernment that supported Nikon's reforms and split the Russian church for all time. For the Old Believers, Moscow no longer stood as the unchallenged authority in matters of faith and dogma. Holy Moscow, the city of hundreds of churches, now became anathema to thousands of Russians who sought to rebuild their lives in the vast, sparsely settled reaches of the far north.

The most controversial of Nikon's efforts to purify the Russian church focused on correcting errors that had crept into its religious texts since the Christianization of Russia in the tenth century. Nikon also condemned the increasingly rich ornamentation of Russia's churches and

called for a return to the architectural simplicity of earlier times. Yet, he found it nearly as difficult to impose architectural austerity as he did to force the acceptance of his other reforms. Intricate icons and richly ornamented churches appealed to the tastes of the wealthy men and women who sought to assure their salvation in the world to come by building monuments to God and his many Russian saints in Moscow. The latter years of the seventeenth century therefore saw the beginnings of Russian baroque. Filtered through Poland and the Ukraine before it made its way to Russia from the West, the baroque assumed a peculiar Russian form

that such Moscow churches as the Church of the Intercession of the Virgin (at Fili) and the Church of St. Vladimir (just to the east of the Kremlin) exemplified. Unique but easily integrated with the architecture of earlier times, these formed a notable part of the surge in church-building that took place in Moscow during the last half of the seventeenth century. As the growing affluence of the city's citizens made it possible for them to build increasingly elaborate monuments to the glory of God, Moscow's skyline became a mass of new church domes and spires.

Onion-domed churches and concentric rings of medieval fortifications concealed the fact that Moscow was changing as dramatically as its church. As merchants and traders came from the West in search of timber, iron, hemp, and the Siberian furs that Europeans so prized, they stirred changes that no Russian before the seventeenth century had dared to imagine. At first, tsar and church had isolated foreigners in special buildings, supplied their food and necessities, forbidden them to dress like Russians, and overseen their movements at every step. When the number of foreigners grew too large to be controlled in that way, Tsar Aleksey Mikhailovich ordered them to live outside Moscow's walls in a closely guarded, fenced-in compound. Military officers who had come to Moscow to offer their services to modernize Russia's army outnumbered all others living in the Foreign Quarter then, but there also were merchants, artisans, and artists who worked to re-create the civilization they had known in the West. By the end of the century, their efforts to reproduce the world of Europe on the edge of Moscow set the stage for a transformation of Russian culture. At first,

this process moved slowly. Then, at the beginning of the eighteenth century, the westernization of Russia began to move at a frightening pace as Peter the Great, the dynamic, impatient giant who believed that his country must immediately take its place among the great powers of Europe, drove the Russians into the modern world.

To symbolize Russia's new direction and to break the ties that he felt bound Russians too closely to their past, Peter moved his capital from Moscow to St. Petersburg, his newly built window on the West. There, Russians adopted European ways as a matter of style because their sovereigns demanded that they do so. Their attempts to come to grips with a culture that they did not understand produced an imitation of western life and culture that, at times, seemed more like a caricature than a genuine copy. In St. Petersburg, men and women lived in the capital of Russia, a copy of the Dutch city of Amsterdam that was beginning to take on northern Italian overtones. There, they wandered through formal gardens built on lands only recently reclaimed from swamps, sat in Chinese pagodas in the midst of Russian birch groves, and danced the minuet in tropical indoor gardens in the dead of the northern winter. Fascinated by the unreality of the new world in which they lived, these Russians even established a chair of allegory at St. Petersburg's newly founded Academy of Sciences.

St. Petersburg abandoned Russia's Muscovite past to mimic the western present, but Moscow endeavored to integrate the two. Secular art, theater, literature, and poetry all had entered the world of Muscovites at the end of the 1660s, when the death of his pious first wife had made

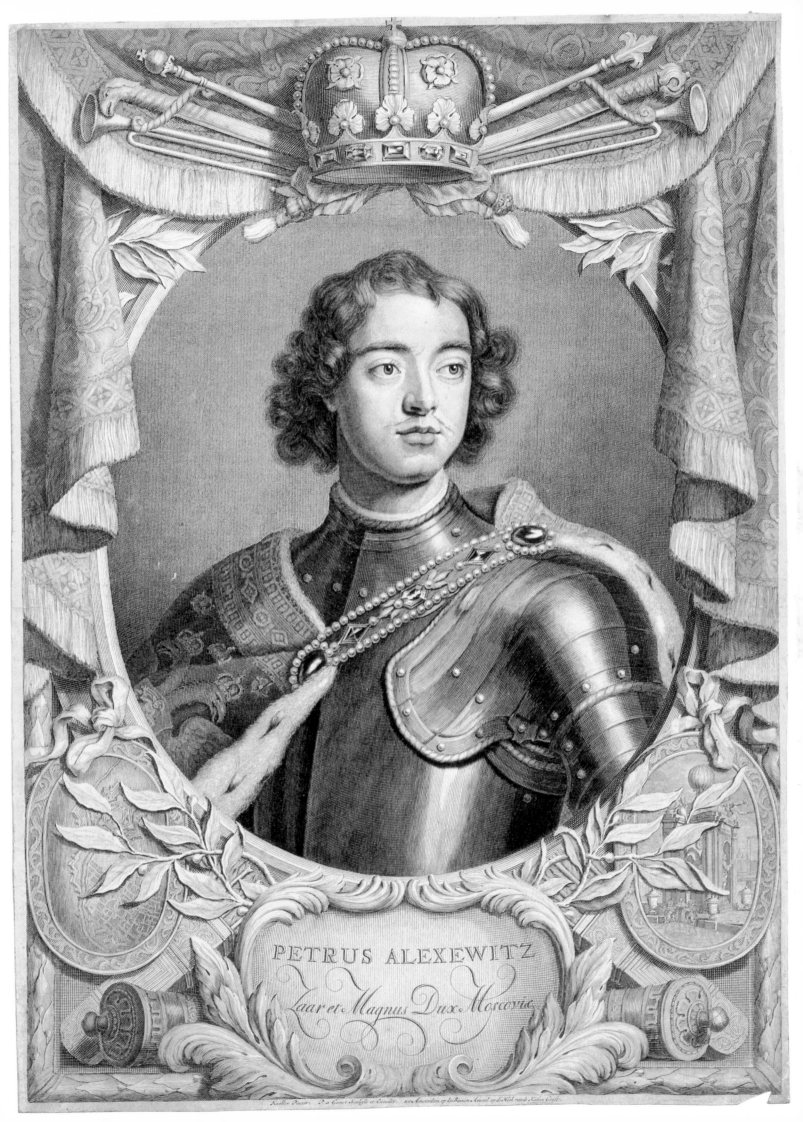

PETRUS ALEXEWITZ

Zaar et Magnus Dux Moscoviæ

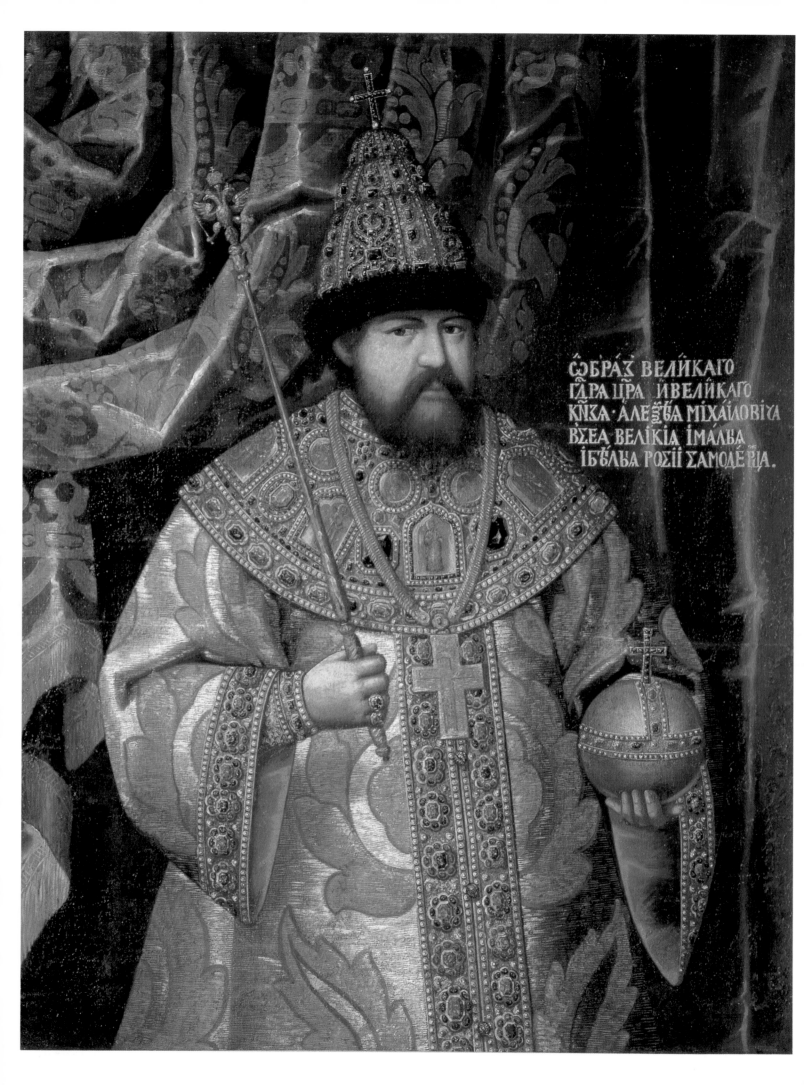

ѾБРАЗ ВЕЛЙКАГО
ГДРА ЦРА ЙВЕЛЙКАГО
КНЗА · АЛЕѮѢА МІХАЙЛОВЇѴА
ВСЕА ВЕЛЇКІА ІМАЛѢА
ІБѢЛѢА РОСЇІ САМОДЕ РЦА .

it possible for Tsar Aleksey Mikhailovich to set aside the dawn-to-dusk religious ritual that had governed court life since their marriage in 1648. As the man who has been remembered as Russia's "most gentle" tsar had begun to pursue secular interests and worldly pleasures at suburban palaces he built at Izmailovo and Kolomenskoe, he had been among the first to experiment with the world that Russia was about to enter as she emerged from the storm of religious and cultural conflict that had raged since the beginning of the century.

With its large western-style gardens, where carefully protected date palms and orange trees stood as monuments to the tsar's belief in his power to defy nature, the palace at Izmailovo represented Aleksey Mikhailovich's newfound interest in science, technology, and progress. All three stood in sharp conflict with the church-dominated, tradition-centered culture of the first sixty years of Romanov rule in Russia. At Kolomenskoe, where he opened a dark old palace from the days of Ivan the Terrible to the light and filled it with western furniture and mirrors to delight his young second wife, the middle-aged Aleksey Mikhailovich built Russia's first monument to the gaiety and frivolity of western culture. On the walls of Kolomenskoe palace hung proud portraits of Julius Caesar and Alexander the Great, heroes who had never before entered the world of Russia's tsars.

Kolomenskoe in the 1670s stood for a world most Russians had never seen and that only a few among them had even begun to think about. Aleksey Mikhailovich's eldest son, the sickly Tsar Fedor Alekseyevich, tried to follow a similar course and even had taken the daring step of ordering his courtiers to cut their beards and shorten their caftans. Fedor had died before these innovations could be pursued very far and before the church could begin to express its outrage at a tsar who would summon men to defile the image of God (in whose image all men were made) by cutting their beards. Two decades later, Peter the Great would make the same demands much more insistently.

Aleksey Mikhailovich and Fedor had seemed to sense that the dynamic culture of the West would overwhelm the more medieval life of Russia if the two were brought into direct confrontation. Prince Vasily Golitsyn, scion of one of Russia's greatest families and lover of the Tsarevna Sofia, who governed Russia after Fedor's death until young Peter the Great reached his majority, held the same view. Like Aleksey Mikhailovich, a man who believed that the Russians could adopt the technology of Europe without allowing it to overwhelm the values upon which Russian life and culture were based, Golitsyn in the 1680s lived in a grand European manner that shocked Russians and astounded the Europeans who visited him. Yet his position remained too uncertain and Sofia's hold upon the reins of power too weak. In 1689, Peter the Great drove Sofia and Golitsyn from the Kremlin and steered a more direct and uncompromising course to the West. When Peter began to rule Russia from St. Petersburg, Moscow continued to follow the somewhat more moderate course that Aleksey Mikhailovich, Tsar Fedor, and Golitsyn had set.

Memoirs and diaries tell us that when Peter II moved Russia's capital back to Moscow in 1728, the foreign diplomats who followed him there found a more elegant society than in St. Petersburg. The Empress Anna moved the capital back to St. Petersburg three years later, but Muscovites continued to develop their own more carefully integrated relationship to the culture and politics of the West. In the 1730s and 1740s, when the court aristocracy in St. Petersburg had assimilated only the thinnest veneer of western culture, some of the lords of Moscow had begun to discuss the political and philosophical systems of the West. Thoughtful Muscovites were the first to criticize the shallowness of Russia's westernization. When Russia's first university was founded in 1755, it made its home in Moscow, not St. Petersburg.

By the end of the eighteenth century, wealthy Muscovites had shaped a rich culture that integrated their country's Russian past with its unevenly westernized present. No longer were their lives centered in small, low, two-story houses, in which women had been relegated to a *terem* apartment in a gabled attic. Now moved to elegant eighteenth-century townhouses in the city's Tverskaya Quarter, Moscow's nobles had begun to greet the winter season with elegant balls and dinners, a far cry from the isolated, introspective lives their ancestors had led a century before. Young lords whose noble origins stretched back to the days of Ivan the Terrible now studied with French tutors but remained conscious of their Russian past. By the beginning of the nineteenth century, literary salons where the city's elite entertained Russia's leading writers and poets had become a substantial part of Moscow's culture. The Urussovs, the Kiselevs, the Rimsky-Korsakovs, the Apraksins, and the great patrons of art and culture, the Sheremetevs, dominated Moscow's cultural life in those days and shaped it to their taste.

Because Russia's sovereigns and their court continued to be the chief patrons of art in the eighteenth century, many painters, sculptors, and architects sought commissions in St. Petersburg. Yet there always were men of talent who chose to work in Moscow. In part, this was because of the patronage offered by the Sheremetevs, some of the wealthiest lords in eighteenth-century Russia, whose ancestors had served Moscow's tsars since before the days of Dmitry Donskoy. Although many Russian artists benefited from their support, the Sheremetevs were particularly known for becoming the special protectors of artists discovered among their several hundred thousand serfs. At their suburban palaces at Kuskovo and Ostankino, built by serf architects and decorated by serf artists, the Sheremetevs maintained serf orchestras and serf theaters that were among the finest in Russia. Ivan Argunov, one of eighteenth-century Russia's most accomplished native portrait painters, was one of the Sheremetev serfs, and some of his best-known paintings captured the likenesses of his masters and mistresses on canvas. Two of Argunov's sons followed their father's footsteps, again with the Sheremetevs' patronage. One became a portraitist like his father. The other became an architect who helped Russia's great late eighteenth-century master Matvey Kazakov to design his benefactors' palace at Ostankino.

The many accomplishments of the Sheremetev serf painters, actresses, and musicians did not mean that the art of eighteenth-century Moscow was mainly the work of talented serfs. Fedot Rokotov studied and taught in St. Petersburg before he moved to Moscow where, more distant from the court of Catherine the Great and its influences, he perfected the more intimate and personal style that had eluded him in Russia's capital. The sculptor Fedot Shubin, the largely self-taught son of a White Sea fisherman, produced his famous busts of the Golitsyns in Moscow, and most eighteenth-century Romanovs built government buildings, palaces, and country houses to adorn its center and suburbs.

Count Petr Borisovich Sheremetev (1713-87) was a cavalier of the orders of St. Andrew, St. Alexander Nevsky, and the White Eagle (cat. 156).

St. Andrew, the first to follow Christ, was claimed by the earliest Christian princes of Kiev as Russia's Apostle. This cross of the Order of St. Andrew belonged to the order's founder, Peter the Great (cat. 86).

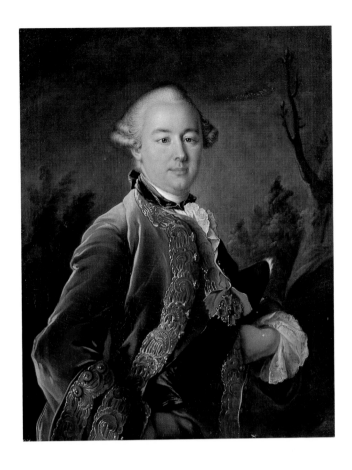

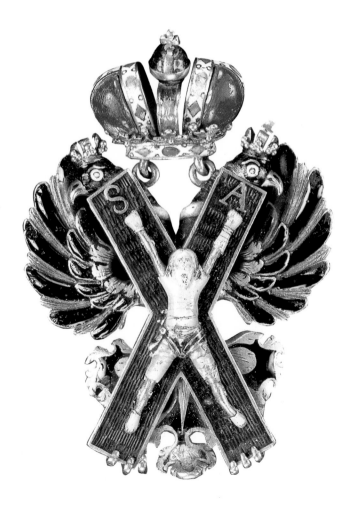

Others followed their example. And, in a village on the outskirts of eighteenth-century Moscow, the Englishman Francis Gardner built the porcelain factory whose brilliant products would grace the dinner tables of the Romanovs and their greatest nobles between the mid-eighteenth and the late nineteenth centuries.

Although Moscow developed somewhat its own style of westernization in the eighteenth century, it was deeply marked by the transformation that Peter the Great and his successors wrought in Russia. Perhaps most striking of all, Moscow's eighteenth-century lords dedicated themselves to Russia's service in a way that their more parochial ancestors had never done. The orders of merit that Russian autocrats created during the eighteenth century showed how important the pursuit of glory in the service of Russia had become. There had been no such decorations in Russia before Peter the Great created the Order of St. Andrew the First-Called in 1698. Orders of St. Catherine, St. Alexander Nevsky, St. Anne, St. George, and St. Vladimir had followed before the end of Catherine the Great's reign. When Nicholas I commissioned Russo-German architect Konstantin Thon to build the Great Kremlin Palace in the middle of the nineteenth century, he would incorporate into it rooms dedicated to each of these orders. The most striking would be the white and gold Hall of St. George, a full two hundred feet in length, seventy feet wide, sixty feet high, where the Knights of St. George, officers who wore Russia's highest order for bravery in battle, assembled to celebrate their patron saint's name day each year.

Apart from some of its suburban palaces, very little of eighteenth-century Moscow survived the war of 1812. Confident of crushing Russia before the first snows fell, Napoleon had led his Grand Army across the Niemen River in June of that year, marched through the smoking ruins of Smolensk in mid-August, and clashed with the armies of Russia's Fieldmarshal Kutuzov in a

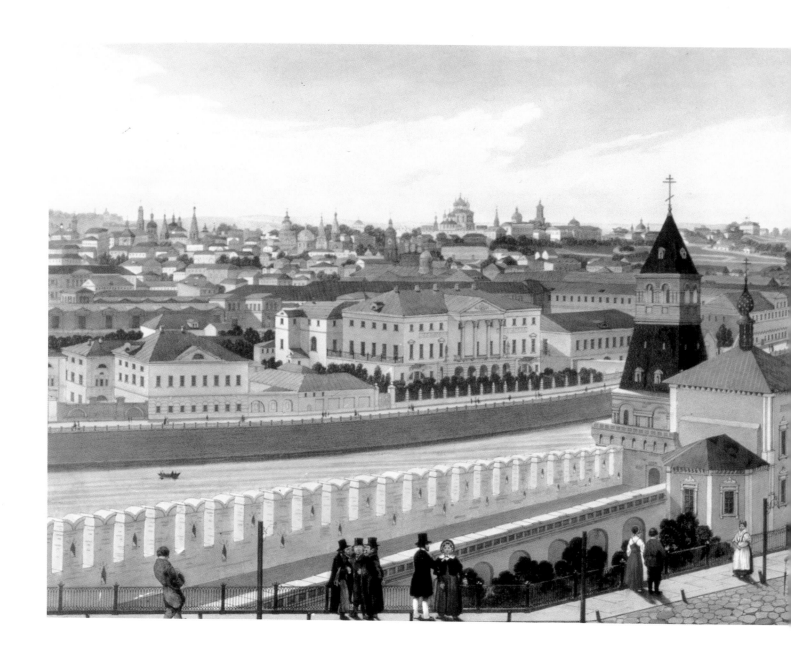

In the extensive reconstruction of Moscow following the fires of 1812, a new city emerged, deemed among the most beautiful in Europe. Here, the newly expanded merchant's quarter—seen from a vantage within the Kremlin—is shown in two of ten panels from an 18-foot circular panorama based on a drawing by Indeytsev (cat. 151d).

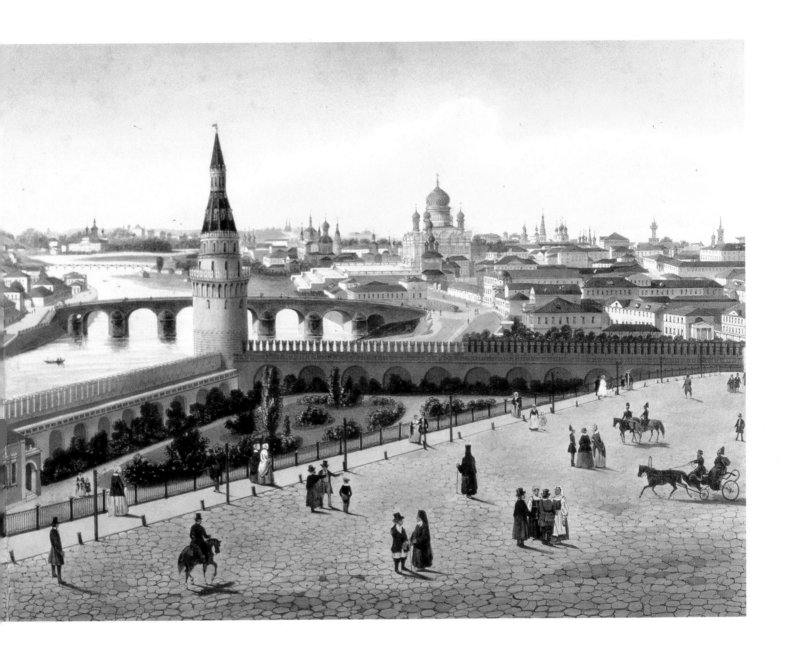

battle of titans at Borodino before the end of the month. On September 2, Napoleon had entered Moscow, just hours after the Russians had evacuated the last of the great icons of the Kremlin's cathedrals, the treasures of its Armory, and the priceless crowns of its tsars and tsarinas to Nizhny-Novgorod. As Napoleon set up his headquarters in the abandoned Kremlin that evening, the first flames of the great fires that would consume the city lit the sky. When the Grand Army left Moscow five weeks later, 6,532 out of its 9,158 buildings lay in ashes.

Despite Napoleon's stern orders to blow up the entire Kremlin as his weary soldiers retreated, his engineers had succeeded only in part. The Arsenal had been destroyed and the Palace of Facets heavily damaged, but the great cathedrals, the main palace, and the Bell Tower of Ivan the Great still remained. Outside the Kremlin walls, in which five huge holes had been blasted by the French, the palace that Kazakov had built for Count Aleksey Razumovsky, the beautiful building he had designed to house Moscow University, and more

than a score of other buildings with which he, Bazhenov, Rinaldi, Rastrelli, and Quarenghi had beautified Moscow all had perished in the flames. All of the city's two hundred ninety churches had been looted and one hundred twenty-seven lay in ashes. When the Russians returned to their city, they found nearly twelve thousand bodies scattered in its streets and courtyards.

The rapid rebuilding of Moscow after the devastation of 1812 showed Russians' love for their ancient capital. War damage in Moscow province had amounted to 270 million rubles in 1812, more than the Imperial goverment's entire annual income, and most of the rebuilding had to be done with private funds. New townhouses rose along the Tverskaya, the Nikitskaya, and the older Arbatskaya, and elegant shops returned to line both sides of the famed Kuznetsky Bridge. In the 1820s and 1830s, Moscow seemed an overwhelmingly aristocratic city, so much so that side streets and smaller alleys took the names of the noble families whose houses fronted upon them. In a city where more than half its residents were serfs, servants, soldiers, or priests in 1829, every eighth Muscovite was an aristocrat.

Although Moscow's nobles built the city's newest and most elegant townhouses, the construction of government buildings dominated the center of the city where Imperial architects built on the same monumental scale during the 1830s and 1840s as they had in St. Petersburg a few years before. A great brick tunnel enabled city planners to submerge the same Neglinnaya River that had formed part of the defenses of the early settlements on the Borovitsky Hill and build the Alexander Park above it—just a few years before Konstantin Thon crowned the Borovitsky Hill itself with the Great Kremlin Palace. Nearly four hundred feet long, and with seven hundred rooms, the palace symbolized the vast distance Moscow's history had covered in the seven hundred years since Yuri Dolgoruky had built his first humble wood fortifications on that spot.

Regimented and regulated to reflect Nicholas I's belief that Russians' only purpose was to serve their country, St. Petersburg was the undisputed center of government in the 1830s and 1840s. Further away from the constraints imposed by court and emperor, Moscow remained a center of ideas and learning. In the newly reconstructed lecture halls of Moscow University and in the drawing rooms and salons of the city's elegant townhouses, thinkers and scientists who had no equal anywhere else in Russia debated the meaning of their country's past and present and tried to discern the direction of her future. What would be Russia's place among the great nations in years to come, they asked. What would Russia contribute to universal civilization that would stake out her claim to greatness? Some thought that their nation must continue along the path already taken by the West. Others believed that Russia had lost her way and must return to her native Muscovite roots. In this debate, the course of Russia's history and, in particular, the origin, purpose, and structure of the communes in which her enserfed peasants lived had particular importance. Was Russia like the West? Or was she, as the Moscow historian and publicist Mikhail Pogodin once wrote, a nation in which "everything is different." Such questions had no easy answers. From positions based more on belief and feeling than on fact and reason, Muscovites grappled with these issues until the Revolution of 1917 had come and gone.

By the end of the Crimean War in 1856, Moscow had begun to change in ways that none of the writers, thinkers, and professors who debated their nation's course had foreseen. By comparison with its seventeenth-century Muscovite counterpart, the aristocratic culture of westernized eighteenth-century Russia had been so costly that Catherine the Great and her son Paul had subsidized it by grants of nearly two million serfs to several thousand of the

nobles who served them best. Although serfdom had begun in Russia several centuries earlier, these gifts had marked its final extension so that, as the eighteenth century drew to a close, nearly half of all the Russians had lived lives of servitude on the estates of noble masters. The Emperor Alexander I had vowed to end this trade in human flesh at the beginning of the nineteenth century and had tried to underwrite the cost of the high culture Russia's nobles had created with low interest loans for which the borrower's serfs served as collateral. Moscow's nobles had used some of these loans to rebuild their lives after Napoleon's defeat, but too many had spent the money on immediate consumption, and too few had applied them to capital improvements. As long as they could meet the modest interest payments that came due every year, very few ever thought about repaying them.

The emancipation of the serfs in 1861 liberated the collateral with which Russia's nobles had secured their unwisely spent loans and drove many of them to the brink of ruin. Now obliged to repay their long-standing debts, many nobles could no longer support the style of life that had shaped Moscow's aristocratic culture in the 1830s and 1840s. The confusion of declining aristocrats and the vitality of merchants-turned-entrepreneurs became the focus of the paintings of Pavel Fedotov, who had been born in the outskirts of Moscow in 1815 and raised amidst the bustle of the city's recovery. Fedotov had studied briefly at St. Petersburg's Academy of Fine Arts but began to paint only after he left the army in 1845. Disenchanted with the world around him, he painted aristocrats who shared squalid rooms with well-trimmed poodles and ate coarse rye bread at richly veneered tables while they read advertisements for costly oysters. His painting *The Major's Courtship,* in which a middle-aged, ruined nobleman pleads for the hand of a rich merchant's daughter, portrayed the dilemma that many of Moscow's noble families faced at mid-century as merchant daughters' dowries

rescued more than one of them from ruin.

The work of the serf painter Vasily Tropinin portrayed this twilight of Moscow's aristocratic world more broadly than did Fedotov. The creator of some three thousand paintings in a lifetime that spanned eight decades, Tropinin had been sent by his master to St. Petersburg's Academy of Fine Arts at the end of the eighteenth century. Although acclaimed as one of the Academy's most promising graduates, Tropinin had to remain a serf for another quarter century, during which he helped to design and rebuild the Moscow townhouse that his master had lost in the fire of 1812. After he received his freedom at the age of forty-seven in 1823, Tropinin chose to work permanently in Moscow where, over the next thirty-four years, he painted the collective biography of its citizens. Street vendors and lace-makers, artisans and merchants, nobles and notables—even the great poet Pushkin—all emerged from Tropinin's canvases. As a broader-based culture began to take root in Moscow, Tropinin captured its first sproutings.

The paintings of Tropinin and Fedotov expressed a new tension in Moscow's life that had its roots in events that had taken place many years before. As traders and merchants who husbanded their resources and believed in hard work, Old Believers had always played a large role in Moscow's economic life and, well before the end of the eighteenth century, some of them had begun to expand their interests in manufacturing and trade. Moscow therefore had become the center of Russia's textile production, with the production of cotton and linen becoming an increasingly large source of wealth. The workers of Moscow and the region surrounding it wove over nineteen million rubles' worth of calicos, chintzes, jacquards, silks, and woolens a year in the 1840s, and by the end of the century, the city's factories accounted for more than half (over a half-billion rubles' worth) of Russia's cloth output. When the factory owners and merchants who presided over this manufacturing

boom entered the city's daily life, the focus of Moscow's culture began to move away from the aristocrats who had patronized its culture and art so generously in the century just past.

After the middle of the nineteenth century, patronage of the arts began to shift from Moscow's declining aristocracy to its energetic merchant princes. Pavel Tretyakov, a man who loved art and Moscow equally, stood prominently among these new patrons from the moment when, at the age of twenty-eight, he vowed to buy only the work of Russian artists and establish a "national gallery of art" in his native city. Icons from the time of Ivan the Terrible, portraits painted by the great eighteenth-century masters Vladimir Borovikovsky and Dmitry Levitsky, seascapes by Ivan Aivazovsky, and historical canvases by Valery Jakoby all were added to his collection on a monthly, sometimes even a weekly, basis. Tretyakov soon became the patron of the *Peredvizhniki,* the Wanderers, the first of Russia's artistic dissidents, who had seceded from St. Petersburg's Academy of Fine Arts in 1863 to launch the beginnings of a brilliant national artistic movement. Ivan Shishkin's landscapes, Ivan Kramskoy's portraits, Vasily Perov's realistic continuation of Fedotov's commentary upon the frailties and failings of Moscow (and Russian) society formed the beginning of the Peredvizhnik collection upon which Tretyakov eventually spent almost a million rubles. To house it, he built the Tretyakov Gallery.

When he built his famous gallery in 1874, Tretyakov devoted an entire room to the huge historical canvases of Vasily Surikov, in which *The Boyarina Morozova,* the artist's portrayal of the ever-defiant patroness of Moscow's Old Believers being taken to prison in chains, held pride of place. Even these paintings could not compete with the masterpieces of Ilya Repin that hung in one of Tretyakov's central galleries. Repin's anguished painting *Ivan the Terrible and His Son Ivan Ivanovich* and his profoundly tragic canvas of a political prisoner's return from Siberian exile that bore the title *They Did Not Expect*

Vladimir Makovsky's *In the Doctor's Waiting Room*, 1870, depicts the daily drama of Moscow life. An elderly office worker, a priest consoling a woman with a toothache, a young man, and a mother with sick child represent a cross-section of the city's middle class (cat. 176).

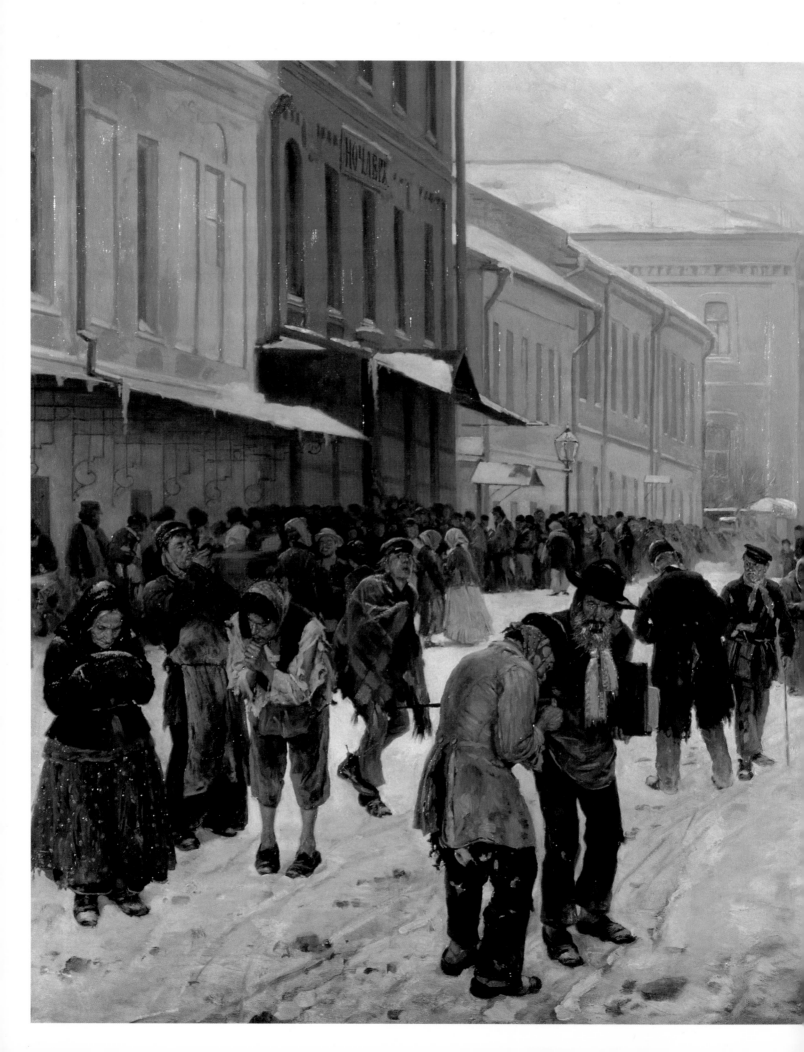

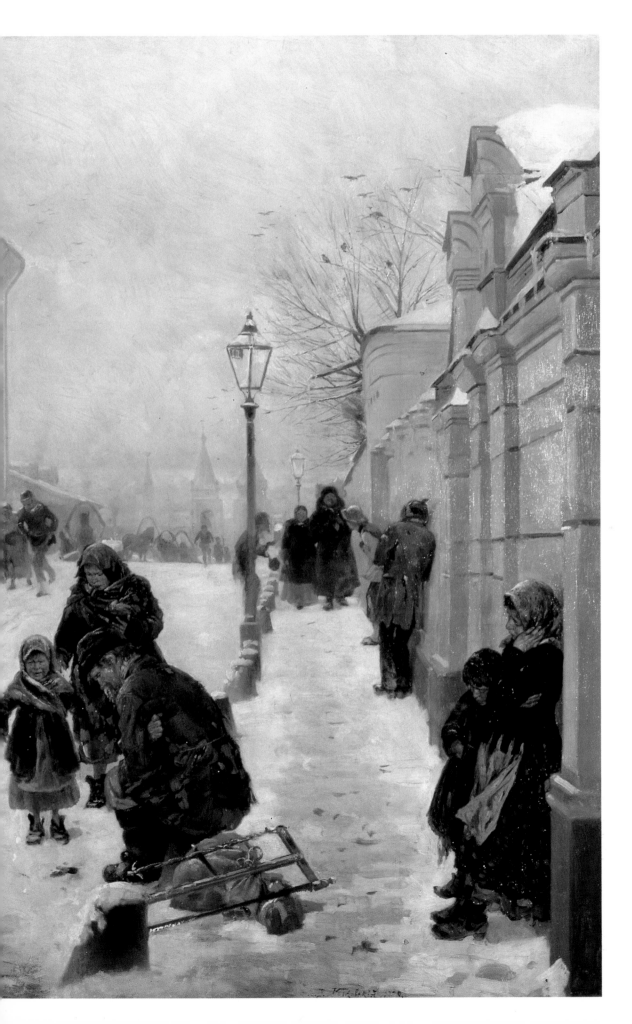

Vladimir Makovsky, as one of the *Pered-vizhniki*, was committed to the power of art to effect social change. *The Doss House*, 1889, portrays the homeless awaiting shelter, a scene not uncommon in Moscow (cat. 177).

Him drew Russians' attention to their past and present in ways that the work of no previous artist had done. Tretyakov spent another two hundred thousand rubles to purchase most of the major paintings in which Vasily Vereshchagin, "a man of sensitivity and genius living through the horror of human carnage," in his patron's words, had portrayed the brutality of Russia's battles in the Balkans and Central Asia. By the time he presented this amazing monument to Russia's artistic achievement to the city of Moscow in 1892, Tretyakov's collection included almost two thousand paintings.

While Tretyakov became one of Moscow's leading patrons by buying art, his brother-in-law Savva Mamontov provided Russia's artists with a glorious pastoral retreat in which to seek new inspiration and explore untried themes. Some thirty-five miles northeast of Moscow, the estate of Abramtsevo nestled among forests of birch and evergreen through which the Vorya River wound its way southward. Once the summer home of the Aksakovs, who had been leading figures among the men who had debated Russia's course in the 1840s, Abramtsevo became Mamontov's passion from the moment he purchased it in the fall of 1870. As Tretyakov had filled his home with great paintings, so Mamontov filled Abramtsevo with great artists. Ilya Repin painted his *Pilgrims* and *Religious Procession* there and began the painting of Ivan the Terrible and his son that was soon to find its home in Tretyakov's gallery. The young painter and architect Viktor Vasnetsov, whose portrayals of folkloristic themes had just raised him to the ranks of Russia's leading painters, worked at Abramtsevo for several summers, and so did Vasily Polenov, the young Peredvizhnik painter whose canvases captured images of life from Russia's past.

With Mamontov's encouragement, guests who worked separately also worked together. After Polenov, Repin, and Vasnetsov decorated the tiny village church at Abramtsevo, Mamontov decided to organize a workshop in which

In the 1880s, severe restrictions of the press, voting rights, and universities followed the assassination of Alexander II, dashing hopes for social reform and polarizing society. A mood of resignation, perhaps even intergenerational conflict, pervades *The Prose of Life*, 1892-93, a youthful work by Vasily Baksheev, whose teaching career in Moscow extended to 1951 (cat. 188).

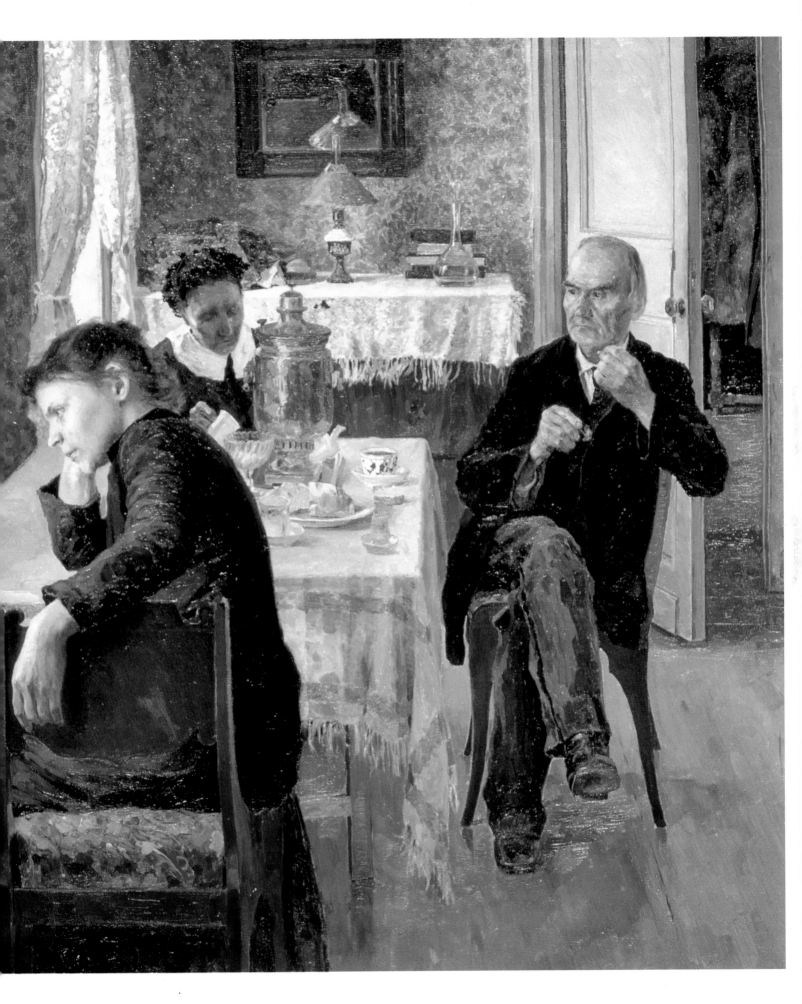

Internationally renowned for his monumental canvases of Russian history and peasant life, Ilya Repin painted family and friends with great intimacy. *In the Sun*, 1900, portrays his daughter Nadezhda *en plein air* using techniques from his Paris studies (cat. 184).

artists would draw upon folk traditions from the past to produce new art for the present. At the urging of Elizaveta Mamontova, whose dedication to helping Abramtsevo's common folk equaled her husband's passion for supporting art, peasants began to pursue their traditional crafts under the eyes of some of Russia's leading painters. Pottery, wood carving, furniture, and utensils that mixed art nouveau with folk motifs and traditional designs became so popular that the demand quickly outstripped the supply. With their work much in vogue at court in the waning years of the century, the Abramtsevo craftsmen eventually opened a small shop in Moscow. Mikhail Vrubel, whose intense and strange vision of the past had haunted his work in such a profoundly disturbing manner that Russia's artistic establishment had rejected his first paintings, decorated it himself.

If the focus and social base of Moscow's cultural world was changing as the nineteenth century drew to a close, so was the city's appearance. Moscow was growing as fast as New York, faster than Vienna, Berlin, Paris, or London, and was about to become the tenth largest city in the world. In the old days, the saying had been, "All roads lead to Moscow." Now, all railroads led there, for the city had become the hub of a transportation network that radiated outward to every corner of the Russian Empire. Railroads were beginning to bring Russia together and they brought it—not the Russia of furs, jewels, and elegant gowns, but the Russia of clumsy bark shoes, greasy sheepskin coats, and large, bright-colored kerchiefs—to Moscow. By 1902, seven hundred thousand peasants lived closely packed in the crumbling wooden buildings that clogged the city's outskirts. Not even the St. Petersburg of Dostoevsky had seen dazzling wealth mixed with grinding poverty on such a massive scale.

As the home of people caught in every gradation of wealth and deprivation, Moscow's architecture reflected the amazing mixture of opulence and poverty that now shaped its daily life. In contrast to the elegant classical townhouses that had drawn so heavily on Bazhenov's and Kazakov's designs a century earlier, the townhouses that such turn-of-the-century architects as Shekhtel and Mazyrin built for the Morozov brothers combined an amazing mixture of medieval, gothic, and modern styles. Vasnetsov's designs for the Tretyakov Gallery drew upon his study of medieval manuscript illuminations, Shchusev incorporated a replica of Kazan's Tartar Syuyumbeka Tower into his plans for Moscow's Kazan Railroad Station, and across the square, Shekhtel mixed art nouveau metal ornamentation with a fantasy of Muscovite elements in the Yaroslavl Station. Along Red Square, A. N. Pomerantsev's famous Trading

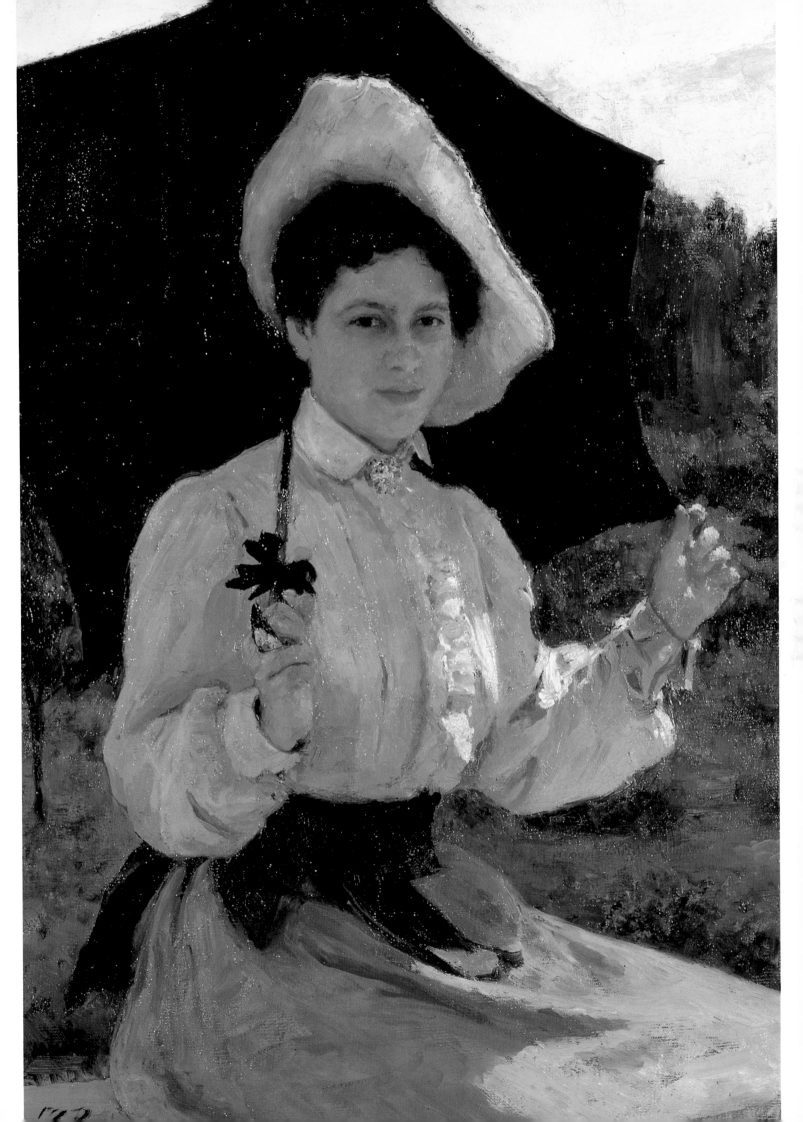

In 1922, in the wake of the turbulence of World War I and the Russian Civil War, of famine, shortages, and drastic social change, avant-garde artist Ilya Mashkov juxtaposes, in careful symmetry, porcelain figurines of an aristocratic past with the working stove of the home front, exotic oranges with the common cucumber (cat. 212).

Rows (the present-day location of GUM) and Vladimir Shervud's Historical Museum both incorporated Old Russian motifs, as did the private museum that B. V. Freidenberg designed to hold P. I. Shchukin's collection of Old Russian decorative arts. Apartment houses, office buildings, banks, and an ever-growing array of structures designed for purposes not conceived of a century before turned Moscow at the beginning of the twentieth century into the vibrant mixture of Old Russian, classical, gothic, Slavic revival, and modern styles that it remains today.

If Tretyakov's and Mamontov's dedication to Russian art had been a major factor in stimulating a flood of brilliant works in the quarter-century before 1900, Sergey Shchukin, the Moscow industrialist whose passion for post-impressionist painting made him one of the great early collectors of Matisse, stirred a revolution on the canvases of Russia's painters. A small man with piercing dark eyes and an unquenchable thirst for modern French painting, Shchukin purchased an average of one major painting every month between 1897 and 1915. He introduced the Russians to Pissarro and Degas, to Monet and Cezanne, to Picasso and, above all, to Matisse. Anxious to share his discoveries with Russia's young painters, Shchukin opened his Moscow mansion to them on Saturday afternoons so that they could be caught up in the flood of new impressions that cascaded from the paintings that covered its walls.

Shchukin's collection was the source from which Mikhail Larionov, Natalya Goncharova, the Burlyuk brothers, Vladimir Tatlin, and Kazimir Malevich drew some of their early inspiration for the modernist movement that exploded upon uncomprehending Muscovites as the First World War approached. Bold, disdainful of tradition, and anxious to confront (or, at least, affront) their critics, they saw themselves on the threshhold of "a great epoch unrivaled in world history," in which, according to one of their manifestoes, "the creation of new forms" would lead to "the true freeing of art." Aligning and re-aligning themselves into groups called the Jack of Diamonds and the Donkey Tail, these young painters proclaimed their allegiance to rayonnism (which the great revolutionary poet Vladimir Mayakovsky defined as a cubist inter-

pretation of impressionism) and laid the basis for Russian primitivism (Larionov and Goncharova), cubo-futurism (Malevich), and constructivism (Tatlin).

The revolution in art that Shchukin's efforts had helped to bring into being foreshadowed an even greater revolution in politics. Exhausted by more than three years of the bloodiest conflict that mankind had yet experienced, the Russians overthrew their Romanov sovereigns and embarked upon a new and utterly untried course. In St. Petersburg (renamed Petrograd in a wave of misdirected anti-German fervor at the beginning of the First World War), the revolutionary events of 1917 took place between February and October with very little bloodshed as Russia moved from the limited constitutional monarchy of the Romanovs' last years to a people's democracy. In Moscow, the Bolsheviks did not take power so easily. Street fighting raged from building to building for the better part of six days until, on the evening of November 2, 1917, Red Guards blasted open the Kremlin's Borovitsky Gate with heavy artillery and scattered the last of its defenders.

In March 1918, the Bolsheviks moved Russia's capital back to Moscow, the city Lenin once called "the heart of Russia." There, amidst the turmoil of civil war and foreign intervention, they began to re-gather the lands that once had been the Russian Empire. These were years when Moscow suffered terrible shortages of food, fuel, and shelter, and when the city's public services crumbled so completely that, according to a report in *Pravda,* seventeen cartloads of refuse—piled in courtyards, alleys, and even main streets—had accumulated for every building in the city. The lives of Muscovites in those days centered around the *burzhuika,* a small portable stove that burned the smallest scraps of wood and paper to provide minimal quantities of heat, while an entire world—the world of aristocratic,

industrialist, Romanov Russia—slipped into the past. Arthur Ransome, the biographer of Poe and Oscar Wilde who had come to see the birth of Communism at first hand, felt that "a gulf seemed to have passed" between the past and present when he visited Moscow in 1919. The plays of Chekhov, which Stanislavsky's famous Moscow Art Theatre had presented with such brilliance a scant decade before, suddenly had become very remote.

The hardships that Muscovites endured while civil war raged in Russia could not dim the enthusiasm with which many of them crossed the threshhold of the new world that the Bolsheviks promised to create. Never had the arts been more vibrant or diverse, for the Revolution had come upon Moscow's writers, painters, and poets just as they passed the point of no return in a daring experimental journey the destination of which was no more certain than the outcome of the Bolsheviks' social and political vision. In the fast-moving world of the Russian Revolution, decadents and symbolists gave way to the impassioned disciples of primitivism, futurism, cubo-futurism, suprematism, acmeism, and constructivism. At Moscow's Poets' Cafe, Mayakovsky cursed the past, cheered the present, and wrote his favorite inscription—"for internal use only"—in books of poems. To celebrate May Day in 1918, Moscow's artists colored the trees along the Kremlin's walls in vivid shades of brick red, violet, blue, and crimson and then turned their brushes upon the city's vendors' booths, townhouses, and long board fences. "Demented squares battled with rhomboids on the peeling facades of colonnaded Empire villas," the writer Ilya Ehrenburg remembered. "Faces with triangles for eyes popped up everywhere."

Revolutionary fervor in the arts only outlived Lenin, who died in 1924, by a few years. Soviet Russia faced challenges in the 1930s that focused her best and most creative energies on develop-

Vasily Kandinsky liberated painting from views of material objects, expressing new visions in pure line, color, and abstract shapes. *Improvisation #34*, 1913, pulses with life and energy (cat. 207).

The quickened pace of technological achievements and the desire of artists to convey movement converge in Alexander Labas' depiction of *The First Locomotive on the Turksib* in 1929 (cat. 214).

ing her industry, constructing gigantic hydro-electric stations to realize Lenin's dream of rural electrification, and uniting a vast, underdeveloped country that spanned a sixth of the earth's surface. During those years, the Soviet Union's industrial output soared, entire new industries came into being, and the resources of great tracts of once-untamed wilderness entered the country's economic life. These achievements provided heroic themes that, like heroes generally, had to be painted without blemishes and larger than life. This became the task of socialist realism, which reduced the inspired and vigorous experiments of the twenties to the simpler, more direct, more "relevant" images of the thirties. Caught up in the urgency of building socialism and industrializing their homeland, many Soviet artists struggled to become the "engineers of men's souls" that Stalin had called for with such urgency. But, as too many happy workers, peasants, and soldiers celebrated too many happy occasions on the screen, stage, and canvas, the "official" side of Soviet art began to lose some of its integrity, the key element that distinguishes the original and the creative from the stereotypical and the mundane.

Despite such excesses, the images of socialist realism were not without foundation. As the capital of the world's first socialist state, Moscow took on a new spirit of self-confidence during the 1930s and expressed it in massive buildings, the beginnings of an incomparable subway system, and efforts to transform workers' slums into model housing. Moscow of the first three Five Year Plans was a city in the throes of transition, a city that had to become the preeminent socialist accomplishment of people who stood in the vanguard of Russia's socialist achievement. Muscovites had to out-work, out-produce, and out-celebrate other Russians by producing more in their factories at the same time as they enjoyed greater opportunities for rest, relaxation, and cultural development.

War challenged the accomplishments that socialist realism celebrated even before they could

Natalia Nesterova reflects her concern for today's isolation from the spiritual tutors of the past in *The House of Pushkin on Arbat*, 1987 (cat. 225).

be completed. On June 22, 1941, the German High Command sent one hundred seventy-five divisions across the Soviet Union's western frontier in a shattering blitzkrieg that stretched from the Baltic to the Black Sea. As the armies of Nazi Germany occupied the rich grain fields of the Ukraine and the coal mines of the Donbas, surrounded Leningrad, and came within forty miles of Moscow, the very survival of Soviet Russia hung in the balance. The fighting made new heroes to be glorified by socialist realism. Even more than the heroes of labor, who had tamed the wilderness and harnessed the forces of nature, heroes born of battle had to be idealized, and Stalin most of all, for it was he (according to the many portraits painted by Alexander Gerasimov) who gave inspiration and courage to the lesser heroes who turned Russia's impending defeat of 1941 into the triumph of 1945.

The German invasion and the counterattack that carried the Red Army to Berlin inflicted unprecedented ruin upon Russian lands that only recently had recovered from the devastation of World War I and the Civil War. Somewhere between twenty and twenty-five million Soviet citizens lost their lives between 1941 and 1945, while the output of the industrial establishment that Stalinism had built in the 1930s fell precipitously. When Stalin died in 1953, Soviet Russia had fewer cattle and its peasants produced less grain per acre than on the eve of the First World War. As in 1918-21, Russia's future looked dark. It would take a full quarter-century to rebuild the devastation that the war had left in its wake, and to this day, rural Russia remains very poor. Yet, if the peasants continued to suffer, the 1960s, 1970s, and 1980s saw dramatic growth in Moscow. By 1990, the city boasted more than two hundred kilometers of subway lines and its people enjoyed hundreds of thousands of new apartments.

Reconstruction after the Second World War had been slow, but the recovery of Russian art from the constraints of Stalinism would be slower still. The liberation of Soviet art began under Khrushchev as the paintings of Renoir, Monet, Degas, Cezanne, Matisse, and Picasso gradually returned to the Pushkin and Hermitage museums. That artists working in the Moscow studio of Ilya Belyutin produced a large number of abstract works in the late 1950s and early 1960s seemed to indicate that the liberalization of the arts was moving more rapidly than had been expected, but the works of Malevich, Tatlin, and Kandinsky reappeared in galleries much more slowly than did those of their European counterparts, and that signaled danger for the forces of liberation. When a handful of modern paintings at the famed Manège exhibition *Thirty Years of Moscow Art* in December 1962 stirred Khrushchev's outrage, those within the Soviet establishment who had supported greater artistic freedom made a hasty retreat. For more than a decade, artists who wished to paint in other than the socialist realist manner had to work underground.

Moscow art recovered very slowly from Khrushchev's Manège fiasco, and only recently have once-underground artists like Vasily Sitnikov begun to win wider acceptance. The force, originality, and unusual technique of Sitnikov's work marks a trend that now is becoming more evident in Moscow's artistic world as young artists begin to weave back into their work the complex threads of modern Russian art that were severed so abruptly after Stalin's rise to power. To repair these broken links in the chain of events that connects Moscow's venerable roots with its uncertain present can help to restore the continuity of Russia's cultural experience. For now, as always, Moscow remains the cultural heartland of Russia, the center of the Russian land, whose traditions and treasures will offer an endless source of inspiration for artists in the years to come.

Lincoln is University Professor of Russian History at Northern Illinois University, DeKalb.

After placing flowers on the Tomb of the Unknown Soldier beside the Kremlin wall, daily processions of bridal couples return to cars festooned with streamers, bears, wedding rings, and bride dolls. Muralist Ivan Nikolaev celebrates the custom in *The Wedding*, 1987, an illusion of surreal light and color (cat. 224).

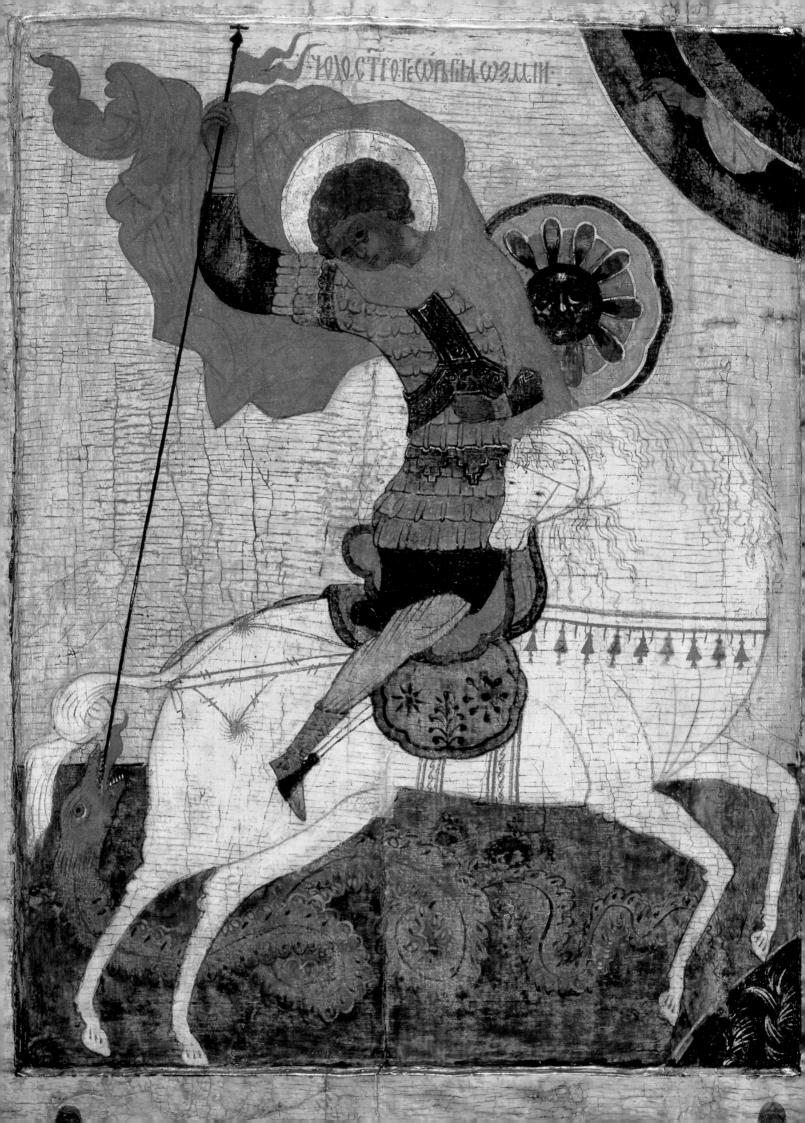

TATYANA V. TOLSTAYA

BETWEEN HEAVEN AND EARTH

THE ETERNAL BEAUTY OF MOSCOW ICONS

<div style="float:left">

The valiant warrior St. George, defender of the faith and protector of princes and paupers, gained great popularity as Christianity spread into new lands. The miracle stories of the saint, martyred in 303 A.D. during Diocletian's persecution of the Christians, were common in the Eastern Church by the 8th century. During the reign of Ivan III this image depicting his triumph over evil became the coat-of-arms of the Moscow state (cat. 1).

</div>

"Let it be known that the icon painters of this city have no equals on this earth, in terms of the quality of their art, the subtlety of their brush strokes, and the skill of their workmanship. . . ."

Paulus of Alleppo
The Travels of Antiochian Patriarch Makarius to Russia in the Mid-Seventeenth Century

The Moscow school of icon painting developed much later than the schools of Old Russia's other cultural centers. However, it was to play a significant, even decisive role in the development of the national traditions of Russian art. Icon painting was meant to express the fullest spiritual ideals of the people. As Moscow gradually became the spiritual center of the Russian state, its icons came to reflect all the fortunes of its flowering.

Moscow was first mentioned in the Russian chronicles of 1147, in relation to the Novgorod campaign of Suzdal Prince Yuri Dolgoruky, son of Vladimir Monomakh. Returning from his travels, he offered to host a banquet for his ally, Sviatoslav Olgovich, prince of Novgorod, with the words: "Come visit your brother in Moscow."

Established at the end of the eleventh century, Moscow at that time was a small, fortified settlement on the outskirts of the Suzdal principality. After the Russian land was devastated by the invading Mongol hordes in the mid-thirteenth century, many ancient settlements, including Kiev, "the mother of Russian cities," experienced a decline.

By the end of the first quarter of the fourteenth century, Moscow regained its strength. It soon controlled a collection of separate Russian lands divided by internecine strife, and conquered its main rival, Tver. Moscow's powerful ruler, Prince Ivan Kalita, began to construct stone churches, new princely mansions, and powerful oaken fortifications. In 1325, the head of the Russian church, Metropolitan Peter, moved from Vladimir to Moscow, making that city the spiritual center of northeastern Russia. These events helped rekindle artistic life in Moscow: Greek painters were invited to paint the new churches, with Russian masters working alongside them.

The few surviving works of that time attest to the deep early influence of both the Byzantine style and the local styles of the ancient central Russian principalities. The works reflect the ongoing quest to convey spirituality, the attempt to balance the reticence of Byzantine forms with the emotional openness of Moscow art.

The Moscow school of icon painting did not attain its distinctive style until the late fourteenth and early fifteenth centuries, during the time of national awakening and consolidation of Russian lands. The victory of the Russian troops over Mongol khan Mamai in 1380 significantly weakened the one-hundred-fifty-year Mongol yoke, inspiring confidence in Russia's ultimate liberation from oppression. Although this would not come to pass for yet another century—and further destruction of towns and countryside still awaited the Russians—the most important element had been established. This was a realization that the road to liberation depended on the spiritual renewal of ethical values and a reunification of the Russian people.

These ideas were reflected in the works of founder and Father-Superior of the first communal Trinity Monastery, Sergey Radonezh (1319-92). He called for spiritual renewal, fraternal unity, and love—"to conquer hateful dissension throughout the world." His call filled the hearts of the people, and his disciples founded cloisters throughout Russia, settling and cultivating the distant northern lands.

The quest for a moral ideal and a path to self-realization and spiritual enlightenment, which paralleled the ideas of the Byzantine mystics, was actively debated in the entire Orthodox community. Echoes of these debates appear in the works of such Byzantine artists as Theophanes the Greek, "the wise philosopher," who worked in many Greek and Russian towns, including Novgorod and Moscow. With virtuoso technique and powerful spirit, he portrayed the saints "in the light of truth," transforming even the paint itself as he offered a compelling image of spiritual enlightenment.

The art of Theophanes the Greek no doubt strongly influenced the Muscovites, but the mainstream of Moscow painting took a different course, best illustrated by the great Russian painter Andrey Rublev. His works, inspired by the teachings of Sergey Radonezh, appeal for peace, love, and charity. Rublev's beautiful images of Our Savior, the saints, and angels, in frescoes and icons, invite compassion for those who seek moral purity and perfection—who must overcome "the adversities of the entire world" on their spiritual journey. His icon *The Trinity,* painted upon the orders of Nikon, the Father-Superior of the Trinity Monastery, is one of the outstanding works of ancient Russian painting. The artist's portrayal of spiritual unity and fraternal love, which opposed "the deep dissension that had infected Russia" (in the words of P.A. Florensky) finds ideal expression here. The poetic melancholy and contemplative mood allow the viewer to experience the image of an enlightened world filled with love.

Valuing both mystical experience and worldly learning, native-born St. Sergius embodied the divergent paths monasticism would later take. He founded the Holy Trinity Monastery at Zagorsk, but was also active in state affairs. The scenes along the border of the icon recall the events of his spiritual life—the visitation by the Mother of God and his vision of the flames (cat. 3).

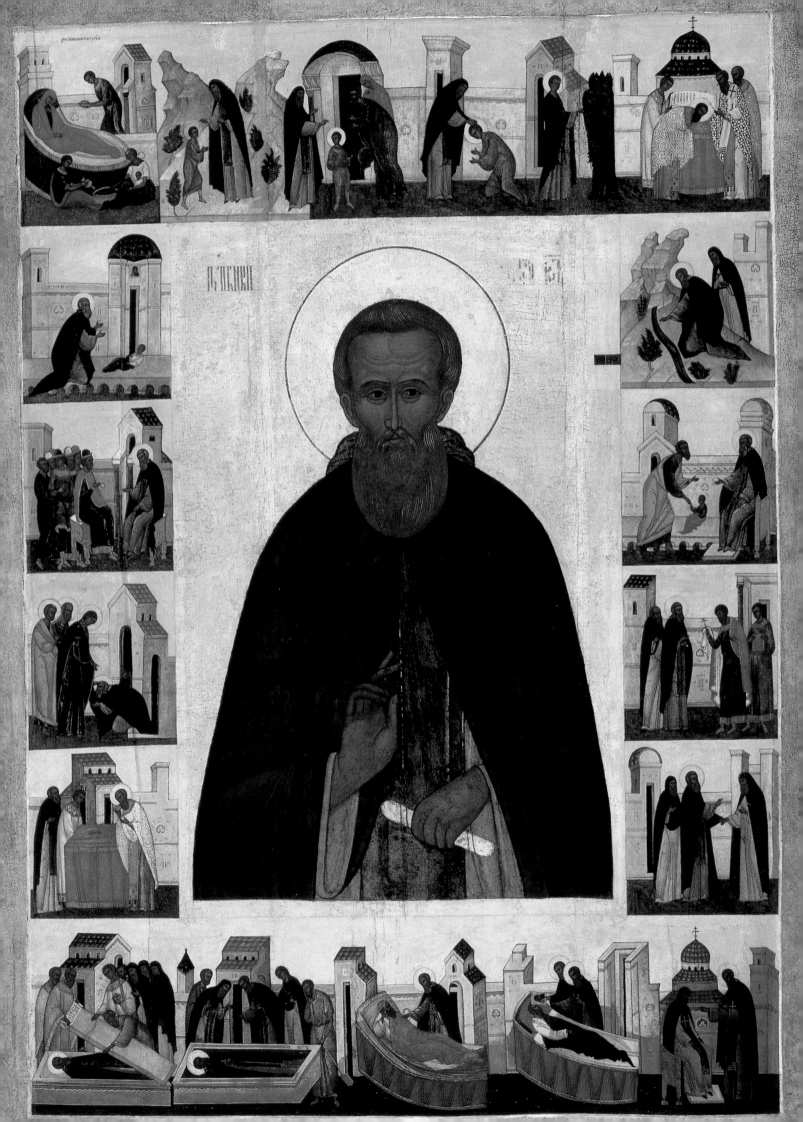

The works of Rublev—the highest achievement of ancient Russian painting—had a powerful effect on the art of Moscow. Throughout the entire fifteenth century, Moscow icon painters created images exuding a gentle sadness, a heartfelt emotion that appealed to the human spirit. However, their artistic language gradually evolved: in some cases it became more simplified and standardized; in others, it became more complex, with a more refined rhythm at the expense of unity of form.

In the last third of the fifteenth century and the beginning of the sixteenth, Moscow experienced rapid political, economic, and cultural growth. With the incorporation of Tver, Novgorod, and Pskov, Moscow became the capital of a united Russian state. In 1480, Mongol rule—which had weighed heavily for over two and a half centuries—was finally crushed. The Turks' victory over Byzantium in 1453 strengthened the authority of the young state. Russia became the stronghold of Orthodoxy and an active participant in European politics. Grand Prince Ivan III, having married the niece of the last Byzantine empress, Sofia Paleologus, assumed the title of Great Sovereign and adopted Byzantium's magnificent court ceremonies.

At that time political doctrines and essays portrayed Moscow as the "Third Rome," and the Grand Prince as successor to the emperors of Rome and Byzantium. It was under Ivan III that the heraldry and symbols of the Grand Prince developed. By his decree of 1464, two equestrian bas-reliefs with the images of Sts. George and Dmitry, "the dragon-slayers," were carved out of stone and placed on the main tower of the Kremlin. Since then, the image of George the Triumphant, symbol of the victory over evil and protector of all Russian warriors—especially the Grand Prince—became the patron of the Muscovite state. It was no accident that the image of "St. George the Dragon-Slayer" appeared on so many icons (cat. 1), banners, coins, and seals. On the seal of Ivan III (1497), it stands beside the double-headed eagle, the ancient emblem inherited from the Byzantine empire.

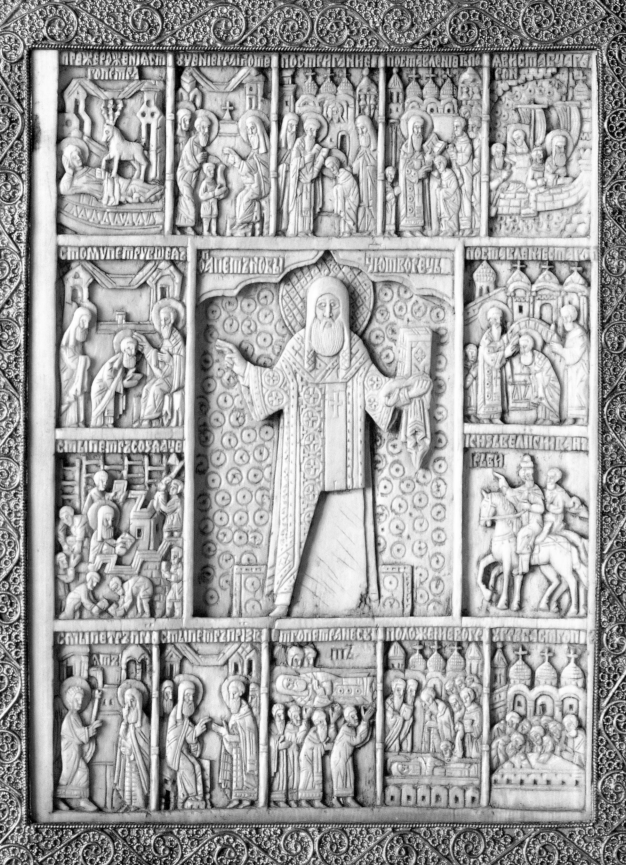

To reflect the Muscovite state's rapid economic expansion, political successes, and improved status, the capital required an architectural face-lift. Ivan III ordered a massive reconstruction of the entire Kremlin com-pound, including its churches, chambers, walls, and towers. Italian archi-tects, bringing the most advanced principles of construction and labor organization—as well as new European achievements in fortification—worked alongside the Russian masters. At the end of some forty years of construction (1475-1516), which continued under Vasily III, the Moscow Kremlin became not only one of Europe's most formidable fortresses, but also a symbol of Moscow's power. It was a beautiful, rationally orga-nized city—for almost two centuries a model for fortresses and monas-teries throughout Russia.

Moscow artists made major contributions to decorating the new buildings, with Dionyssius (1440-ca.1506) assuming the leading role. Their works portrayed men who had attained moral purity and perfec-tion, symbolizing the triumph of justice and universal order—directly linked in the minds of the artists with the essence of a well-ruled state. Compared to the earlier works of Rublev, there is now a greater sense of distance, idealistic loftiness, and refinement. What emerges, as in the portrayals of metropolitans Peter and Aleksey by Dionyssius, is the image of a person who has mastered the long road to perfection. During the time of Dionyssius and his followers icons portraying scenes of the lives of Russian saints were widely disseminated.

Dionyssius, remarkably adept at the art of composition, achieved in his icons an ideal proportional balance between the center and side panels; a consistent unity is attained through measured rhythms, refined silhouettes, and delicate colors. One of the replicas of his icon *The Life of Metropolitan Peter* appears in a small carved icon (cat. 26). The echoes of the Dionyssius style are also apparent in the icon *The Virgin of Vladimir* (cat. 2), a favorite subject of the Moscow school. This is one of the remain-ing copies of an ancient and revered icon brought from twelfth-century Constantinople to Kiev and then Vladimir, where it was considered the palladium of the Russian state. It was transferred to Moscow in 1395 to protect the city from Tamerlane's armies. The icon remained in the Cathedral of the Assumption in the Kremlin until 1918.

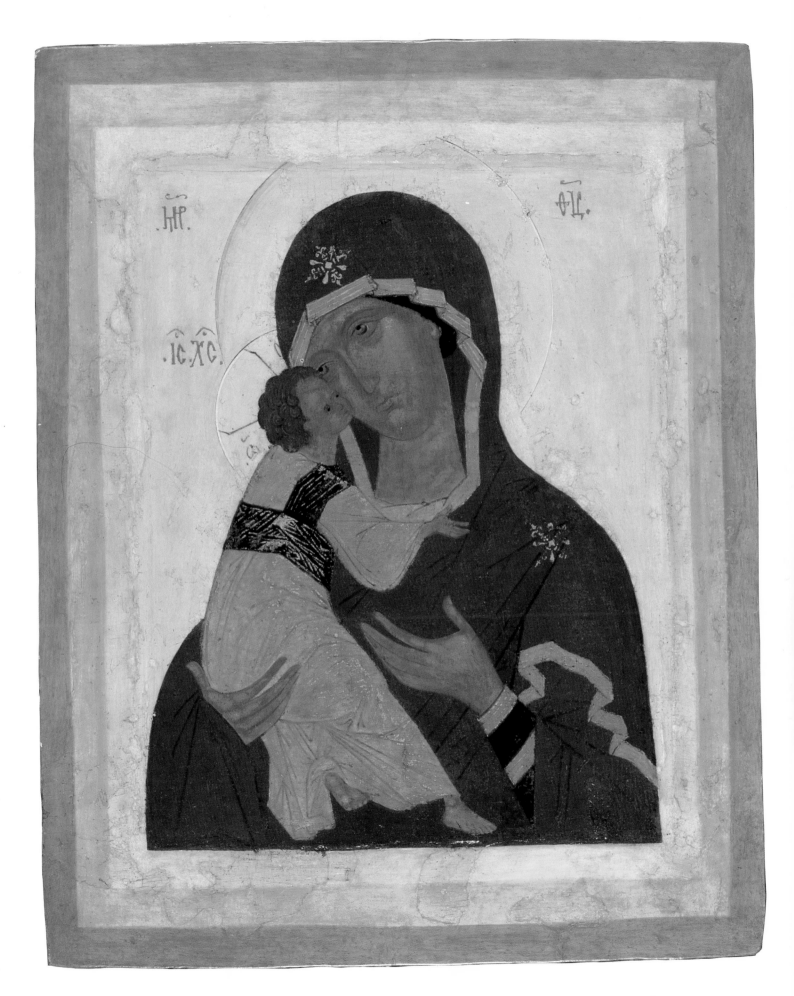

73

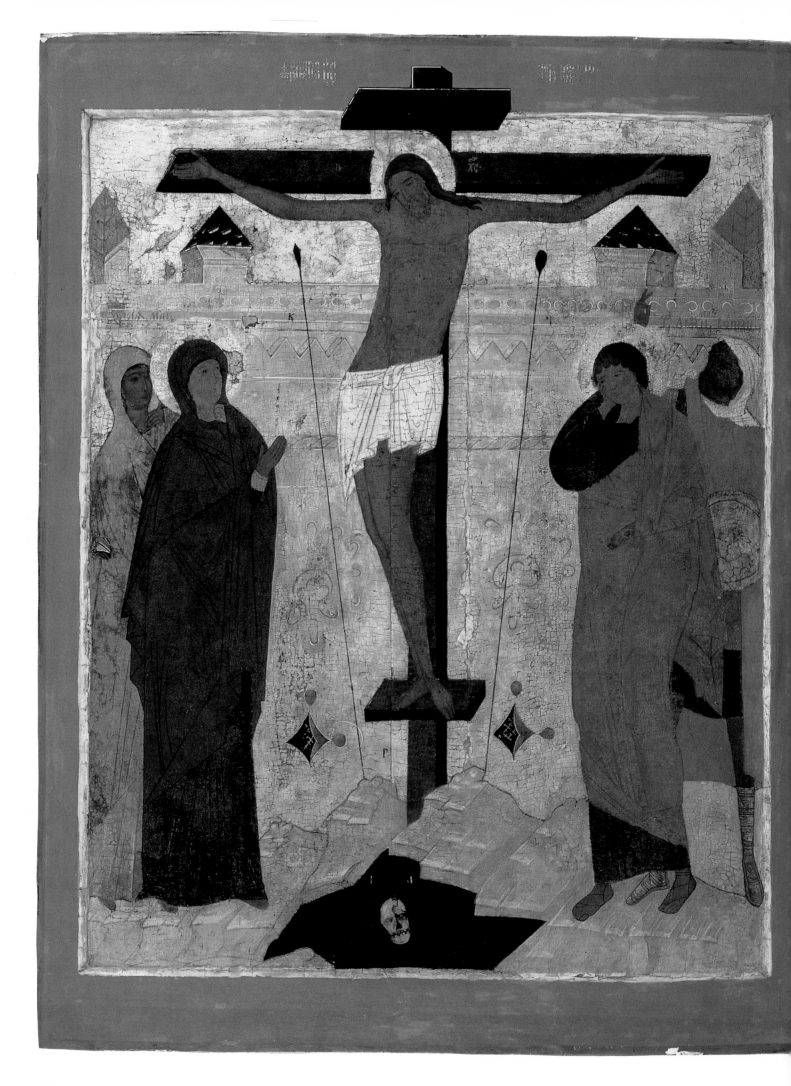

74

The 16th-century icon *The Crucifixion with Mourners,* which comes out of a local tradition of central Russia, still follows the graceful styles of the previous century. The scene depicts the Biblical account, placing the Virgin Mother, the Apostle John, and Longinus the Centurian among the mourners. The skull of Adam perhaps recalls the widespread medieval legend that told of Adam's burial at Golgotha with a sprig of the Tree of Life from Paradise (cat. 4).

Moscow, which long considered itself blessed by the Virgin's patronage, warmly embraced the image of the merciful "Madonna of Tenderness" (*Eleusa*) caressing the Christ Child, the iconic form seen in *The Virgin of Vladimir.* The icon shown here, however, is closer to one of the variations created by Rublev's followers in the early fifteenth century than to the Byzantine original. This is evident in the smoother silhouette, in the placement of the hands—which seem to be praying before Christ—and in the lyrical interpretation. In addition, the clarity of line, the fluid brush stroke, and the delicacy of color characterize the works of Dionyssius' followers.

Another icon in the Dionyssius tradition is *The Life of St. Sergius of Radonezh* (cat. 3), painted in the second quarter of the sixteenth century. It illustrates key elements of the style: proportional scale between the central and side panels, lack of illusory depth, measured rhythms, graceful elongated figures, architectural elements on the borders, and, finally, the light background. The slightly heavier rhythm of line, exaggerated colors, and thick brush stroke, however, foreshadow the next period's style.

Not all the trends in the Moscow painting of the fifteenth century and the first half of the sixteenth belong to the mainstream. Among Moscow icons one also encounters an archaic tendency linked to the local traditions of central Russia. An example is *The Crucifixion with Mourners* (cat. 4) from the sixteenth century. Its creator was guided by an iconographic model widely used both in Moscow art of the preceding century and in Dionyssius' famous icon from the Pavlovo-Obnorsky Monastery (1500). Although *The Crucifixion* incorporates the compositional and rhythmic principles of the Dionyssian icons, its effect is quite different from that of the refined poetic images of Dionyssius.

The stormy and contradictory reign of Ivan the Terrible (1533-84) marked a new stage in the history of Moscow and its art. The first years of young Ivan's rule, when he triumphantly crowned himself tsar in Moscow's Cathedral of the Assumption, were marked by several successes: victories against key rivals, such as the Kazan and Astrakhan khanates; the incorporation of western Russian territories through a battle for access to the Baltic; and the beginning of the settlement of Siberia. This completed the consolidation of the state that Ivan III had begun.

Great attention was now paid to the organization of the Muscovite state. All kinds of orders and decrees were created, which affected not only economic and social life, but also education, book publishing, and art. The church, which became the spiritual mentor to the state, played an active role in establishing a unified code of law.

The Council of a Hundred Chapters, convened by Ivan in 1551, codified icon painting. New rules demanded strict emulation of the existing icon format, so that artists would not depart from the "iconographic originals." There were guidelines for painting not only saints but also living people, above all the tsar.

Having uncovered the grand traditions of its past, the Russian state took a greater interest in national and world history. Under the leadership of Metropolitan Makarius an enormous collection of historical and literary works was assembled, including *The Definitive Compilation of the Lives of the Saints* and *The Illustrated Collection of Historical Chronicles.* Historical themes also permeated icon painting and art, which by their very nature seemed destined to portray eternal, timeless subjects. In 1552-53, to commemorate the taking of Kazan, a magnificent icon was painted, *The Church Militant (The Blessed Army of the Heavenly King).* A small replica of this icon, executed at this time or a bit later, is preserved in the Kremlin Museums (cat. 5). Through allegory, the work glorified the "blessed," triumphant Orthodox army, which courageously protected the borders against "invaders and destructive hordes" throughout the centuries.

The Church Militant closely linked events from the ancient past to the political concerns of the time. To the Russians, the victory over Kazan reflected the universal process—and in its own way the very essence—of Russian and world history. The image of a tempestuous, sinful city was

Ivan IV's popular victory at Kazan in 1552 over the marauding Tatars carried Orthodoxy to Asia and brought the vast lands of the Volga as far as the Caspian Sea into the state of Muscovy. The icon *The Blessed Army of the Heavenly King* (seen here in a smaller replica) commemorated the event. In this allegory of Kazan and Moscow, the Archangel Michael, protector of the Church Militant, leads the army from the burning city of Sodom toward the Heavenly City, with Ivan IV and cross-bearing Vladimir Monomakh following directly. Dmitry Donskoy leads the upper troops, Alexander Nevsky the lower (cat. 5).

associated not only with the Old Testament city of Sodom, but also with conquered Kazan; the heavenly city of Jerusalem alludes to Moscow, "the Virgin's City," distributing crowns of triumph to its heroes; and powerful contingents of princes and warriors, striding along in triple-file procession toward the triumphant Russian city, were compared to great ruler Constantine (Vladimir Monomakh) and glorious leaders Alexander Nevsky and Dmitry Donskoy.

In the work, the Archangel Michael, leader of the army, leaps onto a winged horse at the head of the troops. He turns to a young horseman clad in armor and a scarlet cloak, beckoning him to follow, as a host of angels places a crown of victory on the young warrior's head. Contemporaries saw in this figure the image of young Ivan IV, the victorious marshal and worthy descendant of his glorious ancestors—the great Russian princes of the past and the emperors of Byzantium. This icon-treatise epitomized the ideology of Ivan and his entourage, the so-called "Chosen Council": that the tsar's clan was chosen by the Mother of God and a multitude of Russian and ecumenical Orthodox saints who served as its patrons and protectors.

Despite its many figures, the icon is distinguished by logical clarity and proportion. In the victory procession, which is divided into three streams of warriors on foot and on horseback, the breaks in the rows clearly set off the main characters. Upon the icon's flat background, the artist has painted a bird's-eye view of an extensive panorama. In this way, the composition resembles those of European landscape-procession painters, whose famous paintings and engravings began filtering into Russia in the sixteenth century. These engravings—such as those illustrating the German *World Chronicle* by Shedel (1650)—often served as images for series of Rus-

sian miniatures, enriching the iconography of icons.

In addition to such complex, controlled compositions as *The Church Militant*, more traditional icons continued to be produced in the mid-sixteenth century. Among these were icons for the chapel iconostases in the Kremlin Cathedral of the Assumption—created to honor Ivan IV's Polovetsian campaigns of the 1560s—as well as the chapel iconostasis portraying Christ's entry into Jerusalem (cats. 6-14, frontis 2). Icons produced in the tsar's workshops in Moscow, where masters from all over Russia worked together, reflected the gradual merging of local artistic traditions into a single style in the Russian painting of the second half of the sixteenth century.

Horrible and tragic events visited Russia in the late sixteenth century: the defeat in the Livonian War (1558-83), a decline in the people's living conditions, the terrors of the *oprichnina* (purges), and the tyranny of Ivan the Terrible. The art of the period has a tragic, sorrowful tone. The colors are flat, dark, subdued; the faces, gloomy; the figures, ascetic. The ideal was no longer to be found in transforming the world, through love or spiritual purification, but rather in asceticism and individual redemption.

Under the reign of Fedor Ioannovich and Boris Godunov, aristocratic tastes began to affect artistic styles, demanding greater decorativeness and refinement. Paintings of the late sixteenth century also emulated ancient models. An example is an exact copy of the ancient icon *The Life of St. Demetrius of Thessalonica* (cat. 15), now preserved in the Kremlin Cathedral of the Assumption. The work was executed in 1586 under a decree by Dmitry Ivanovich Godunov, the uncle of the future tsar, Boris. An inscription on the icon's silver cover indicates it was placed in

Modeled on an earlier image, this large icon of *The Life of St. Demetrius*, protector of Russian Orthodoxy, was commissioned in 1586 by Dmitry Ivanovich Godunov, uncle of Boris. The Godunov family wielded great power at court—Irina was married to Tsar Fedor; her brother Boris, a favorite of Ivan IV and regent for his son Fedor, ultimately ruled from Fedor's death in 1598 until 1605. The lavishly chased silver cover reflected aristocratic tastes (cat. 15).

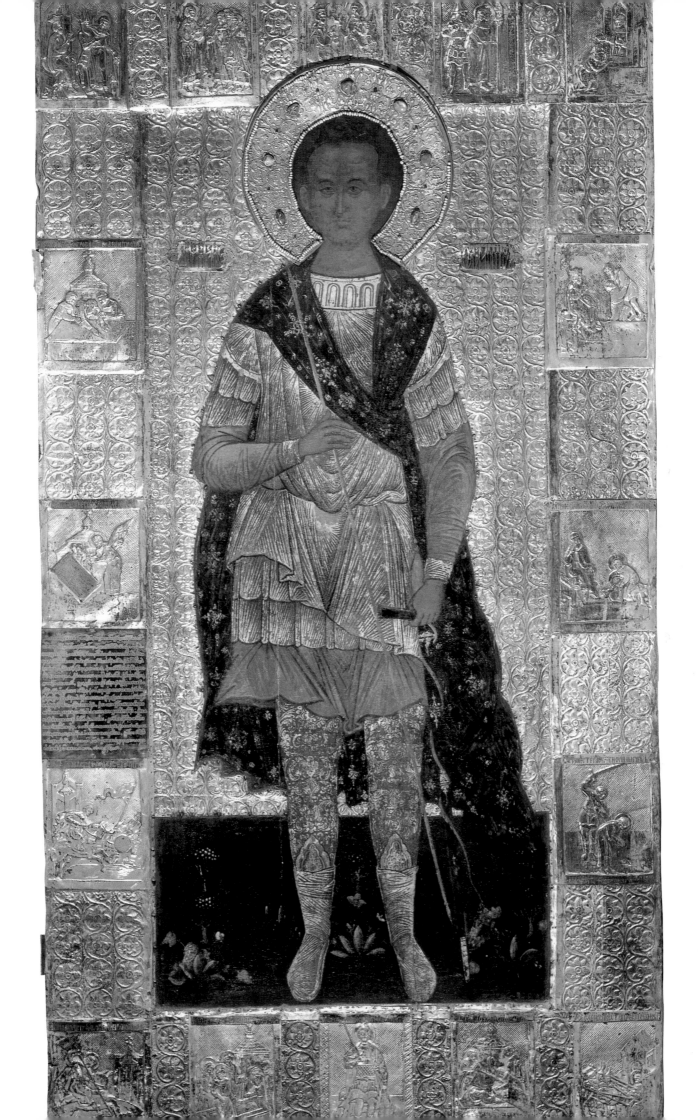

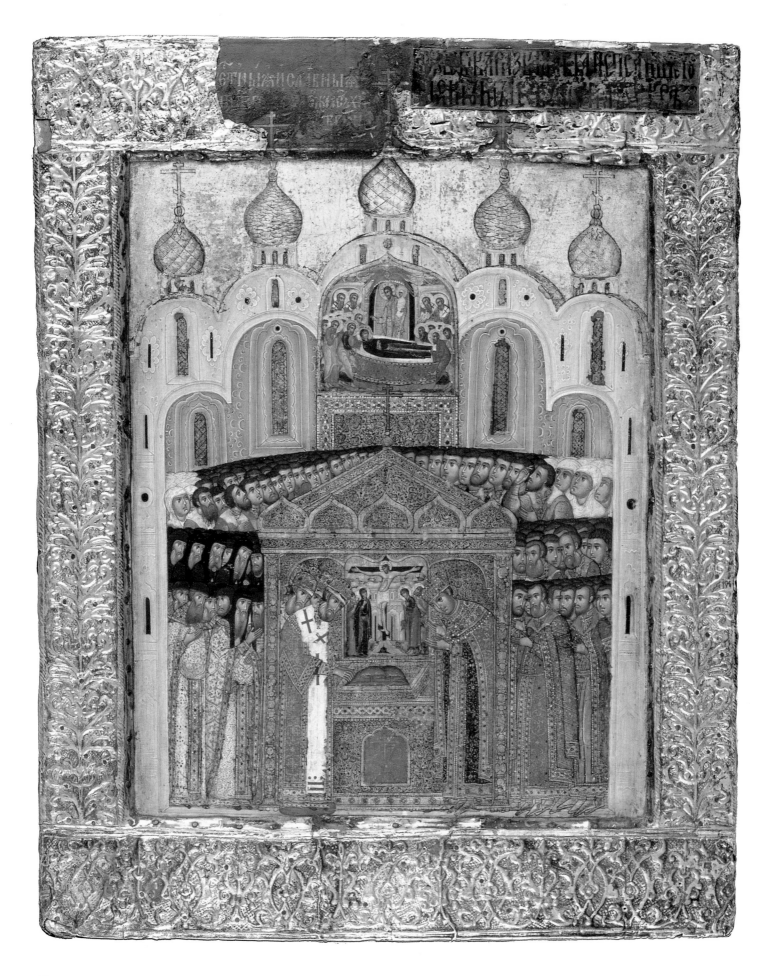

The private patronage of the wealthy Stroganov family made possible small, exquisitely painted icons for private devotion. *The Deposition of Christ's Robe* (1627) records an historic event of 1625: Patriarch Filaret and his son Tsar Mikhail Romanov, surrounded by clergy and laity, place a reliquary—containing a piece of Christ's robe brought to Moscow by envoys of the Persian shah—within a bronze, gabled "Lord's Tomb" in the Kremlin Assumption Cathedral. *The Deposition of the Virgin's Robe* provided the compositional model for this new icon type (cat. 16).

the Godunov's burial vault, located in the Cathedral of the Holy Trinity in Ipatevsky Monastery in Kostroma.

The choice of the image was not accidental. According to legend, the original icon, painted in the twelfth century by Kirill Ulanov, was moved from Solun in 1197 by Vsevolod Big-Nest (his Christian name was Dmitry) to the church of his patron saint, the Church of St. Dmitry, in Vladimir. Then, in 1380, it was brought to Moscow by Dmitry Donskoy, who placed it near the entrance to the altar of St. Dmitry in the Cathedral of the Assumption. In this way, Dmitry Godunov secured three patrons: the saint by his name and the two princes of the Moscow and Vladimir dynasties. The Godunov epoch's propensity for refined, aristocratic elements was reflected in the extremely expensive covers that adorned icons of the period.

Art during the rule of tsars Fedor Ioannovich and Boris Godunov, which followed the terrifying period of the oprichnina, was characterized by the collapse of grandiose, officially propounded social ideals and a revival of the quest for moral values through self-realization—to be expressed through humility, modesty, and indifference to worldly possessions. It is not by chance that one of the most respected saints of that time was Basil the Blessed, who gained the title "Fool in Christ." He was canonized in 1588 and buried in Red Square under the walls of the Pokrovsky Cathedral, which was built from 1555-61 by Ivan IV to commemorate the taking of Kazan and later named to honor that occasion (but now popularly known as St. Basil's Cathedral).

The icon portraying St. Basil (cat. 28, p. 93) is richly mounted and painted in the "Stroganov style." This style, which evolved in the late sixteenth and early seventeenth centuries, was inspired by the artistic taste of the Moscow court. The name "Stroganov" was introduced by art collectors of a later period who associated the style with the Stroganovs, the merchants, landowners, and art patrons who regularly commissioned icons for their churches and chapels.

Icons in the Stroganov style were usually small and exquisitely painted, with extremely refined and elaborate gold ornament. They were meant for long, penetrating contemplation and admiration—to prepare the soul for enlightenment and harmony. These icons were frequently adorned with lavishly detailed covers and decorated with precious stones. Viewers focused less on the faces, which often bore stereotypical features, than on the richly ornamented costumes of the ceremonial participants and the interwoven patterns executed in gold tracery on the latticework of the canopy-reliquary. A notable example is *The Deposition of Christ's Robe* (cat. 16). The subject of this icon, which was unusual for Russian iconography, was an historical event. Later replicas of the icon are also famous; one is in the Tretyakov Gallery and the other in the Pokrovsky Cathedral of Rogoz Cemetery in Moscow.

Painting from the first quarter of the seventeenth century was still tied to the traditions of the Godunov epoch; the break in style did not begin until the 1640s. The first years of the seventeenth century were marked by interdynastic struggles and the Polish-Lithuanian intervention, which destroyed Moscow and the central Russian lands. This troubled time ended in 1613, when the Romanov dynasty's first tsar, Mikhail Fedorovich, rose to power. However, stormy events continued to plague the Russian state, particularly the repeated insurrections led by villagers and merchants who had been driven to desperation, enslaved, and downtrodden.

At the same time, a strengthening of the autocracy was taking place on a different social level. The autocracy depended upon the service of the nobility and the church; the latter, which benefited from the growth of the state, imbued the tsar with an aura of sainthood.

The rapid growth of the cities, the flourishing of trade, and the assimilation of new territories from the north and Siberia promoted the growth of a new urban, commercial culture, distinct from that of the court and the peasants. This took place in concert with an active exchange and enrichment both with the West and the East. New genres in literature emerged: moralistic novellas, tales of adventure, satires. Themes adopted from Catholic and Protestant didactic tracts penetrated ecclesiastical literature, giving birth to complex symbolic and allegorical works based on Polish, Ukrainian, and Belorussian sources marked by the influence of baroque culture.

The debates sparked by the reforms of Patriarch Nikon (1652-60), who strove to unify and reestablish church life "according to the Greek model" and attempts to make the church more powerful than the tsar led not only to the deposition and exile of Nikon himself, but also to a schism in the church. The church split between "Nikonians" and the "Old Believers," at the head of which was the violent publicist, the archpriest Avvakum.

The difficult process of state-formation and social organization also affected artistic spheres. In icon painting, spiritually inspired figurative imagery gave way to rational, allegorical icons as exemplified in the works of Simon Ushakov. Since the 1640s, artists working in the icon studio of the Kremlin Armory—a unique "Academy of Arts" of Ancient Russia—played a decisive role in the art of Moscow and all of Russia. In 1644, Simon Ushakov was selected to head this studio. His works, like the aesthetic treatise of his friend Iosif Vladimirov, reflected new artistic ideals.

Ushakov, Vladimirov, and their followers strove to bring art closer to life. To make the iconic image more life-like, they resorted to a more three-dimensional treatment of the figure and the use of chiaroscuro modeling of the faces, although the traditional technique of applying the paint—from dark to light—was preserved. To endow the background with spatial depth, they borrowed architectural and landscape motifs from Italian and northern European art, from which they also took depictions of clothing styles.

Frequently, Ushakov and other painters of the Armory circle modeled their work on engravings from western European bibles, such as the Borcht and Merian Bibles (named for their publishers) and the Piscator Bible (printed in Amsterdam in 1650 and especially popular in Russia). Among direct borrowings are three remarkable icons from the end of the seventeenth century: *The Presentation at the Temple* (cat. 20), *Christ Before Caiaphus,* and *The Washing of the Feet.* They were painted by masters of the Armory for the iconostasis in the Ascension Convent in the Kremlin, which served as a burial vault for women of the nobility.

In the second half of the seventeenth century, not only the Moscow painters but artists from

The story of the presentation of the Virgin at the temple is related in the apocryphal Gospel of St. James. This icon of the late 17th century meticulously follows the text: chaste maidens with burning tapers accompany the Virgin and her parents to the temple; the priest Zachary places the Virgin on the third step before the altar; an angel feeds Mary in the temple. The altar, sacred ark, menorah, and censer were taken from an engraving in the European Piscator Bible (cat. 20).

In the late 17th century, western influences grew through German and Dutch trading and contacts with Poland. Changes in Russian life and culture, still feared by many, were more accepted within Moscow's ruling circles. In 1686, the same year that saw Poland cede Kiev to Russia, Sergey Rozhkov—for twenty years a master in the Armory icon workshop—painted this Nativity scene. Elements from western engravings enter the decorative manner of the traditional style (cat. 17). From the iconostasis of the Church of the Intercession at Novodevichy Convent, a different treatment of the theme is seen in a balanced composition similar to the work of Kirill Ulanov, known to have worked there (cat. 19, right).

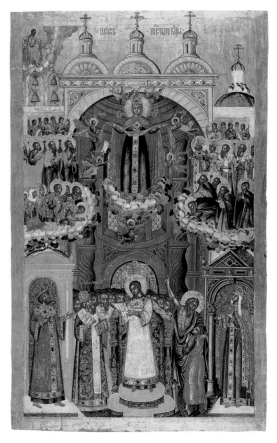

Baroque architectural forms and coloring are seen in the icon *The Intercession of the Virgin (Pokrov)* painted by Vasily Rakhomov in 1690. This popular theme celebrates the 10th-century appearance of Mary in Constantinople, holding her veil over the congregation, a symbol of her intercession on their behalf (cat. 18, far right).

many Russian towns—Kostroma, Yaroslavl, Ryazan, Kazan, Uglich, and others—traveled to Moscow to paint churches as part of the massive construction and renovation work going on. They created some one hundred fifty large artels, which were dissolved once the work was done. Some of these artists, called salaried icon painters, received annual compensation, while others were paid only for the hours worked (so-called "foragers").

At that time fresco-painters were beginning to work on the "division of labor" principle. Some executed the rough sketches, others painted faces and hands, still others painted figures and backgrounds, and so on. Though this deprived each of self-expression, it ensured stylistic continuity, which was ultimately determined by the team's leading artist. It is evident that the same principle was used in creating large iconostases in compositions.

At the same time, some icon painters, breaking with the medieval tradition, began to sign their works. This allows one to identify artistic style according to artist.

An example of this was the tsar's famous icon painter, Sergey Rozhkov. Born in Kostroma, Rozhkov came to Moscow in 1666 and entered the Armory icon studio, where after two years he received the title of "salaried master."

Rozhkov took part in the decoration of the Nikitniki Trinity Church in the Ivanovsky palace estate, painted the churches and icons of the tsar's Ismalovsky estate in the late 1670s and early 1680s, and produced book illustrations. He also lent his brush to the icon *The Nativity* (cat. 17). The distinguishing marks of this icon, which depicts the adoration of the Magi, a scene not traditional for Russian iconography, are the obvious borrowings from western European engravings.

In the cities along the Volga, including Kostroma, the leading artist was Gury Nikitin, whose style resembled Rozhkov's. The typical features of his works, and those of other artists of that region, included marked decorativeness, "mannerist" fragmenting of form, elaboration of space through complex landscapes and architectural borrowings from antiquity, and brilliant yet well-balanced color schemes.

A variation can be seen in another icon of the same subject (cat. 19) distinguished by its more traditional treatment and balanced composition. The characteristic modeling of faces with light and shade, the smooth, flowing gestures, and the detailed interior space are features of the work of another renowned court icon painter, Kirill Ulanov. His icon *The Fedorovskaya Virgin,* portraying the Virgin Mary and selected saints, is remarkable for its elegance (cat. 23). The silver framework, with its decorative ornamentation, greatly complements his refined manner of painting.

Kirill Ivanovich Ulanov (? -1731) became a salaried icon painter at the Armory studio in 1688. From 1698 to 1699, under a decree issued by the tsar's daughter, Praskova Fedorovna, he painted the iconostasis for the Pokhvalsky chapel of the Kremlin Cathedral of the Assumption. He also painted icons for the tsar's chambers and the Kremlin chapels, and helped create the iconostases in the Pokrovsky Church in Fili and the Pokrovsky Church in the Novodevichy Monastery.

Elements of the baroque style, which emerged in icon painting in the late seventeenth to early eighteenth centuries, are evident in the icon *The Intercession of the Virgin* (cat. 18), painted by Vasily Pakhomovy. These elements are apparent not only in the almost illusionary interpretation of the church interior, but also in the baroque architectural forms and saturated, multicolored palette.

The evolution of the "Armory School," which crowned the century-long development of Moscow's artistic culture, was not homogeneous. As early as the 1640s, one can observe a phenomenon new to Russian art: a division between icon painters, who held to the more or less traditional, sacred forms of art, and painters, who produced landscapes and *parsunas*—portraits "from life," that is, from nature. This was the first step on the road to the secularization of art, which by the beginning of the eighteenth century had already matured into distinct genres of secular style, including portraiture, landscape, and still-life.

Tolstaya is Chief of the "Museums-Cathedrals" Department, State Museums of Moscow Kremlin.

This small, elegantly painted folding icon—attributed to Kirill Ulanov, an honored Armory master—was embellished with the supreme artistry of Moscow jewelers (cat. 23).

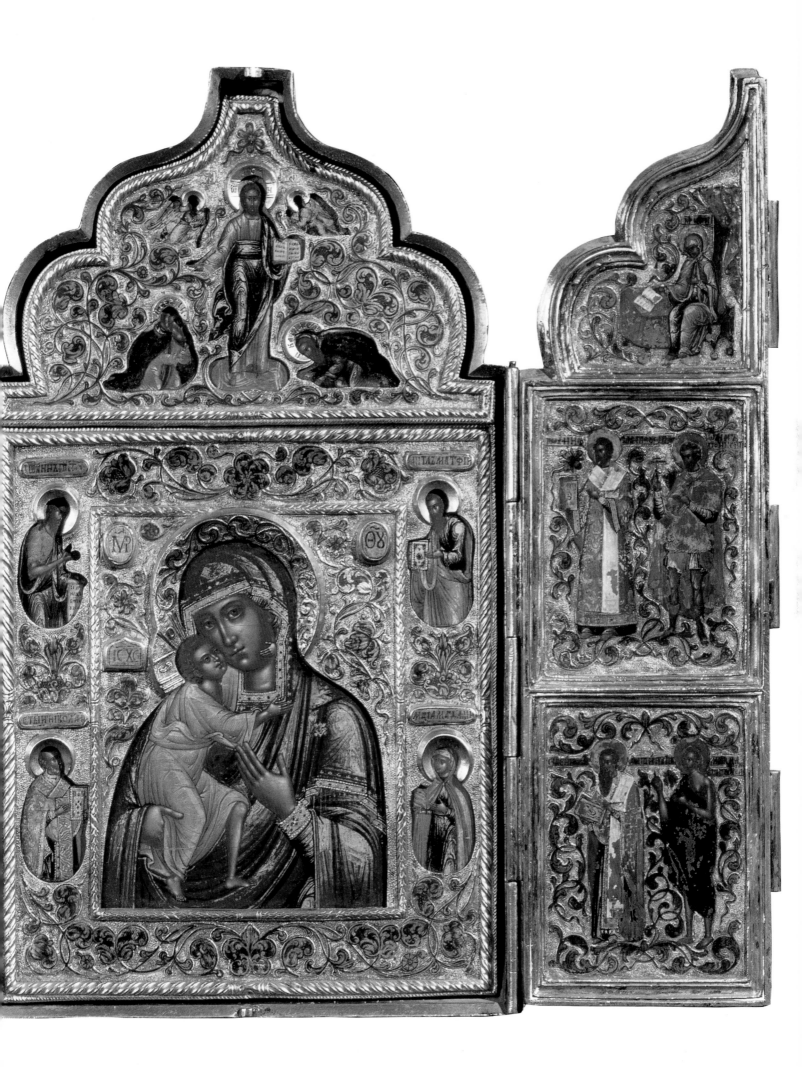

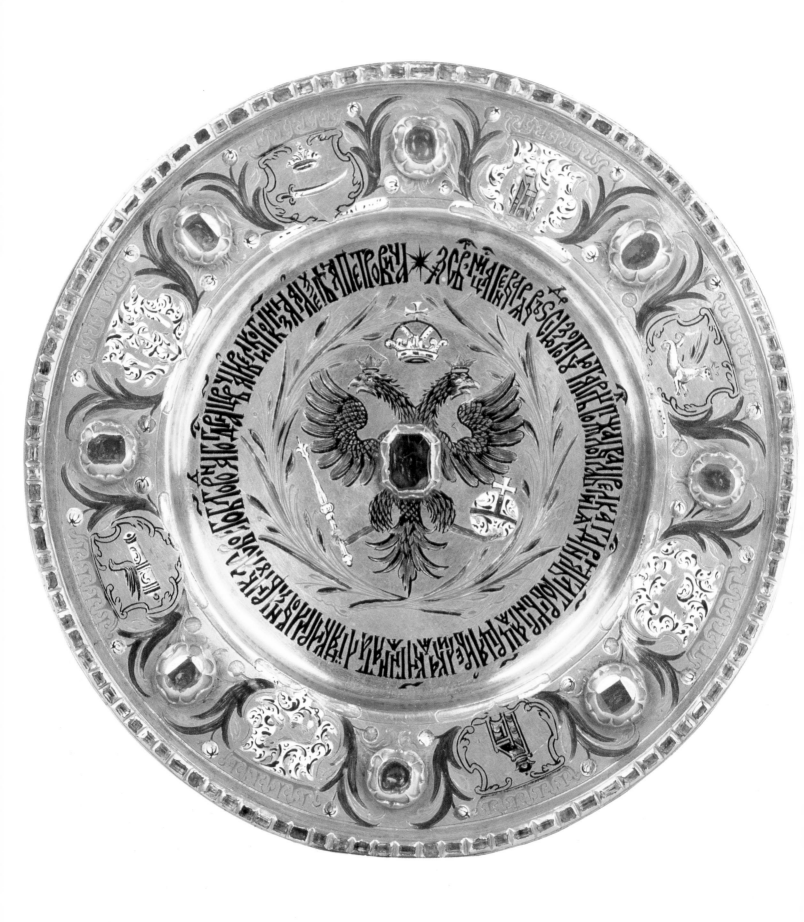

IRINA A. BOBROVNITSKAYA

THE GOLDEN AGE
OF RUSSIAN JEWELRY

MOSCOW METALWORK, 1500-1800

This gold plate with rubies and emeralds was given in 1694 by Natalya Kirillovna, mother of Peter the Great, to her four-year-old grandson, Tsarovich Aleksey. Encircling the coat of arms of Russia are those of the lands joined to it—including the distant Astrakhan, Perm, and Siberia—a vast empire now encompassing part of the Ukraine and reaching to the Amur River (cat. 37).

The gold and silver work of Moscow is a glorious page in the centuries-old history of Russian artistic culture. The priceless pieces produced by Moscow craftsmen, decorated with sparkling precious stones and bright enamels—often featuring fine filigree lace and delicate niello patterns—impel admiration for their virtuosity of execution, refinement of decoration, and perfection of sculptural treatment.

The works of Moscow goldsmiths in the museums of the Soviet Union are distinguished by richness and variety. Pieces made earlier than the fifteenth century, however, are rarely encountered there. The Mongol invasion—during which workshops were devastated, valuable articles destroyed, and master artists killed or taken prisoner—dealt a serious blow to jewelry production. Its recovery began in the first half of the fourteenth century, when Moscow, leading the struggle against foreign oppressors, gradually became a large center for producing precious metalwork.

Significantly, the culture of this era was marked by an increased interest in the pre-Mongol epoch of national independence and its artistic heritage. Jewelry making was no exception. A number of valuable examples from Moscow of the fourteenth century recall earlier treasures both in their physical features and technique.

Like the goldsmiths of the twelfth century, the Moscow jewelers of the fourteenth used various techniques. Filigree—decorative designs of thin gold and silver wire, widely used by the master craftsmen of Old Russia—appeared again. The uncomplicated but at the same time unusually pictorial ornament, based on spiral-shaped twisted curls, was also prevalent in metal chasing and carving.

Enamel work also became more common, although the technique was changed and significantly simplified. The masterful art of cloisonné, which had flourished in the twelfth century, was lost during the years of the Mongol conquest. Enamel—as a rule in blue-green tones—now covered the background around the figure and inscriptions. It was also used to outline the contours of images.

In a similar way niello, known to Russian jewelers since ancient times and used much more extensively by them than western Europeans, was used to decorate articles of silver. Two-dimensional decorations executed in a thin niello or enamel line were characterized by a singing rhythm of fluid lines, harmonious proportions, regularity and purity of contour, and balance.

These qualities are also found in the carved images, as in the figures of saints on the inside of the round silver *panagia* (cat. 24). This piece, typ-

ical for Russian gold and silver work of the time, combines several jewelry techniques—casting, chasing, carving, and niello.

The growing skill of Moscow jewelers became especially noticeable by the end of the fifteenth century. This period in the history of Russia was marked by important political and economic shifts—the final liberation from Mongol dominance and the formation of a centralized state. Moscow, which not long before had been a modest capital city of one of the central Russian principalities, became the capital of a great nation. The newly reconstructed Kremlin, with its massive fortress walls and splendid cathedrals, was transformed into one of the most majestic architectural ensembles in Europe. Court craftsmen filled the sacristies of the new churches with valuable religious objects. Some of these works have come down to our time, among them a gilded silver censer from the Kremlin Cathedral of the Assumption (cat. 25, p. 30). Its high artistry and technical excellence give full proof of the professional mastery and taste of the Moscow goldsmiths of this period.

The sixteenth century was the golden age of Russian jewelry, and the leading center was unquestionably Moscow. The best artistic forces were concentrated in the workshops of the Kremlin (although the first documentary evidence of them dates from the beginning of the century, it is not out of the question that they were active even earlier).

A large number of artists, calligraphers, wood carvers, embroiderers, gunsmiths, and

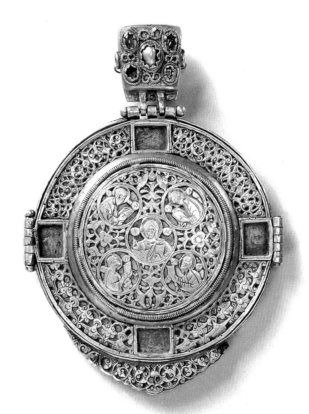

casters—assembled from every corner of the Russian lands—labored in the workshops. In a special tsarist silver studio, where gold and silver utensils were made for the sovereign, the best goldsmiths of the capital crafted precious articles that were intended to add luster to solemn court ceremonies and church services. These luxurious objects, which in their time had great significance for strengthening the authority of the feudal state, are outstanding treasures of Russian art, reflecting the aesthetics of talented native artisans.

Unfortunately the names of these craftsmen, with a few exceptions, are unknown, since the surviving written records contain almost nothing about them, and their works have no hallmarks. Foreign artisans working at the Kremlin enriched the professional experience of the Rus-

Within this rare 15th-century *panagia*, engraved images of the Virgin and Trinity reflect the veneration of the Mother of God. In the Service of the Panagia, the blessed bread marked with her image is carried in solemn procession to the refectory of the monastery, linking the nourishment of the soul and the body. On journeys, monks carried small pieces of the bread in a travel panagia, a pectoral icon. The exterior of this treasure, from the Assumption Cathedral, shows Christ surrounded by the four Evangelists (cat. 24).

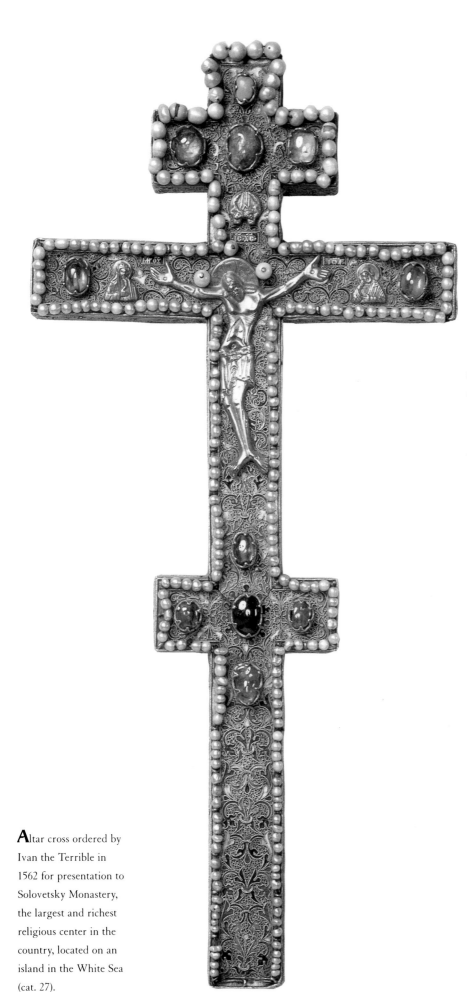

sians in a creative interchange of artistic influences from many countries.

These works are marked by a refined simplicity and logic of forms. The ornamentation is elegantly designed, with a clear, strictly rhythmic scheme composed of stylized plant motifs—floral rosettes and curling trefoil stems. In individual elements as well as general construction one senses the influence of the Renaissance, even as the Moscow jewelers preserved a deeply national and distinctive character.

Precious stones always played a large part in the decoration of Russian gold and silver articles. In the sixteenth century, as before, cabochons—uncut round stones—were used. These softly gleaming precious and semi-precious stones, in their charming natural form, organized and enriched the ornamentation.

The Moscow artisans achieved perfection in many techniques for processing and decorating articles. Enameling continued to be widely used. In the pieces of this period, however, enamel is combined with filigree, which serves as an elegant setting for it. The range of enamel colors is especially refined; white and light blue predominate among a multitude of hues, from intense cornflower blue to delicate turquoise. Filigree trefoils, on long curling stems of gold or silver threads set off by enamels, are typical features of Moscow jewelry; a fine example is a gold enamel cross from 1562 (cat. 27).

Niello also remained a favored technique, now more often used to decorate gold articles than silver. Niello of deep black color, marked

by high quality of execution, characterizes the period. Contrasting beautifully with the gold—its velvety appearance standing out against the gold background—niello was at once an elegant and nobly refined decoration. In the latter part of the sixteenth century there was increased attention to clarity and purity of drawing and to harmony and beauty of composition. A prime example is the cover of the icon *Basil the Blessed* (cat. 28).

The craftsmen of ancient Russia not only decorated icons with valuable covers but, following the example of painters, not infrequently created images themselves—by chasing or carving metal, stone, wood, or bone. Thus miniature icons appeared with engraved or repoussé representations of saints and with many-figured compositions not inferior in their delicacy of workmanship to those of Moscow icon makers. Such a treasure is the bone icon *The Life of Metropolitan Peter* (cat. 26, p. 71), whose creator was both a skillful carver and fine draftsman.

In the seventeenth century Moscow jewelry making entered a new era, supported by the high achievements of the goldsmiths of the preceding period. The beginning of the century, however, was an extremely unfavorable time both for the development of Russian artistic culture as a whole and for precious metalwork in particular. This was the so-called "Time of Troubles," brought about by the complex political situation in the country and the intervention by the Poles and the Swedes. The widespread disorder and the presence of foreign intruders at the capital boded ill for treasures from the past, which not only fell into enemy hands but were often melted down into bars.

After the invaders were expelled at the end of 1612, life in the country gradually returned to normal. In 1613, following the coronation of Mikhail Romanov, the first representative of the new dynasty, the Kremlin artisans quickly resumed work. The silver and gold chambers again became the leading centers for fine metalwork.

Documents from the seventeenth century reveal the national makeup of the Kremlin workshops. There were craftsmen from the central Russian and Volga cities as well as from the northern centers. In the second half of the century—when cultural contacts with the Ukraine, Belorussia, and western Europe expanded—many artisans, with various

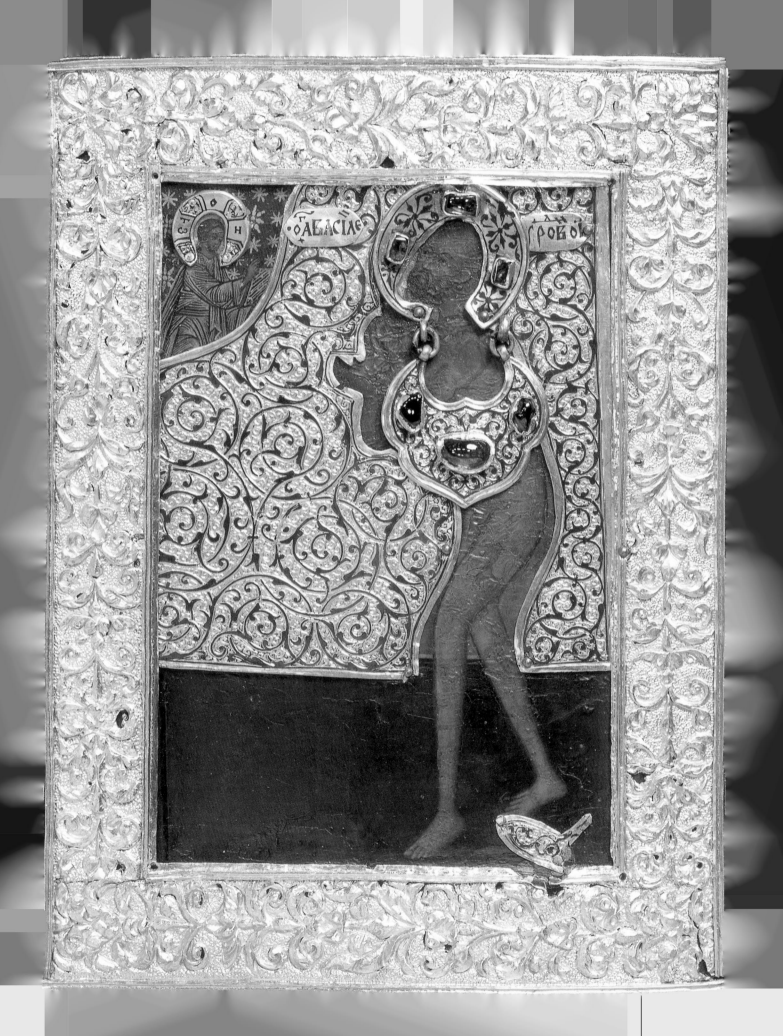

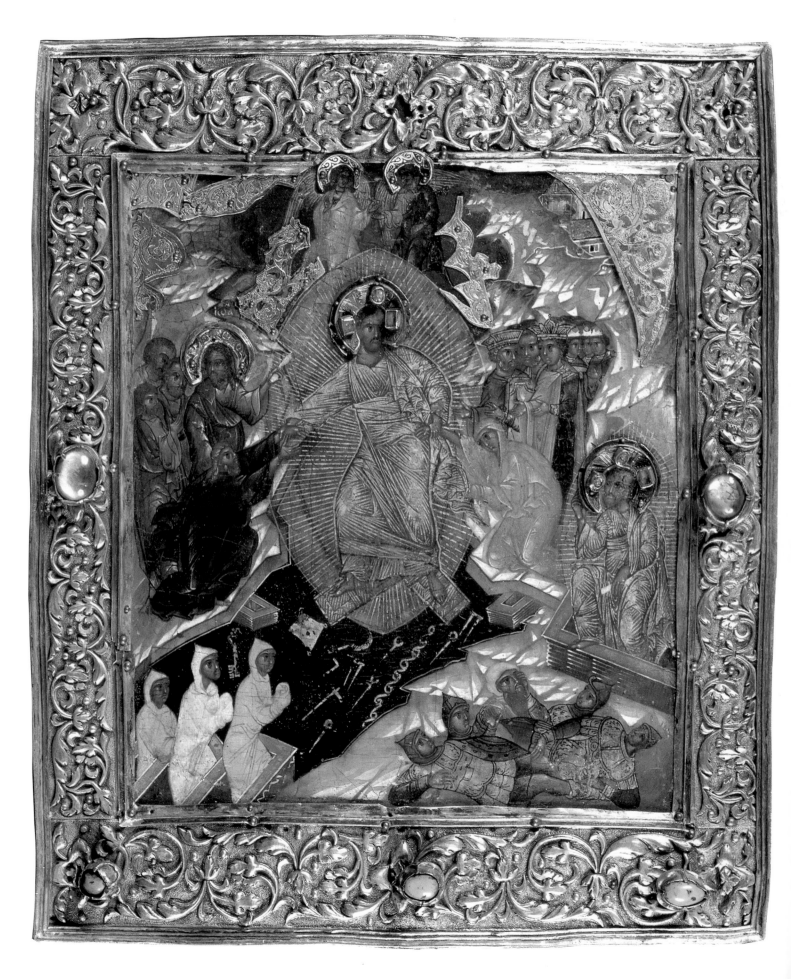

The gold or silver *bratina* (from the word for "brother") was a friendship cup, shared at banquets for toasts and ceremonially placed on tombs during funeral rites. This silver bratina, inscribed to Moscow nobleman Timofey Izmaylov, is decorated with chased and niello trefoils and vines (cat. 31).

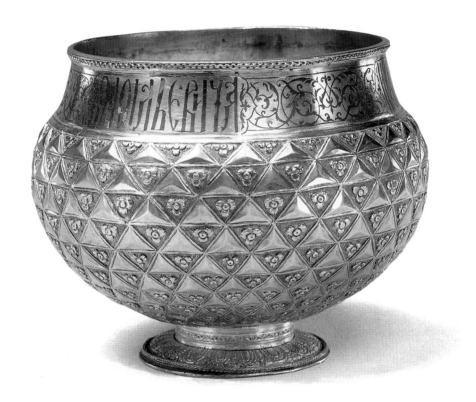

Silver and semi-precious stones encase this small icon, *The Descent into Hell*, which hung over the tombs of the tsars of the Romanov dynasty in Archangel Cathedral (cat. 29).

specialties, came from those regions. They affected Moscow somewhat, but at the same time the influence of Russian culture can be noted in their works. There were jewelry makers in the city as well, their numbers increasing dramatically over the course of the century.

The metalwork traditions of the sixteenth century continued for almost the entire first half of the seventeenth. This was evident in the technique, treatment of color, ornament, and structure. It may be that this conscious emulation of the earlier period reflected the desire of the patrons—the new ruling house and its entourage—to emphasize a link to the old dynasty. An example is the icon *The Descent into Hell* (cat. 29), whose refined severity recalls the art of the sixteenth century.

Laconicism of form and decor also characterized Russian silver hollow ware of the first half of the seventeenth century, such as the *kovsh* of Tsar Mikhail Fedorovich (cat. 30, p. 105), the *bratina* (toasting cup) of Timofey Izmaylov (cat. 31), and the dish of the Patriarch Yosif. The bratina's spherical surface is chased with triangles, and the only decoration of the kovsh and dish are the carved inscriptions executed with an especially decorative script—the so-called ligature often found in Russian art treasures from the sixteenth and seventeenth centuries. The letters of ligatures had complex ornate outlines, making them difficult to read. At the same time, they were emphatically elegant and often embellished with floral rosettes, little stars, and curls. Inscriptions of such intricate letters, enclosed individually or in ribbon bands, stood out on the smooth gold or silver surface, producing their own form of ornament.

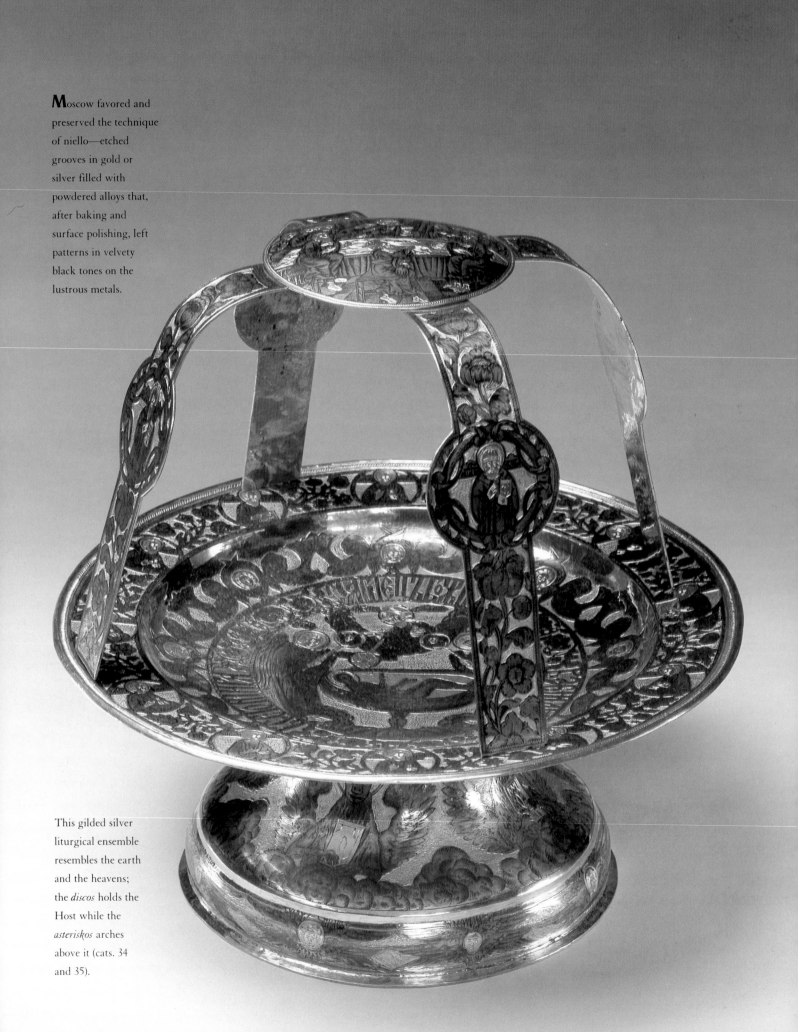

Moscow favored and
preserved the technique
of niello—etched
grooves in gold or
silver filled with
powdered alloys that,
after baking and
surface polishing, left
patterns in velvety
black tones on the
lustrous metals.

This gilded silver
liturgical ensemble
resembles the earth
and the heavens;
the *discos* holds the
Host while the
asteriskos arches
above it (cats. 34
and 35).

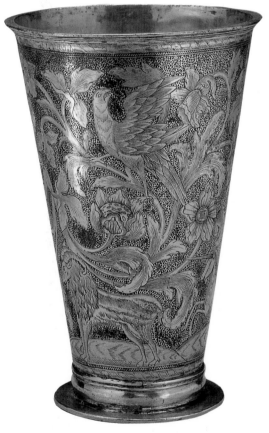

In the second half of the seventeenth century the process of secularization challenged the medieval view of religious dominance. Reality penetrated into art ever more boldly and persistently, filling it with worldly attitudes. The change in plant ornamentation, long a favorite in Russian art, shows the strengthening of temporal representation in metalwork. Luxurious flowers, clearly imitating nature, replace the stylized motifs of the bending trefoil stem that typified the earlier period. This can be seen in the plant designs on the chalice, *discos*, and *asteriskos*, cats. 34 and 35. Lifelike daisies, carnations, and tulips on long, flowing stems now freely adorn the surface of articles. Among the flowers, as in a real landscape, birds and other animals animate the scene. A silver niello beaker (cat. 40) exemplifies this new, richly realistic decor. The gilded engraved representations of flowers and animals are mounted on a background of small blades of grass executed in niello, quite typical for the silver articles made in Moscow at that time. New motifs from the floral style of western European baroque were easily accepted because they conformed so well to the internal needs of Russian culture.

New features also appeared in composition. The silver craftsmen, like the realistic painters, strove for a three-dimensional treatment; thus there was a focus on illusion of motion, architectural motifs, and landscape backgrounds. The range of subjects also expanded: along with the traditional Gospel themes from medieval Russian art one also encountered scenes from the Old Testament. The subjects "Solomon's Judgment" and "The Fall of Adam and Eve" were especially popular. Parables and allegories also attracted the attention of Moscow jewelers, who frequently transformed these edifying subjects into genre scenes filled with narrative detail and telling aspects of everyday life. In such compositions, temporal features clearly prevailed over

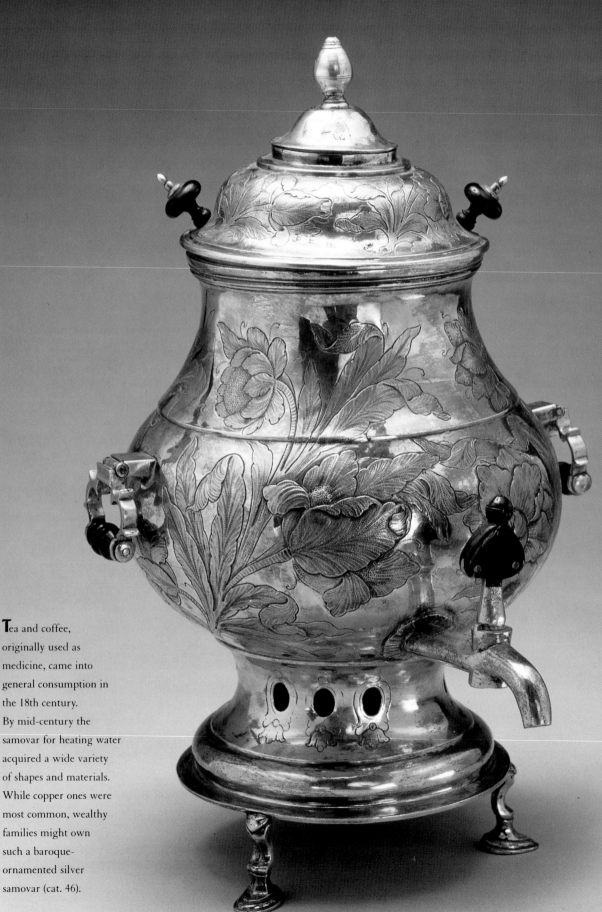

Tea and coffee, originally used as medicine, came into general consumption in the 18th century. By mid-century the samovar for heating water acquired a wide variety of shapes and materials. While copper ones were most common, wealthy families might own such a baroque-ornamented silver samovar (cat. 46).

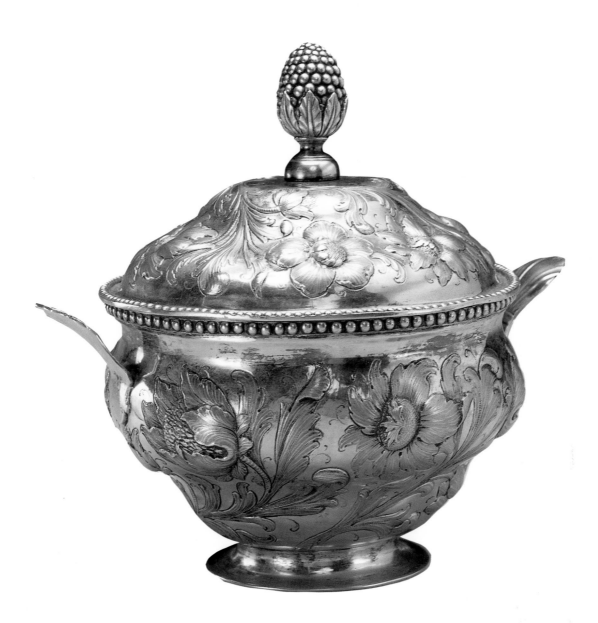

The reforms of Peter the Great created the need for western-style tableware, which replaced traditional Russian forms. The stylized seashell handles and oyster-shell trim of this silver tureen reveal a rococo influence (cat. 47).

didactic thought. To use the words of the famous Soviet art critic M.V. Alpatov, these works were "full of the naive thirst for knowledge of a person opening his eyes widely to the world and noticing a multitude of interesting details in it."

The secularization process was also manifest in the general artistic treatment. The strict refinement and restrained color characteristic of the sixteenth century gave way, in the second half of the seventeenth, to an emphatic elegance, a brilliance, a rich polychromy of enamels and precious stones. Many items from this period are surprising in their exultant festiveness, which was typical not only in secular pieces but also in objects for the church. Enamel, with its marvelous palette of sparkling colors, suited the new tastes better than anything else and hence was exceptionally popular. The craftsmen continued to use enamel in combination with filigree ornamentation—a technique mastered to perfection not only by the artists of the Kremlin silver chamber but also by the artisans of the city.

Enamel on engraving, which was also known earlier in the century, was used by the Kremlin metalworkers to trim luxurious gold objects. An example is a gold plate from 1694 (cat. 37). Especially fine are the transparent emerald-green enamels through which the gold background can be seen, intensifying the brightness and depth of their color.

The masters of the seventeenth century, while perfecting their enameling methods, introduced a new technique as well—decorative painting with variegated enamel colors on a monochrome enamel background. Historical documents suggest that this technique appeared first in Moscow, where the master craftsmen reacted sensitively to all the new trends, both in style and technique. The first attempts to use enamel painting can be observed in Muscovite works from the 1630s, when monotone enamels were enlivened with curls and dots of colored enamels. In the second half of the seventeenth century, this technique, which had great pictorial possi-

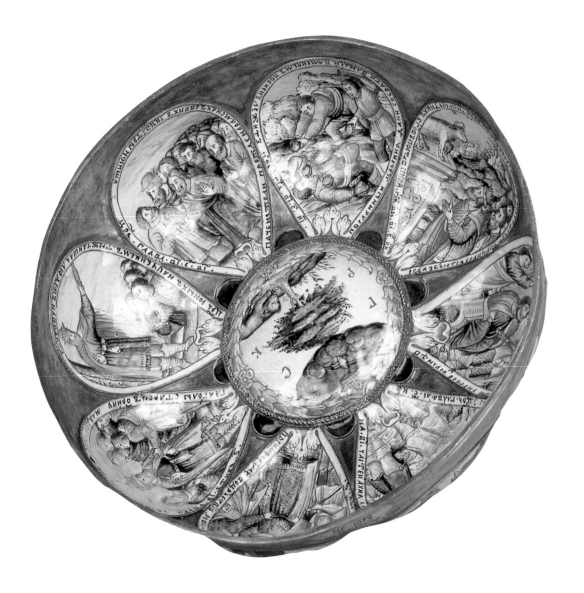

Virtuoso enamelwork embellishes this drinking bowl of Fedor Romodanovsky, confidant of Tsar Peter the Great. The Old Testament scenes from the life of King Rehoboam, Solomon's son, were based on images from Europe's Piscator Bible (cat. 38).

In 1751 Ivan Grigoriev, one of the finest silver workers in Moscow, used three pounds of silver to create this Gospel cover for Solovetsky Monastery. Large altar Gospels were part of the church service, solemnly carried through the "tsar's doors" of the iconostasis and displayed to the congregation as incarnations of truth (cat. 44).

bilities, was further developed and used in both gold and silver articles. On costly pieces, covered as a rule with a white enamel ground, artisans painted flowers as well as people and animals, sometimes forming complicated multi-figured compositions. A striking example is the drinking bowl of Prince Romodanovsky (cat. 38).

Probably professional painters of the era took up the technique of painted enamel along with the jewelers, because there was an improvement in the quality of enamel painting. This led to the appearance, at the turn of the century, of the enamel miniature, which thereafter became a basic technique in Russian gold and silver work.

In the history of Russia, the seventeenth century completes the medieval period. The eighteenth century marks the transition to a new worldly culture—prepared for by the innovations of the preceding period and hastened by the fundamental shifts in the country's socio-economic life.

In the eighteenth century Russian art developed within the flow of general European trends. This applied to gold and silver work as well, which in addition went through great changes in the organization of production. Fine Russian metalwork ceased to be anonymous; in 1700, stamps bearing makers' names were added to marks of assay and year. While these signatures were still rare at the beginning of the century, in time they became obligatory, as they were for the western European masters. Therefore, most of the surviving works of the eighteenth century can be precisely dated and attributed to a specific center and craftsman. This in turn makes it possible to identify special features and styles of artisans working in other Russian cities.

Although in the eighteenth century the role of Russia's leading metalwork center belonged to the new capital—St. Petersburg—production in Moscow continued to be of high quality. The

old capital was more closely linked with the traditional culture; thus a silver kovsh from 1712 (cat. 42, p. 105) relates to the art treasures of the past in its form and general treatment. Only the baroque cartouche on the handle points to the new century.

The motifs of the baroque, especially of the so-called floral style, were very popular among Moscow jewelers for most of the eighteenth century. The ornamentation on a samovar (cat. 46) and a tureen (cat. 47) illustrates the style. Both are decorated with luxuriant chased flowers on long stems, with leaves drawn from baroque decor. One often encounters a baroque motif like the leaves of the acanthus—which can be seen, for example, on the cover of the Gospel of 1755 (cat. 44). This cover is also an interesting early example of the Russian use of rococo elements: stylized shells are intertwined with the acanthus garlands. On the cover's massive rectangular panel, with its strictly centrist composition—somewhat overloaded with figures and details—these light and capricious details seem rather incongruous. The artist was attracted to rococo ornament, but the style was still alien to him.

The golden age of rococo in Moscow would come later—in the 1760s and 1770s. A silver kovsh of 1774 (cat. 45, p. 106), with its characteristic wavy breaks along the bowl and rococo curls in the decor, is a striking example of this style.

In the last quarter of the eighteenth century, Moscow craftsmen turned to the classical style. In their works, in contrast to those of St. Petersburg, classical motifs were frequently combined with rococo. The severity of form, refinement of proportions, symmetry of composition, and use of elements borrowed from antique art—all characteristics of classical style—found clear expression in a gilded silver chalice of 1795 (cat. 48).

A silver flagon of the Moscow master Stepan Kalashnikov was also made in the classical style. Its form and decorative treatment are especially noble. Oval niello medallions set off the elegance of the azure filigree ornament, which contrasts with the brilliant shine of the polished metal.

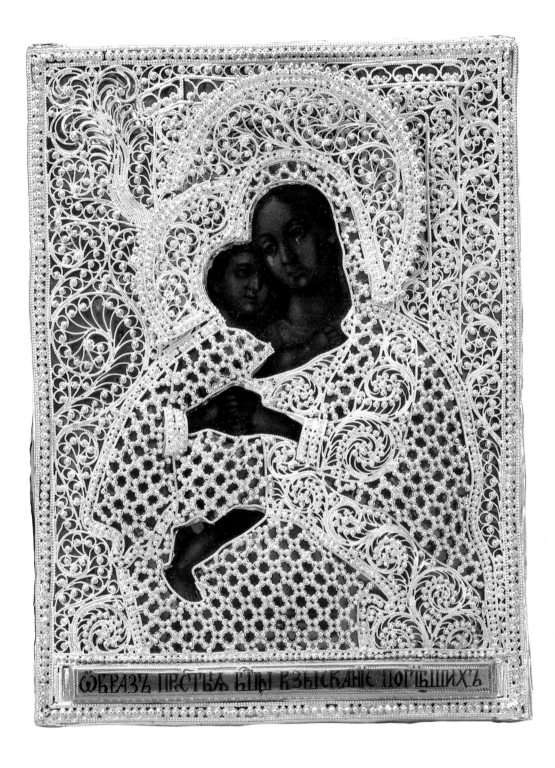

The *Virgin in Search of Sinners Astray* is fitted with an ornate silver cover, which revives ancient Russian techniques and styles—silver filigree in a spiral and floral design decorated with grain-like silver beads, now underlaid with colored foil. Granulation also dots the meshwork of the *riza* of the Virgin and Child (cat. 50).

Classical forms and motifs characterize late 18th-century chalices for the Eucharist, the principal sacrament of Orthodoxy. By tradition, deesis figures and the Crucifixion appear on the bowl and base, here in enamelwork, while around the rim are inscribed the words of Christ at the Last Supper (cat. 48).

The superimposed filigree seen here was used often in Moscow during the late eighteenth century—for both secular and religious objects. The Moscow artisan Matvey Kostrov made a silver filigree cover for the icon *The Virgin in Search of Sinners Astray* (cat. 50). The technical perfection of the cover and the refined purity of its pattern exemplify the best traditions of the marvelous art of Russian masters of filigree.

The final stage in the development of classicism falls in the first third of the nineteenth century. After it there begins a period of many years of searching for a new artistic ideal, a new means of expression, which was called forth both by growing interest in the national past and by the mastery of technical innovations.

Bobrovnitskaya is Senior Scientific Worker, "Armory Chamber" Department, State Museums of Moscow Kremlin.

JULIE EMERSON

VESSELS OF TRADITION

THE KOVSH

Vast forests blanket northern Russia from western Europe to Siberia, punctuated at measured intervals by mighty rivers flowing north and south. In this impenetrable taiga of spruce and fir, birch and aspen, the networks of rivers and streams were the natural highways for the early Slavs who settled along their banks. Hunters, fishermen, and traders—they lived by the rhythms of the seasons, observing the flocks of ducks, geese, and swans summering on the myriad lakes and ponds left by retreating glaciers. The traditional beliefs and artistic forms of these ancient peoples were deeply rooted in the natural world surrounding them.

From the wood of the forests the early settlers fashioned not only boats and dwellings, but implements for daily life—bowls, dippers, salt boxes, and distaffs. Animist symbols predating the Christian era—the Sun disk, the Tree of Life, horses associated with the sun god, birds— adorned and even lent their forms to these household goods. Salt, the vital essence of life and hospitality, might be offered from duck-shaped containers. Carved heads and tails of horses and ducks graced the roof ridges of northern houses as protective spirit sentinels.

One of the most distinctive and appealing of these ancient forms, which continues into the present day, is the *kovsh*. Evocative of floating birds or boats, the earliest forms were carved wooden bowls, dippers, and small cups for drinking fermented honey (mead), kvas, and

beer. In some examples a bird head and tail served as handles; in others, the handles resembled abstracted ships' prows. In the Moscow region, the dipper forms—called *sudy* (boats)— were broad with short handles.

Kovshi in precious metals appeared as early as the 1300s. By the 1500s Moscow jewelers were creating a distinctive type—low and wide with a flat bottom. Such a kovsh belonged to Tsar Mikhail Fedorovich (cat. 30). Its flowing curved lines are reminiscent of the swimming ducks of the older wooden forms. An inscription, carved and chased around the outside of the simple shape, declares the full title of the tsar; inside, a crowned double-headed eagle is engraved. At that time, such kovshi were still used as drinking cups in ceremonial receptions. When not thus employed, they were displayed as decoration with other precious vessels in the court halls of the Granovitaya Palace, to demonstrate the wealth of the state and the skill of Russian silversmiths.

By the eighteenth century European-style vessels had replaced the kovsh for drinking at court. Kovshi created by the craftsmen of the Kremlin continued as tokens of esteem, and as such were awarded by tsars to individuals for service to the state, to Cossack chieftains for faithful protection of the borders, and to merchants for dutiful collection of state custom duties and fees. Although Peter's focus may have been on the ways of the West, when giving an of-

For centuries, monks retreated to Solovetsky Monastery in the far north to live in harmony with nature, a scene portrayed by Mikhail Nesterov in 1903 (cat. 192).

Created in the Kremlin workshops, this ceremonial drinking cup belonged to Tsar Mikhail Fedorovich, founder of the Romanov dynasty (cat. 30).

A likeness of Peter the Great, the coat of arms of Russia, and a laudatory inscription on this kovsh of 1712 express the tsar's gratitude to Fedor Malakhnevsky (far right, cat. 42).

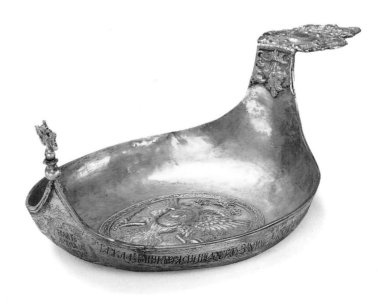

ficial gift he chose the kovsh of Moscow. A kovsh he gave in 1712 (cat. 42) typifies the form at this time, with its royal double-headed eagles in relief on the bottom and in a small sculpted ornament on the point. Baroque ornamentation appears on the handle.

Rococo ornament, with its shells and curling waves, animated kovshi of the late eighteenth century, an apt reflection of the splendor of the court of Catherine the Great. Watery motifs of ships, dolphins, and swirling vines ornament a kovsh that the empress presented to Moscow merchant and tax collector Abram Zubkov in 1774 (cat. 45). Large cast eagles spread their wings at each end of the boat, while the embossed eagle in the bottom carries the coat of arms of Moscow—St. George on horseback.

Succeeding generations breathed new life into the form. In the second half of the nineteenth century, a burgeoning class of merchants and manufacturers embraced traditions that Moscow kept alive during the period of westernizing trends, which led to a renaissance in the decorative arts. There was a revival of techniques from the great period of enamel and precious metalwork of the sixteenth century and of motifs from ancient Russia and peasant life. Arising initially from historicism, by the end of the century the traditional forms were reevaluated, now within the context of art nouveau. The features of art nouveau—luxurious ornament, brilliant textures, and flowing forms from nature—were adapted by Moscow jewelers to create a "neo-Russian" style.

By this time in the history of Russian metalwork, kovshi were far removed from their earlier incarnations as drinking vessels and presentation pieces. Now they reappeared as delightful, nostalgic, and precious ornamental objects. The enameled kovsh made by Sergey Sha-

Rococo ornament billows as imperial eagles perch on both ends of this cast silver kovsh of 1774—given on behalf of Catherine the Great to Moscow merchant Abram Zubkov for encouraging commerce and being first in the Senate to buy Moscow and St. Petersburg public houses (cat. 45).

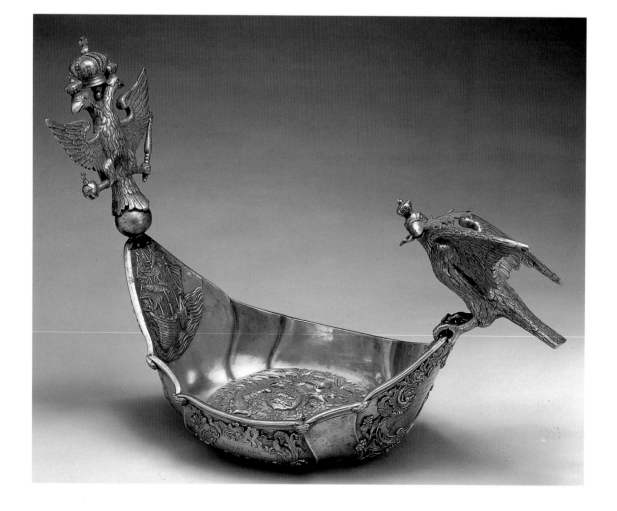

poshnikov (cat. 63) between 1899 and 1908 reveals the distinctive patterns of art nouveau in the pastel scrolling plant motif. A tiny kovsh (kovshik), produced by Moscow's sixth artel between 1908 and 1917, combines geometric folk patterns with scrolling, stylized foliage (cat. 62). These small jewel-like objects embody the high degree of craftsmanship, superb filigree work, and glowing enamels that characterized the fine art of metalwork at the turn of the century.

Although the life and land of Moscow and northern Russian have changed enormously over five centuries, in Moscow you may still find the beautiful form of the ancient kovsh ever-present in colorful woodenware and contemporary works.

Emerson is Associate Curator of Decorative Arts at the Seattle Art Museum.

Moscow jewelers of the early 20th century created marvels like this small kovsh by Sergey Shaposhnikov (cat. 63) by returning to the blend of Byzantine gold techniques, Islamic decor, and Russian forms that first flowered in the Kremlin workshops during the 17th century.

Fantasy forms in neo-Russian style, influenced by art nouveau, cover a tiny kovsh crafted between 1908-1917 by the Sixth Moscow Jewelers Artel. At the end of the century, and particularly after the 1905 Revolution, a number of cooperative jewelry workshops (artels) emerged in Moscow (right, cat. 62).

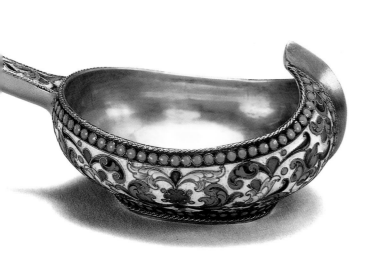

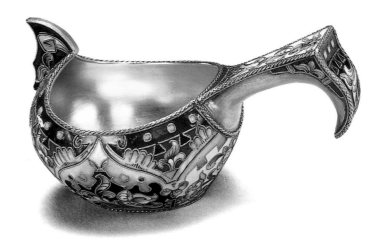

GALINA G. SMORODINOVA

A FLOWERING
OF RUSSIAN STYLE

MOSCOW METALWORK, 1800-1910

Russia's gold and silver work changed dramatically during the nineteenth and early twentieth centuries. A domestic jewelry industry took root, fostering a renaissance of national styles; traditional forms and enameling techniques were revived from as far back as the days of Kievan Rus. Thanks to this artistic flowering, Russian metalwork became famous the world over.

But the large jewelry firms appearing at the time did more than revive old designs. New styles of ornament paid high tribute to the technical prowess of the industry and the virtuoso skills of its craftsmen. The wealth of techniques and striking use of materials enriched the artistic language of Russian jewelry as never before.

In no other country of Europe had the problem of developing a national style been so acute and urgent, heightened by the Russian people's concern for the future course of their nation and a growing awareness of its unique qualities. These factors gave rise to the "Russian style" in 1850-60, which reached its peak in 1870.

At the birth of this style stood great archeologists, restorers, art historians, architects, literary critics, and artists such as I. Zabelin, F. Solntsev, V. Stasov, V. Prokhorov, and L. Dal. Their contribution to the study of the art and way of life of the Russian people cannot be underestimated. The art of the period can be explained largely by their attempts to restore a genuine *Russian* path

of artistic development. The discovery of "primitive" cultures became an invaluable source of forms, helping forge the language of modern art. This would have been unimaginable without the legacies of the past.

In the early 1800s, St. Petersburg was still the nation's arbiter of artistic direction, followed by artists and artisans throughout the country. In the second half of the century, however, Moscow emerged as an independent artistic center, founded on the traditions of ancient Russia before the time of Peter the Great. The study of the native traditions of early Russian art was the source of Moscow's originality and cultural independence from the capital. The Russian style, whose focus on everyday life encouraged the return of many traditional utensils and motifs, was welcomed enthusiastically by various strata of society, but it particularly acquired many patrons among the rich merchant class, whose influence on Moscow life at that time was very great.

The style's evolution can be roughly divided into two phases—a Russian historical period and a neo-Russian period. The Russian historical style took inspiration from the archeological study of ancient Russian art. The neo-Russian style owed its existence to the interaction between national motifs and modern art. It was based on ancient forms and ornamentation—

The ancient Slavic *bratina*, traditional toasting cup of brotherhood, was revived in gold and enamel as an objet d'art (cat. 56).

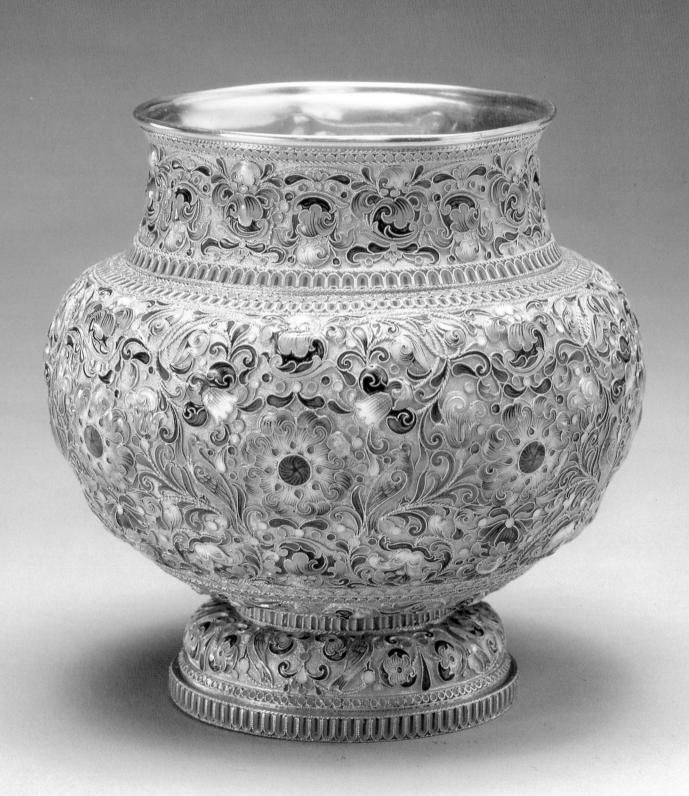

In the popular fairy tale, *The Three Princesses of the Underground Kingdom*, a peasant boy, Ivan, encounters the princesses of gold, iron, and precious stones. Viktor Vasnetsov, true to the story, painted them in sumptuous attire, symbolizing the riches of the earth (cat. 181).

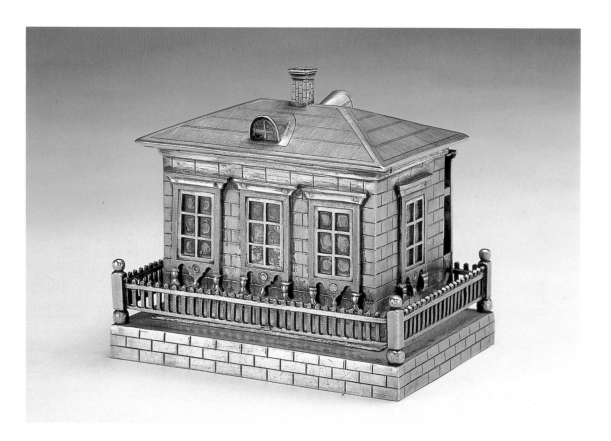

both their proportions and rhythmic patterns—enriched with illustrative elements borrowed from history, folklore, and literature. The neo-Russian style was particularly widespread in Moscow.

The time when these styles found fullest expression—the second half of the nineteenth century and the beginning of the twentieth—is one of the finest chapters in the history of Moscow. It was an era of economic and cultural progress, when many schools, museums, and theaters were established. The city had a beautiful appearance and a rich cultural life. "The seekers of native beauty"—V. Vasnetsov, K. Korovin, V. Polenov, S. Mamontov, and others—initiated a quest for new forms of expression that permeated all branches of art. They approached Russian culture not just as archeologists and restorers, however, but also as innovators whose ideas arose through mutual exchange of images and skills.

From the middle of the nineteenth century, talented jewelers responded to these national needs—first by copying ancient and "primitive" forms and ornamentation, then by creating original works. Thus numerous small silver objects appeared: salt cellars echoing wooden country forms, dippers and cups ornamented with proverbs, replicas of peasant houses (cat. 51), and imitations of birch baskets or linen sacks.

Another step in reviving Russian national art—led by Moscow and its art school—was the reclaiming of decorative principles typical of ancient Russian culture. In gold and silver work, the Moscow firms of P. Ovchinnikov and I. Khlebnikov best represented this direction. Inspired by the beauty of Russian art neglected during many years of imitating western Europe, they succeeded in restoring it in a wealth of hand-crafted articles.

These firms were joined by those of P. Olovyanishnikov, N. Nemirov-Kolodkin, O. Kurlyukov, A. Postnikov, and F. Rukert. All were at the forefront of remarkable progress in the art of enameling, the branch of metalwork that reveals the Russian style most strikingly. The new range of enamel colors was extraordinary, matched only by the many ways of combining it with precious metals and forms of ornament. The enamel patterns of the seventeenth century were revived, along with the long-forgotten methods of cloisonné, champlevé, plique-à-jour, stained glass, and enamel lacquer.

For the most part these firms favored the style of filigree-enamel decoration, where enamel lavishly covers the surface of silver, leaving the background more or less free. Sometimes

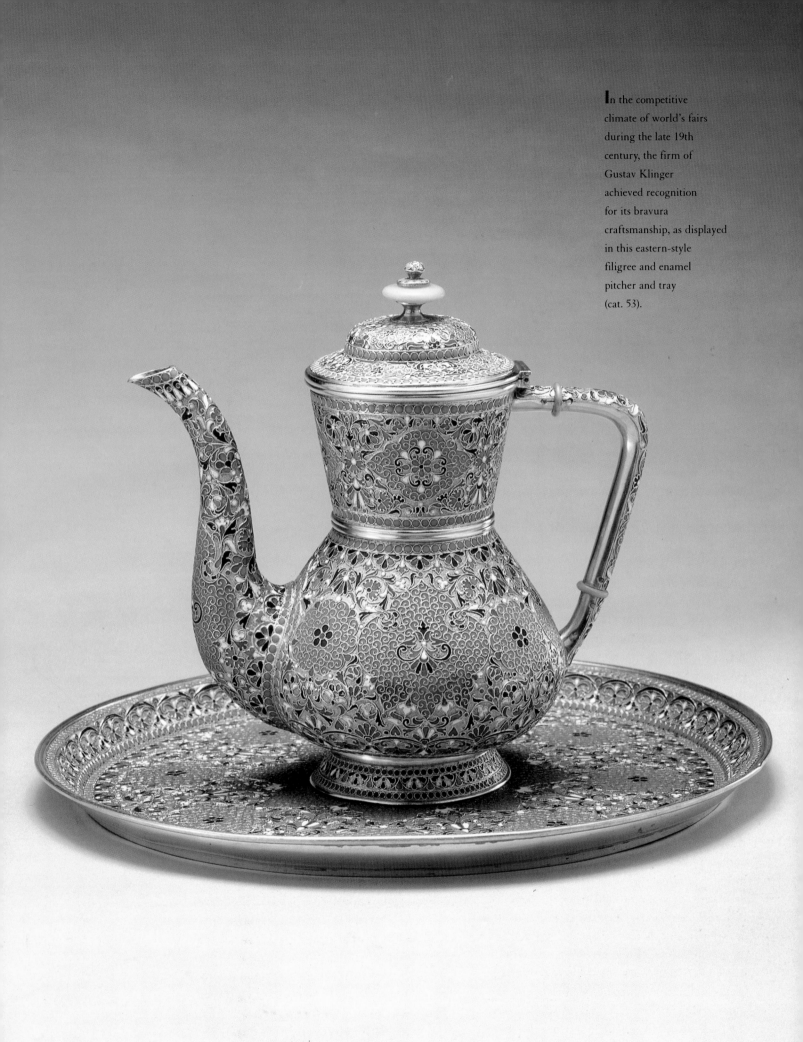

enamel completely covered both the decoration and the background, leaving only the pattern of twisted filigree wire. This innovation was used by G. Klingert's firm, which was awarded a bronze medal "for enamel handicraft articles" at the Chicago World's Columbian Exhibition in 1893.

P. Ovchinnikov's firm, founded in 1853 in Moscow, held the title of "court purveyor" from 1868, giving it the right to stamp the two-headed eagle, the imperial emblem, on its articles. The firm produced all kinds of gold and silver articles, but it was particularly famous for those featuring multicolored enamel. While practically a novice in the industry, the firm was awarded a prize at Moscow's All-Russia Exhibition of Industry and Art in 1865. The wares displayed were remarkable not only for their highly original patterns and superb quality of execution, but also for their improvements of the national style.

The enamel articles of Ovchinnikov's firm showed the beauty of Russian design and the endless possibilities inherent in drawing on traditional motifs. Ornaments borrowed from hand-written vignettes and from the books of the series *The Antiquities of the Russian State* decorated items of all sorts: icon settings and religious objects, household utensils, boxes, writing implements, and more. The generous efforts of archeological researchers, as well as the ingenuity of artist-jeweler Ovchinnikov, who enlisted their talents, produced an abundance of expressive new forms. The results were highly original

works that were nevertheless tied to national traditions.

The firm of Khlebnikov (another court purveyor) produced articles in all the basic styles of the period—Russian historical, neo-Russian, and modern. His factory, for the production of diamond, gold, and silver articles, was set up in 1867 in St. Petersburg and then in Moscow in 1870-71. The firm first attracted international attention at the world exhibition of industry and art in Vienna in 1873, where its works captured the eyes of the experts. Displayed were a diverse range of well-chosen articles in the Russian style; particularly impressive were the enamel objects.

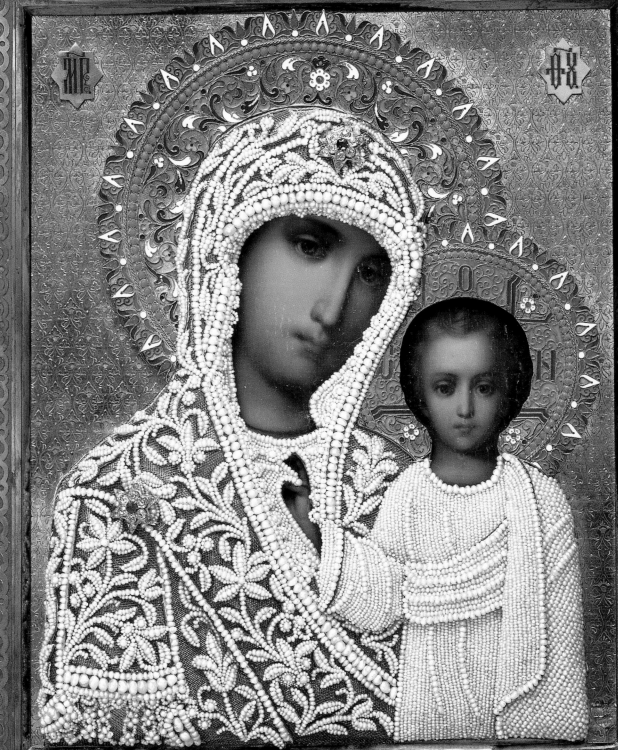

ᛗᚱ ѲХ

Казанскія прс. Бцы.

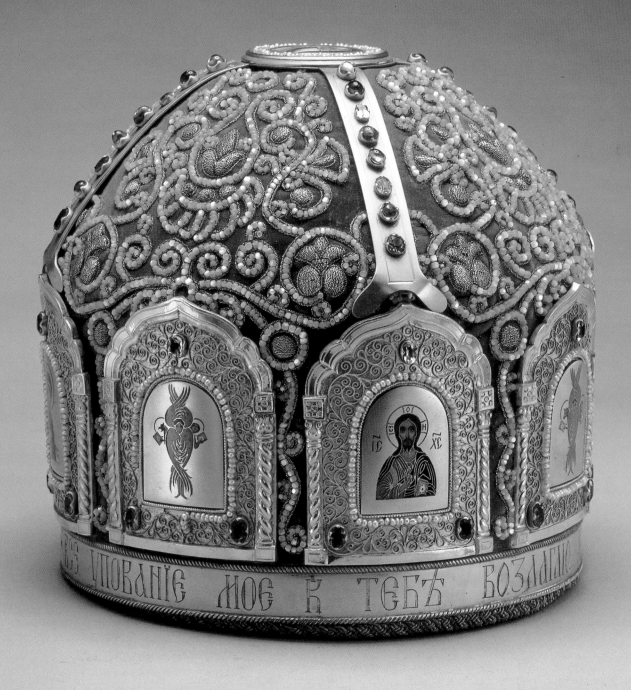

Stunning in its combination of embroidery, precious stones, engraving, and enamelwork is this early 20th-century miter by the Olovyanishnikov firm. Along the lower rim is a prayer to the Virgin; on the eight medallions are the deesis figures, the Crucifixion, and angels (cat. 65).

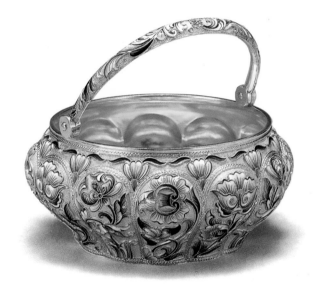

Many of Khlebnikov's works are now preserved in the State Historical Museum, notably a wine set composed of a decanter in the shape of a rooster and goblets in the shape of chickens—all decorated with champlevé enamel ornament. There are also Easter eggs (cat. 58), little vases, tankards, and blotters. The patterns on these objects are simply wonderful, the quality beyond reproach.

At the beginning of the twentieth century, P.I. Olovyanishnikov's firm—one of the oldest (known since 1866) and a court purveyor—relied heavily on the designs of S. Vashkov, an artist whose contribution to reviving and popularizing national forms cannot be overestimated. In fact, it was mainly his genius that determined the originality of all the articles the firm produced. S. Vashkov sought to capture the simplicity of archaic art. He made subtle stylizations of

early Christian symbols and variants of motifs of Kievan Rus and Vladimir-Suzdal, as well as drawing inspiration from the art schools of Moscow, Novgorod, and Pskov.

Olovyanishnikov's firm continued work in the technique of cloisonné enamel, which Kievan Rus had borrowed from Byzantium then lost during the Mongol invasion. A miter by Olovyanishnikov (cat. 65), with the image of the crucifixion, made use of mixed techniques of cloisonné and painted enamel. The miter is embroidered with golden thread and mother-of-pearl beads and adorned with precious Ural stones and ornamental silver medallions with filigree and enamel. The depictions dazzle by their high quality of execution, delicate graphic stylizations of ancient emblems, and exquisite range of enamel colors.

In the art of enamel, especially for the Moscow school, the system of decoration changed in the early twentieth century. The exterior of the object was treated as a special panel for compositions of rhythmic linear floral patterns, including traditional motifs and completely new forms in neo-Russian and modern styles. The classical rapport was replaced by free ornamentation; geometric patterns and forms were combined with plant designs. The palette also became more complicated and diverse—colors ranged from bright, vibrant tones to soft pastels.

Enamel, so characteristic of the neo-Russian style, was produced in gold by many Moscow factories, workshops, and associations of goldsmiths. The new style was also expressed in many articles of silver: drinking cups; dippers; and little pots used as vessels for punch, hot beverages, salt, and candy or merely as decoration. The wide use of these objects also reflected the desire to restore folk traditions and ways of thinking. As a rule, the surfaces of such articles were richly ornamented.

At the turn of the century, the striving for new artistic expression is seen in many gold and silver articles designed for domestic life, primarily in neo-Russian and modern styles. A wine set (cat. 59)—consisting of a silver vessel depicting bogatyrs (an imitation of a peasant's wooden bucket), small glasses, and a small dipper—exemplifies the neo-Russian style. A silver tumbler (cat. 60) features the same ornamental theme, this time highlighting warriors in ancient armor.

Two ancient Russian warriors revive a victorious past on this presentation wine cup, given by artel workers to the Association of P.M. Riabushinsky and Sons on its 25th anniversary (cat. 60). This wealthy family, supporters of the arts, had interests in textiles, banking, and manufacturing. Similar motifs decorate a silver wine service, which borrows forms from peasant households— bucket, ladle, and cups (cat. 59).

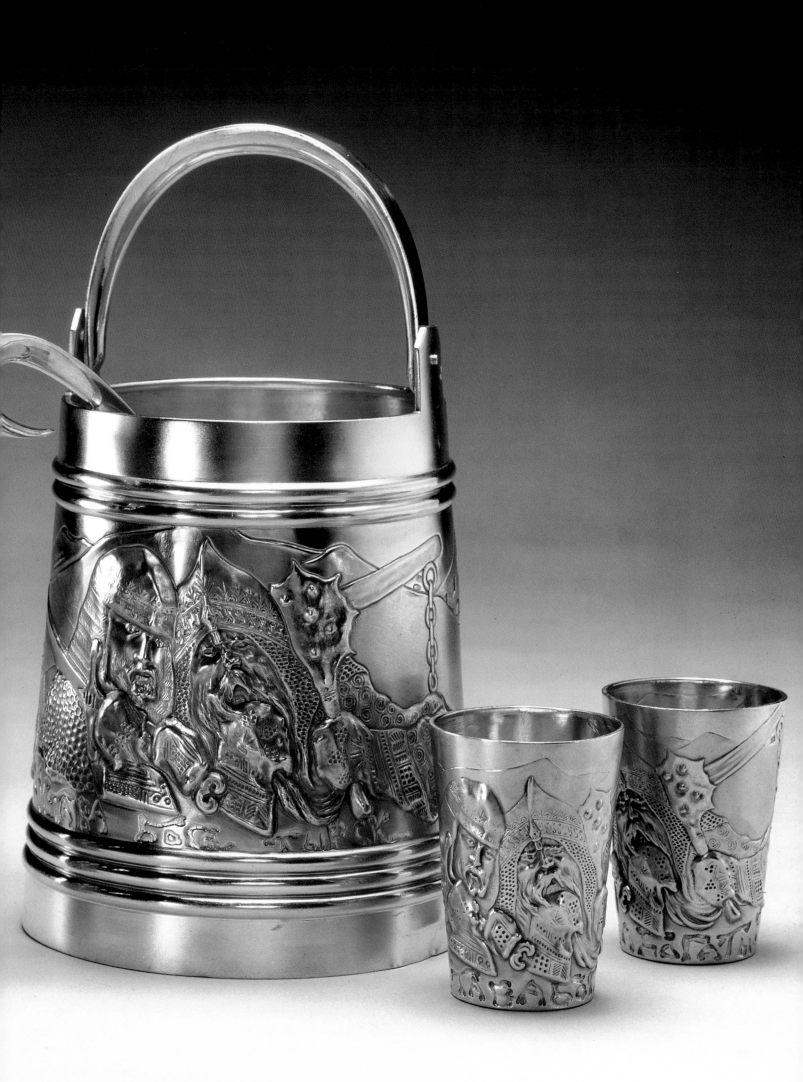

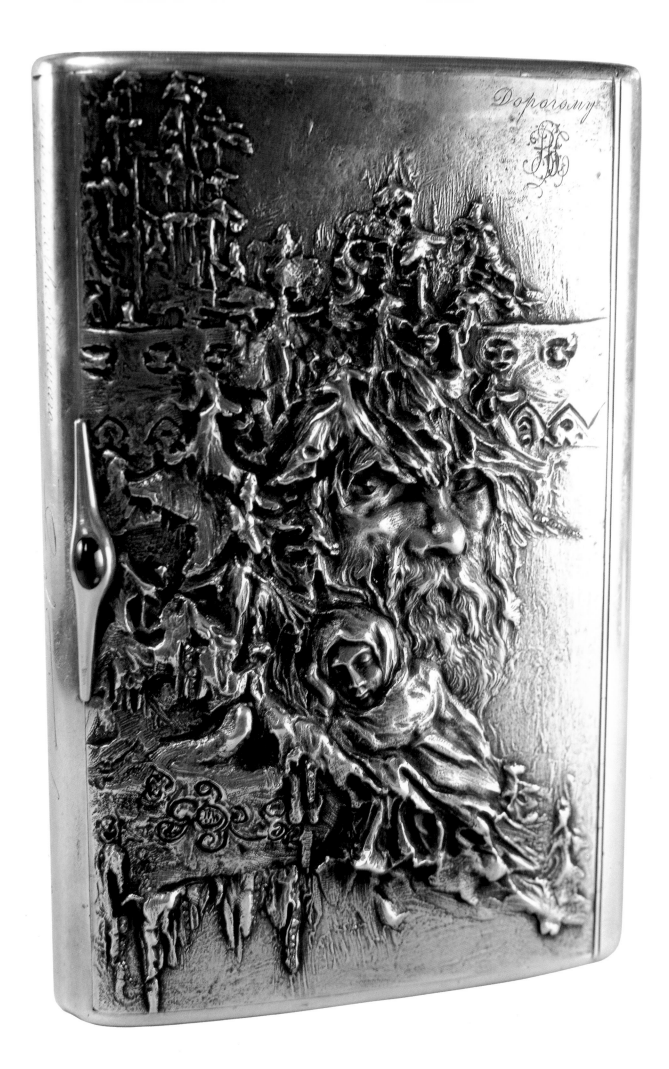

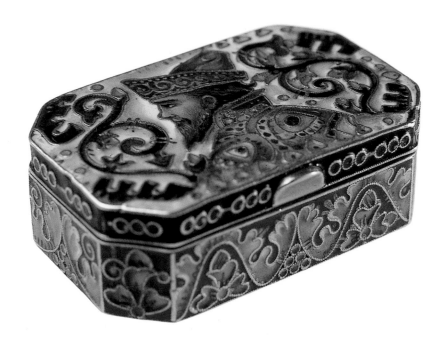

Fabergé boxes reflected the resurgence of themes from Russian history and folklore. On the lid of this cigar case, the snow-covered firs, old man, and sleeping girl, all in silver relief, recall the tale "Morozko" (Father Frost). The small box with neo-Russian motifs in filigree features an enamel portrait of a boyar (cats. 67 and 66).

The Moscow branch of the famous St. Petersburg firm, Carl Fabergé, was opened in 1887. The articles of this branch differed considerably from those of St. Petersburg in their shapes and patterns of ornamentation. In St. Petersburg, the firm worked mainly on orders for the court and its circle, which at the beginning of the eighteenth century was oriented toward western European art. In Moscow, however, it produced articles such as silverware and dishes for various strata of society.

A silver box made by Fabergé (cat. 66) is in the style of the Moscow school. Its multicolored filigree enamel, combining ornaments of the neo-Russian style with the classical "plant style" in a border of acanthus leaves, was almost a trademark with the firm. The painted portrait of a boyar on the surface of the box makes this design particularly striking.

The connection of gold and silver smithery with folklore and literature was a notable feature of Fabergé's Moscow branch. An example is a silver cigarette case featuring motifs from the folktale "Father Frost" (cat. 67).

In the stylistic evolution of gold and silver work in the late nineteenth and early twentieth centuries one finds a close correlation with the general development of the art of this period. It is only thanks to the exceptional knowledge of precious materials and metalworking techniques —and the sensibilities of both craftsmen and patrons—that such a renaissance in the history of jewelry making could have taken place.

Smorodinova is Senior Scientific Worker, Precious Metals Department, State History Museum, Moscow.

ALEXSEY K. LEVYKIN

A COAT OF MAIL AND COLD STEEL

THE ART OF HIS MAJESTY'S ARMORERS

Helmet made in 1557 for the three-year-old son of Ivan the Terrible, who was tragically killed by his father twenty years later (cat. 75).

Memories of the great medieval armorers of Moscow linger in the names of the city's streets: Bolshaya and Malaya bronnaya (Big and Little Armorers), Pushechnaya (Cannon). The name of the Kremlin's principal museum, Oruzheynaya Palata (Armory Chamber) is a vivid reminder of Moscow's proud arms-making traditions. The Armory at the Kremlin is unique in Russian history, and both its name and function—as the chief depository of national treasures, including fine weaponry—remained unchanged for hundreds of years.

From the fifteenth to the seventeenth centuries Moscow held a key position in the manufacture of arms and armor. Thus the Moscow school of arms-making occupies an important place in the history of the craft in Russia. The resistance to the Mongols' oppressive yoke and the later "eternal war" with the Crimean khanate demanded a huge arsenal of effective weapons. At the same time, Moscow's grand princes increasingly required richly appointed arms and armor for ceremonies at court. Both kinds of weaponry were produced by the armorers of the Kremlin, who had inherited the traditions of

many generations of Russian craftsmen.

When the Kremlin armories were established is still under dispute. The earliest direct reference to them appears in the 1547 chronicles. The chronicler writes of a great fire that destroyed many buildings all over Moscow—including those within the Kremlin's walls—and mentions that the armories burned along with the arms they housed. Some historians date the armories as early as 1508. In fact, it is likely that they were founded even earlier than that.

The Oruzheynaya Palata of Old Russia implied a stone building designed for keeping arms and armor. Therefore, any record of its having been built in the Kremlin cannot be regarded as the date when the first armory actually appeared in Moscow. As the arsenal of the Kremlin fortress, the armories must have been established when the town itself was founded in 1147. As the depository of ceremonial weaponry for the grand princes, on the other hand, the Kremlin armories no doubt arose in the mid-fourteenth century, probably with the armor workshops that supplied the court.

Gradually, while the Moscow principality was

123

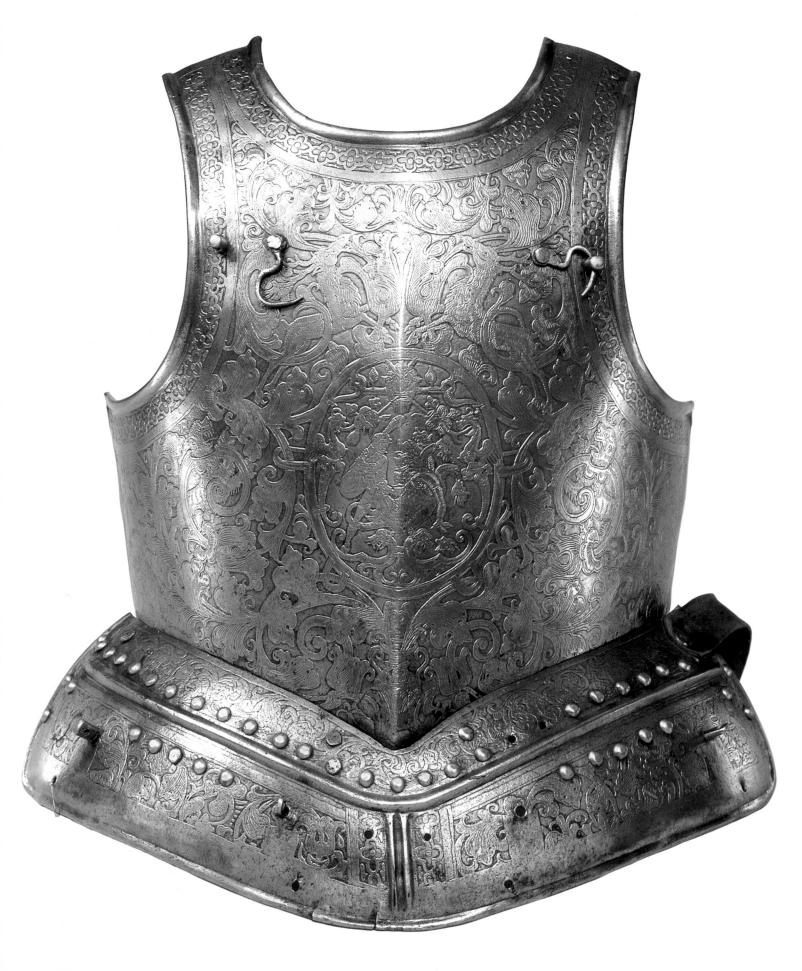

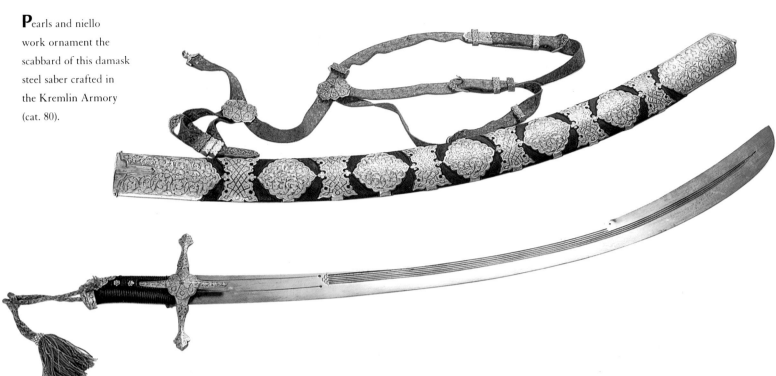

Pearls and niello work ornament the scabbard of this damask steel saber crafted in the Kremlin Armory (cat. 80).

Hercules destroying the Hydra dominates this European-style cuirass crafted by head armorer Nikita Davydov, whose achievements spanned fifty years (cat. 79).

growing into a centralized state, the functions of many court institutions were acquiring a national significance. In this manner the Kremlin armories were turning into the principal arsenal of the state. A European visitor at the turn of the sixteenth century wrote that "the Arsenal is so big and so richly stocked, that twenty thousand cavalry men could be armed with its weapons."

In the sixteenth and seventeenth centuries, in addition to functioning as the royal treasury for safekeeping the tsar's arms and armor, the armories became the largest armor-making center in Russia, responsible for the production and purchase of arms as well as its distribution to regiments of the Russian army. The armories also controlled the activity of all armor workshops outside the capital, specifying the required quantity and quality of their output.

At the head of the armories was the *oruznichy,* the head armorer, a fairly important position at court established in the early sixteenth century. The position's original duties—safekeeping the rich arms of the tsar and his family and participating in court ceremonies—gradually grew to include carrying out important missions on the tsar's orders.

The first head armorer was L. Saltykov, appointed to the post in 1508. Later, during the reign of Ivan the Terrible, the office was held by one of the tsar's closest associates, the *oprichnik,*

A. Vyazemsky. The armories' most outstanding achievements occurred in the reign of Tsar Aleksey Mikhailovich, when they were supervised by the boyarin (nobleman of high rank) B. Khitrovo, who oversaw all the Kremlin workshops.

In the early sixteenth century, a unique structure of arms and armor manufacturing was established. Almost the entire network of armor workshops throughout the country was controlled by the state. Many towns, military fortresses, and even some larger monasteries had workshops to manufacture or repair arms for local arsenals.

The best of the craftsmen from these workshops were invited to Moscow, where they became known as "masters of His Majesty's Armories." By the mid-seventeenth century over a hundred of these "contract" masters worked in the Kremlin, alongside two hundred gunsmiths, barrel-makers, and locksmiths manufacturing ordinary field weapons.

The craftsmen specialized in a number of professions. There were armorers, sword-makers, knife-makers, bow-makers, gunsmiths, locksmiths, barrel-makers, and other masters. Each historical period favored a particular craft. Thus in the sixteenth century the leading role belonged to the armorers, sword-makers, and bow-makers, as the accoutrement of the Russian

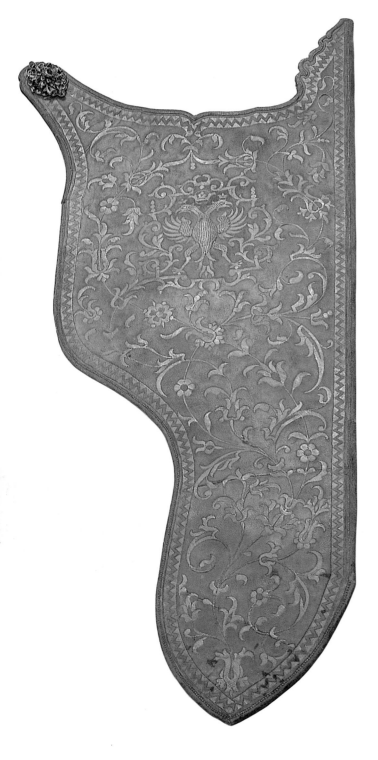
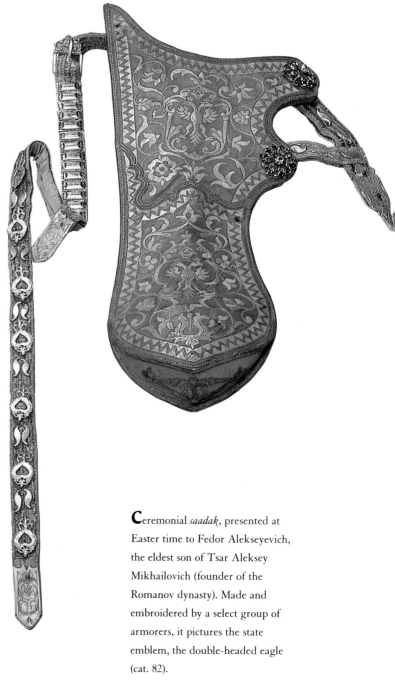

Ceremonial *saadak*, presented at Easter time to Fedor Alekseyevich, the eldest son of Tsar Aleksey Mikhailovich (founder of the Romanov dynasty). Made and embroidered by a select group of armorers, it pictures the state emblem, the double-headed eagle (cat. 82).

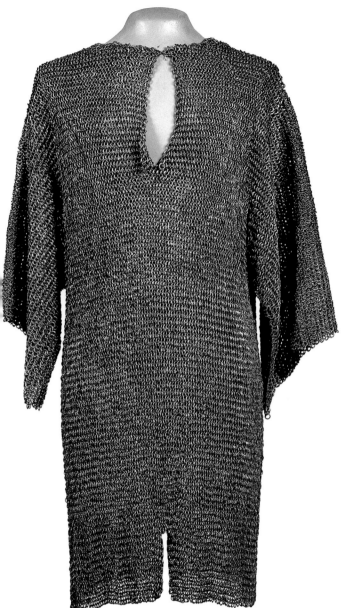

Chain mail of forged iron, 17th century (cat. 76).

Tsar's sporting gun, with damask steel barrel forged in Turkey, features ornamented inlaid stock and flintlock created between 1616-25 by Moscow gunmaker Pervusha Isayev (cat. 77).

soldier at that time consisted of a coat of mail and cold steel. According to the records of that time, the Russian warrior entering military service was to provide his own mount as well as a helmet, breast- and backplates, a coat of mail, limb-defenses, a spear, a saber, and a *saadak* (long bow, bow case, and quiver with arrows).

Military equipment evolved over several centuries. The geographical position of the country, on the border of both Europe and Asia, determined the two principal types of enemies—the lightly armed and extremely mobile nomad and the heavily armed and armored western European knight. Hence the distinctive feature of the Russian warrior's military outfit: comparatively light and thus suitable for quick maneuver, it was still strong enough to withstand heavy weapons.

The Russian warrior's armor consisted of a helmet (cat. 75), either conical or dome-shaped—effectively protecting the head from a cutting blow of sword or saber—and a shirt of mail, either plated or made of interlinked iron rings. Usually two kinds of mail were worn together: a strong and flexible shirt of chain mail and a coat made of loosely riveted plates covering the warrior's upper body. The armor, made of damask steel, was often decorated with gold,

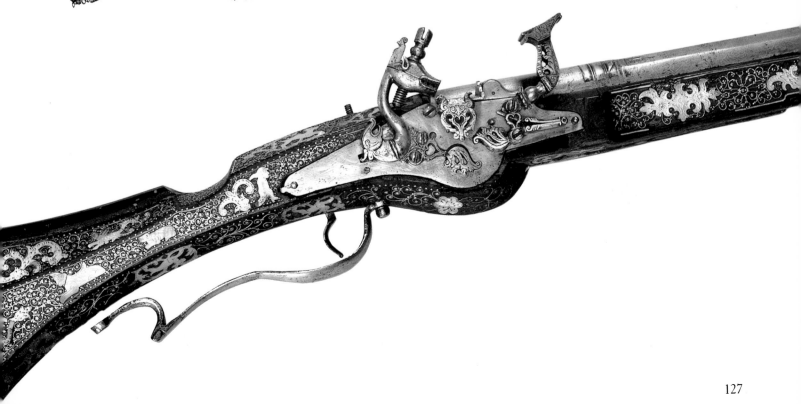

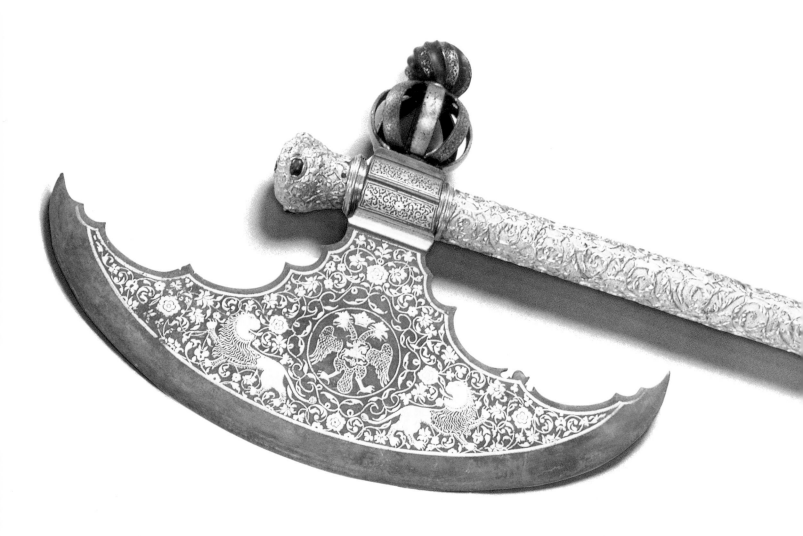

silver, gem studs, and filigree work. Said one author of an old chronicle: "My father was clad in the armor of gold and his helm [helmet] was of gold with precious stones and pearls, and my brothers were clad in silver armor, and only their helms were of gold."

The Moscow workshops were renowned for their shirts of chain mail and coats of mail, which sold equally well in western Europe and in the East. This specialization, typical for the sixteenth century, was reflected in the name of the office supervising the armor-makers at that time, Bronny prikaz (Armor Department), and in the name of the Moscow neighborhood where the armorers lived, Bronnaya sloboda (Armorers' Quarter).

Many types of cold steel entered the complex of weapons of war: swords, sabers, knives, spears, bear-spears, battle-axes, and maces. This array of artillery did not weigh down the effectiveness of skilled cavalry, however. The ambassador of the Holy Roman Empire once re-

marked that "although they hold in their hands the rein, the long bow, the saber, the arrow, and the lash at the same time, they can use all these skillfully and without apparent difficulty."

The function and significance of different types of arms changed with time and the evolution of battle techniques. Beginning in the late fifteenth century, the principal weapon in hand-to-hand combat was the saber, which by that time had completely replaced the traditional straight double-edged sword. The Kremlin armorers achieved superb results in manufacturing this formidable weapon. The blades and hilts of the sabers, adorned with silver and gold (cat. 80), were fine examples of various decorative techniques: enameling, niello, and filigree work with inlays of mother-of-pearl, precious stones, and jade.

In the sixteenth century, the most common cavalry weapon was the saadak—the long bow, complete with bow case and quiver with arrows. Thousands of arrows were shot at enemies in the

field and when taking or defending fortresses and towns. A skillfully aimed arrow could pierce a warrior's body or kill his horse on the spot. The Kremlin armories continued to produce this traditional weapon throughout the seventeenth century, mostly to replenish the royal depository, the saadak still being widely used for court rituals and hunting (cat. 82).

Hand firearms came to Russia in the late fourteenth century; by the sixteenth century, units of Russian soldiers were armed with matchlock guns, a type of weapon that became widespread in the next century. The appearance and spread of firearms altered not only the Russian army and its battle tactics, but the structure of the armories as well. From the early seventeenth century onwards, the bulk of the output came from specialists in gun-making: barrel-makers, locksmiths, and gunsmiths. Now, the professional elite were not only the masters of the crafts, but also the inventors of new, more effective mechanisms and weapons.

The surviving examples of guns and pistols produced by masters such as Ivan and Timofey Luchaninov, Pervusha Isaev, Grigory and Afanasy Vyatkin, and Vasily Titov bear witness to the high level of workmanship, technical competence, and artistic taste of Russian gunsmiths (cat. 77). The wooden parts of firearms were decorated with carving and/or inlaid with bone and mother-of-pearl. The metal parts—the lock and barrels—were embellished with elaborately carved designs combining foliar motifs with figures of grotesque, fantastic, and heraldic animals: eagles, lions, unicorns, and griffins. It was a common practice in those days to employ the very best gold- and silversmiths, enamelists, carvers, and jewelers for the task of decorating valuable weaponry, made for the tsar and his immediate entourage or given as gifts to foreign legations (cat. 81).

With Moscow serving merely as a backdrop, Peter Picart's scene records the lengthy celebration following Peter the Great's victory at Poltava over the Swedish troops of Charles XII (cat. 147). The main event was the entry of the Russian army into the city through seven triumphal arches. Peter himself headed the Preobrazhensky Guards Regiment, which brings up the rear of the parade.

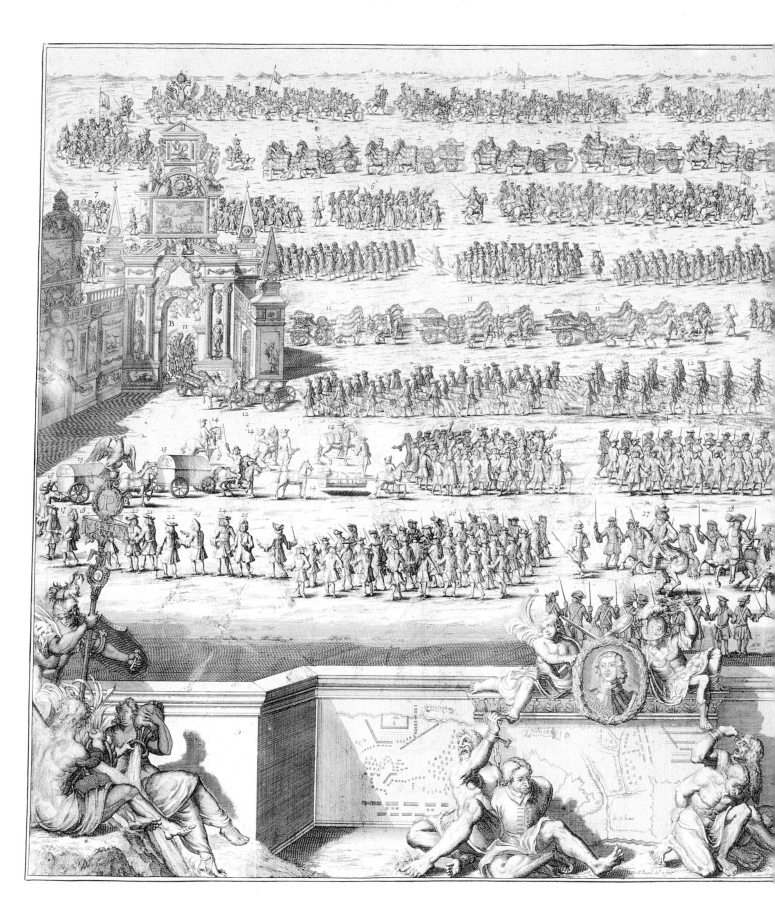

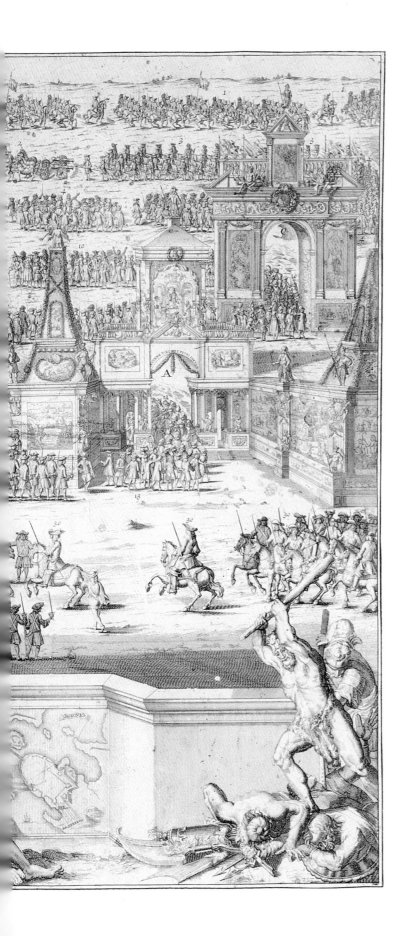

Side by side with the Russian craftsmen worked many armorers invited from abroad—Germans, Poles, Dutchmen, Turks, Persians, and others. No other arms-producing center could boast such a complex fusion of local, Oriental, and western European influences. The result was a style distinct from any other in the world.

The seventeenth century brought changes in military equipment. New types of troops—infantry, heavy cavalry, and dragoon regiments—were introduced following the European example. They were called "the regiments of the foreign order." Inevitable innovations in battle tactics led to the use of an increasing number of various European weapons: carbines, muskets, pistols, halberds, swords, and cuirasses (cat. 79). Specimens of all these weapons, manufactured by Kremlin craftsmen, soon found their way into the royal armories to be kept there side by side with the traditional arms.

The late seventeenth and early eighteenth centuries saw a gradual decline of arms-making in Moscow. Peter the Great summoned the best craftsmen to his new capital, St. Petersburg. The Kremlin armories, thus losing their significance as the center of arms production, became the chief depository of artistic treasures and relics from the past.

Today we can see the superb level of craftsmanship achieved by Moscow's armorers in the technical and decorative treatment of metals. In their hands, the deadly weapons of war became true works of art.

Levykin is Senior Scientific Worker, Arms and Equestrian Regalia Section, State Museums of Moscow Kremlin.

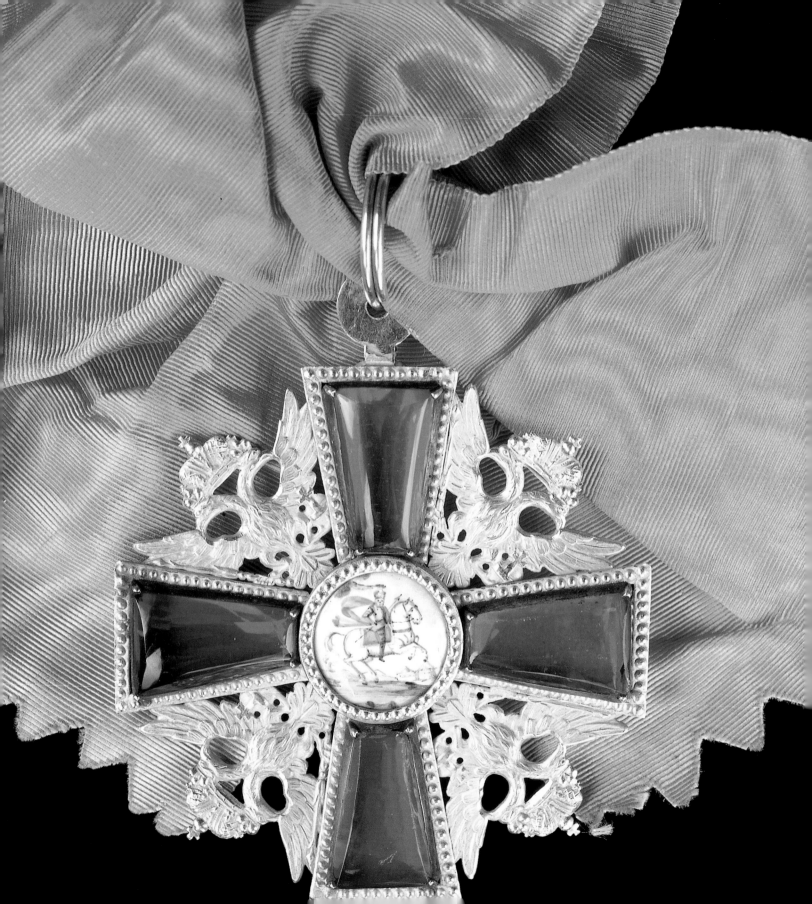

VALENTINA M. NIKITINA

"THE TSAR'S HIGHEST FAVOR"

RUSSIAN ORDERS AND MEDALS

The earliest decorations to be awarded for civil service and feats of arms appeared in Russia at the turn of the seventeenth century, although the origins of the system of awards itself go back to the beginning of the Old Russian state. The custom of awarding valiant warriors with special decorations existed in Kievan Rus in the eleventh and twelfth centuries. The earliest such decoration was the *grivna*—a torque made of precious metals and worn around the neck. There is evidence in early chronicles of Prince Vladimir of Kiev awarding a gold grivna to the brave commander Aleksandr Popovich, who destroyed an army of Polovetsians at the city walls.

As the Russian principalities united under the banners of the Grand Prince of Moscow and consolidated into a centralized state, a wide range of decorations and awards came into use. Individuals distinguishing themselves by valor or loyalty were rewarded rich gifts of expensive furs, luxurious garments, arms and armor, and gold and silver plate. A large number of such presentation pieces is preserved to this day in the Kremlin Armory.

From 1469 onwards, gold and silver-gilt coins were increasingly used for rewarding soldiers for feats of arms. These coins were not used for currency, but were worn attached firmly to the sleeve or hat for all to admire. The English ambassador to Moscow, Giles Fletcher, wrote of the decoration in 1591: "to anyone who distinguishes himself by his courage or performs an important mission, the tsar sends a goldpiece with St. George on horseback, and it is regarded as the greatest possible honor."

Gold coins were used as awards up to the late seventeenth century. Entire army regiments could be given them for victorious military operations. Thus all those who took part in the Crimean campaigns of 1687 and 1689 were awarded gold coins of various value (cat. 83).

The sixteenth century saw the appearance of a new type of decoration—the medal. At first very few of these medals, also made of gold and silver, were awarded. But gradually their number increased, particularly during Peter the Great's reign.

Although they continued the old tradition of rewarding valiant warriors with gold coins, the medals differed in appearance from their predecessors. The medals of the eighteenth century were the size of the rouble introduced in the course of Peter I's reforms. The front usually carried a formal profile of the tsar, while the back showed a war scene with an inscription giving the time and place of a particular battle. Thus every medal memorialized a specific event.

The Russian army's success in the twenty-year war with Sweden for access to the Baltic was cause for decorations on a grand scale. Spe-

cial medals commemorated twelve of the war's battles; in all, three to four thousand were awarded. Particularly interesting is the silver medal marking the seizure of Schlisselburg on October 11, 1702 (cat. 84), and thus dedicated to the Russian army's first victory in the war. The medal, struck in Moscow, was designed by one of the leading medalliers of the time, Fedor Alekseyev.

The late seventeenth and early eighteenth centuries in Russia brought a wide scope of political, economic, and cultural changes and innovations. A new type of decoration—the order—now enriched the repertoire of official awards. Toward the end of the seventeenth century the highest Russian order, that of St. Andrew the First-Called, was established. Peter the Great first presented it in Moscow on March 10, 1699, to Admiral-General and Fieldmarshal Fedor Golovin.

The designation of St. Andrew as the order's patron was not a random choice. In the draft of the statute for the order, composed with Peter's participation, the selection of St. Andrew was accounted for by the desire "to hand down to posterity the glorious memory of our first teacher in Christianity and the apostle of the Russian land." The motto of the order was "For Faith and Fidelity."

The head of the Order of St. Andrew, or its principal holder, was the tsar, although Peter decorated his closest associates with it before receiving the order himself. Peter was given the Order of St. Andrew in 1703, after two Swedish battleships were captured at the mouth of the river Neva. Thus he became the sixth holder.

This highest Russian order was awarded to members of the royal family, heads of foreign states, diplomats, high-ranking officials, and generals. Among its holders were the greatest

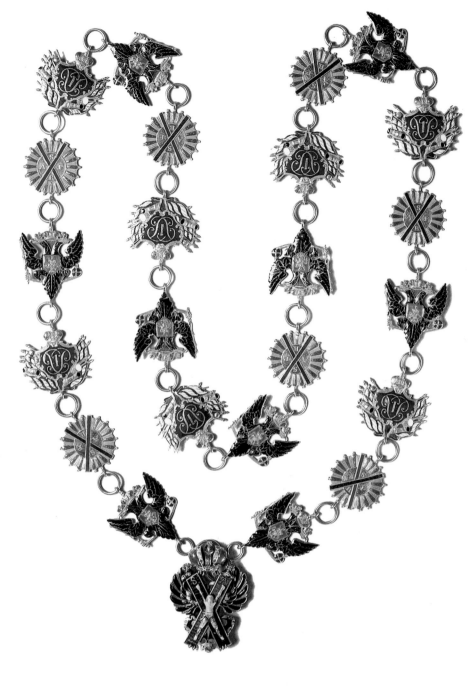

Chain with the cross of the Order of St. Andrew (cat. 88).

Russian military commanders of the eighteenth and nineteenth centuries, Aleksandr Suvorov and Mikhail Kutuzov, as well as many who distinguished themselves in the war against Napoleon in 1812.

Many orders had several classes, an order of the first class being the most prestigious. The Order of St. Andrew had only one class, and consisted of four components: a gold cross, a blue ribbon, an eight-pointed star (cat. 87), and a gold chain (cat. 88). The first insignias made could differ in minor details from later ones and according to the prospective holder's wish could be embellished with diamonds and other precious gems. From 1797, however, an order encrusted with diamonds signified the tsar's highest favor.

The order's cross was worn on a wide blue ribbon across the right shoulder, and the star was pinned to the left side of the chest. In the late eighteenth century the blue cross was supplemented with the royal symbol of the double-headed eagle. On ceremonial occasions the holders of the order wore the cross on the chain, instead of the usual blue ribbon.

Apart from medals and the Order of St. Andrew, the early eighteenth-century awards included badges with miniature portraits of the tsar decorated with diamonds and the imperial crown. These badges were worn with a bow of the blue St. Andrew ribbon pinned to the chest. The Kremlin collections have preserved these rare badges with the portrait of Peter the Great (cat. 85, p. 25), created in the early eighteenth century at the Armory workshops by the first Russian painters of miniatures in enamel, G. Mussikisky and A. Ovsov.

In 1714 Peter I established the highest order for women: the Order of St. Catherine. It had two classes, whose insignias—the cross with dia-

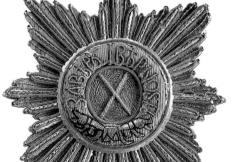

Star of the Order of St. Andrew (cat. 87).

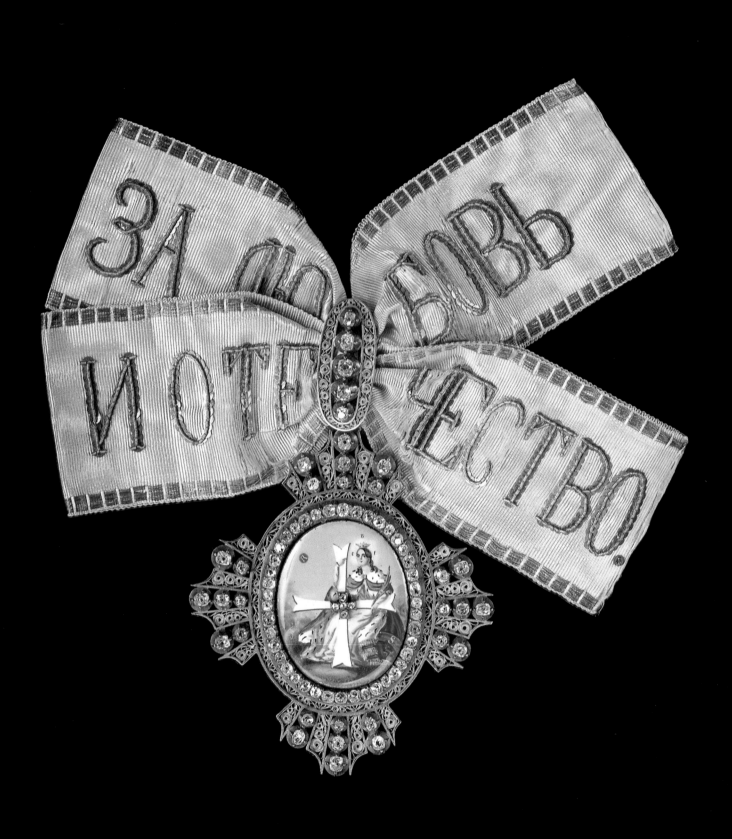

Cross and ribbon
of the Order of
St. Catherine
(cat. 89).

Star of the Order of
St. Alexander Nevsky
(cat. 92).

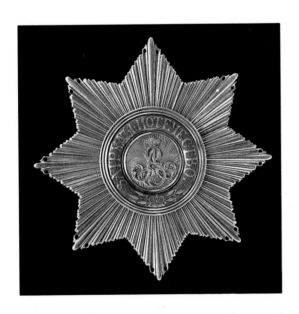

monds (cat. 89) and the star and the ribbon—differed mostly in size and decoration. The Order of St. Catherine was worn on a bow with the embroidered motto "For Love and Country." The bow was fastened onto a broad ribbon of red moire with a silver border.

The first Order of St. Catherine was awarded, with great ceremony, by Peter to his second wife Catherine on her name day. Up to 1726 she remained the only holder. Later the order was granted mostly to ladies-in-waiting distinguishing themselves by philanthropic activities.

A third Russian order was also initiated by Peter the Great, who decided to establish a military award commemorating Prince Alexander Nevsky and his victory over Swedish invaders on the river Neva in 1240. The Order of Alexander Nevsky was instituted following Peter's death and his daughter Anna's marriage to Karl-Friedrich, Duke of Holstein. His widow, Tsarina Catherine I, designated the order as an award for feats of arms and loyal service to the country.

The order, which had one class, consisted of three insignia: a gold cross, an eight-pointed star, and a red moire ribbon (cats. 91 and 92). The cross was worn on the ribbon across the left shoulder, while the star was pinned to the left side of the chest. A diamond-encrusted cross and star of the order was its highest class of decoration.

Very few Russians were awarded the highly prestigious Order of Alexander Nevsky, but the original idea that feats of arms should be rewarded with special military decorations was not forgotten. Twenty years later Catherine II signed the statute of the highest military award of the Russian empire—the Order of St. George, officially instituted in St. Petersburg on November 26, 1769. The first holder of the order was the empress herself, and its status as an esteemed decoration was maintained up to the Revolution of 1917.

The Order of St. George, whose motto was "For Service and Valor," was awarded for fortitude, bravery, and zealous service, as well as for military acts that increased the "glory of the Russian arms."

St. George the Victorious, courageous and

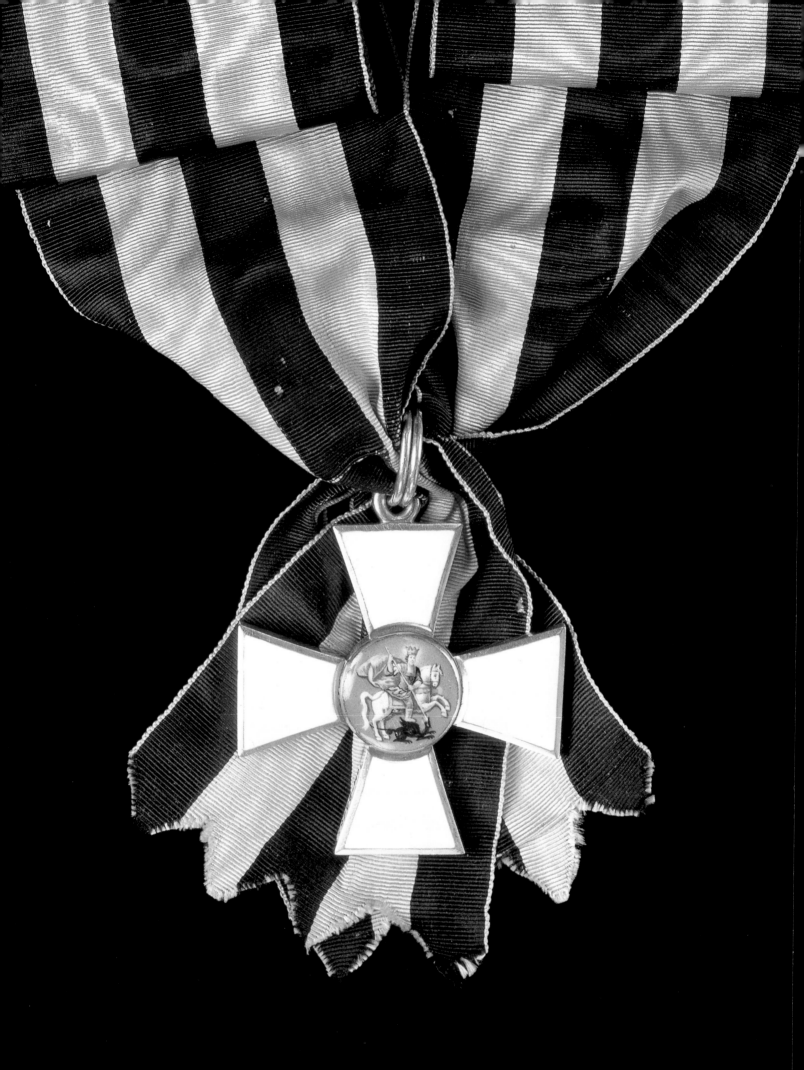

Cross and ribbon of
the Order of St. George
of the First Class
(cat. 93).

triumphant warrior, was greatly esteemed throughout Russia, becoming the patron saint and defender of the Russian lands. Numerous representations of him are found on Russian icons, princely seals, coins, helmets, *saadaks* (bow cases and quivers), banners, and most especially the coat of arms of Moscow itself. St. George was also commemorated in the names of many Russian churches and cathedrals and glorified in various celebrations in his honor.

The Order of St. George was divided into

four classes and consisted of an enameled gold cross (cat. 93), a four-pointed star (cat. 94), and a black-and-orange ribbon. The statute of the order forbade decorating its insignia with precious stones. The awarding of the Order of St. George usually began with its fourth-class insignia; the first and second classes were awarded only according to the emperor's personal nominations.

Only twenty-five people received the order's first-class insignia (compared to over a thousand

One of only four citizens in Russia's history to receive all four classes of the Order of St. George, General Mikhail Kutuzov fought Napoleon's army at the Battle of Borodino (cat. 101).

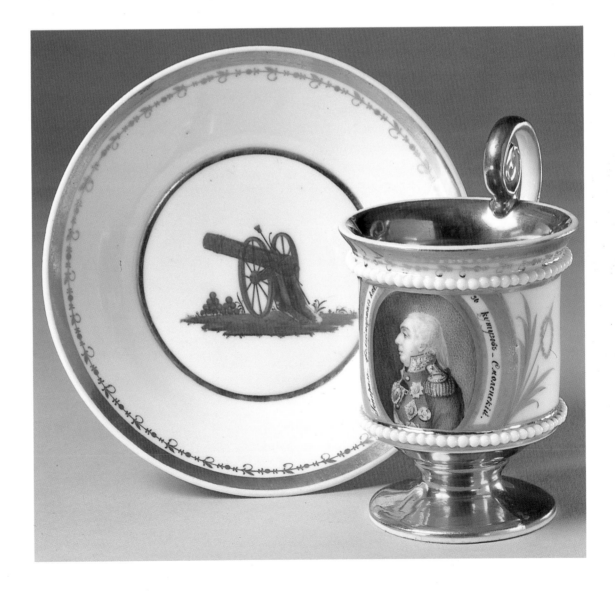

139

for the Order of St. Andrew), underscoring its unique prestige and rarity. Throughout the entire history of the Order of St. George only four people (the great military commanders Mikhail Kutuzov and Mikhail Barklay de Tolli and later Ivan Paskevich and Ivan Dibich) were awarded all four classes of the order. One of the grandest state rooms in the Great Kremlin Palace (built in 1849) was named the Hall of St. George in honor of the order and its holders.

Side by side with their officers, ordinary soldiers of the Russian army had always demonstrated great courage and loyalty to their country. However, the earliest order designed specifically for soldiers and non-commissioned officers was not instituted until 1807. This was the badge of the Military Order, which from 1913 onwards was known as the Cross of St. George.

In 1782 Catherine II founded the Order of St. Vladimir—which became second in rank only to the Order of St. Andrew—for zealous military service and feats of arms or for thirty-five years or more of irreproachable civil service. The order was divided into four classes. Its insignia were an enameled gold cross, an eight-pointed star (cat. 95), and a ribbon of red moire with black borders. Quite a few celebrated persons were decorated with the Order of St. Vladimir, among them the historian Nikolay Karamzin, the writer and lexicographer Vladimir Dal, and the surgeon Nikolay Pirogov.

Under Catherine II the system of Russian awards and various privileges associated with them were further elaborated. Those decorated with the Orders of St. Vladimir and St. George were entitled to a pension, and any commoner

awarded either was ennobled.

On the day of Paul I's coronation in 1797, a new Russian order, that of St. Anne, was instituted officially. The order, in fact, had been founded sixty-two years before (in 1735) by Paul's grandfather, Karl-Friedrich of Schleswig-Holstein, in honor of his wife Anna Petrovna, daughter of Peter the Great. The order's motto was "To Those Who Love Justice, Piety and Faith."

The Order of St. Anne—for "great deeds in civil service and labors for the public benefit"—had three classes and no restriction as to the number of possible holders. It was made up of a red enameled cross with gold open-work ornamentation at the corners and an image of St. Anne in the center, with a star and red ribbon with yellow borders. Soon after its institution the order received a fourth class designed as an award for junior officers of the army and navy. It was in the form of a round medal with a crown and a red cross on top. Fastened to the hilt of sword or saber, it carried the words "For Courage."

The earliest crosses of the Order of St. Anne had red glass on the arms and diamonds in open-work ornamentation, but in the nineteenth century the glass was replaced by enamel. Diamond-encrusted crosses were reserved exclusively for decorating foreigners. The 1829 statute specified that the insignia of the order's first and second classes be supplemented with the imperial crown. The latter was attached to the upper arm of the cross (cat. 97) and to the top of the star over the medallion. The crown increased the importance and prestige of the order. In contrast with all the other decorations, the star of St. Anne was worn on the right side of the chest.

On August 5, 1855, the design of all military orders, except for the Order of St. George, was supplemented with a pair of gold swords that intersected the center of the cross and the star.

In 1831, following the division of Poland that led (not for the first time in its history) to its partial annexation by the Russian empire, two Polish orders—those of the White Eagle and of St. Stanislav—were added to the list of Russian orders and given the "Imperial" designation. This addition completed the evolution of the Russian system of decoration, although proposals for new orders continued to appear. "The Decoration Regulations," enacted under Paul I in 1797, guided the entire system of awards—including the principles of decoration—up until 1917.

The orders and other decorations in this exhibition embrace almost the full history of Russian official awards, vividly illustrating the techniques used to craft them. The earliest badges and orders were produced at the Kremlin Armory workshops, and in the eighteenth and nineteenth centuries they were made by the best metalworkers in St. Petersburg. The nineteenth century saw the appearance of many metal workshops and large firms specializing in making all kinds of orders, badges, and decorations that employed the most skilled gold- and silversmiths, artists, and enamelers.

The quality of craftsmanship, the brilliance and purity of the enamels, the fine use of precious gems turn each of these medals into things of high artistic value and timeless beauty.

Nikitina is Chief of the Numismatics Group, State Museums of Moscow Kremlin.

INNA I. VISHNEVSKAYA

"GLADDENING THE SPIRIT"

A TREASURY OF ECCLESIASTICAL TEXTILES

A love of color has always animated Russian applied arts. The need to compensate for the subdued tones of the landscape, the desire to beautify reality, the unshakeable faith in dream and legend—all have played a part in this phenomenon. Moscow crafts of the late sixteenth and seventeenth centuries, some representing Russia's highest cultural achievements at the time, are distinguished both by their brilliance of color and heightened ornamentalism. Churches and civic buildings alike were decorated with multicolored majolica tiles and colored glass, while contrasting colors outlined roofs, walls, and domes. Inside, colorful icon screens, canopies, and prayer chapels all caught the eye. The iridescent enamel ware of the palace and the colorful wooden distaffs of the peasant hut contributed equally to creating a bright, festive, and joyous environment.

Patterned textiles and embroideries also played an important part. Bright and beautiful fabrics were everywhere, sewn into secular and ecclesiastical garments as well as wall-coverings, curtains, bench covers, throws, and various liturgical objects. Even ceremonial trappings for horses were made from precious fabrics.

Up to the eighteenth century, when the foundations of a native velvet- and brocade-producing textile industry were laid, these fabrics were imported from foreign lands. In sixteenth- and seventeenth-century inventory lists of goods from abroad, one constantly comes across patterned fabrics from the major textile-producing centers—Italy, Persia, Turkey, and China. These imports were greatly admired in Russia, for the beauty and variety of their designs, for the brilliance of their colors, and for the high quality of their workmanship. But they were costly. To some degree this was a direct consequence of the complexity of production. Patterned gold and silk polychrome fabrics demanded much painstaking hand labor. They were woven on special looms and required much preparatory work with the gilt and silk skeins of thread, including dyeing with various colors. Moreover, the raw materials needed for weaving patterned silks—raw silk, silver, dyes—were themselves very expensive and often imported from abroad. While all these factors increased the prices of these fabrics tremendously, they also caused them to be highly cherished, carefully treated, and recycled time and again.

Italian velvets and damasks were widely used in Old Russia. In an inventory list of Tsar Ivan IV's clothing, a *ferez* (a ceremonial outer robe) made from sixteenth-century Venetian red- and gold-patterned velvet was placed first, as the most valuable garment. A bishop's vestment of

Embroidered with pearls, this Orthodox vestment (*palitsa*) was fastened at the waist—symbolizing the "sword of the Lord" (cat. 71).

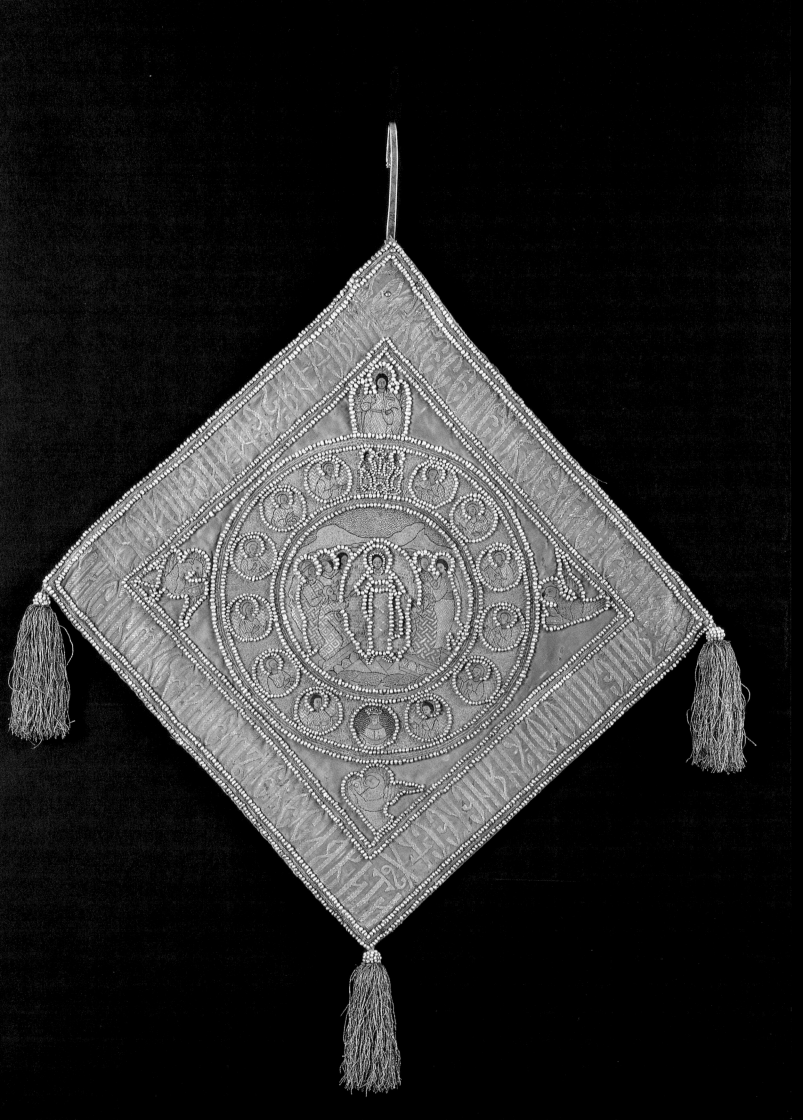

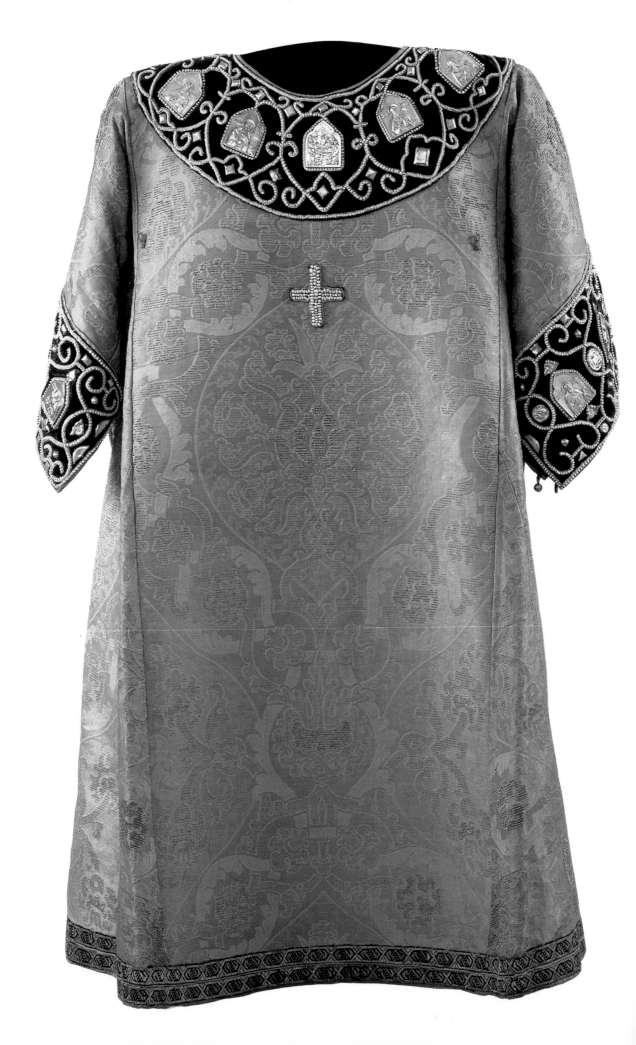

This late 16th-century *saccos*, ceremonial robe of the upper ranks of Orthodox clergy, belonged to the first Russian patriarch, Job (cat. 69).

Russia's first patriarch, Job, was also sewn from a piece of Italian material—a magnificent pile brocade of a gold and cherry silk (cat. 69). The fabric design, called the "pomegranate" pattern, was very common in fine Italian weaving of the sixteenth and seventeenth centuries.

Here, a large design in the form of a stylized fruit surrounded by foliage and flowers is contained within an elongated oval, all framed by a chain of intertwining vines and stylized flowers and fruits. Some of the details are woven in gold pile. The yoke is outlined with chased silver-gilt medallions of Byzantine and Russian saints. Depictions of church fathers Basil, Gregory, and John Chrysostom symbolize the Byzantine origins of the church, while images of metropolitans Peter and Alexis confirm the power of Russian Orthodoxy. The central image, of the Assumption, celebrates the Kremlin Cathedral of the Assumption, where Job was enthroned as patriarch in 1589. Images of Christian saints Demetrius of Thessalonika, Theodore Statelates, and Job the Righteous decorate the borders of the sleeves.

A significant amount of fine Italian textiles found its way into the Moscow treasury in the second half of the seventeenth century. Russian traders bringing goods from Venice and Florence, and Moscow's court purchasing items from foreign merchants in Archangelsk and other Russian trading cities—all served as sources of foreign fabric.

Imported textiles appearing in the government treasury were carefully registered; notes were made on their pattern-type, color, size of piece, and price. Thus, from the inventory list of the Tsar's Treasury for 1654 we know of the purchase of nineteen *arshins* of double-cut Italian velvet (1 arshin equals .72 meter). The subsequent fate of that piece was recorded also. Some of the velvet was used the next year (1655) in a robe for Tsar Aleksey Mikhailovich, who gave the rest to Patriarch Nikon as a gift. During 1656, in a workshop of the Kremlin, the fabric was sewn into a "caftan" (home dress) for the patriarch, which remains a unique example of Old Russian secular clothing (cat. 73).

The pattern of this magnificent bluish-purple velvet—created by juxtaposing piles of different lengths—is a traditional foliate design, with leaves and flowers encircling a large creneleted crown. The effect is very ornate and festive, despite the fact that the material is all one color. In making the caftan, workshop tailors were able to emphasize the fabric's best features. The absence of busy details in the cut of the garment, and the width of its sleeves, direct attention to the beauty of the large pattern, while the long length and slight widening of the silhouette toward the hem show off the luster of the velvet and chiaroscuro play of its two-toned nap.

The Old Russian costume, in its general features, was the same for all levels of society. It was very distinctive. The English merchant and diplomat Anthony Jenkinson, who visited Moscow in the sixteenth century,

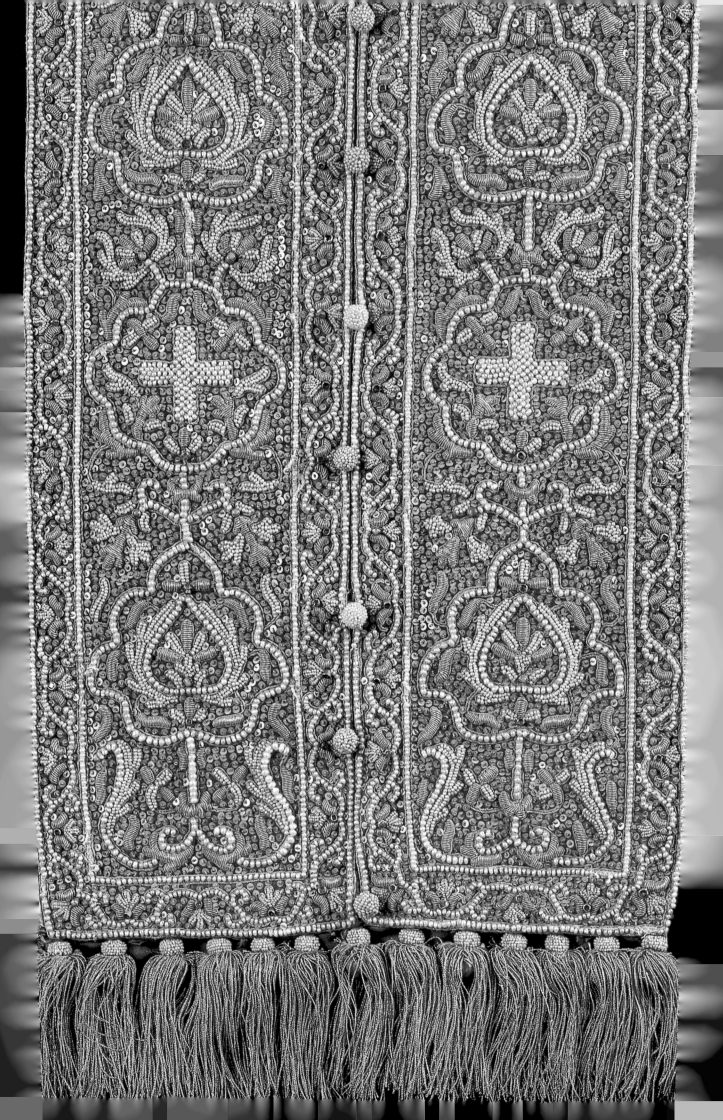

wrote that the "clothing, in accordance to the custom of this land, is badly cut and reaches the ground." These floor-length robes, loosely cut with a free-flowing silhouette, gave the wearer's movements and way of walking a special smoothness and stateliness much valued at that time.

Ornamental details were very important in Old Russian clothing. These included numerous buttons (gold, silver, or covered in fabric), lace (woven from gold thread), and fur (sable, marten, and fox, both silver and red). Embroidery was often used as trim, which for the clothing of the upper classes was likely to be stitched with gold thread, pearls, and precious stones.

Decorative and pictorial needlework has a long tradition in Old Russia. The first Slavic embroideries, discovered at archeological sites, date from the ninth and tenth centuries. They were done in thread made from local flax. By the twelfth and thirteenth centuries, imported gold thread had come into use. The first reference to seed-pearl embroidery, in the chronicles, also dates to this time. In the following centuries, in addition to gold thread and pearls, gold and silver medallions appeared.

The embroidery of the sixteenth and seventeenth centuries was particularly festive and ornamental. At this time needlework came to be liberally decorated with colorful precious stones and pearls (by then also considered a precious stone). By the end of the seventeenth century, complex carpet patterns emerged, in which precious stones, jeweled gold or silver medallions, and gold spangles were combined with the embroidery—often completely covering the base fabric. With the beginning of the eighteenth century, the first examples of chiaroscuro needlework appeared, though it did not become fashionable until the late eighteenth and nineteenth centuries.

Each type of needlework had its own technique. Embroidery with silk, as a rule, was done in a smooth chain stitch, with the needle piercing through to the other side of the back cloth, then reemerging again. Most popular in gold embroidery was "fastener" stitching (also called couching), in which the gold thread was arranged in a pattern on the surface of the fabric, and then stitched to it with varicolored silk threads. The bright silks of the fastener stitches formed different patterns, which made each gold embroidery design unique and very decorative. For embroidery with pearls, the contours of the design were first sewn onto the fabric with linen or cotton thread. Then, individual pearls (which had been drilled) were strung on a thread, a hair, or a thin wire. This string was then arranged on the design, and fastened down with perpendicular stitches, one after each pearl.

Up to the seventeenth century, gold and silk thread and precious stones were imported from foreign lands. The pearls were usually local, however, coming from the fisheries of more than sixty northern rivers. Imported pearls were widely used as well—such as *kafim* pearls from the Black Sea and *gurmyzh* pearls from the Persian Gulf.

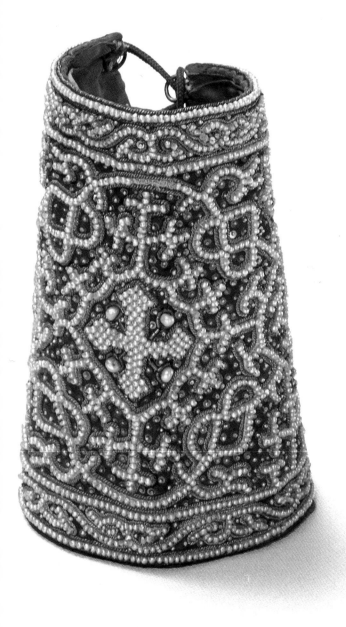
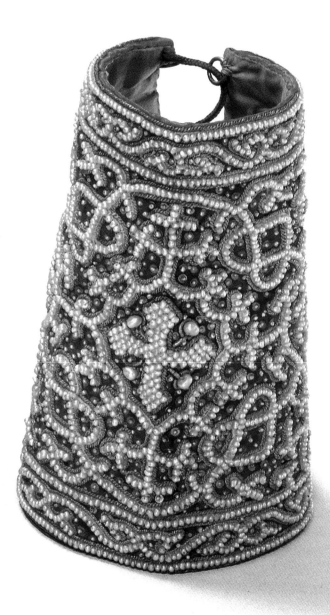

The foliate motif was basic to Russian ornamental needlework, whether in images of nature native to Russia, fairy-tale flowers of folklore, or patterns from imported fabrics. The nature images were often very general, conventional, and stylized, but nevertheless recognizable. The pearl embroidery on the cuffs (cat. 72) features such a motif, delicate stems with many foliate scrolls and stylized stamen and sprigs. In other cases the foliate design was much more defined. Thus, in the pearl design on a stole, also made in the seventeenth century (cat. 70), one can clearly make out carnations and pomegranates. The stole, part of Orthodox vestments, was shaped like a bib and worn directly over the cassock. The festive ornamentation is heightened by the handsome gold and silver tassels hanging from the bottom.

Decorative embroidery was not bound by canonic rules; its essential purpose was to create bright decorative objects that gladdened the eye. Thus it clearly reveals the people's aesthetic, what they considered beautiful. Decorative needlework was available to all classes, while pictorial embroidery was limited mostly to the feudal elite. Pictorial embroidery, which reproduced religious subjects and is related to painting, required the services of a professional artist. Workshops of such artists were located on princely and boyar estates and in large convents. There were whole staffs of craftswomen-embroideresses with different specialties. Some only stitched faces, others clothing and architectural details. Artists were also on hand to make the initial sketches of pictorial compositions and decorative patterns, as were scribes to make inscriptions.

In the sixteenth to the seventeenth centuries, the most important decorative needlecraft workshops were within the Kremlin—in the renowned "Tsaritsa's Workshop Chamber" and the equally famous workshop of the Assumption Convent, where, traditionally, women of the royal family took religious vows.

A *palitsa* (thigh shield) from the early seventeenth century, with its image of "The Resurrection of Christ" (cat. 71), was most likely created in the tsaritsa's workshop. The soft contours of the faces and the graceful figures are in the best tradition of the Moscow school. The many-hued patterns of the fastener stitches on the gold embroidery, as well as the abundance of pearls, are both characteristic of the Kremlin workshops.

The thigh shield, worn by Orthodox clergymen, symbolized the "sword of the Lord." It was worn on the hip. In addition to the symbols of the New Testament's four evangelists—lion, eagle, ox, and angel, one in each of the four corners—there is an inscription embroidered in silver.

The ancient Russian tradition of pictorial and ornamental needlework was practiced in more recent times as well. Thus the large shroud depicting "The Saviour Not Created by Human Hand" and "The Cross on Mt. Calvary" was executed during the first decade of the twentieth century (cat. 74, p. 196). It was used to cover the coffin of Grand Duke Sergey Aleksandrovich, Governor-General of Moscow, who perished from a bomb thrown by socialist revolutionary I. P. Kalyaev on February 4, 1905. This memorial veil, representing a spiritual appeal to God in the ancient tradition of the Russian Orthodox church, was placed in a chapel built in memory of the grand duke by Muscovite art patrons and artists. One of these artists, V. M. Vasnetsov—a major figure in the revival of historic and religious themes—composed the design. From an inscription on the lining we know the shroud was made by nuns of the Assumption Convent in Moscow, behind whose walls over the course of several centuries many magnificent examples of Russian pictorial embroidery were created.

Vishnevskaya is Chief of the Textiles Section, State Museums of Moscow Kremlin.

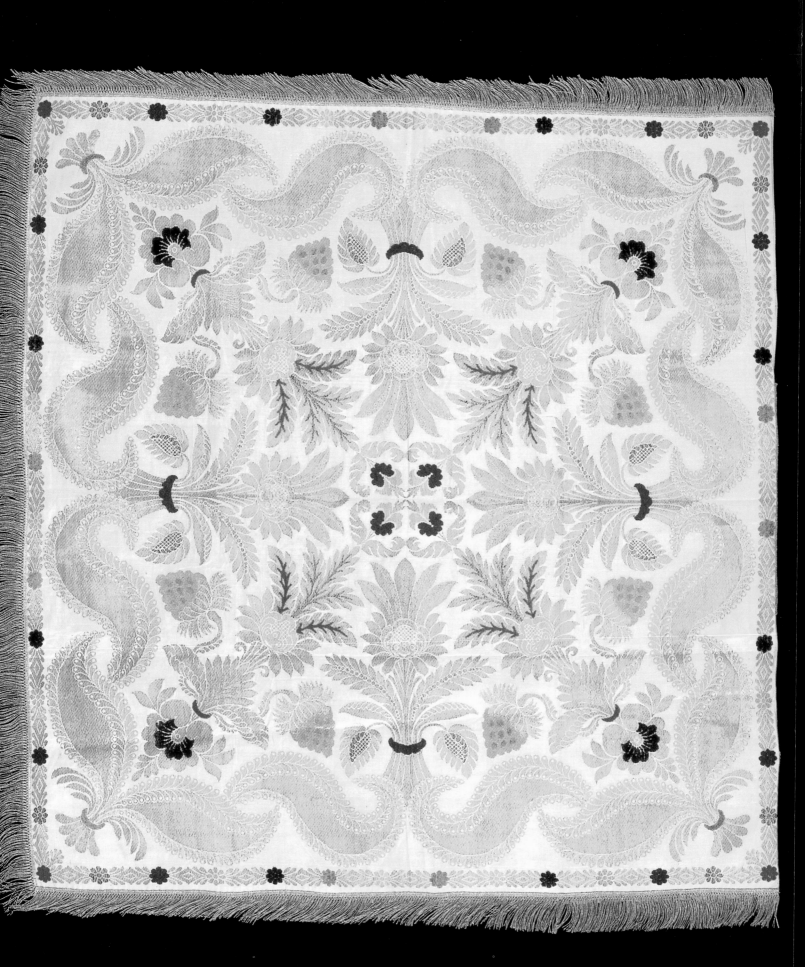

OLGA G. GORDEEVA

SPINNING GOLD FROM MOSCOW THREADS

FASHIONS AND FINERY

Gold-brocaded silk kerchiefs, in opulent patterns, were identified with the thriving textile industry centered in the Moscow region. This scarf was made by the factory of Gury Levin in the early 19th century (cat. 135).

Moscow, over the course of its history, has been a center of Russian life—political, commercial, industrial, and cultural. In Moscow, as in a giant melting pot, the cultures of Russia's northern and southern provinces, as well as those of its indigenous peoples, mingled with Oriental and European influences, fashions, and ideas to form something entirely new and unique. The city drew people from all over; some came to trade, others hoping to find work, still others to search for an education. It is not without reason that ethnographers list Moscow and Moscow Province as a contact zone, where traditional local cultures meet and undergo change.

The traditional clothing of Moscow and the surrounding area carried features of the northern Great Russian folk costume; the predominate dress for women was the *sarafan* ensemble, apparently first appearing in these regions during the seventeenth century. The sarafan (derived from the Iranian word *sarapa*—"to be covered from head to toe") evolved from a more ancient full Russian garment with long sleeves. Specialists believe that such a garment, worn unfastened and minus the sleeves, served as the prototype for a new and festive costume for women, which came to be known as the sarafan.

In the suburban villages surrounding Moscow, the gored sarafan—similar to the one worn in Novgorod and Tver—was popular. In Moscow itself, however, a unique type evolved. Called a "round," "Moskvich," or "Moscow" sarafan (cat. 132a), it was constructed from up to seven straight pieces of fabric sewn into a tube, then gathered at the top—above the breast—and attached to a yoke and thin shoulder straps, without other fasteners.

The Moscow sarafan, because of its novelty and because of the growth of the central state with Moscow as its capital, eventually crowded out more traditional local models across the Russian lands. Outside of Moscow, even up to the beginning of the nineteenth century, the round sarafan was considered the most up-to-date fashion, worn primarily on special occasions by young women from manufacturing centers.

The sarafan ensemble, which included a wide-sleeved blouse and a belt for the waist, was worn throughout Russia at the end of the seventeenth century and the beginning of the eighteenth, by the populations untouched by the dress reforms of Peter I—peasants, small-town inhabitants, and, in the cities, merchants and the petty bourgeoisie.

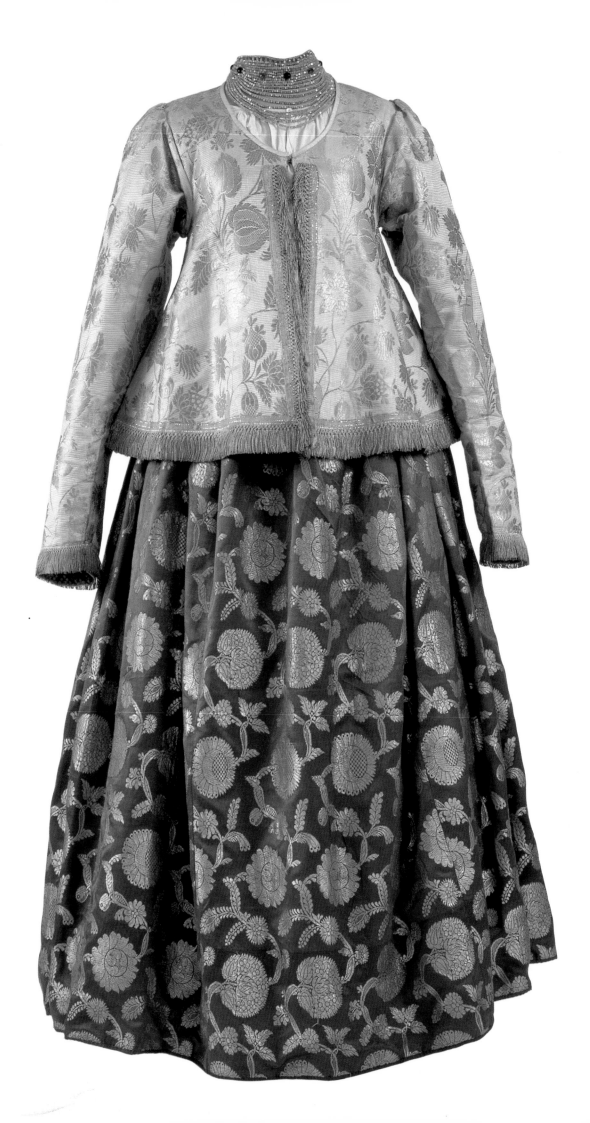

Festival ensemble: *sarafan* (sleeveless dress), *dushegreya* (jacket), blouse, and necklace. From Moscow Province, end of 18th century (cats. 132a,b,c,d).

On cold days a long-sleeved jacket, a
dushegreya, was worn over the ensemble. Differ-
ing from the traditionally loose lines of Russian
national clothing, the jacket bore a resemblance
to European city dress. It was fitted at the waist,
with a pieced back in large pleats. Dushegreya
jackets for holidays and festive occasions were
sewn from velvet, patterned silk, and brocade,
and decorated with embroidery, galloons, and
gilt fringe.

A holiday outfit was completed by various ac-
cessories—necklaces, beads, ribbons, earrings,
brooches, bracelets, rings. Master jewelers cre-
ated them from gold, silver, precious stones, col-
ored glass, fresh-water pearls, mother-of-pearl
chips, and gold foil.

The most popular headdress for women was
the *kokoshnik*, a solid little hat made of a rigid
foundation and decorative upper part. The
shapes of these kokoshniki were unusually var-
ied and distinctive—horned, crescent-shaped,
pointed, pine-cone shaped, and even flat with
ear flaps. The headdress was the most archaic
element in womens' costumes; each district had
its own ancient versions of the kokoshnik.

Experts believe that these local kokoshniki
date back to the pre-Christian, Slavic past. The
ancient Slavic custom had survived in which the
maiden's headdress must be distinct from that of
the married woman's. An unmarried girl might
wear her hair loose, or in one braid, while a mar-
ried woman had to plait two braids, pin them on
her head in a knot, and usually avoid appearing
in public with an uncovered head. Thus two
types of headdresses developed, the ones for
married women, which covered the hair, and the
ones for unmarried girls, which left the hair ex-
posed.

The kokoshniki from the eighteenth century
and the early nineteenth were masterfully em-
broidered with fresh-water pearls, mother-of-
pearl, silver-gilt embroidery, different colored
foils, and faceted steel beadwork. Kokoshniki
were highly cherished objects, passed down for
many generations, and were a necessary item in
every bride's trousseau. They could be ordered
from monastery workshops or from workshops
in cities and larger villages where kokoshniki
were made and decorated.

The Moscow kokoshnik (cat. 133) had a high
oval facade, covered in red velvet and decorated
with gold-thread embroidery, with a silk bow
fastened on the back. It was worn by women of
the merchant class, the petty bourgeoisie, and
the richer peasant women from the suburban
villages. From the beginning of the nineteenth
century, it was the custom among the nobility for
the wet-nurse to wear a Moscow kokoshnik.

The Russian silk and wool manufacturing in-
dustry was centered in Moscow city and prov-
ince. The first silk textile mills appeared in Rus-
sia in the early 1700s, and by mid-century there
were more than twenty silk textile mills in the
Moscow region. The widespread use of silk by
the richer peasants, merchants, and city folk en-
couraged the development of fabrics designed
specifically with sarafans in mind. The design of
these fabrics—distinguished by their bright
colors and distinct floral bouquet patterns—viv-
idly illustrate the direct influence of traditional
Russian folk art.

It was in Moscow that the most well-known fabric designs developed: large flowers, feathery leaves, bouquets tied with bows, "winged" bouquets, and lace ribbon patterns. And it was from Moscow mills that patterned silks, *kolomenskoe* brocades, and gold-weave scarves found their way to the various county and district fairs. There was great demand for the renowned brocade of Moscow, to be used for sarafans, dushegreya, and kokoshniki as well as for religious vestments. Women of Russia—in the north, along the Volga districts, and across Siberia—all wore the damasks, brocades, and scarves of Moscow. From the eighteenth century, Moscow dictated tastes in such traditional clothing throughout the land.

Silk gold-brocaded head kerchiefs came into mass production at the end of the 1700s, replacing another ancient form of Slavic hair covering, the *ubrus*—a length of patterned or embroidered white linen thrown lightly over the hair or wound in complicated headdresses to cover it. Women from the merchant caste and the petty bourgeoisie, as well as the richer peasants, paraded about in emerald green, cherry, blue, pink, and white head kerchiefs. These decorative accessories were brocaded with gold thread in foliate patterns of fantastically intertwined flowers and bunches of berries, patterned leaves with scrollings, or luxuriant bouquets. The patterns were woven with colored silk thread intertwined with gold wire, as well as with foil ribbons of gold or silver.

The Kolomna merchant Gury Levin owned one of the largest factories specializing in gold-brocaded silk kerchiefs (cat. 135). Kolomna, in the Moscow region, remained a thriving center for the production of silk. Levin's trademark appears on pieces from the 1780s onward.

Members of the Levin family of merchants owned several silk textile mills. During the first half of the nineteenth century we know of trademarks for Iakov, Vasily, Martyn, Artamon, and Egor Levin. Their products, often exhibited at trade fairs, were singled out for their unusually high level of quality and for the virtuousity of their rich and complex designs. The Levin factories, whose marketing was oriented toward the peasant and merchant classes, ceased production in the mid-nineteenth century.

After the clothing reforms of Peter I in 1700, the dress of urban dwellers followed all the vicissitudes of European fashion. Baroque, rococo, Empire, Biedermeier, art nouveau all left their mark on the dress of the Moscow aristocracy, petty gentry, and other city folk—from the petty bourgeoisie and merchants to intellectuals and civil servants.

Nevertheless, in some unexplainable manner, despite the sincerity of their attempts to follow French fashions to the letter, the colorful inhabitants of Moscow managed to infuse their own idiosyncratic note into the fashion scenario. As a multitude of observers have testified, in contrast to sophisticated and proper St. Petersburg, a certain unaffected negligence was characteristic of the Muscovites, a charming lack of pretension, a slight tendency toward exaggeration—whether in an over-large shawl, a parasol covered with an impossible plethora of bows, an over-long train, or an over-wide crinoline. Colors and patterns played an important role. Bright tones were preferred, with colorful ornamentation. Stores and workshops maintained the highest standards; the execution of the costumes was always faultless.

Eighteenth-century ladies' costumes and mens' frock coats, which followed western models in their essential design, were trimmed in braid and gilt thread, as was the traditional folk dress. Dresses from the Empire period were decorated with folk embroideries, in the white

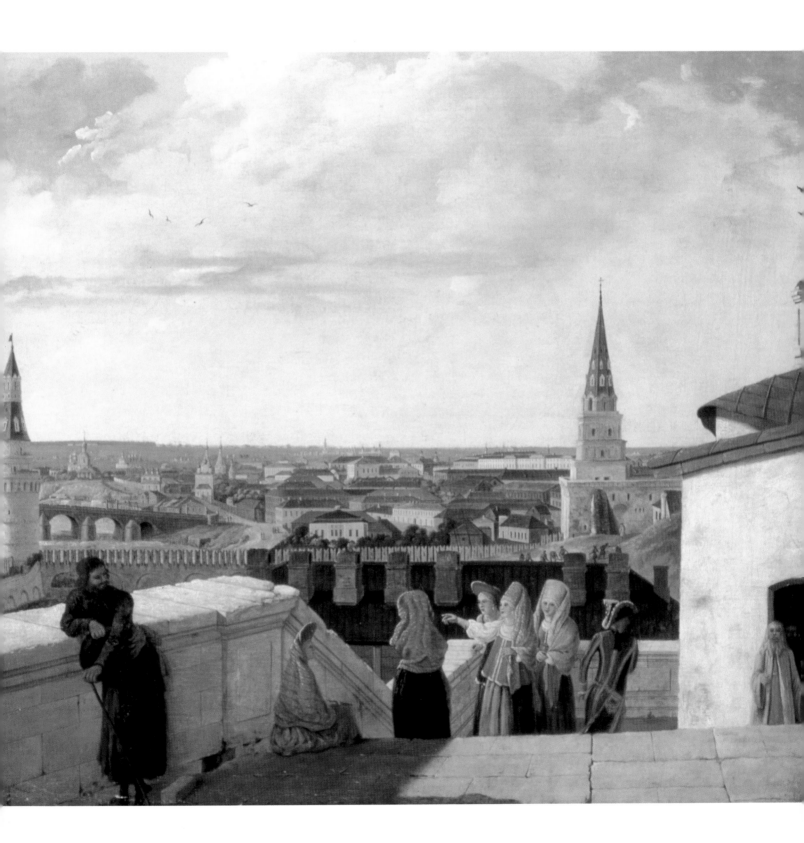

on white pattern, "broderie anglaise," tambour-embroidery, and open work.

In the early 1800s, the simple and slender silhouette of the Empire style replaced the busy forms of the rococo costume, and dresses came to resemble Grecian chitons and tunics, sewn from light, semi-transparent fabrics such as tulle, gauze, tarlatan, and batiste. An example with a high waist, a wide decolletage, broad "lantern" sleeves, and a relatively narrow skirt descending to the ankle in front and gathered in pleats behind typifies the style (cat. 136a). This hand-sewn dress is gathered on a drawstring, allowing one to regulate the width of the neckline. The combination of the translucent fabric with the matte surface of the embroidery against the light yellow background of the slip leaves an impression of subdued refinement and lightness. As we examine this dress, the well-known image of Pushkin's heroine Tatyana Larina rises before our eyes. These dresses were hand-embroidered by unknown craftswomen, possibly serfs. The painstaking labor that produced such astonishing results often cost the health of these patient serf women.

With the "classical style" dresses of the early nineteenth century, light flat slippers on thin leather soles were worn. Ribbon ties crisscrossed the ankles in the style of ancient sandals. Such handmade shoes, sewn from tapestry fabric, velvet, fine leather, and prunelle (a wool-cotton blend), were decorated with embroidery, beadwork, ribbons, and gold and silver thread. The soles were cut identically for both the right and left foot. Women from a lower stratum of society, who actually had to walk distances on foot, wore this same style in sturdier materials.

Nineteenth-century Moscow had many shoe-makers and retail shoe stores serving it as well as other cities and districts in Russia. The label in a

Empire-style dresses were worn by fashionable aristocratic women in Moscow during the early 19th century, as seen in this embroidered cotton gauze dress with lantern sleeves (cat. 136a) and in N.I. Argunov's portrait of famous actress and singer Praskovia Kovaleva-Zhemchugova (cat. 161). Both painter and actress were serfs, trained with the support of their masters—the enormously wealthy Sheremetev family, whose vast holdings included the Moscow estates of Kuskovo and Ostankino as well as 140,000 serfs. A fairy-tale romance between Count N.P. Sheremetev and the young actress—whom he emancipated and secretly married in 1801—was short-lived. She died following the birth of their son; in her memory, the bereaved count founded a hospital for orphans in Moscow, its decorations painted by Argunov.

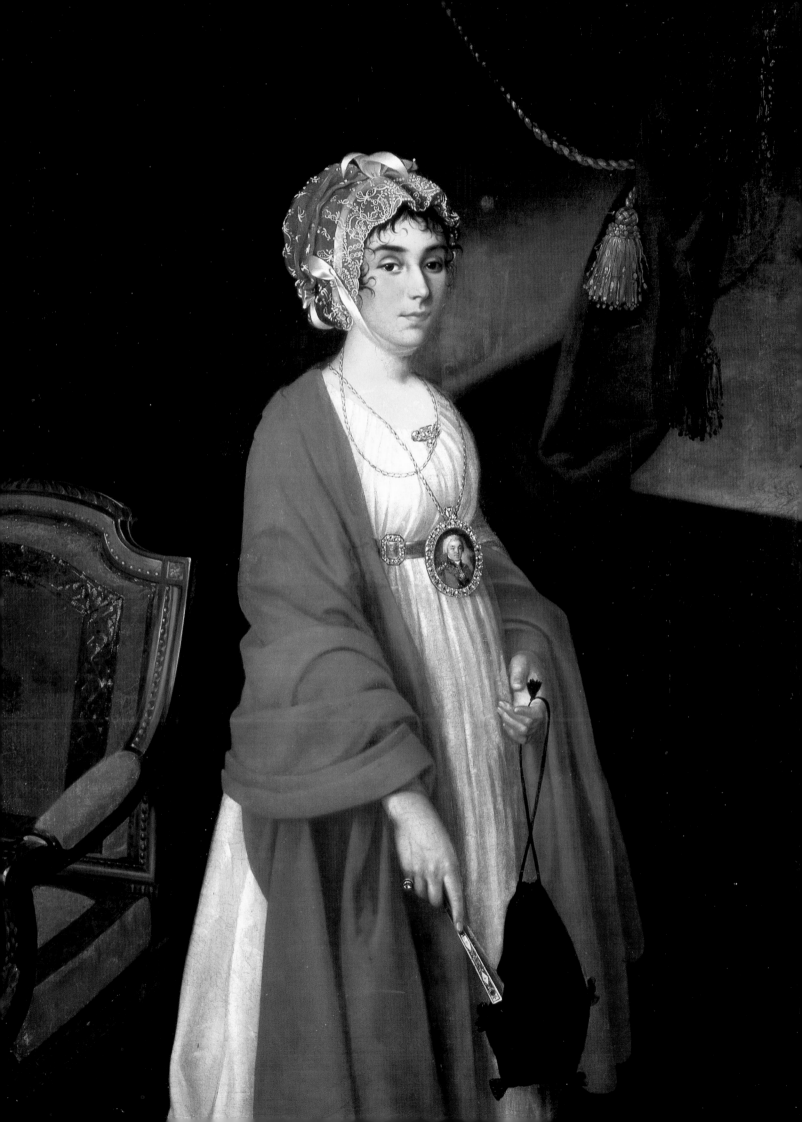

pair of slippers (cat. 136b) reads "Koralev's Shoe Store No. 2 at Ilinka near Moskatelny Row." The Koralev brothers were the largest shoe merchants in Russia during the nineteenth and twentieth centuries. Their store, located on Ilinka Street in Moscow, offered up to seventy-five designs. The most famous makers sent their products to trade fairs in Moscow and St. Petersburg, as well as abroad, where their shoes measured up in quality to the best the West could offer.

The combs manufactured in Russia during the first half of the nineteenth century are interesting both as examples of handicrafts and decorative arts and as fashionable coiffure accessories. Made from imported tortoise shell, pressed horn, steel, and copper gilt, they were carved, engraved, and decorated with precious stones.

Combs reflected the changes in ladies' coiffures from 1800 to 1850. Upswept hair was in fashion, either as chignons or braids arranged on the crown of the head. Natural hair was also back in style; however, if one's locks proved insufficient, artificial switches were bought from hairdressers. Coiffures at the beginning of the century followed ancient Greek and Roman styles, and hair combs were shaped like diadems, or half-circle wreaths, fastened above the brow. Later, in the 1830s and 1840s, braids, chignons, and more complex arrangements appeared. The most popular was the "Apollo knot." As described in 1835: "It was actually a knot or wide bow made of artificial hair, not less than a quarter of an arshin [18-20 centimeters] high." It was secured with a comb on the very crown of the head. Another comb from this period (cat. 136c) resembled a Spanish form, with a high ridge,

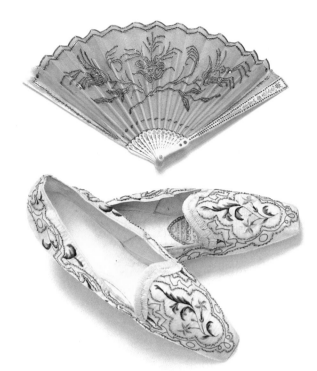

Folding fan
(cat. 136e).

Silk slippers
(cat. 136b).

slightly concave shape, and long teeth.

Besides holding up the coiffure or the knot, combs also served as an ornament for the head. They were inserted on either side of the coiffure, peeked out coquettishly from beneath locks of hair, or were placed at the nape of the neck, giving the hairdo a sense of finish. This is seen in the watercolors, miniatures, and women's portraits executed by Russian artists of the time.

The sight of a luxurious antique fan usually brings to mind splendid balls, masquerades, and festive ladies filling up theater boxes and palace reception rooms. However, the true cause of the appearance of the fan has less to do with fashion's caprice than with dire necessity. The oppressive heat, the lack of ventilation, the closeness of the air in rooms illuminated by candles—all made it necessary to resort to artificial means of circulating the air.

Fans existed in Russia from the seventeenth century. The first examples, called *opakhaly*, were used only in court ceremonies. By the eighteenth century they had become firmly established among the nobility, and were adopted both by the merchant class and the urban bourgeoisie. This graceful object served as an original means of communication in matters of the heart, as well as a fortune-telling device.

In the nineteenth century, however, the fan took on a new utilitarian meaning. Everywhere—at the theater, at soirees, at balls—the decorative fan became a required accessory.

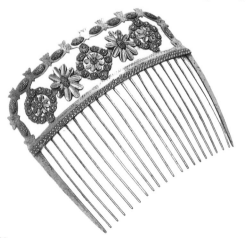

Steel comb from Tula
(cat. 136c).

Young girls and married women took their promenades fan in hand. It was held on a ribbon or cord looped around the wrist of the right hand. Along with the light, transparent dresses sewn in the "antique manner," small fans (cat. 136e) came into fashion, made from light, transparent materials such as gauze, chiffon, and tulle, covered with metal spangle embroidery. Master jewelers fashioned these decorative, but useful, articles, leaving a valuable historical record of artistic styles and taste.

Double-faced woven shawls and scarves were fashionable throughout the first half of the nineteenth century, first introduced into Parisian fashion through examples from India, Turkey, and Persia. Empire dresses, with their straight silhouette, required straight-angle shawls, artfully draped about the body. However, the fashion for puffy sleeves, which appeared in the 1820s, called for long scarves, often striped, with a luxurious ornamental border. With the wide

Shawl (cat. 137).

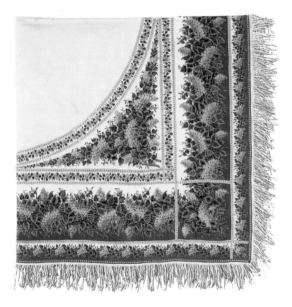

skirts of the 1830s and 1840s a scarf or a square-shaped shawl, folded into a triangle, was usually worn about the shoulders. Such shawls also had ornamental borders: the two visible sides, with their very wide design, had applied ornament in the corners; the two hidden sides, however, had just a narrow ornamental strip.

During the first decades of the nineteenth century, Russia imported two million roubles' worth of shawls per year from the East and western Europe. Russian manufacturers responding to the demand began to produce their own woven woolen shawls.

Shawls woven in the double-faced technique were particularly renowned. Though often called by the factory owners' names—*merlinskye* or *kolokoltsevskye* shawls—they could just as well have been labeled "serf-labor" shawls, thus giving due credit to their anonymous creators.

One of the most well-known workshops belonged to the landowner Nadezhda Merlina. Her mill, located from 1806 in the province of Nizhny Novgorod, was moved in 1834 to Ryazan Province, to be closer to the commercial center of Moscow. Merlina's enterprise was a typical gentry manufacturing concern; the whole production process, from beginning to end, took place on her estate. Serf craftsmen spun the fleece of Kirgiz goats into incredibly thin thread; thirteen grams of fleece gave forty-five hundred meters of it. The thread was colored with natural, home-made dyes; up to thirty different shades were produced. The most demanding work was done by the female weavers, who had to have thin, flexible fingers and very keen eyesight. On small weaving frames, with tiny wooden needle-like shuttles, they wove patterned strips, corners, and background.

The double-faced weaving technique presented particular difficulties. The ends of the multicolored threads had to be fastened invisibly, to create an identical surface on both sides of each shawl's patterned edges. At the end of the process, all the separate segments and the background were sewn together to make one whole item. Each shawl was made to individual order, according to a special design. The weavers executed these complex compositions, with their subtle nuances in color, with a remarkable degree of accuracy.

The fancies of the artists composing the designs blossomed in countless variations of the flower motif. Here we have the luxuriant lilac with its thick greenery, elegant chrysanthemum bouquets, budding roses, and delicate wild-flower blossoms (cat. 137) . These beautiful creations were very expensive, their market limited to the richest aristocratic circles.

The manufacturing operations on the gentry estates could not withstand the growing competition from capitalist factories, which produced much more widely affordable goods. Despite the fact that the abolition of serfdom in 1861 completely destroyed its labor base, gentry manufacturing had begun to decline much earlier. The last time a shawl from the Merlinova factory was shown at a trade fair was in 1851, at the first International Industrial Trade Exposition in London.

Uniforms were very visible in Moscow social life during the period of the Napoleonic wars and afterwards, when, during the reign of Nicholas I, Russia had the largest standing army in Europe. The uniform of the Hussars—a kind of light cavalry that first appeared in Hungary during the fifteenth century as troops of the gentry—was very distinctive. It consisted of two cord-trimmed jackets—a doloman and a fur-trimmed pelisse (cats. 138a, b)—as well as a fur cap with a plume, *chakchiry* or cord-trimmed breeches, and short boots with spurs.

First mentioned in Russia in 1634 and intermittently gathered in the next century, the first regular Hussar regiment was formed only in 1751, staffed by men from the borderlands of the Russian empire and emigres from neighboring countries. The Life Guards Hussar Regiment, a light cavalry unit, received its baptism by fire at the Battle of Austerlitz on November 20, 1805. During the War of 1812, and the foreign campaigns of 1813-14, the regiment participated in all the major engagements. On April 13, 1813, the entire unit was awarded three St. George

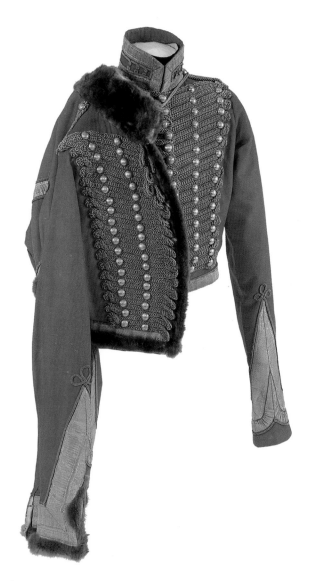

Doloman and pelisse from general's uniform, Life Guard Hussar Regiment (cats. 138a,b).

Standards for bravery and valor, with the following inscription: "For distinction in service during the defeat and expulsion of enemy forces from Russian soil in 1812."

In 1831 the regiment was awarded twenty-two St. George Trumpets; for their part in the Battle of Telish during the Russo-Turkish War of 1877-78, the unit received pins for their caps. The regiment was disbanded in March 1918.

At the same time, in contrast to this formal public dress, Moscow men wore robes at home in the morning, and, if circumstances permitted, for the rest of the day as well. In fact, this custom may be observed from the eighteenth century onwards. These robes were made from satin,

Within the Kremlin, uniformed cavalry officers ride among priests and city folk in this picturesque view of 1838 by Edward Gartner (cat. 164). Spassky (Savior) Tower, the main entrance gate built in the 16th century, dominates the scene. On the left, behind the pale green gothic revival Church of St. Catherine built in 1817, the gold dome of the 14th-century Voznesensky Cathedral appears (neither was preserved in the Kremlin renovations of the 1930s). The small Tsar's Tower on the right, built in 1618, initially housed an alarm bell for the Kremlin.

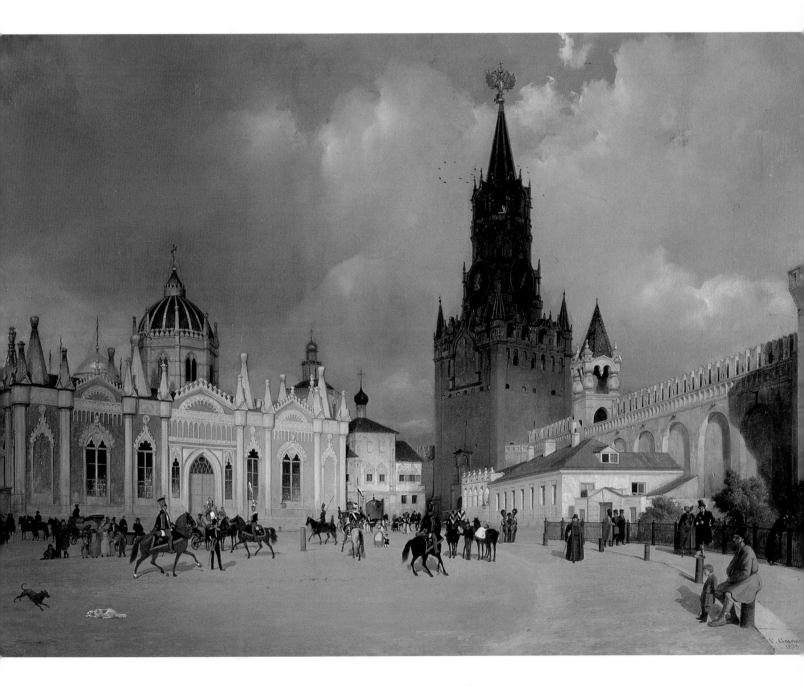

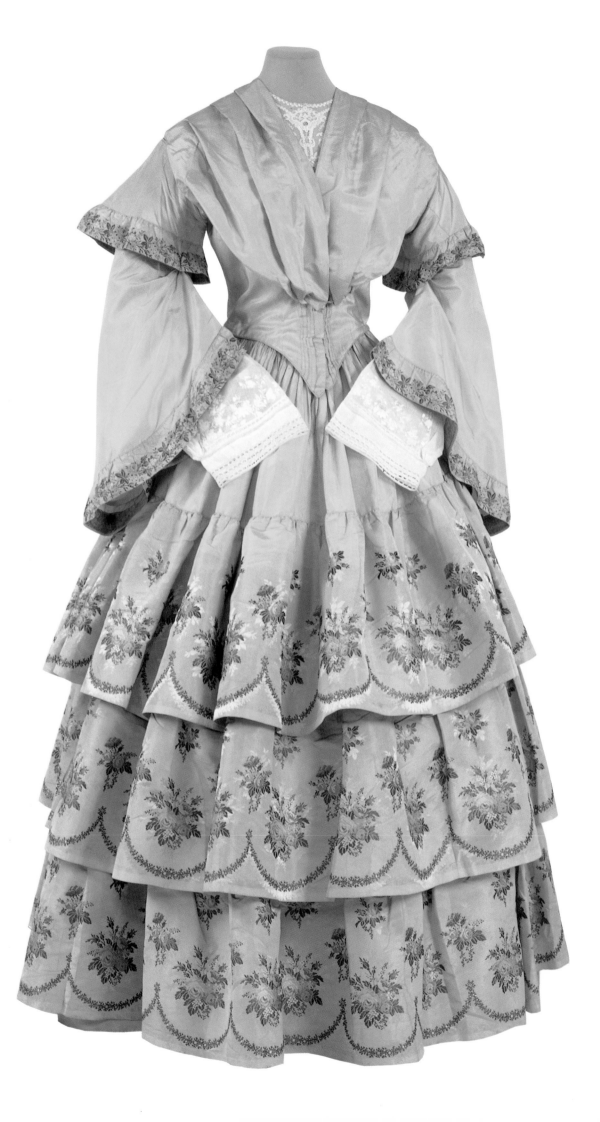

Moscow flourished
as a mercantile center
in the mid-19th century.
The wives of affluent
merchants followed the
fashion of full-skirted
dresses with narrow
waists—often worn
with large patterned
triangular shawls
(cats. 141a,b,c).

expensive Oriental silks, cashmere, or a blend of silk and wool; winter robes were lined with wadding or fur. At the beginning of the nineteenth century, when all sorts of "exotic" clothing became the fashion, Chinese, Bukhara, and Turkish robes appeared accompanied by their proper headgear in the form of little caps or fezes. Oriental costumes, fabrics, and patterns were very popular. These robes were usually cut wide, in a single-breasted style, and reached down to the ankle, with a wide overlap, a shawl collar, long sleeves, and turned-back cuffs. Pantaloons or harem pants were usually worn with these robes, and soft bedroom slippers or unstructured boots.

A very rare example of mens' at-home footwear is seen in a pair of green velvet boots—decorated with gold solid-stitch embroidery—from Torzhok (cat. 139b). During the eighteenth and nineteenth centuries, the road linking Moscow and St. Petersburg passed through that city, which was renowned for its decorated leather. In Torzhok, moroccan leather slippers, soft boots, belts, and other small items were embroidered with gold and silver designs for sale to well-to-do travelers from across the Russian lands and abroad. Similar designs may be found on women's headdresses, holiday vests, and shirts from Torzhok. At the 1851 trade exposition in London, the merchant Shikhonin had for sale—among other gold-embroidered items—a pair of velvet boots, for thirty-five roubles. A pair of velvet boots embroidered in silver was also offered, for thirty roubles. It is possible that the shoe merchant Korolev sold similar boots in Moscow, advertising them as "men's morning boots—from Torzhok." According to the 1850 statistics, Torzhok produced fifteen thousand roubles' worth of such goods that year. In 1865 the volume had grown to twenty-five thousand roubles, with three hundred craftsmen employed in the industry there.

Out of doors, the petty bourgeoisie and mer-

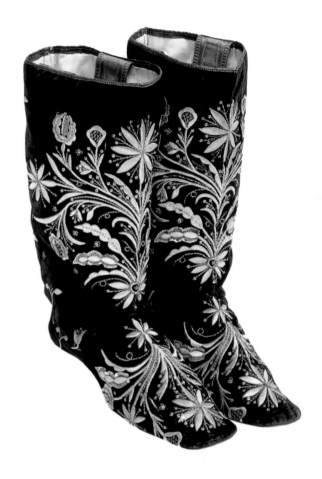

chants of Moscow wore a soft, warm, quilted *salop*—a bathrobe-like outer garment—right into the twentieth century. The European frock coat became the uniform for all social strata; however, while the nobility wore it in the current European fashion, merchants and commoners modified it to resemble their habitual Russian long-skirted coat or "caftan."

In the mid-nineteenth century, the merchants' wives and daughters of Moscow wore fashionable European-style dresses. The luxurious pattern and vivid colors of a dress from that time (cats. 141a,b,c) suggest that it might have been worn by a well-to-do woman of the urban bourgeoisie, perhaps from the upper merchantry. Typical of European fashion in general, the boned waistline is tight-fitting; the "pagoda" sleeves are narrow at the shoulders and wide at the wrists; and the wide, gathered skirt is trimmed with three horizontal flounces.

The dress was hand-sewn by anonymous seamstresses at an unknown, presumably Muscovite, atelier. The fabric trim of graceful bouquets and garlands of flowers is centered on the horizontal stripes placed along the edges of the sleeves and on the flounces at the hem. Such colorful patterns were created on mechanical jacquard looms, installed in Russian textile mills during the 1830s. In the mid-nineteenth century, Moscow and Moscow Province were the centers for the production of patterned silk fabrics, the oldest silk mills having been founded during the reign of Peter I.

In the middle of the nineteenth century, it was fashionable to fill in the open necks of the dresses a bit with all sorts of collars, dickeys, fichues, kerchiefs, capelets, and insets. Wide pagoda sleeves required undersleeves, which were also made of lace or gauze fabrics, trimmed with the finest decorative embroidery stitches in white cotton thread. This "fine sewing" was done by anonymous serf-craftswomen in gentry workshops on the estates of the nobles or by free, professional seamstresses in the cities.

The parasol played an important role in a woman's toilette during summer walks. In the nineteenth century, city women tried to preserve their faces from sunlight by means of wide-brimmed hats or parasols. The parasol was small, with deep rims; a hidden hinge allowed it to tilt, shielding the face from dust and sun. Its fabric, as well as the rich ornamentation of precious stones and metal sculpture on its handle, all point to the parasol's use as part of a festive holiday summer ensemble, perhaps for making calls. Only a member of the wealthy elite could allow herself such a costly and refined accessory.

In the nineteenth century an important cotton industry developed in Moscow. Cloth goods manufactured there began to appear in the most out-of-the-way corners of the Russian Empire, displacing domestically produced woven stuffs. Both the city folk and the peasantry were particularly attracted by the new patterned cottons, and by the calico scarves featuring them.

In Moscow Province, earlier than in other districts, manufactured elements were incorporated into the traditional folk costume. Printed cotton appliques and store-bought silk ribbon trim replaced the ancient woven and embroidered ornamentation. In the Moscow peasant costume there were often touches of the southern-Russian tradition—the decorative weaving of Ryazan, the embroideries of Kaluga, and the lace galloons and spangled applique of Voronezh. A vivid example is the ornamentation on a mid-nineteenth-century festival dress from Verey (cat. 140).

In the Verey district of Moscow Province a group of former serfs of Count Shuvalov, commonly called *shuvalovtsy*, stood out from the surrounding peasantry because of their distinctive dialect, and their dress. Their festival costume combined features of both the northern and the southern Russian traditions.

The Verey sarafan was sewn from dark blue cotton chintz. The first cotton fabrics were imported into Russia from China; chintz (whose root word is "China") gradually came to cover Russian-made fabrics as well. Russian chintz, dyed and printed with indigo, was usually referred to as "kubov chintz" after the special equipment necessary for its time-consuming manufacture. The peasants valued cotton very highly and wore it only on holidays. The design of the Verey sarafan was very old, appearing in seventeenth-century engravings of Moscow women.

The Verey shirt also had some archaic features—in the shoulder insets, straight *poliki* of

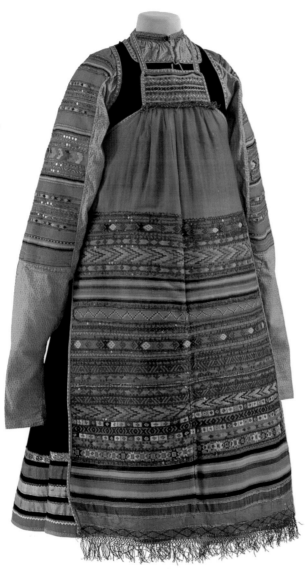

red characteristic of northern Great Russian shirts. The sleeves of the holiday shirt were also very long, going down below the wrist. These sleeves were gathered at the arm by means of bracelets, or sometimes a slit was made at wrist level, for emergencies. There is a folk proverb, "to work with lowered sleeves," meaning to be idle, which comes from the custom of wearing long sleeves on festive occasions.

The sarafan, shirt, and apron are all trimmed with store-bought silk ribbon, galloon, and spangles. With the growth of the market, manufactured elements came to replace home-made embroidery and hand-made patterned weavings.

In the late nineteenth century, recognition of the artistic and historic importance of Russian dress initiated collecting by individuals and institutions. The State Historical Museum now has one of the largest collections of Russian textiles and costumes in the USSR, more than two hundred thousand items, from which the selections in this exhibition have been drawn. Its acquisition activities, which have been going on for more than a hundred years, brought into the museum outstanding materials from well-known Russian collectors P.I. Shchukin, A.P. Bakhrushin, and many other admirers of Russia's past.

Workers from the museum were among the first in Russia to systematically send out expeditions to various regions to acquire on-site artifacts of people's everyday lives. The famous expedition of the 1920s to the Russian north, expeditions to the southern provinces in the 1930s and to Siberia after World War II—as well as more recent expeditions—have yielded very rich materials for research.

Throughout its existence the museum has emphasized the history of Moscow—the everyday experiences of its citizens, the growth of industrialization in the city and the surrounding region, and life in the suburban villages. The materials preserved in the museum are invaluable as historical sources, and provide the means for tracing a uniquely Muscovite cultural tradition that has developed over the course of many centuries.

Gordeeva is Senior Scientific Worker, Department of Textiles, State History Museum, Moscow.

KATRINA V. H. TAYLOR

HALLMARKS OF PERFECTION

PORCELAIN OF THE MOSCOW REGION

Today, chinaware is taken for granted all over the world, but this was by no means always the case. From around the eighth century to the early 1700s, the Chinese alone understood how to make clay vessels that were thin, hard, white, translucent, non-porous, and smooth, providing an ideal surface for delicate painted decoration. Popularly called "china" for the country of its origin, ware with these appealing qualities is more precisely designated true or hard paste porcelain.

For centuries western Europe and Russia produced earthenware only, which was often coarse, thick, and dark. Peter the Great (1682-1725) and rulers in the West considered imports of porcelain from the Far East more desirable than gold or silver, and were eager to start native manufacture. The first to succeed was August II, Elector of Saxony. Workers in a factory he set up in 1710 at Meissen near Dresden managed to create a formula to make true porcelain with the essential ingredients, which included a rare white clay called kaolin.

Peter's efforts to bring back the formula from China had failed and in addition he had been unable to wrest the method from Meissen where it was a jealously guarded secret. Finally in the reign of Peter's daughter Elizabeth (1741-61), a factory was founded in 1744 in St. Petersburg where a chemist on the staff named Dmitry Vinogradov worked out the formula independ-

ently. This factory, which was administered by the state government and became known as the Russian Imperial Porcelain Factory, then took the lead in supplying the court and other well-to-do customers in the capital city. Its ensuing inability to fill the increasing demand encouraged several private individuals to set up workshops, which however eventually failed and their wares have disappeared.

An enterprise that did succeed was established in the Moscow area in 1766 by Francis Gardner, and it was the only one besides the Imperial Factory to continue operating into the nineteenth century. Mention of his English name often elicits puzzled questions, but the fact is there were innumerable foreign businessmen in Russia in the eighteenth century, when financial rewards could be great, especially if one attracted imperial favor.

Gardner emigrated to Russia in 1746 and spent many years there as a timber merchant before resolving to found a porcelain factory. What led him to this decision is not known. By 1760, he had traveled widely with official support to find suitable clays. He started out in Gzhel, an area rich in clays not far from Moscow that had attracted various makers of glazed earthenware in the late seventeenth and early eighteenth centuries. He proceeded to the Ukraine and continued as far as Siberia. His quest was successful.

Idealized, sentimental scenes of rural life decorate this Empire-style sugar bowl from a Gardner table service of the late 1820s (cat. 103).

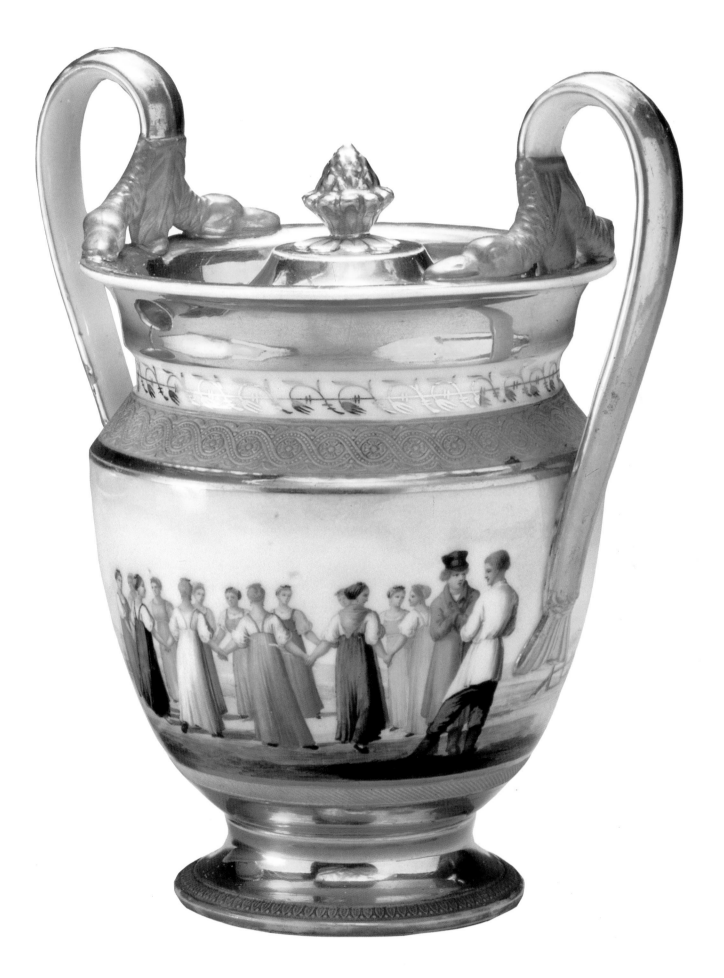

Eventually, he received permission from the government to acquire land for a factory in the village of Verbilki, located a few miles from the city of Dmitrov in the Moscow district. He had been attracted to the site by its extensive forests, which could supply firewood to heat the kilns.

A major concern and chronic problem for Gardner over the years was how to acquire an adequate number of workers. As a foreigner he faced constant legal obstacles in his requests to buy serfs. Further, there was a risk in hiring non-serfs with passports; once trained, they were free to leave for better positions elsewhere. However, this problem was surmounted and toward the end of the 1770s Gardner had one hundred fifty-five employees.

For advice on technical matters at the beginning he had access to a well-established ceramics factory in Moscow proper, which had been founded in 1724 by Afanasy Kirilovich Grebenshchikov and continued by his sons until 1773. Old records indicate that Ivan, one of the sons, knew how to make true porcelain around 1747, but commercial production eluded him because the director of the Imperial Factory suppressed the Moscow factory's potential competition.

In any case Gardner must have been technically proficient before he went on his travels. Then at the outset he benefitted also from the experience of the Imperial Factory by hiring a former worker from there, a German named Johann Gottfried Müller who had come originally from Meissen.

Gardner's initial aim was to rival the products of Meissen, which had been exported to Russia and greatly admired. He imitated their rococo shapes, mythological and allegorical themes, figures from the commedia del arte, romping putti, romantic rustic couples, molded basket weave, and painted clusters of flowers in natural color on a white ground. He even went so far as to use

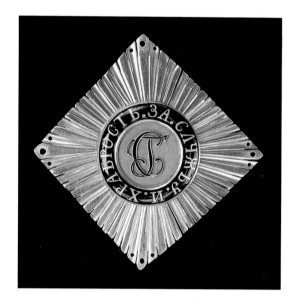

as his factory mark an adaptation of the crossed swords of Meissen. Even with this dependence on the Meissen style there was no direct copying, for example the stylized representation of a single rose that was repeated constantly was so distinctive it was known as the "Gardner" rose.

In the 1770s a painter from Meissen, Joachim Kaestner, was also on the Verbilki staff. Evidence of his presence is an inscription on an oval tray from a small teaset in the Russian Museum in Leningrad, bearing the mark of the Gardner Factory—"J.C. Kaestner inv. et fecit 1775." The decoration is a scene from the Russian victory in the war with Turkey and featured in the design is the crowned cipher of Catherine the Great. If Catherine actually saw this set she could have been impressed by its quality. In any case she had an opinion of Gardner's achievement high enough to give him an important commission. At the same time, she wished to support a native industry, thus limiting expensive imports.

In 1777 Catherine issued a ukase for Gardner to make dinner services for three orders (honorary societies comparable to the Order of the Gar-

The St. George service made by the Gardner Factory was first used at the palace banquet on the feast day of the order, November 26, 1778. The star of the Order of St. George (left, cat. 94) and the black and orange ribbon identify the service. Even the squirrel adorning the custard cup was symbolic, recalling the popular proverb: "Without effort you will gain nothing" (cat. 99).

ter in England) named after saints especially revered in Russia: St. George, St. Alexander Nevsky, and St. Andrew. The appropriate service was for use once a year when the knights of the order dined at the Winter Palace on the feast day of the name saint of the order. The various pieces were painted with facsimiles of insignias worn by the dinner guests—ribbons, stars, and badges. The service for the Order of St. George (cat. 99) comprised eighty place settings and was finished in 1778; the services for the Order of St. Alexander Nevsky, with forty place settings, and the one for St. Andrew, with thirty place set-

tings, were finished in 1780; a fourth service commissioned in 1783 for the Order of St. Vladimir, with one hundred forty place settings, was completed in 1785.

Ideas for the shapes in the services were provided not only by Meissen prototypes, but also from a service made in the Berlin factory and presented to Catherine in 1772 by Frederick the Great of Prussia. The Gardner services included dinner and soup plates, serving dishes shaped like leaves, and bowls with molded open-work imitating woven baskets. For sherbert or custard there were little covered cups. Knives and forks

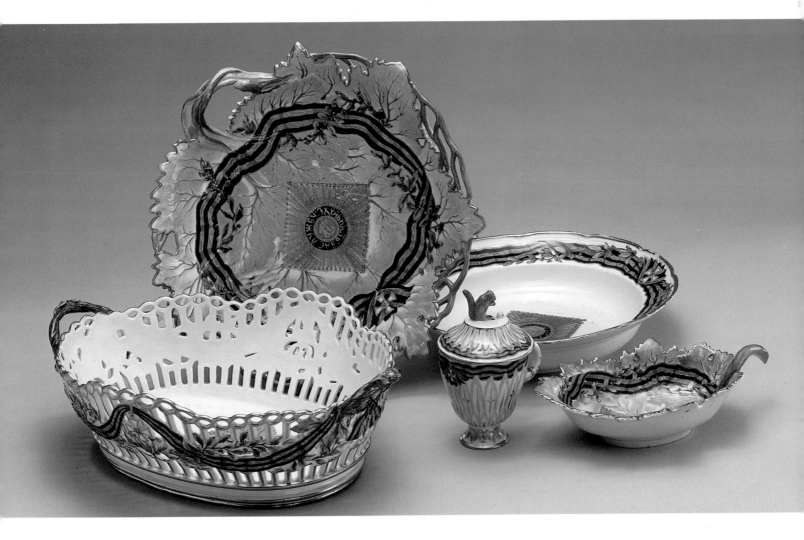

In the years
following the War of
1812, military motifs
were popular. The
medallion on this
Gardner cup from the
1820s depicts a skirmish
between a Russian
hussar on a white
horse and a French
uhlan on a bay
(cat. 102).

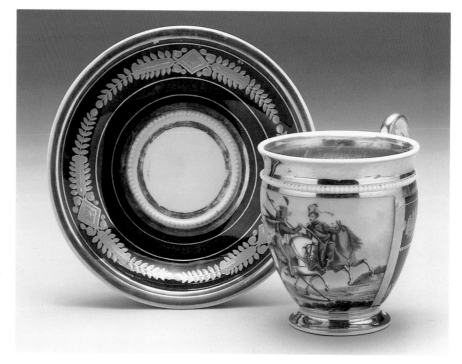

Artist Petr Vereshchagin captures the atmosphere of Moscow's famous second-hand market, where people of all classes and professions mingled daily (cat. 172).

A figure from Gardner's Magic Lantern series, the doorkeeper sweeping the cobbled street, and a Popov Factory figure, the peasant woman carrying a basket of mushrooms (cats. 111 and 104).

with porcelain handles, small receptacles for nuts, salt, or condiments, and tall candelabra further embellished the banquet table.

Imperial commissions such as these lavish sets must have introduced Gardner's name to a wide circle of titled nobility in St. Petersburg as well as to prosperous merchants in Moscow. In the meantime, items aimed at a less affluent clientele continued in production: white ware with a few flowers and little or no gold as well as small statuettes.

At the very end of the eighteenth century some of the statuettes represented contemporary types, in contrast to the literary figures made earlier. But when Russian victories in the Napoleonic wars gave rise to a wave of patriotic fervor, the subjects became even more realistic. A new journal appeared in 1817 reflecting the growing enthusiasm for native folk customs. Entitled *Magic Lantern,* it contained an array of colored engravings of artisans and vendors such as one could see on the streets at the time, with their distinctive garb and attributes of their occupations. The sculptors of the Gardner Factory used these illustrations for a group of statuettes modeled with slender proportions and set on plain rectangular bases (cat. 104). Other engravings of peasants with idealized features, conforming to the neoclassic fashion of the 1820s, served for statuettes and at the same time for the painted decoration on richly gilded tea sets made with the highest standards of craftsmanship (cat. 103, p. 186).

This tea set, its bright colors and exuberant features typical of Moscow's merchant tastes, was produced about 1830-40 at the Safronov Factory in the Gzhel region, long a center of Moscow ceramics (cat. 117).

The high quality of these products rivaled those of the Imperial Factory in the first half of the nineteenth century, a period of comparative stability dominated by an opulent court. The porcelain industry in general prospered as dozens of new factories sprang up, mainly in the 1830s and 1840s. One of the earliest challenged Gardner's supremacy, that of Aleksey Gavrilo-vich Popov, who took control in 1811 of a factory in Gorbunovo about twenty miles from Verbilki, and remained the director until his death in the 1860s. It then passed from one owner to another at short intervals until it closed in 1875. Statuettes were a staple at the factory as they were at the Gardner (cat. 111). Often both firms used the same models and repeated prototypes in the late eighteenth century thus making it difficult sometimes to establish a provenance and date for a particular piece.

Both Gardner and Popov maintained sales rooms in St. Petersburg and catered to the wealthy court and diplomatic circles in the capital at the same time they aimed to attract a broader range of customers with bourgeois taste and less money. One small enterprise, unusual in that it had no commercial goal, was founded by an aristocrat, Prince Nikolay Borisovich Yusupov, on his estate Arkhangelskoe near Moscow. It was more of a studio than a factory for there were no kilns. Plain white ware was imported to be only painted on the premises with subdued decorative motifs frequently copied from books in the prince's library. The results were not for sale but served as gifts to the friends and family of the owner. When Prince Yusupov died in 1831, the factory was closed.

As the years passed, taste changed and by mid-century the straight lines and plain borders

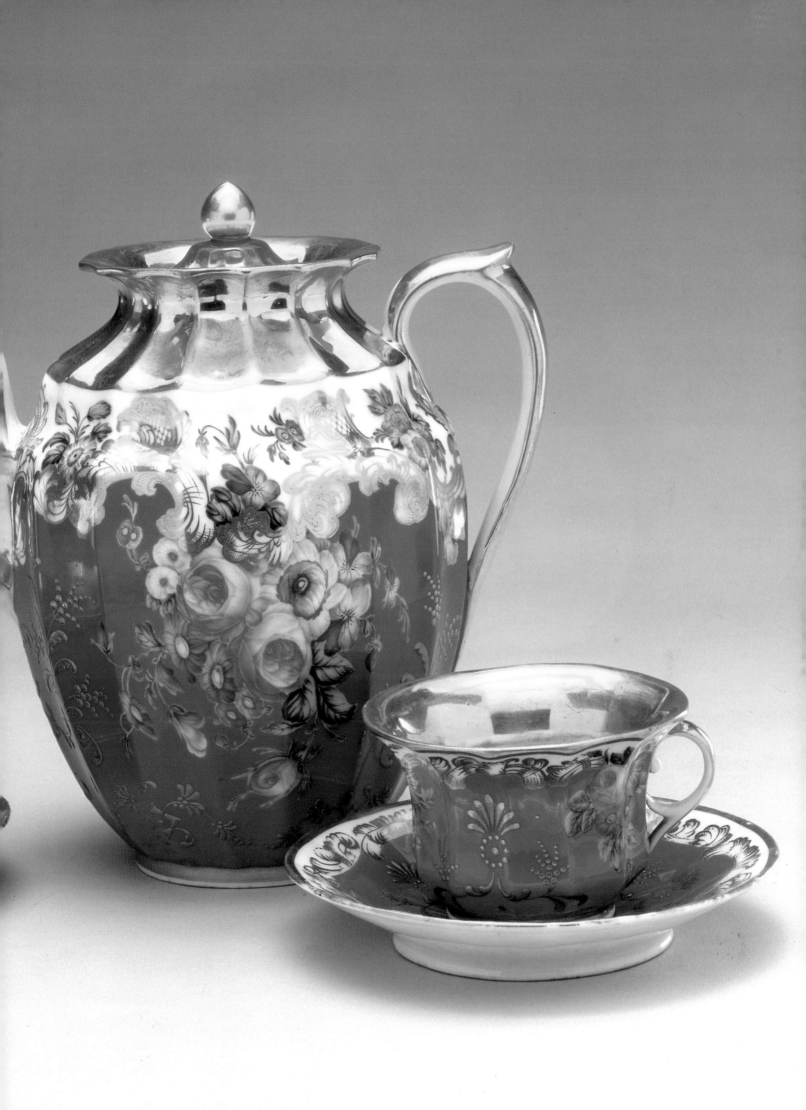

The opening on May 15, 1935, of Moscow's first subway line, seven miles long with thirteen stations, supervised by city party chief Nikita Krushchev, marked one of the greatest construction projects of the 1930s. It is commemorated in a porcelain service, *For the Soviet Metro* (cat. 128).

A concern for vanishing village life and crafts led artists to preserve such scenes in many media—here in porcelain, which found a popular urban market. A Russian village with traditional log houses is surrounded by wheat fields and forests (cat. 119).

of the neoclassic mode gave way to the curves and scrolls of the rococo revival, a change reflected in the wares of all the many porcelain factories of the period. One might single out the names of a few of those located in the Moscow area—Novye, Fomin, Gulin, Safronov, Kudinov, Kiselev.

The majority of the smaller factories ceased production during the second half of the nineteenth century after they lost many of their workers with the freeing of the serfs in 1861 and then were unable to keep up with new technical developments. When the Gardner's fortunes also began to decline it was sold in 1892 to the M.S. Kuznetsov Company. The family Kuznetsov had started out in the porcelain business in 1810 by acquiring a single factory and then in the 1830s and 1840s bought out other plants includ-

ing one in the town of Dulevo in Vladimir Province. By the beginning of the twentieth century the company had become a huge combine with an extensive export business not only to western Europe and the United States but also to the Middle East and Central Asia.

When the imperial regime was overthrown in 1917, the state nationalized the porcelain industry. Kuznetsov's factories at Dulevo and at Verbilki, the old Gardner works, later called the Dmitrov, have been retained as state-owned centers of production in the Soviet Union along with the old Imperial Factory now called Lomonosov.

Around 1900 Russian porcelain reflected the tenets of art nouveau with its sinuous lines. Right after the revolution when the factories were controlled by the workers themselves they

Russia's folk traditions inspired the designs that Petr Leonov, chief artist of the Dulevo Factory, created for porcelain mass production. A cherished folk tale, "The Fisherman and the Fish," is interpreted in this service made for the 1937 Paris World's Fair (cat. 130).

used abstract forms based on the theories of avant-garde movements of the period such as suprematism, cubism, and contructivism. At the same time they incorporated motifs from Russia's art of the past and symbols and slogans fostered by idealists who proclaimed that art should serve the people. However it became apparent around 1925 that the government and the general public did not like abstract art nor understand the aesthetic principles on which it was based.

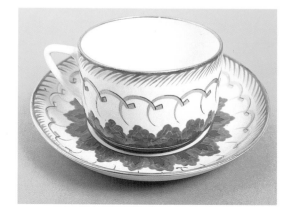

The hammer and sickle—representing industry and agriculture—symbolized the new Communist state. The widely used motif here delicately adorns a cup and saucer from the Dulevo Factory (cat. 124).

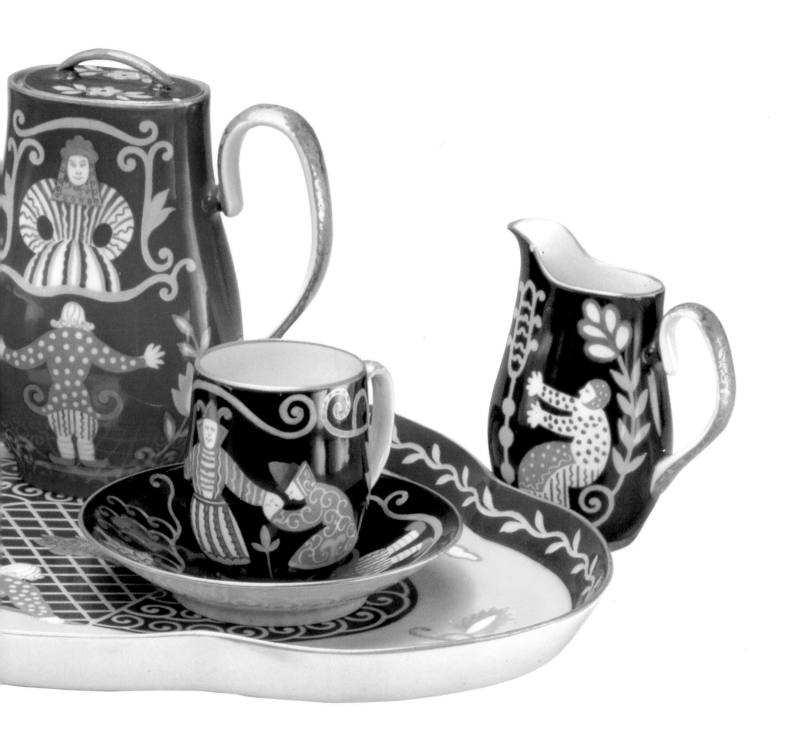

Thereupon artists were directed to represent their subjects realistically. Favored themes on porcelain in the 1930s and 1940s were the buildings of heavy industry as achievements of the Communist regime, historical monuments, heroes of Russia's past, and idealized workers and peasants. Single pieces and small sets were exported widely and sold as souvenirs at international trade fairs. Old fairy tales and flowers and fruit in bold colors were pictured frequently on ornamental vases and other vessels in a manner not strictly close to nature but stylized as in folk art. Shapes tended to be eclectic; echoes of the nineteenth century predominated while the simple silhouettes of the early twentieth century were not entirely abandoned. These tendencies have persisted through later decades with special emphasis on native folk tradition.

Taylor is Curator of the Hillwood Museum, Washington, D.C.

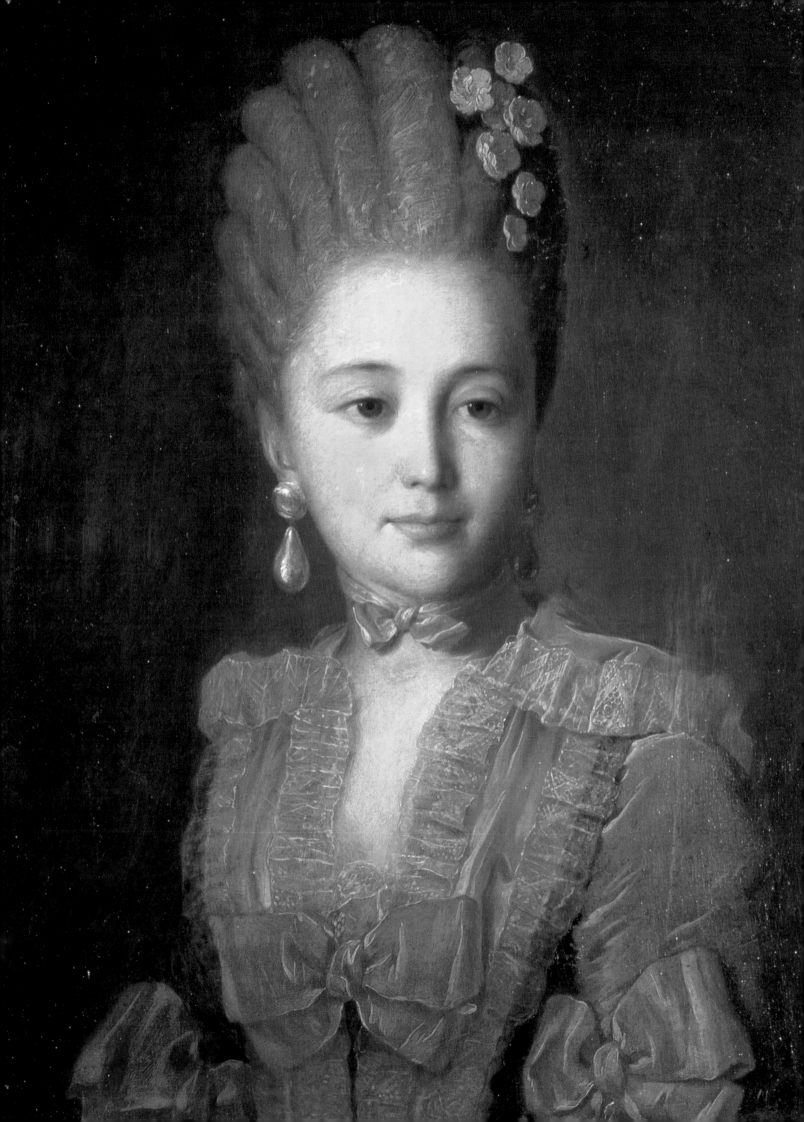

MIKHAIL M. ALLENOV

CAPITAL WITHOUT A COURT

MOSCOW PAINTING, 1700-1910

Up until the eighteenth century, Moscow's role as a unique cultural entity was understandably justified by the mission that any capital of a medieval state was expected to fulfil under the historical and geographical conditions of that time: unification and centralization. It was this mission that made Moscow a central focus of Russia's political and spiritual life. While Moscow may not have initiated all the cultural trends that took root in Russian soil, it certainly served to draw them together. Because of this, to a certain point the development of the Moscow school coincided with the history of Russian art as a whole.

From the beginning of the eighteenth century, this situation changed substantially. Once St. Petersburg became the capital in 1712, Russian culture assumed a completely new orientation. As Pushkin once aptly remarked, St. Petersburg became Russia's "window on Europe." Peter the Great's official arts policy, which advocated the active assimilation of European culture, was a clear departure from the traditional Muscovite legacy.

Thus, not of its own accord, Moscow found itself in opposition to the new capital. The Moscow-St. Petersburg rivalry became the theme of countless essays focusing on the "St. Petersburg period" of Russian history. This theme had a great influence on Russia's quest for national self-determination, a development reflected in the famous debate between "Slavophiles" and "Westernizers." Although this debate did not crystalize into established doctrines until the late 1830s, it created a frame of mind in Russian society from the moment St. Petersburg became the capital. It is important to touch upon the foundations of this rivalry, to get a better understanding of the originality of Moscow's cultural life.

First of all, Moscow was the old and St. Petersburg the new capital of Russia, and it is particularly significant that St. Petersburg was at the same time a newborn city. Moscow, like most medieval towns, had been growing like the rings of a tree, with the Kremlin fortress at the center. While Moscow branched out organically, St. Petersburg was constructed on the basis of a rational, symmetrical plan. The skilled work of compass, ruler, and plummet, which produced the picturesque vistas and facades of St. Petersburg, clearly had no hand in the development of Moscow's uneven landscape and whimsically winding streets. While Moscow was firmly planted in the heart of the Russian land, St. Petersburg was hanging on the mouth of the Neva River, symbolizing Russia's rise as a sea power, a status Peter the Great earned through

his successful naval campaigns during the Northern War. While Moscow was characterized by its cupolas and hipped roofs, the main feature of St. Petersburg was the spire of the Admiralty, rising above the city like a ship's mast over the surface of the sea.

Although Moscow was not a planned city, the artisans who built it were clearly inspired by the architectural monuments of ancient Russia, which held a sacred place in Russian customs and traditions. The builders of St. Petersburg, on the other hand, drew upon western models of construction. With the mirrored effect produced by the Neva River and its network of canals, St. Petersburg was modeled after such famous waterfront cities as Amsterdam and Venice, becoming known as "The Venice of the North."

This image of St. Petersburg was embodied in the works of F. Alekseyev (1753-1824), a Russian painter who studied in Venice (1773-77) and learned the traditions of Venetian *veduta* painting. Upon his return to Russia, he became

known as the "Russian Canaletto," because he portrayed St. Petersburg through the prism of his impressions of Venice. Though less apparent, the Venetian influence also affected his paintings of Moscow. While St. Petersburg appears in his works to be suspended between sea and sky, Moscow is deeply rooted in the earth. Its walls spring from the hillsides like an extension of the land itself.

Alekseyev's works also highlight another notable feature of Moscow's genius loci that distinguished it from St. Petersburg. This is Moscow's sense of interiority. While some of his Moscow panoramas are painted from the perspective of an outside observer, a significant number of them portray Moscow "from within," as if the viewer were surrounded by the city walls (cat. 162). In contrast, he portrays St. Petersburg at a contemplative distance and from the front, its architectural facades solidly dominating the scene. This image supports Pushkin's portrayal of St. Petersburg as a "window" in Russia's fa-

As interest in Moscow history and architecture grew, Fedor Alekseyev, by order of Paul I, painted more than a hundred watercolors of the city between 1800-02. The Kremlin received special attention. This painting (cat. 162) depicts the Bell Tower of Ivan the Great with the newly rebuilt Kremlin Palace to its left; new stone-lined embankments (seen through the arch of the Stone Bridge, built 1687-91) contrast with the old log retaining walls (foreground).

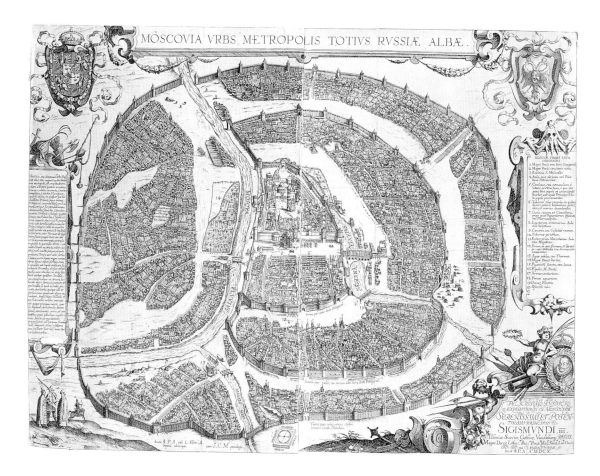

Moscow's expanding rings of fortification—the Kremlin, 1485-95; Kitai gorod, 1535-38; White City, 1586-93; and Skorodoma gorod ("Quickly Built City"), 1591—are seen on this rare engraved "Sigismund" map published in Augsburg in 1610. Based on a plan drawn up shortly before by order of Tsarevich Fedor Godunov, it accurately depicts the streets and buildings of central Moscow (cat. 143).

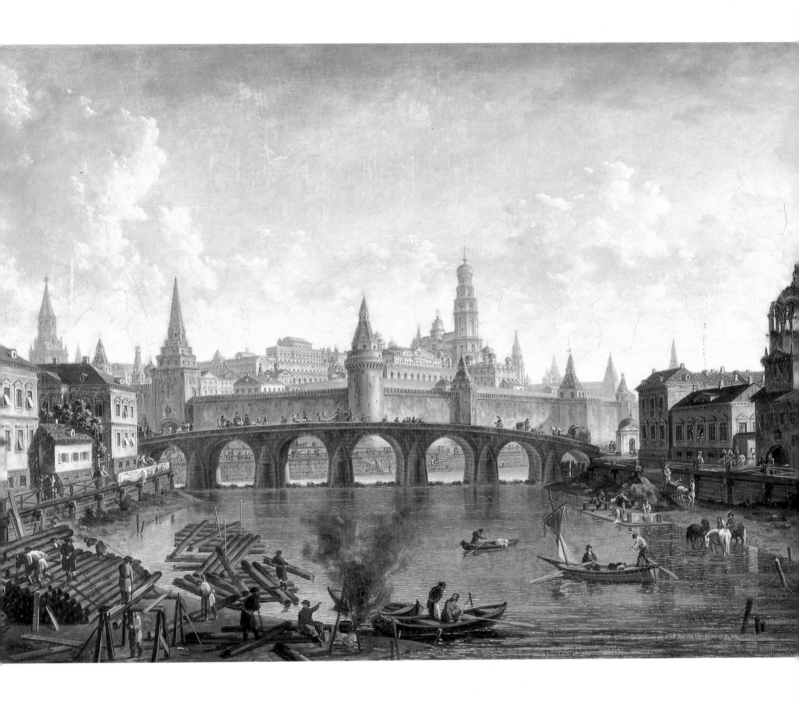

cade, to be admired by the European world from a distance. Further developing this metaphor, Moscow could then be compared to a "door" leading to Russia's interior, particularly since St. Petersburg existed on the perimeter of Russia, whereas Moscow sat solidly in the center. As Pushkin wrote, St. Petersburg was the "antechamber" and Moscow the "living room" of the nation.

As time went on and St. Petersburg began to acquire its own specific character, Moscow became more and more a capital "in retirement." The coronation of Russian monarchs still tradi-tionally took place in Moscow, in the Kremlin Cathedral of the Assumption, but the apparatus of court and state was now in St. Petersburg. In Moscow, popular interest turned inward, with everyday life and customs centering increasingly on events within the home. Private mansions began to dominate Moscow's architectural ensemble, in contrast to St. Petersburg's proliferation of official buildings. The owners of these mansions enjoyed comfortable lives and designed their homes like country estates, with large courtyards, many wings, servants' quarters, and a main gate. A brilliant example is the

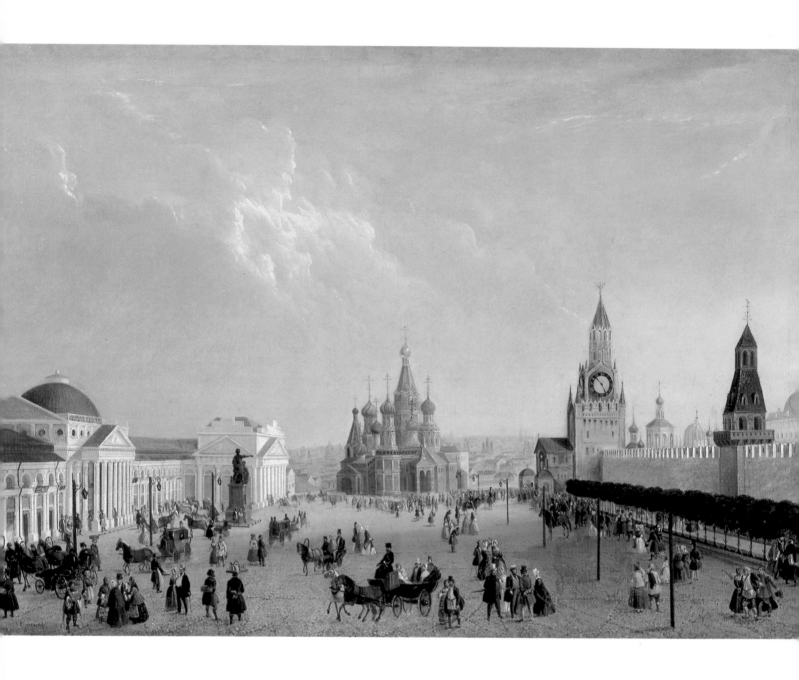

stately classical residence of P.E. Pashkov (now the Lenin Library), which crowns a hill not far from the Kremlin.

Moscow's hierarchy of values allowed a mixing of private and public life. This is evident in the layout of Bolshoi Theatre Square. Completed in the 1810s according to a strict plan, the prominent central square was lined with private houses rather than official buildings. This would have been unthinkable in St. Petersburg.

In the huge fire caused by Napoleon's invasion in 1812, Moscow lost over half its buildings. This vacuum allowed classical architecture to be introduced into Moscow's characteristically me-

dieval profile. But even as Moscow architects incorporated classical elements into the reconstruction, they strove to retain the original flavor of the former capital. In 1814 Red Square was rebuilt according to O.I. Bove's plan. The Kremlin walls and towers and the facade of St. Basil's Cathedral, previously blocked by commercial buildings, suddenly became visible in all their splendor. The newly renovated Trade Building, a distinctly squat structure with strong horizontals and gently rounded cupolas, provided a striking contrast to the soaring verticals and pointed roofs of the Kremlin towers. The building's main cupola stands directly opposite the

cupola of the Senate, located behind the Kremlin wall; together, the two form an axis across Red Square.

Along this axis stands a monument to Minin and Pozharsky, who in 1612 liberated Moscow from Polish and Swedish invaders (cat. 116). Minin points toward the Kremlin—"the altar of Russia" in the words of Lermontov—and gestures to his wounded comrade in arms to make the final effort to liberate Moscow from its enemies. Because of the position of Minin's extended arm, from a certain perspective he appears to be holding the Kremlin cupola in his palm. This monument, constructed with the aid of community donations, was conceived in 1804. Its construction continued throughout the Napoleonic invasion and Russia's victory in 1812—a full two centuries after Minin and Pozharsky's successful campaign in 1612—and was completed in 1818. Centrally situated on the Kremlin's main axis, the monument accentuates the key role of the Kremlin in Russia's past and present. In this context, Minin appears to be reaching out from the past and proclaiming,

"Long live the Kremlin now and forever onwards," upholding it as a sacred, incorruptible, and indestructible place.

In St. Petersburg, the main symbols of power were official buildings and palaces. In Moscow, it was the nation's first university—Russia's bulwark of independence and freedom of thought—that captured the pride of the people. A decree of 1755 gave some of the reasons why Moscow had been chosen for its site: 1) The city's large number of people from diverse walks of life; 2) The central position of the city, within reach of many parts of Russia; 3) Students' required expenses would be relatively low in Moscow; and 4) Most students would have relatives or friends in the city who could provide room and board.

The university's role was particularly significant during the rule of Nicholas I, called the "Iron Winter" by F.I. Tyutchev. A graduate of the university, A.I. Hertzen, described its significance this way:

The growing importance of Moscow University was linked to Moscow's rise in stature after 1812.

Following the Napoleonic invasion of 1812, a sculptural monument of Minin and Pozharsky—defenders of Moscow against Polish invaders in 1612—was raised in Red Square. Here, the legendary heroes are shown in painting and porcelain (cats. 163 and 116).

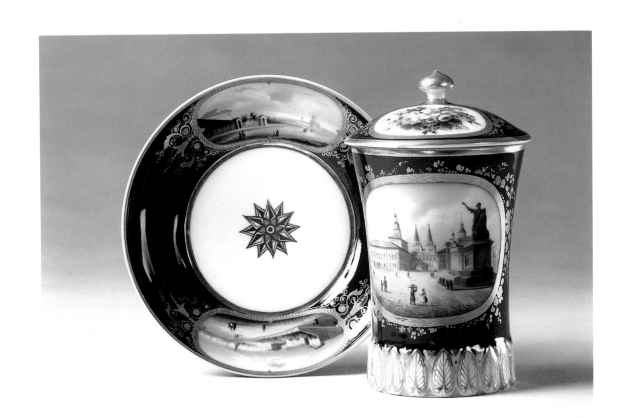

Deprived by Peter the Great of its status as capital, Moscow was again made the "capital" of the Russian people by Napoleon, although it was certainly not his intention. Once the Russian people got word of Moscow's occupation by the enemy, they realized how dear Moscow was to their heart and how strong their blood ties were. Thus, a new era began for Moscow. Moscow University became the educational capital of the Russian people. All the conditions for its success were there: the historical significance of the area, the geographical position, and the absence of the Tsar. The awakening of the minds in St. Petersburg following the death of Pavel came to a gloomy end on December 14 [the 1825 Decembrist revolt]. This was a setback for those seeking action. Their repressed ambitions continued to bubble within, however, and the University was the first place they were able to take shape.

The situation was different in the artistic domain. In 1757, almost concurrently with the establishment of Moscow University, an academy of arts was founded in St. Petersburg. Its orientation was on the European art academies and for nearly a century it was the only center in Russia for the training of professional artists, including architects, sculptors, and painters. Not until 1833 was a class of painting organized in Moscow, which in 1843 expanded into an institute of painting and sculpture.

Thus the character of Moscow's cultural world was a result not only of the city's own traditions but also of the European trends flowing into Russia through the "window" of St. Petersburg. This new status quo gradually replaced the medieval mindset and from the early eighteenth century framed the development of the "Moscow school." Its characteristic features were a diversity of styles and a reappearance of elements from an earlier period, traits that did not weaken the work but instead gave it its distinct quality. Innovation, especially if it threatened

the usual order of values, was rejected until it could be reconciled with the traditional way of life and blend comfortably with the established customs.

The delayed acceptance of artistic trends penetrating from St. Petersburg prolonged transitional forms, genres, and styles in Moscow. One such genre, which exerted a lasting effect on portrait painting of the eighteenth century (particularly in the provinces), was the *parsuna,* a distorted pronunciation of the word "person." The

first examples of this genre were produced by masters from the Kremlin Armory.

It was quite difficult for the Russian masters, who had grown accustomed to the traditions of icon painting, to adopt a new style based on illusive, three-dimensional representation. Portraiture was particularly difficult, since its very concept was completely alien to the artistic consciousness of medieval Russia. An icon depicts something not of this world; a three-

Vasily Tropinin, a serf of Count Morkov, was sent to study art in St. Petersburg, but returned to paint in Moscow, gaining his freedom in 1823. He is best known for his intimate portraits of Moscow gentry and sympathetic scenes of working life. Tropinin's portrait of Ekaterina Sisalina embodies his concept of beauty and inner harmony (cat. 167).

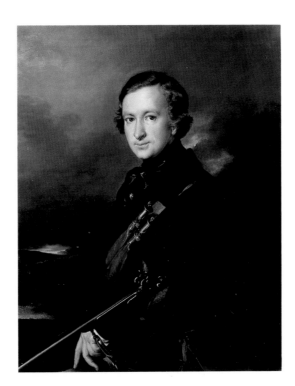

dimensional painting portrays something that can be seen and touched.

The parsuna's distinctive look comes from its combination of the icon's impersonal, static image with the portrait's animated features, gestures, and poses. The parsuna reflects the eternal problem of the dual nature of human beings, torn between the physical and the spiritual. Russian poet G.R. Derzhavin expressed it in the phrase: "I am a tsar, I am a slave; I am a worm, I am God himself." References to this dualism appear in the works of A.P. Antropov, a portrait painter of the middle of the eighteenth century.

Russia's art and architecture experienced the same stylistic stages as did Europe's—baroque, rococo, classicism, sentimentalism—gradually gaining speed and catching up with the West. But the trends coming from St. Petersburg had to pass the test of the individual Muscovite, who judged them on the basis of their relation to his everyday, private life. This created some unexpected results in the realm of art, and produced some masters in Moscow who surpassed the St. Petersburg artists.

Such was the case with F.S. Rokotov, an outstanding portrait painter from Moscow who graduated from the St. Petersburg Academy of Art in 1766 but returned to Moscow to paint his best portraits. *Portrait of A.P. Sumarokov* (the poet and playwright) and *Portrait of a Woman in a Blue Dress* (cat. 157, p. 178) typify his style. Rokotov portrayed his models in an atmosphere of absolute trust and intimacy. In his portraits, the soft, pervading light and shimmering texture add a subtle and elusive tone to the figures, as if they were the living spirits of a vivid memory. It appears that the slightest touch of the brush could frighten the images away from their dark backgrounds. Rokotov was the first Russian painter who, while staying within the bounds of Russian art traditions, nonetheless managed to capture the form of a chamber portrait, and in so doing was a forerunner of the aesthetics of sentimentalism.

Later, in the first half of the nineteenth century, one can see a different situation in the works of Moscow portraitist V.A. Tropinin. In this period of romanticism he retains some elements of the rococo style and certain aesthetics of sentimentalism (cats. 167 and 168). Tropinin's portraiture, which was largely influenced by the atmosphere of Moscow life, is best examined in contrast to works of his contemporary, O.A. Kiprensky, the first Russian romantic painter. Both artists painted Pushkin, "the sun of Russian literature," in 1827.

Kiprensky's portraits conveyed the feeling of fresh air bursting through an open window and carrying sounds from afar that make the soul rejoice or even tremble at the approach of something new. Kiprensky's Pushkin is always on guard, prepared for an emergency. The portrait

by Tropinin is quite different. Pushkin wears a wide dressing gown and appears gentle and slightly absent-minded. The portrait emanates a quiet, warm, amber light that calms the soul.

Tropinin could be regarded as the precursor of "genre painting," although that form had not yet taken root in Russia. His sentimentalist world view is evident in his attempts at genre painting, which depict a peaceful and idyllic life, free from the buffeting winds of romanticism. Tropinin's hero was not a warrior in "the battle of life," but a true homebody, which is not surprising in view of Moscow's social environment at that time.

While St. Petersburg strove to achieve a European standard of cosmopolitanism and to symbolize the urban ideal to the rest of Russia, Moscow became increasingly provincial and was even satirically dubbed "a big village." Moscow's "provincialism" meant more than just a lack of cosmopolitan gloss and fanfare, but also expressed a general distaste for St. Petersburg's bureaucracy, despite the civility of its officials. Moscow remained the capital of the Russian provinces and had close connections with the rest of the country, whereas St. Petersburg was quite alien to it. When in 1868 the young V. Surikov, who later became quite famous for his historical paintings, stayed in Moscow en route from his native Siberia to the St. Petersburg Academy of Arts, he admitted that Moscow was just the place for "sharing his Siberian impressions." When V.D. Polenov (a resident of St. Petersburg and graduate of the Academy of Arts) moved to Moscow, his first important work there was the painting *A Little Yard in*

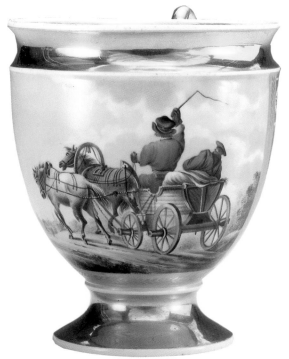

In the 1820s, the scenes of rural life that attracted Venetsianov appeared in popular prints as well as fine porcelain, such as this Empire-style service from the Gardner Factory (cat. 103).

Moscow, which depicted a typical Moscow "landscape interior" indistinguishable from thousands of similar places in provincial towns, country houses, and villages of Russia. A newcomer to Moscow, Polenov demonstrated his allegiance to its artistic traditions by comparing the features of Moscow to provincial landscapes.

Genre painting and the closely related practice of interior painting became established in Russia rather late, at the end of the 1830s. Two main trends developed within Russian genre painting—the rural idyllic poem (as represented by A.G. Venetsianov) and the urban satirical drama (as represented by P. Fedotov).

Venetsianov, the father of Russian genre painting, depicted peasants in the small village where he lived in Tver Province, located between Moscow and St. Petersburg. He portrayed the saga of their everyday life and endless labor. The peasants' clothing and rural scenery in his paintings contain little to indicate the historical period depicted; thus there is an element of timelessness. The works could equally represent either ancient Russia or Russia in the nineteenth century.

In contrast, Fedotov conveyed dramatic

*T*he *Podklyuchnikov Gallery of Art* portrays the artist in his Moscow apartment with friends, family, and some of the two hundred artworks in his collection. Son of a serf portraitist, Podklyuchnikov was granted his freedom in 1839, after his studies at the Moscow Art School. Deeply interested in Russian antiquities, he also restored major icons and paintings (cat. 171).

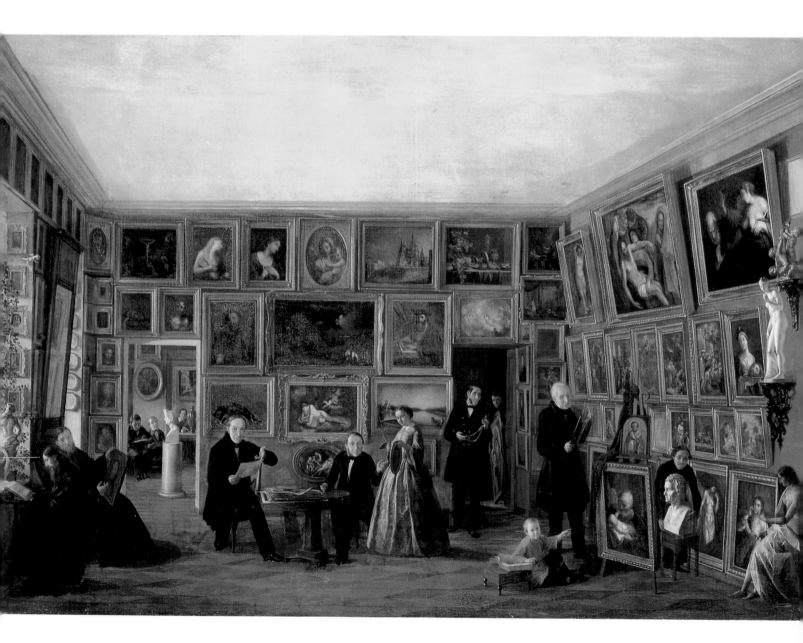

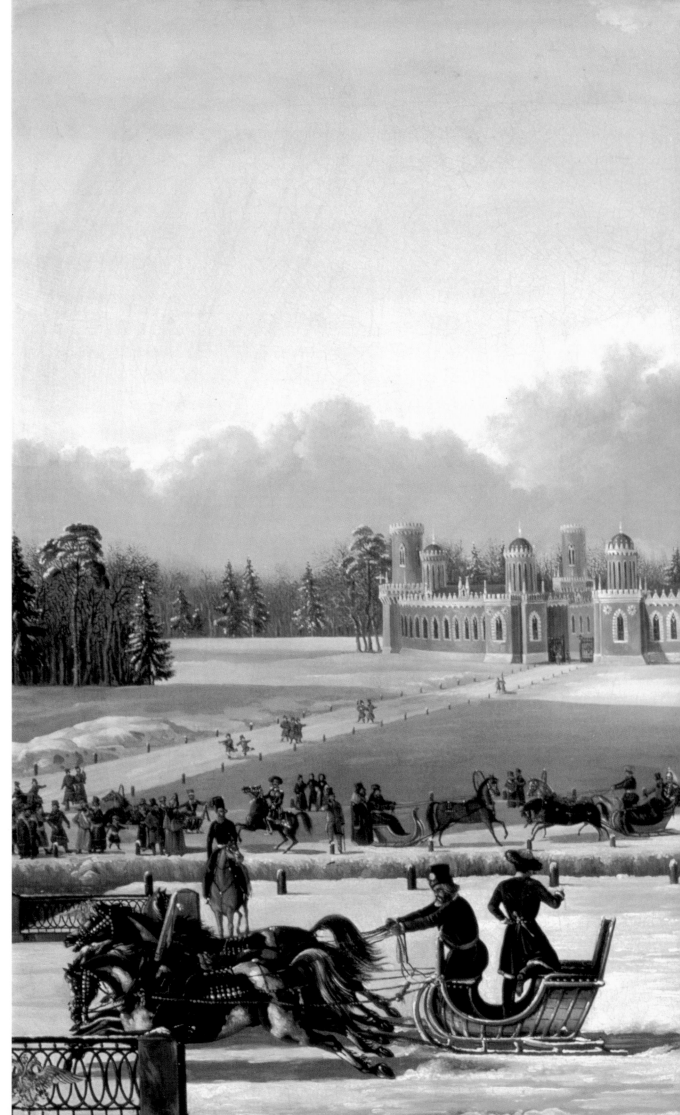

Petrovsky
Palace, built by
Catherine the
Great, served as
the final stop on
ceremonial visits
to Moscow from
St. Petersburg.
Surrounded by
large, formal
parks, by the
1840s it had
become a popular
setting for
promenades,
trotting, and
troika sleigh
races. In style,
this festive
painting by
Golitsyn resem-
bles popular
prints of the
day (cat. 166).

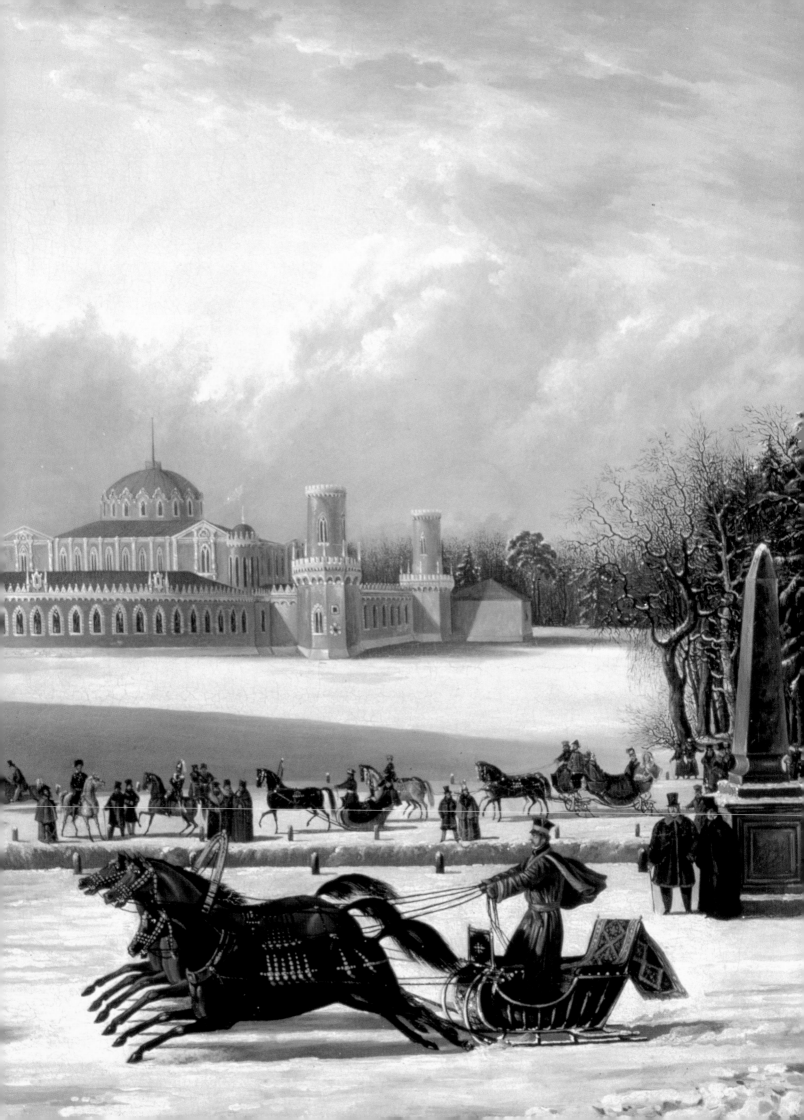

It was the custom for wealthy worshippers on pilgrimage from Moscow to the Trinity-St. Sergius Monastery to stop for tea in the village of Mytishchi, famed for its water. Perov's *Tea-Drinking in Mytishchi* condemns the ingratitude of the clergy and the Russian government; he portrays an incapacitated veteran of the Sebastopol campaign who, wearing the Order of St. George, must beg for charity (cat. 173).

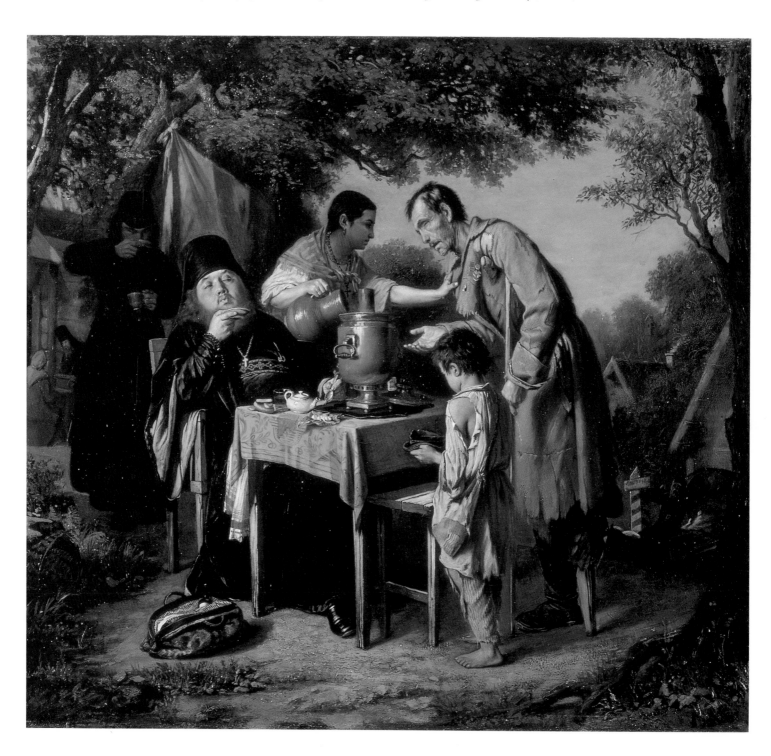

action against an urban backdrop, and his figures have a tragicomic appearance. However, both Fedotov and Venetsianov shared themes inspired by Rousseau's philosophy of the "noble savage," in which nature opposes civilization. This is not at all surprising in view of the fact that both artists were born in Moscow and left it for St. Petersburg as adults. Fedotov acknowledged that his youthful impressions of Moscow greatly influenced his artistic approach.

Thus, the difference in style between the Moscow and St. Petersburg schools was not so much a product of the different environments in and of themselves. The Moscow ideal emphasized the comforts of life and the warmth of human relationships. As a result, class-based prejudices were less pronounced in the Moscow works as compared to those of St. Petersburg, an observation borne out by Rokotov and later by Tropinin. The St. Petersburg school portrayed a world in which false ideas and artificial passions enslaved people and drove them to seek power over others. Rousseau's noble savage disappeared behind a mask of class distinctions like an actor enveloped by his role.

During the second half of the nineteenth century, it was common practice in genre painting to dramatize scenes from life as in the theater, in compositions filled with many "characters." But as this approach became more popular throughout the country, it lost its novelty and became clichéd. The social situation in Russia in the early 1860s contributed considerably to the growth of this style and of genre painting in general. In 1861, serfdom was finally abolished, and this was an indirect admission by the tsarist government that its former policies were clearly incompatible with modern-day realities. As a result, society in general and artists in particular turned to a more realistic and often critical portrayal of life. It was only natural that genre painting met these demands better than any other type of art. Thereafter it strove to be as life-like as possible,

to portray everyday experience at close range.

However, the realism of genre painting was not as impartial as the lens of a hidden camera and in fact involved a certain amount of stage-setting. This contradiction, of which the artists themselves were seldom aware and which at times created a certain humor, is typical of the genre painting in the second half of the nineteenth century, represented in this exhibition by the works of V. Makovsky and V. Baksheyev (cat. 176, p. 49, and cat. 188, p. 53).

The contradiction reaches its fullest expression in the works of the greatest master of the critical genre, Moscow artist V.G. Perov. His painting *Tea-Drinking in Mytishchi* (cat. 173) portrays a blind veteran of the Crimean War who is missing one leg and who, accompanied by a boy guide, begs for charity from a priest who is taking tea. The scene takes place in Mytishchi, a suburb of Moscow.

The artful composition and masterly technique call attention to the rhetoric of the painting; at the same time, a sense of verisimilitude suggests "and so it happened." This artistic tension plays a dual role: even as the act of portraying the scene is revealed as artificial, the viewer is encouraged to accept this artificiality as a natural part of life. Perov did not invent this idea; it exists in everyday experience, such as when someone carelessly tells a joke at the wrong moment.

Thus Perov seems to color every sad, serious, rude, banal, and even scandalous incident with his sarcasm. In *Tea-Drinking in Mytishchi* he grouped his figures quite evenly in the center, by making their natural poses and gestures part of a circle framed by the timber coulisses and set against a pastoral, rococo landscape. At the upper part of the circle, a woman tavern-keeper pushes away an aged and incapacitated soldier. The shadows beneath the woman's eyes make her appear blind—symbolizing both a physical and moral handicap—and her superficial beauty

With the publication of his short stories in 1901 Leonid Andreyev became a famous and controversial figure—lionized by critics for his forthright examination of dangerous subjects, suspected of revolutionary sympathies, and attacked by Countess Tolstoy for his frank treatment of sex. Repin, whose studio was not far from the Andreyev home on the Gulf of Finland, mirrors the vitality and intensity of the era in this portrait of his friend (cat. 185).

takes on an uglier hue than the disfigured face of the old soldier.

The bottom edge of the circle is composed of the legs of the stool and the table as well as the wooden legs of the soldier. The tactful design contrasts powerfully with the tactless social situation. Thus the painting questions the very idea of "harmony"—both in composition and in life. Perov's realistic style presupposes that the viewer will accept every fact on the canvas, including the symmetrical grouping, as true-to-life. This was the "living theater" aspect of his work, which presented life as it really is—banal, indifferent, cruel, and light-hearted all at once. Simultaneously, the picture-postcard splendor imposes an elegance on this scene that is most inappropriate. Perov meant for the incongruity to challenge the viewer's artistic *and* moral sensibilities. *Tea-Drinking in Mytishchi* is a kind of criticism through art, which transcends even the artwork itself.

The sharply critical orientation that art adopted during the 1860s was influenced by the surrounding atmosphere of social optimism, which encouraged society to eradicate its evils by exposing them. This became all the more true as the government itself began to initiate reforms. It seemed that a single beam of light was sufficient to illuminate the dark corners and alleys of life. While the truth freed the consciousness of burdensome and inert forms of thought, it took much longer for emancipation to have any effect on real life. Everyone felt that the autocracy was quite late in enacting reforms, and by the end of the 1860s its refusal to carry out radical changes had undermined the former sense of optimism. The critical attitudes gave way to a sorrowful

recognition of reality. The generation of "disappointed expectations" projected a joyless existence without sun, warmth, or shelter, an image that influenced Russian art for many years. This view is easily recognizable in V. Makovsky's *The Doss House* (cat. 177, p. 50).

People began to ask themselves what they could believe in, what could inspire them, what they could they live for. These were major themes in the art of the 1870s. They became even more pertinent than the critical approaches of the 1860s because, to put it simply, they asked the question "What is of value in this life?" This new orientation characterized the period of mature realism in the second half of the nineteenth century.

In 1870, the artists of Moscow and St. Petersburg joined together in a new artistic group, the Association of Traveling Exhibitions, known as the *Peredvizhniki,* or Wanderers. The Moscow artists proposed that the exhibitions travel not only to major cities but also to the provinces, thus reaffirming the indissoluble connection between Moscow and provincial Russia. Nearly all the great Russian artists of the time participated in the association. Despite the diversity of the works exhibited, all were based on the Wanderers' aesthetic platform: "nationalism, populism, and realism." The main achievements of Russian art during the second half of the nineteenth century were based on a realistic portrayal of everyday life, despite the delusory nature of this notion. A similar phenomenon appears in the literature of Turgenev, Tolstoy, and Dostoevsky and in the music of the "Mighty Handful," most of all in the work of Mussorgsky, which drew on the intonations of prosaic conversational speech.

The greatest masters of realist painting during the second half of the nineteenth century were I.E. Repin and V.I. Surikov. Their most prolific period was the 1880s. The popular critic of that time, V.V. Stasov, called Repin "The Samson of Russian Painting." He excelled as a portrait artist, and was a master of genre and historical painting. And yet it is not so important to categorize him. His significance lies in his ability to interrelate different genre forms in works uniquely his own. In this manner he applied the effects of "plein air" painting to portraiture, striving to capture every moment as unique and to focus exclusively on a particular place and time.

V.A. Serov, one of Repin's pupils, was a key figure in Russian art at the turn of the century. Serov breathed new life into the traditional aristocratic full-dress portrait; he suddenly became quite fashionable. In his portraits of the nobility, Serov ironically combined the ostentatious "chic" of salon painting, tinged with art nouveau, with a precise facial representation inherited from Repin.

Serov often imbued his figures with symbolic meaning. His sharply realistic portraits captured the core of the sitter's personality, but also drew upon the subject's carriage and attitude to create a symbol that transcended psychological insight. In a portrait of an aristocrat there is a feeling of immeasurable distance—imposed by his position—from the world of simple mortals.

As in his portrait of Golitsyn, Serov took inspiration from the model's attitude toward the long sittings (usually several of them) and toward the artificial setting required for a full-dress portrait meant to establish a social image.

Moscow's history greatly influenced the themes of many artists, Surikov first among them. Upon graduating from the St. Petersburg Academy, he settled in Moscow, whose very walls chronicle Russian history. In the 1880s, Surikov created a series of paintings devoted to the transitional upheaval between the Moscow period and the St. Petersburg period in the late seventeenth and early eighteenth centuries. These paintings include *Morning Execution of the Streltsy* (1881) and *The Boyarynya Morozova* (1887).

The Boyarynya Morozova was undoubtedly the peak of Surikov's creative output. It reflects one of the most important turning points in seventeenth-century Russia, an event similar to the Reformation in Europe. When the state imposed reforms on the Russian Orthodox Church, an opposition group emerged called the *Raskolniki* (or schismatics); the boyarynya Morozova was one of the most active among them. This painting depicts the moment when the disgraced boyarynya is being carried on a sledge along a Moscow street; she is either going to the Kremlin for interrogation or leaving the Kremlin for the prison where she has been sentenced.

Surikov focused on the end of the medieval period in Russia, when the bonds of the old faith had not yet been torn asunder but had been weakened. In Surikov's artistic consciousness, the term *raskol* (schism) was not just an historical notion, but quite pertinent to contemporary events. Surikov's own life, forged in a remote Siberian village and imbued with the strong patriarchal influences typical of those regions during the 1880s, imparted upon him a truth that was essential to historical painting: that historical turning points are not isolated moments but rather take place within the constant flow of history. All the figures in Surikov's canvases of the

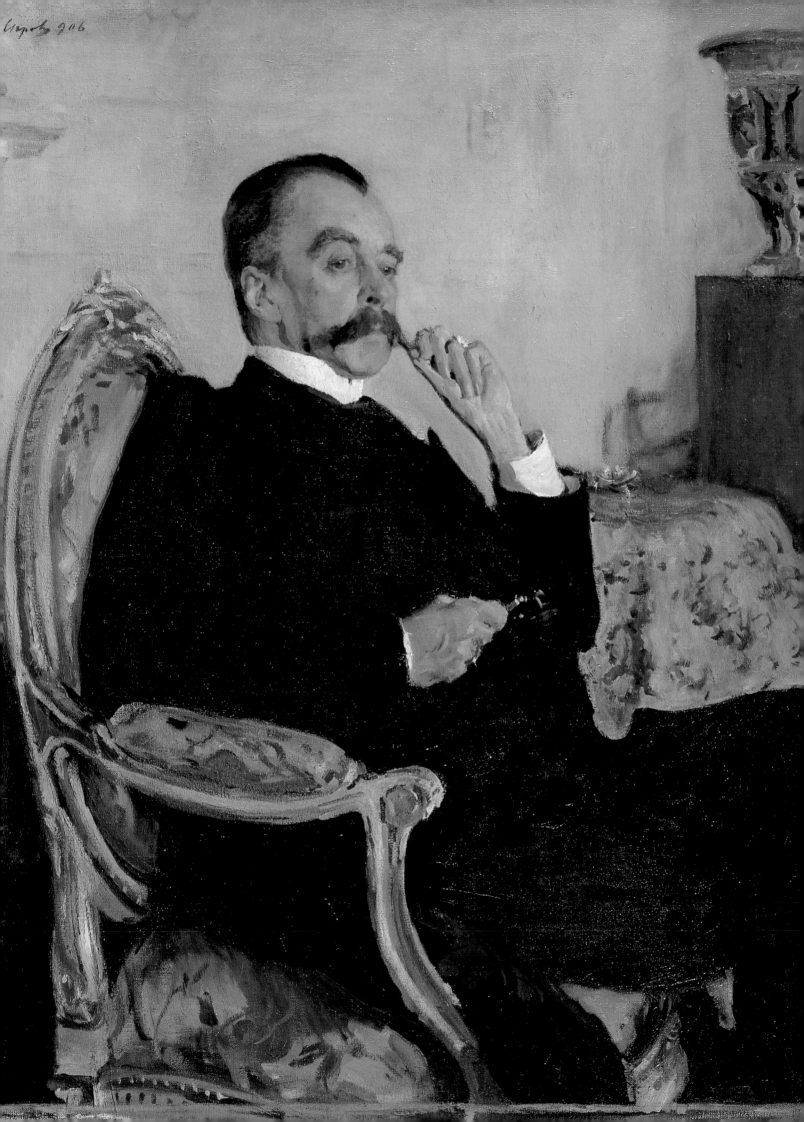

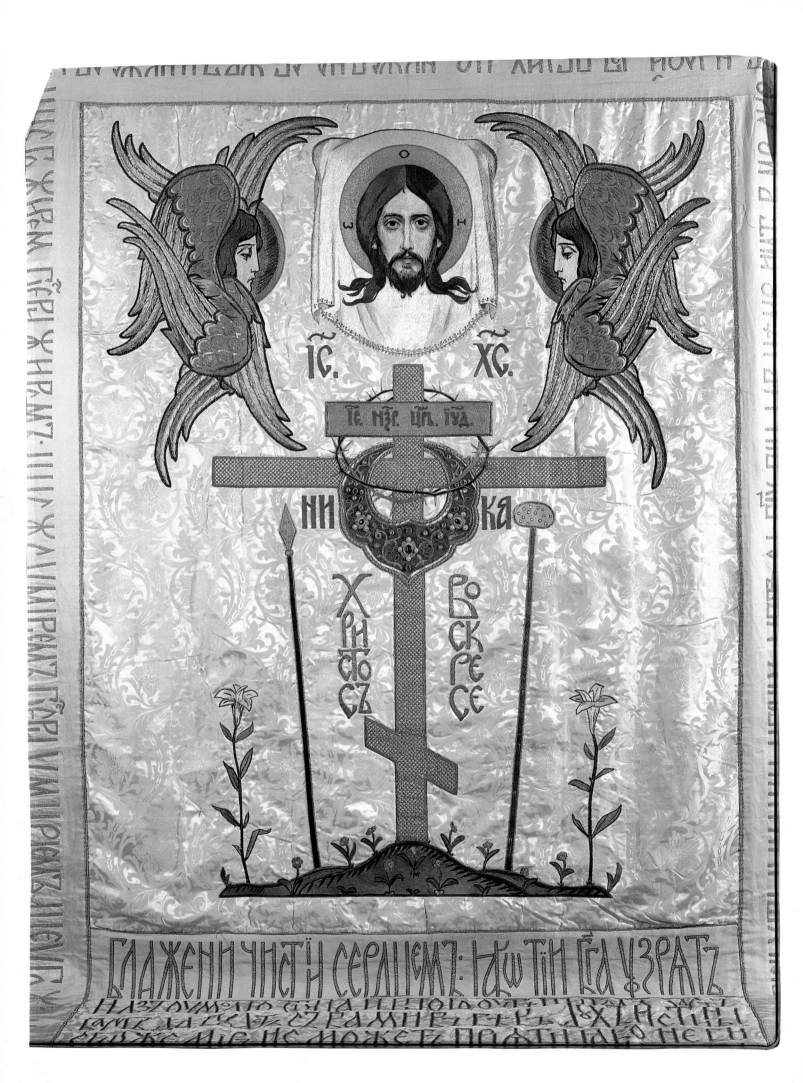

The neo-Russian style, popularized by Viktor Vasnetsov, found widespread application in the decorative arts. His 1889 painting, *The Tsarevich Ivan on the Grey Wolf,* is reproduced in enamel on the Fabergé box with filigree ornamentation (cat. 68).

Donated by art patrons and artists including Vasnetsov (who may have been its designer), the shroud (left) was sewn by the nuns of the Assumption Cathedral for the tomb of Grand Duke Sergey, assassinated in 1905 by a revolutionary (cat. 74).

1880s are in some way standing before an abyss, be it psychological, physical, or compositional. The tribulations of someone on the verge of this abyss are essential elements of the tragic in his art. The same theme appears in Surikov's later work, *The Visit of the Tsarevna to the Convent* (cat. 186, p. 28), but here the spirit is milder and more lyrical, devoid of dramatic conflict.

In the 1890s, a legendary version of history based on traditional epics and folksongs began to replace historical fact in Surikov's works. V.M. Vasnetsov pioneered this trend in his painting *After the Battle Between Igor Svyatoslavich and the Polovetsians* (1880), which depicted the most famous work of ancient Russian literature, *Song of Igor's Campaign*. This painting was followed by a series of compositions inspired by fairy-tales: *The Three Princesses of the Underground Kingdom* (cat. 181, p. 110) and the monumental canvas *The Bogatyrs* (1898), which depicts the beloved heroes of the Russian chronicles.

This trend took root among a group of artists who had gathered around S.I. Mamontov, a manufacturer and patron of art, and who met regularly at his suburban estate, Abramtsevo, outside of Moscow. The Abramtsevo circle defined the national character of art differently than did the artists of the 1860s. The Wanderers had tied it to a sympathetic narration of the life of the peasants; the Abramtsevo circle saw it as a revival of national spirit in modern art marked by the assimilation of features of folk art. These artists collected cottage handicrafts and organized private workshops to study the decorative motifs of peasant art—in textiles, toys, and wood carvings. This same aesthetic also led to the pseudo-Russian architectural style of the late nineteenth century. The facade of P.M. Tretyakov's gallery in Moscow (1900-05), designed by Vasnetsov, is a monument in this style from his architectural oeuvre.

Mamontov's circle was also associated with the most outstanding master at the turn of the century, M.A. Vrubel. His work is the first and most vivid manifestation of symbolism in Russian art. Vrubel's repertoire of subjects consisted of "eternal" themes and images linked to a host of historical and cultural associations: Hamlet, Faust, the demon, fairy-tales, and mythological and folklore motifs. Vrubel's fantasy permeated his literary, theatrical, and musical works as well. He worked quite often as a decorator for Mamontov's private opera theater in Moscow, where Fedor Shalyapin made his debut. Vrubel's distinct style drew upon the technique of breaking down forms into sharp fragments, giving them a crystalline appearance. The colors of the painting were like rays of light refracted through the crystal exterior. *Demon* (1890), which was painted in this way, is an excellent example of his artistic transformation of reality.

Vrubel was the most consistent romanticist of his time, incorporating in his paintings the cult of the night, which was typical of romantic tradition. Vrubel's love of water poetry, as embodied in the operas and symphonies of Rimsky-Korsakov, was reflected in his majolica sculptures with their intricately undulating features and silhouettes. Their lustrous surface glitters with patches of sunlight and a rainbow spectrum, a visual counterpart to Rimsky-Korsakov's colorful orchestration.

Several factors of Moscow cultural life in the second half of the nineteenth century gradually changed the city's relationship to St. Petersburg. In 1843, the Moscow College of Painting and Sculpture had replaced the former School of Arts. The new college was more liberal than the St. Petersburg Academy, less prone to pedagogical conservatism, and more in touch with progressive elements in the arts. In 1856, P.M. Tretyakov began to develop his collection in Moscow. Opened in 1892, it became the most comprehensive collection of the national school of painting of the 1880s and later periods.

Mikhail Vrubel was attracted to sinuous form, and to the luminous color and light of Byzantine mosaics. Akin to European symbolism, his works are intensely expressive. Vrubel's study with Serov brought him to the colony of artists at Abramtsevo, where— among works in other media—he created unique majolica sculptures. *Spring* was inspired by the Rimsky-Korsakov opera *The Snow Maiden* (cat. 229).

Intimately familiar with *The Artist's Studio,* Prianishikov was a founding member of the *Peredvizhniki* and taught in the Moscow School of Painting from 1873-94. About his work, critic Stasov commented "what a real Russian painting it is . . . true, sincere, . . . no pretense, everything is Russian here as it is in actual reality" (cat. 178).

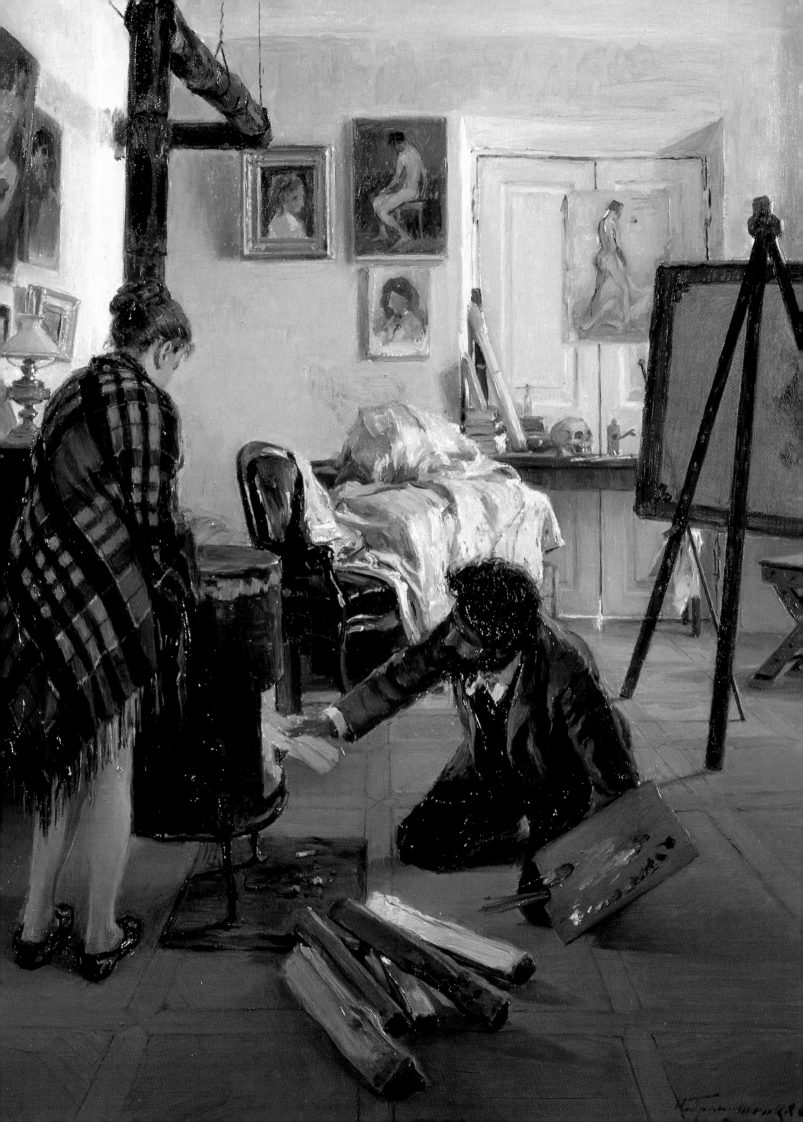

Aleksey Savrasov, founder of the Moscow school of landscape painting, was only twenty-one when he painted his poetic *View of the Kremlin in Rainy Weather.* While traces of romanticism linger, his images were true to nature, simple and lyrical. The lower bank of the Moscow River by the Crimean Bridge, shown here, is now the site of the exhibition complex of the State Picture Gallery (cat. 174).

The development of what may be called the Moscow artistic tradition was in many respects determined by works created outside Moscow, which nonetheless took root and found a kindred spirit in the ancient capital. In the early 1860s, Alexander II established a public museum in Moscow and ordered the collection of St. Petersburg's Rumyantsevsky Museum to be transferred there. This museum contained Russian paintings collected by F.I. Pryanishnikov. As a result, Moscow came to own all Fedotov's major works as well as the most outstanding collection of Ivanov's works, including his most famous large canvas, *The Appearance of Christ to the People*. This last piece is of great significance, for V.I. Surikov drew inspiration from it for his own monumental historical canvases, *Morning Execution of the Streltsy* and *The Boyarynya Morozova*.

Moscow at this time attracted Russia's most brilliant artists. In the 1880s, Mamontov's circle included Vasnetsov, Vrubel, Serov, Korovin, and a number of others. By the end of the nineteenth century, the Moscow college had on its faculty such teachers as Serov and Korovin, sculptor P. Trubetskoy, and other masters who were on the cutting edge of artistic trends and greatly respected by younger artists. Earlier, such artists as Perov, Savrasov, and Polenov had also taught at the college.

The bourgeois nobility of Moscow, which developed more quickly than its counterpart in bureaucratic St. Petersburg, inherited the traditional Muscovite inclination to play the *frondeur,* to take the opposite side. Because of this, Moscow proved more receptive to the latest trends in European art than did "respectable" St. Petersburg, which considered such developments passing sensations. The salons of *The Golden Fleece* journal exhibited not only the works of young Muscovites in 1908-09, but also many important French paintings and sculptures, including works by Degas, Sisley, Braque, Picasso, and Bourdelle. This journal, subsidized by banker and manufacturer S. Ryabushkin, was the symbolists' main forum for debate.

At this time, Moscow merchants and art patrons S.I. Shchukin and I.A. Morozov began their large collections, which were largely composed of the newest French works. In such a way, the cultural community of Moscow was substantially enriched by contemporary art and artistic developments that went relatively unnoticed by the St. Petersburg group, World of Art.

It is well known that landscape painting initiated the stylistic changes in art during the second half of the nineteenth century. In Russia, the Moscow school of landscape painting was clearly on the leading edge of this process, acquiring its own specific direction by the end of the 1870s.

From the early eighteenth century, landscape painting had been executed in the form of the veduta, carefully staged arrangements of nature and architecture. City scenes also fell into this category. Even when foreign artists working in Russia (de la Barthe, for example) portrayed Moscow as the exotic "East," they preferred to create static general views of the city. The veduta thus became the dominant form of painting in Russia in the first half of the nineteenth century.

The rejection of the veduta was the first step toward realism in landscape painting. The new guiding principle was to convey the poetry of the daily interaction with nature. Artists had grown so accustomed to carefully composing their views that they had half-forgotten nature's true spontaneity. The overlooked essence of nature soon became the subject of a whole trend, and it was like Cinderella undergoing her magical transformation.

The first manifestation of the movement was the famous painting *The Rooks Have Come* by Savrasov. The paintings by Savrasov in this exhibition represent a turning point in his creativity, a moment when he transformed the old ways of perceiving the image on canvas into a more realistic interpretation. Tretyakov, founder of the famous gallery in Moscow, described the new credo in a letter to an artist producing a work for him: "I need neither abundant nature scenes, nor magnificent compositions, nor lighting effects nor any other kinds of small miracles. Just

paint a mud puddle and make it true to life, reflecting truth and poetry—there is poetry in everything. And poetry is an artist's business. . . ." Simplicity and the ordinary were the hallmarks of Russian landscape painting of the second half of the nineteenth century.

Savrasov's pupil, I.I. Levitan, further developed his master's lyrical approach. Levitan became known for his "landscapes of moods." He depicted nature as if caught in the wink of an eye and then refracted through the prism of his innermost feelings. Levitan valued nature's many variations and invisible transformations as reflected in its forms and colors. This explains his affinity for the transitional seasons of spring and autumn, as well as for the transitions during the day and in the weather. Levitan, following the path of his teacher, Polenov, made further progress in plein air painting, bringing it closer to impressionism.

Another figure worthy of mention is Korovin, whose mature style at the turn of the century is the most vivid example of Russian impressionism. Devoid of any "psychological complexes," Korovin's paintings are rather a feast for the eyes. A brilliant master of etudes, he affirmed that such studies were worthy of being considered finished works. He taught others to appreciate the particular charm of incompleteness, transforming the improvisational art of the etude into an entirely new category of artistic expression.

The colorful refinement of Korovin's works enriched the traditions of lyrical landscape painting—also championed by Savrasov, Polenov, and Levitan—which took a firm hold in Moscow, where all the abovementioned masters taught at the Moscow college. The main features of this tradition were its affinity for the chromatic harmonies of winter and spring and for the provincial nooks of the countryside insulated from urban civilization. Artists accustomed to life in the city saw a deep emotional and compositional sharpness in these pastoral subjects. The tradition was supported by the Moscow association, The Union of Russian Artists, whose members at the turn of the century included I. Grabar, K. Yuon, S. Zhukovsky, S. Ivanov, F. Malyavin, and A. Vasnetsov.

M.V. Nesterov adopted this style in many of his works, which in some respects resembled that of the English Pre-Raphaelites. His transformation of nature into a lyrically colored psalm is meant to convey the image of monastic Russia—a timeless ideal, he felt, for the interaction between man and nature, unburdened by the yoke of civilization and far from the cacophony of contemporary life.

The evolution of landscape painting is connected with yet another trend in turn-of-the-century art, symbolism's "second wave" (the first

Levitan offered these thoughts on landscape: "What is a painting? It is a piece of nature as seen through the filter of the artist's mood." *Evening on the Volga* expresses his initial response to the boundless expanses of the river that has played a special role in the spiritual life of Russia (cat. 182).

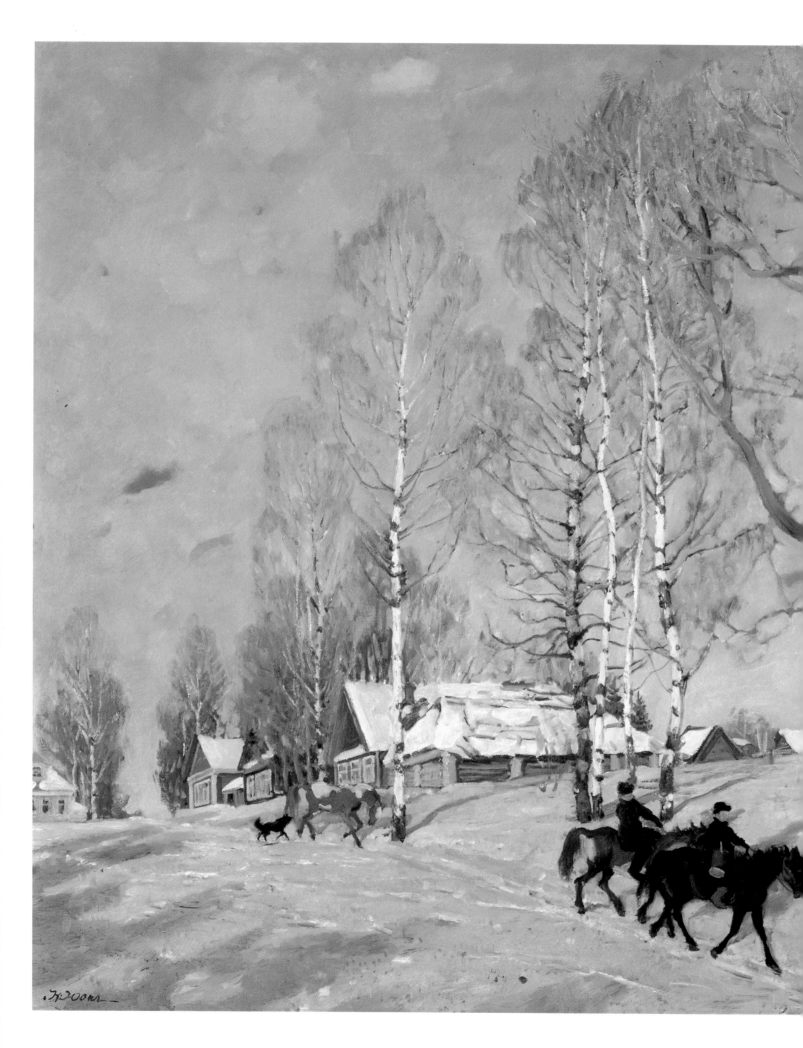

The beauty of life and
nature that heralds the
long-awaited Russian
spring permeates
Konstantin Yuon's
March Sun (1915).
Landscape painting
dominated Russian art,
and the words "Yuon's
landscapes" became
synonymous with
joyous and energetic
depictions of nature
(cat. 195).

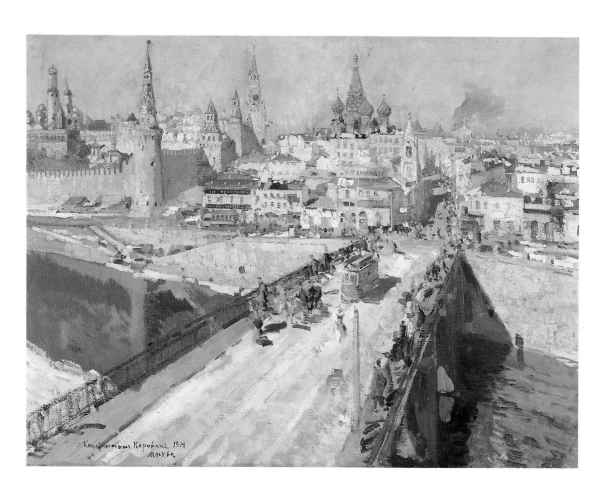

wave being Vrubel's art). Stylistically, this trend resembles a decorative variation on post-impressionism, as represented by the masters of the "Nabi" group, and in Russia by V.E. Borisov-Musatov. This artist projects a universe resembling the human memory, a kind of "land of reminiscences," where unconnected elements lost in time and space coexist within a global whole.

Musatov's disciples—P. Kuznetsov, M. Saryan, N. Krymov, and a few others—belonged to the symbolist group The Blue Rose, named after the 1907 exhibition in Moscow where these artists first expressed a common platform. Russian critic S. K. Makovsky called them "the prophets of the new primitivism." This was several years before the term "neoprimitivism" was applied to another trend of the 1910s, which also took root in Moscow but belonged to a wider phenomenon of the Russian avant-garde.

Among Europeans, the turn of the century saw a rising interest in ancient culture, which was far removed from contemporary urban life. This inspired the "Oriental" trend in art. In Russia, the trend caused a shift: European artistic influences now found affinity in the "easternness" of Moscow rather than in the "westernness" of St. Petersburg. Thus Moscow became the focus of European artistic innovations in Russia, completely reversing the city's role vis-a-vis St. Petersburg some two centuries before.

Allenov is Professor of Art History at Moscow State University.

Filipp Malyavin
continued the portrait
tradition of his
teacher, Ilya Repin—
accurate portrayal
of character with
confident, free
brushwork. His subject
Igor Grabar, also a
noted painter, was
director of the
Tretyakov Gallery and
editor of the multi-
volume series on the
history of Russian art.
Malyavin's brilliant
portrayals of country
women, in saturated
colors and exuberant
strokes, won him wide
acclaim (cat. 194).

JOHN E. BOWLT

FROM AVANT-GARDE TO AVANT-GARDE

RUSSIAN ART, 1910-1990

On December 10, 1910, an exhibition opened on the Bolshaya Dmitrovka in Moscow under the strange title of *Jack of Diamonds.* Many assumed that the announcement referred to a casino or to a house of ill repute, and few believed that it could really be an exhibition of paintings by professional artists. In fact, the Jack of Diamonds was the name of perhaps the most famous group of Moscow avant-garde artists, led by Natalya Goncharova and Mikhail Larionov. With its provocative allusion to the uniform that prisoners used to wear, the Jack of Diamonds brought together outsiders and dissidents united in their common dissatisfaction with the status quo and in their sincere desire to create a new artistic worldview.[1] The foremost members of this group—Goncharova, Vasily Kandinsky, Larionov, Aristarkh Lentulov, Kazimir Malevich, and Vladimir Tatlin (many of whom are now represented in this exhibition eighty years later)—helped change the history of Russian art through their application of new and complex aesthetic concepts such as neo-primitivism, cubo-futurism, rayonnism, suprematism, constructivism, and even a "pre-post-modernist" movement called "everythingness."[2] Convinced that Moscow was the new center of artistic enterprise, these artists rejected the narrative realism of the *Peredvizhniki* (the Wander-

ers) and the introspections of their symbolist predecessors and embarked into unexplored and exciting avenues of artistic enquiry.

In their search for fresh sources of inspiration artists such as Goncharova and Larionov gave particular attention to the indigenous arts and crafts of Russia such as the icon, church architecture, the *lubok,* peasant artifacts, and urban folklore, identifying themes and methods that they then incorporated into their paintings and sculptures. The results of this neo-primitivism were profound and permanent: Goncharova, for example, after exploring French impressionism, turned to scenes of everyday Russian country life—the harvest, washing linen, and religious ritual (an orientation that also left an indelible impression on Malevich), while her companion, Larionov, preferred graffiti, pigs, and titillating motifs from barrack life and whorehouses. More moderate artists such as Boris Kustodiev, Nikolai Krymov, and Sergey Sudeykin, also drawn to this rediscovery of tradition, were content to evoke more sentimental scenes of merchants drinking tea, dachas, and Pushkinian gentlemen dallying with their ladies on chaises longues.

But the artists of the Jack of Diamonds, who included Petr Konchalovsky, Ilya Mashkov, and Vasily Rozhdestvensky (all represented at our

The introduction of suprematism by Kazimir Malevich at the exhibition *0.10* in 1915 provoked violent disagreement among artists and viewers over the purpose of art and abstraction. Seeking a spiritual foundation for art beyond mere appearance, Malevich discarded the recognizable images of cubism and three-dimensional space for planes of geometric shapes connected purely through shape and color, as in *Suprematism #56* (1916, cat. 209).

Resembling a brightly painted carousel figure or a warrior saint from an early icon, Tsar Nicholas II on a white horse triumphs in *Victory Battle* (1914, cat. 205). The colorful striped ribbon of St. George unfurls amidst a cubo-futurist landscape of battle fragments in this distinct synthesis of traditional and contemporary styles that marks the work of Aristarkh Lentulov. Just two years earlier he had commemorated the War of 1812 in similar style.

exhibition), and of subsequent radical groups such as the Donkey Tail and the Target, were also well aware of French cubism and Italian futurism and sometimes produced curious amalgams such as Lentulov's *Victory Battle* of 1914 (cat. 205). As far as post-impressionism and cubism were concerned, these artists had no need to travel to Paris to see the latest trends, for superb paintings by Braque, Gauguin, Matisse, and Picasso were readily accessible in the great collections of the Moscow businessmen Ivan Morozov and Sergey Shchukin.[3] Not surprisingly, therefore, Larionov and his colleagues often paraphrased the works they saw there and/or portrayed their owners (as in Konstantin Korovin's *Portrait of Ivan Morozov* of 1903). But for all their bravura, the role of artists such as Goncharova, Larionov, and Malevich at this time should not be exaggerated. It should be remembered that they constituted a tiny minority and that, in any case, as the poet Benedikt Livshits wrote later, Russian artistic taste was generally too low to appreciate the niceties of cubo-futurism: "the supporters of the 'old' art . . . foamed at the mouth and defended the rights of 'common sense' so trampled by the innovators."[4] Much more popular with the Russian public then were the gentle interiors of Stanislav Zhukovsky (*Easter Table,* 1903, cat. 196, frontis 3), the latterday impressionism of Konstantin Korovin (as in his *Moscow River Bridge* of 1914, cat. 191, p. 206), and Konstantin Yuon's evocations of old Moscow and Zagorsk.

Still, paintings such as Korovin's *Moscow River Bridge* and Yuon's *March Sun* (1915) are misleading in their tranquility, for in the 1910s Moscow was where the action was, and the average citizen must have been astonished by the social and cultural transformations manifest at every step. Not only was the urban silhouette changing with the rapid construction of the first multistory buildings and the proliferation of technological marvels such as automobiles and telephones, but suddenly culture, too, seemed to be rejecting the comfortable values of formal elegance. Even art exhibitions now contained combinations of a "broken table-leg, a sheet of iron, and a broken glass jug";[5] Vladimir Mayakovsky recited poetry that began "The street caves in like the nose of a syphilitic";[6] David Burlyuk, Goncharova, and Larionov walked in Moscow's fashionable streets wearing weird clothes and cryptic signs on their faces; and they asserted that "the Academy and Pushkin are more incomprehensible than hieroglyphics"[7] and that "Velasquez and Raphael were philistines of the spirit."[8] As the critic Pavel Ettinger wrote in his review of the 1912 *Jack of Diamonds* show, it was hard to know "where bluff ends

While still a student
of Serov, the youthful
Nikolai Krymov
painted *A New Tavern*
(1909, cat. 200). The
bright colors outlined
in black reflect the
influence of traditional
folk woodblock prints
and primitive painting,
sources then favored by
Moscow artists
Larionov and
Goncharova, with
whom Krymov had
shown in the 1909
Golden Fleece
exhibition.

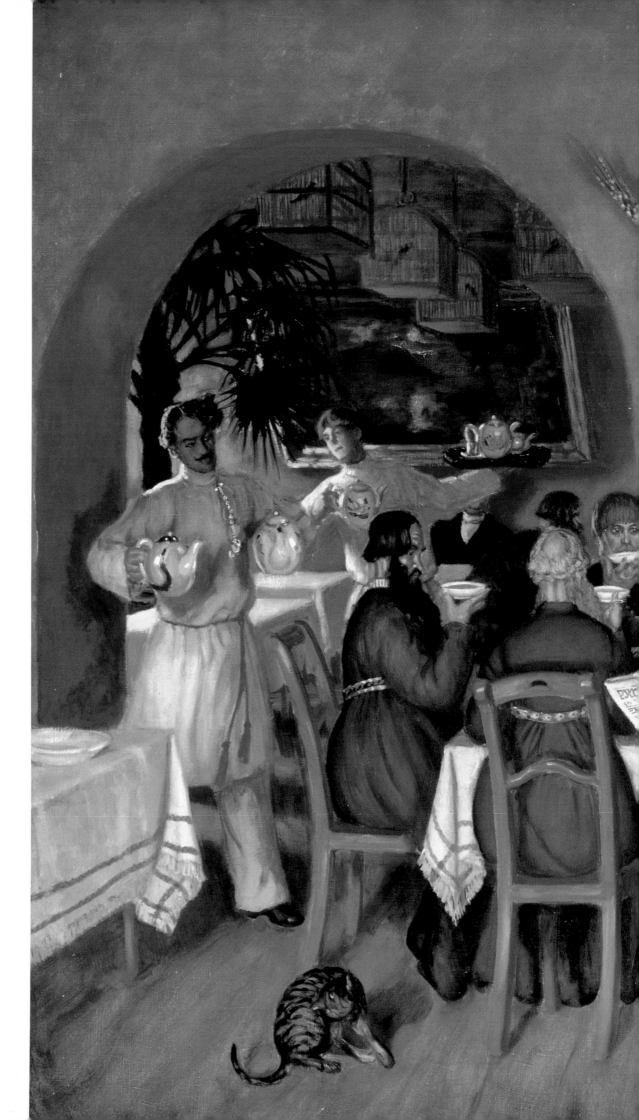

Boris Kustodiev portrayed the colorful side of merchant life; this is how his son describes the creation of *Moscow Tavern* (1916, cat. 197), with its clientele legendary for distinctive speech and behavior: "There was a tavern where coachmen used to drink tea and rest . . . they wore blue caftans. All of them were Old Believers. . . . A saucer was kept at stretched fingers. They drank tea, burning themselves, blowing on the tea in the saucer. Their talk was unhurried and ceremonious. My Father said 'It makes you think of Novgorod icons and frescos . . . red background, red faces, the same color red walls . . . they should be painted like St. Nicholas the Wonder-worker . . . The 84-pint samovar should gleam . . . I think the painting turned out well! There is color, an icon quality and the images of cabmen are just those I wanted.'"

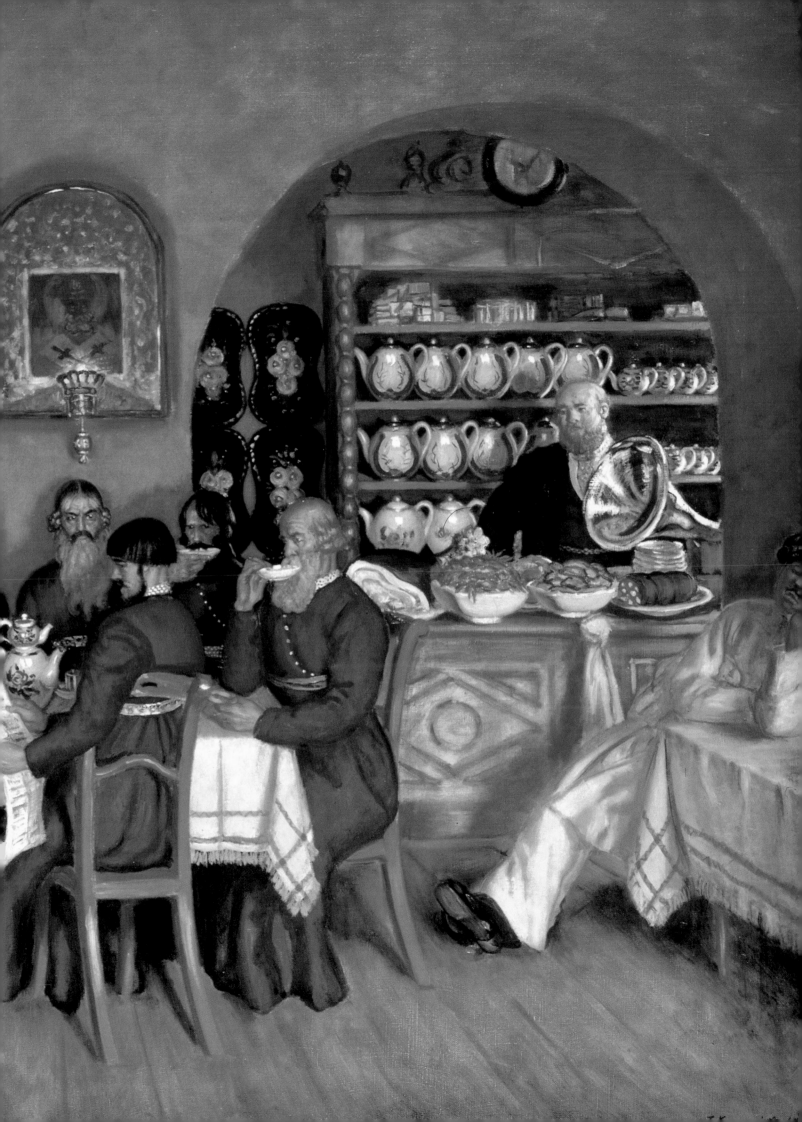

Symbols of Russian life and spirituality shaped a series of paintings by Lentulov from 1913 through the war years—*Moscow, St. Basil's,* and *View of the New Jerusalem Church* (1917, cat. 206). Patriarch Nikon, whose reforms even outlawed tent domes on churches, built many monasteries including the New Jerusalem (1658-1685) outside of Moscow, where some believed the Holy City would be reborn. The many-storied Gate Church is seen on the left.

and genuine, sincere research begins."[9] Things came to a head, so to speak, when, in response to chastisement from the conservative critic Sergey Yablonovsky at the *Exhibition of Painting* in 1915, Lentulov there and then squeezed out some ocher paint onto a piece of cardboard and hung it up with the caption "Sergey Yablonovsky's Brain."[10]

Of course, Moscow was not the only center of artistic progress in pre-Revolutionary Russia and, as a matter of fact, St. Petersburg (and Kiev and Riga) also hosted some of the spectacular events of the avant-garde endeavor, such as the performances of the cubo-futurist opera *Victory over the Sun* in 1913 and Malevich's first public showing of his abstract system suprematism at the *0.10* exhibition in 1915-16. Even so, Moscow with its disorder, muddle, and "southern" temperament was the primary arena for the noisy encounters between the modernists and their inquisitive audience—who tended to regard them more as a circus or fairground act than as "artists." However, even though the avant-garde artists were, indeed, influenced by the clown and the conjurer, they regarded their innovations as part of a serious program of creativity, and the fact that at *0.10* Malevich hung his *Black Square* in the *krasnyi ugol* (icon corner) of the hall, that Lentulov applied cubist principles to his renderings of ancient monasteries (*New Jerusalem,* 1917, cat. 206), and that Tatlin incorporated the craft of icon construction into his reliefs indicates not necessarily an iconoclastic dismissal of hollowed traditions, but rather a subtle adjustment of them to the new art. In turn, this would seem to express a deep-seated conviction that art, like a religious belief, should transfigure and transcend.

It is perhaps in this broadest philosophical context and not in a narrow ideological one that we can refer to the avant-garde's engagement

with the political and social revolution of October 1917. In the early 1900s many Russian intellectuals spoke of an impending apocalypse and proceeded to identify the fulfillment of their prophecy with the Russo-Japanese War, the 1905 Revolution, the First World War, and then the Bolshevik coup. Kandinsky's dynamic painting *Red Square* (1916-17, cat. 208) conveys this eschatological mood, and many avant-garde artists welcomed the events of October, equating political revolution with their own aesthetic revolution, even arguing, as Malevich did, that "Cubism and Futurism were revolutionary movements in art, anticipating the revolution in the economic and political life of 1917."[11] Indeed, many of the innovations in painting and sculpture now often associated with the ethos of the October Revolution or interpreted as visual extensions of political ideas were produced or prepared *before* the Revolution. The entire movement of constructivism and Production Art, for example, when artists such as Lyubov Popova and Alexander Rodchenko concentrated on industrial design (textiles, ceramics, furniture, architecture, and so on) was a natural outgrowth not of Bolshevik demands but rather of prior artistic tendencies—Malevich's geometric abstractions of 1915, Tatlin's reliefs of 1914, and the considerable achievements in utilitarian design by Alexandra Exter, Ivan Puni, Olga Rozanova, and others before and during the First World War.

It would be misleading to assume that all leftist artists sympathized with the Marxist cause or that all creative supporters of the new regime were avant-garde. Some seemed not to react to the new political reality, others felt that the ideas of the avant-garde were a bourgeois product alien to the proletarian consciousness. All this is to say that the artistic environment in Moscow immediately after the October Revolution should not be categorized as "leftist" or as "rightist," but rather as a constant interchange of the most varied styles and personalities—from Kustodiev to Tatlin, from Kuznetsov to Malevich, from Isaak Brodsky to Popova. Indeed, the continued, forceful presence of traditional styles represented by artists such as Sergey Malyutin, Mikhail Nesterov, and Yuon and their coexistence with the avant-garde contributed much to the consolidation and reinforcement of the realist aesthetic in the early 1920s onwards.

With the transference of the capital from Petrograd to Moscow in March 1918, Moscow assumed an even greater role in the development of Russian culture, a hegemony that is certainly maintained today. Moscow became the museum and exhibition center, Moscow assumed primary censorship control, Moscow became the major art market. Many of these and allied activities now fell under the auspices of Anatoly Lunacharsky's People's Commissariat for Enlightenment (NKP), which in the case of painting, sculpture, architecture, and museum management adopted the responsibilities of the Ministry of Fine Arts projected but not ratified just before the First World War. The Visual Arts Department of the Commissariat (IZO NKP), led by David Shterenberg and Tatlin, quickly assumed vast bureaucratic power, paving the way

Kandinsky spent the war years in Russia, returning from Munich in 1914 where he had already founded the Blaue Reiter group and published *On the Spiritual in Art* (1912). This reserved intellectual revolutionized art with his creations of "abstract," "non-objective," and "synthetic" art. Words, colors, and sounds to him were all in harmony—yellow was the sound of trumpets. In *Red Square* (1916, cat. 208), the site of public and official demonstrations, he sought to unify "the complex and the simple into a single sound."

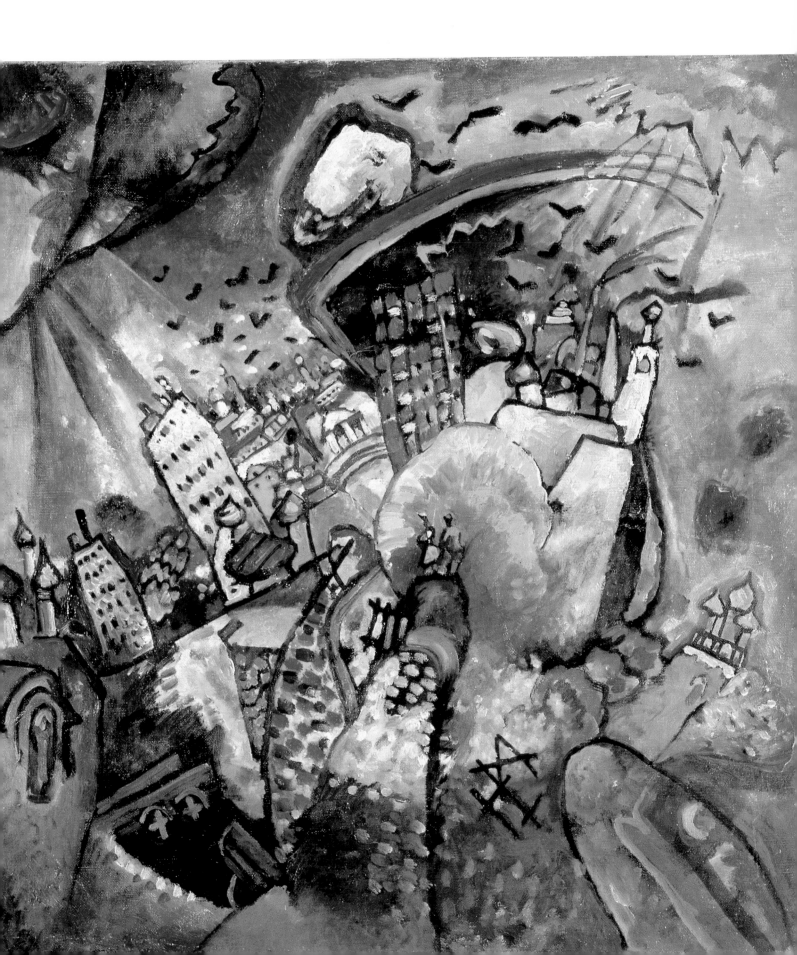

for the sophisticated mechanism of the Ministry of Culture of the USSR, which until very recently was the most influential arbiter of artistic taste in the Soviet Union. IZO NKP did much to propagate the artists of the avant-garde, acquired their works for museum distribution, allowed them to teach in the restructured art schools such as Vkhutemas (Higher State Art Technical Studios), established research institutions for artists, critics, and historians such as Inkhuk (Institute of Artistic Culture) and GAKhN (State Academy of Artistic Sciences), organized jury-free exhibitions, and nationalized art collections. On a more specific level, IZO NKP supervised Lenin's Plan of Monumental Propaganda.

In April 1918 Lenin decreed that "monuments erected in honor of the tsars and their servants . . . are to be dismantled . . . and projects of monuments intended to commemorate the great days of the Russian Socialist revolution [are to be produced]."[12]

In a rare example of direct presidential intervention in the arts, Lenin charged Lunacharsky with the urgent expedition of this ambitious plan, a measure that provided a vital stimulus to the development of monumental Russian sculpture and the concept of art in public space. This particular correlation was rather new to the history of Russian art, for pre-Revolutionary sculpture had tended to explore more intimate genres as is evident, for example, from Anna Golubkina's bust of Savva Morozov or Mikhail Vrubel's majolica *Spring*. Even so, Lenin's call to create statues and reliefs eulogizing the heroes of progressive culture such as Beethoven, Marx, and Robespierre attracted a wide range of talents—from the extreme left to academic realism (Nikolay Andreyev)—and provided a strong foundation for the development of monumental

Savva Morozov, heir to an industrial empire begun by his serf grandfather and enlarged by the ruthless practices of his father, devoted himself to improving worker conditions, social change, and the arts. His total support of the Moscow Art Theater and Stanislavsky — which fostered "method" acting and sets by leading artists — changed theater forever. Anna Golubkina's bust of Morozov (1902, cat. 231) reflects the complexity of this reformer who subsidized Lenin's newspaper, was disowned by his mother for proposing worker profit-sharing, and took his own life in 1905.

Courage, patriotism, and morality are conveyed in the irrepressible forward motion expressed by Vera Mukhina in *The Partisan* (1942, cat. 237, right).

This elegant portrait head of the model *Tsita Volina* by Sarra Lebedeva (1928, cat. 234, far left) is nearly startled from its cool classicism by the deep voids of the cut-out eyebrows. Quite different is her boldly modeled portrait of the Soviet aviator Valery Chkalov (1904-38). Already famous for his long distance non-stop flights, he would fly from Moscow to Vancouver, Canada, in the next year (1936, cat. 235).

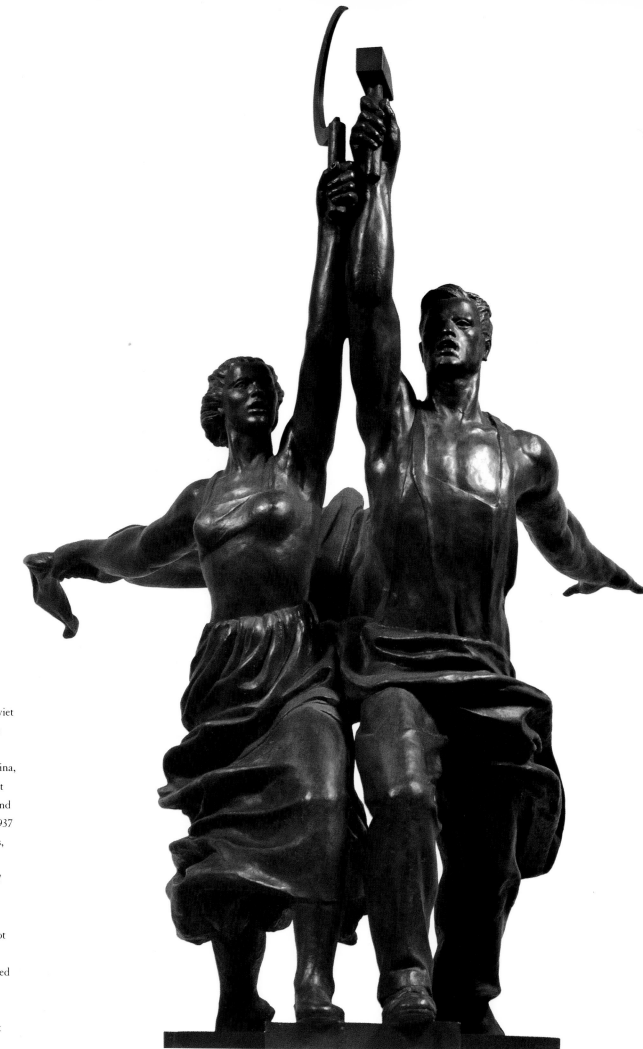

The character of Soviet monumental art was determined by the sculptor Vera Mukhina, accomplished student of Yuon, Mashkov, and Bourdelle. For the 1937 World's Fair in Paris, her model of *The Industrial Worker and the Collective Farmer* (1936, cat. 236) was executed in an 80-foot chrome-nickel steel sculpture that crowned the Soviet Pavilion, becoming a creative symbol for the Soviet state.

The Reaper, an image familiar in art and life, attracted the interest of Kazimir Malevich in his peasant series of 1909-13, and again in 1928-32, creating some dating difficulties as he reworked and redated paintings. The sturdy forms and landscape details were quickly simplified to emphasize contour and volume, ultimately becoming vivid geometric abstractions (ca. 1928, cat. 210).

sculpture as a primary expression of socialist realism in the 1930s, as we see in Sarra Lebedeva's *Valery Chkalov* (1936) and Vera Mukhina's *The Partisan* (1942, cat. 237).

The diversity of styles manifest in the sculptural contributions to the Plan of Monumental Propaganda further testifies to the fact that the years just after the Revolution were a period of artistic plurality and fluidity, even if the voices on the left tended to be louder. The most extraordinary artistic contrasts could be seen. On the one hand, Tatlin was working on his visionary *Monument to the Third International,* whose form, as the critic Nikolay Punin, affirmed, "shows in what direction the artist is to work

when he has grown tired of heroes and busts . . . the forms of the human body cannot today serve as an artistic form, form must be discovered anew."[13] On the other hand, Nesterov and Yuon were painting their calm landscapes just as they had been long before the Revolution, while Nisson Shifrin and Petr Viliams, as students at Vkhutemas, were paying homage to the radical movements of the 1910s. In 1921 Exter, Rodchenko, and their colleagues announced the death of painting and their move into constructivism[14] while just a few months later their achievements were dismissed as "abstract concoctions" by the young enthusiasts of AKhRR (Association of Artists of Revolutionary Russia).[15]

In 1929 this scene represented a major achievement; education was a primary goal of the Soviet government. The 1897 census had noted that only 22 percent of the Russian population was literate, with great inequities between city and country. In *Teacher Training* (cat. 215), Efim Cheptsov, who first studied icon painting, pictures the teachers in his village in the Kursk region.

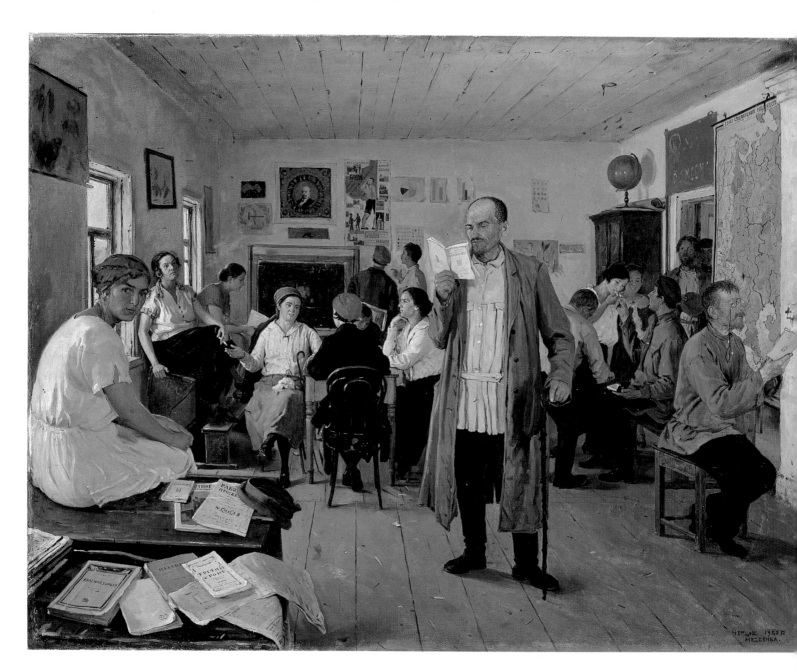

This rich constellation of artistic trends lasted throughout the 1920s, in spite of increasing pressure from above and from below for art to be readable and "relevant." We should not forget that, as late as 1929, Malevich had his first one-man show at the Tretyakov Gallery just as he was painting his "robotic" super-peasants (*The Reaper,* ca. 1928, cat. 210) and that Tatlin was designing his most fantastic project—his bicycle airplane called Letatlin. But by 1929 Malevich and Tatlin, the extreme poles of the old avant-garde, were middle-aged, and their utopian visions seemed suddenly remote to a society concerned with the pressing tasks of the first Five Year Plan, collectivization, and the White Sea Canal. No doubt, for the new masses, clear and simple artistic statements such as Efim Cheptsov's *Teacher Training* (cat. 215) and Aleksey Zelensky's *October,* both of 1929, had much more meaning and topicality.

Socialist realism of the 1930s described these new social commitments, and the paintings of the Stalin style, rhetorical and rousing, appealed to a clientele very different from the suave industrialists such as Shchukin or the cultured intellectuals such as Lunacharsky. Of course, the advance of socialist realism was accelerated by the forced removal of impediments, especially by the Party decree of 1932 "On the Reconstruction of Artistic and Literacy Organizations," which abolished alternative movements. Furthermore, conservative artists and critics who supported a return to the academic style seized the reins of bureaucratic power and, among other things, reestablished the Academy of Arts in Moscow in 1947. Paradoxically, this "return to order" with its verity of perspective and proportion is an artistic legacy that western critics and collectors admire in Soviet painting today. But even if artists such as Vasily Efanov and Aleksandr Gerasimov championed a moribund style as they glorified a corrupt regime, the doctrine of socialist realism surely maintained, rather than replaced, the conventions of the avant-garde. Not iconographically, of course, but rather in its advocacy of art as a sacred, prophetic discipline that could guide, elevate, and transform society. This basic impetus was expressed in the socialist realist charter published in 1934: "Socialist Realism . . . requires of the artist a true, historically concrete depiction of reality in its Revolutionary development. In this respect, truth and historical concreteness of the artistic depiction of reality must be combined with the task of the ideological transformation and education of the workers in the spirit of Socialism."[16]

Until Stalin's death in 1953 socialist realism was the single, monolithic style that shaped the evolution of Soviet painting, architecture, applied arts, literature, music, and the performing arts. As the axis of Stalin's centralized state, Moscow became a primary vehicle for the visual expression of socialist realism, culminating in

the erection of Stalin's "wedding cakes," in the organization of enormous theme exhibitions such as *XX Years of the Red Army and Navy* (1938), and in the production of masterpieces of painting that, directly or indirectly, referred to Stalin, the Kremlin, and Moscow—such as Efanov's *A Memorable Meeting* (1936) and A. Gerasimov's *Stalin and Voroshilov in the Kremlin* (1938). In the 1930s Moscow assumed an almost millenial guise as the capital of the Promised Land, and its elaborate festivities and parades seemed to express this new spirit of self-confidence and optimism. However false, the photographs that survive of the gymnastic displays and salutes on Red Square, the amusement parks, and children bathed in sunlight demonstrate this public celebration of the 1930s. The first line of the Moscow metro (1935) linked the two major parks of culture and rest (Sokolniki and Gorky parks); the documents of the time emphasize sunshine, not snow, as the dominant weather pattern; and the art and literature of socialist realism concentrated more and more on sunlight and abundance (as in Sergey Gerasimov's *Collective Farm Harvest Festival* of 1935). Stalin himself was bathed in light (as in Irakly Toidze's *Stalin at a Hydroelectric Station* of 1935), a visual metaphor that associated him immediately with the Sun King—and Moscow, therefore, with the City of the Sun. In the 1930s Stalin was the Sun, and the hymns and songs dedicated to him reiterate that "he, like the morning, rises above the world" and "the sun shines for us on earth in a different way now— knowing that it has visited Stalin in the Kremlin." In view of the position of special privilege that Moscow began to enjoy in the 1930s, Hitler's invasion and sudden threat to Moscow, the inviolable capital of Stalin's empire, must have been especially alarming—a trepidation clearly expressed in Aleksandr Deyneka's *Outskirts of Moscow* (1941, cat. 216).

For obvious reasons, the Second World War curtailed artistic activity in Moscow. Some art-

In the grim days of 1941, the defense of Moscow against advancing German troops inspired this vivid image of the *Outskirts of Moscow* by Alexander Deyneka. The painting, with its stark contrasts of bristling anti-tank traps set against snow, empty streets, silent buildings, and a solitary military lorry, is an expressive counterpoint to Deyneka's arresting monumental canvases of men and women at work from earlier decades (1941, cat. 216).

After the enormous losses and dislocations of war, society welcomed the return to normal life—to family and children. In this extremely popular painting by Fedor Reshetnikov, *Poor Grades Again,* viewers delighted in an intimate moment of universal recognition (1952, cat. 219).

In the Krushchev "thaw" of the late 1950s, the reappearance of French impressionist paintings to public view encouraged a renewal of the Russian plein-air landscape tradition, which had been criticized earlier. With amazing freedom of execution Vladimir Stozharov paints *Shatov Mountain Village,* in which the raking sunset light transforms the bleak northern landscape (1964, cat. 220, right).

ists were evacuated to the south and east, others such as Boris Prorokhov served as battle painters on the front line, and still others stayed behind in their studios. All heeded the call of duty, adjusting their talents to patriotic themes as Pavel Korin did with his evocations of great moments from Russia's history or turning their art into a powerful weapon of satire and parody. Such was the case with the *Kukryniksy,* the famous trio of Mikhail Kupriyanov, Porfiry Krylov, and Nikolay Sokolov, whose trenchant caricatures and posters made an obvious and incalculable contribution to the national war effort. In spite of inclement conditions, Moscow artists produced some major paintings and sculptures during the war including Sergey Gerasimov's *Mother of a Partisan* (1943) and Arkady Plastov's *A Fascist Flew Past* (1942). Victory and a new self-assurance also inspired a series of socialist realist classics just after the war such as Fedor Bogorodsky's *Glory to the Fallen Heroes* (1946) and Aleksandr Laktionov's *Letter from the Front* (1947).

The artists who painted these poignant scenes were sincere in their desire to convey a mood or episode that had profound meaning to Soviet citizens, and there can be no question that these evocations move them even today. However, the postwar period was also the period of *zhdanovshchina,* when Andrey Zhdanov assumed his de facto role as Stalin's minister of culture, embarking on a brutal campaign of vilification of all artists, writers, and musicians who deviated from the canons of socialist realism. The passing of time may have blurred these iniquities of the Stalin era, but it should not be forgotten that art-

ists and critics were, indeed, punished severely for supporting styles outside of socialist realism. Enthusiasm for the painting of Cezanne, for example, led to Punin's arrest and imprisonment.[17] It is important to emphasize this state of affairs in order to better appreciate the new-found freedom that the Soviet artist enjoys today. During the 1930s and 1940s, an underground or dissident movement was impossible, and it was only in the mid-1950s that alternative styles began to develop diametrically opposed to the anecdotal, if endearing kind of art epitomized by Fedor Reshetnikov's *Poor Grades Again* of 1952 (cat. 219) or Vladimir Stozharov's *Village of Shatov Mountain* of 1964 (cat. 220). Evgeny Evtushenko began to recite his exposés of Stalin, Ilya Glazunov to illustrate Dostoevsky, and Ernst Neizvestny to create his expressionist

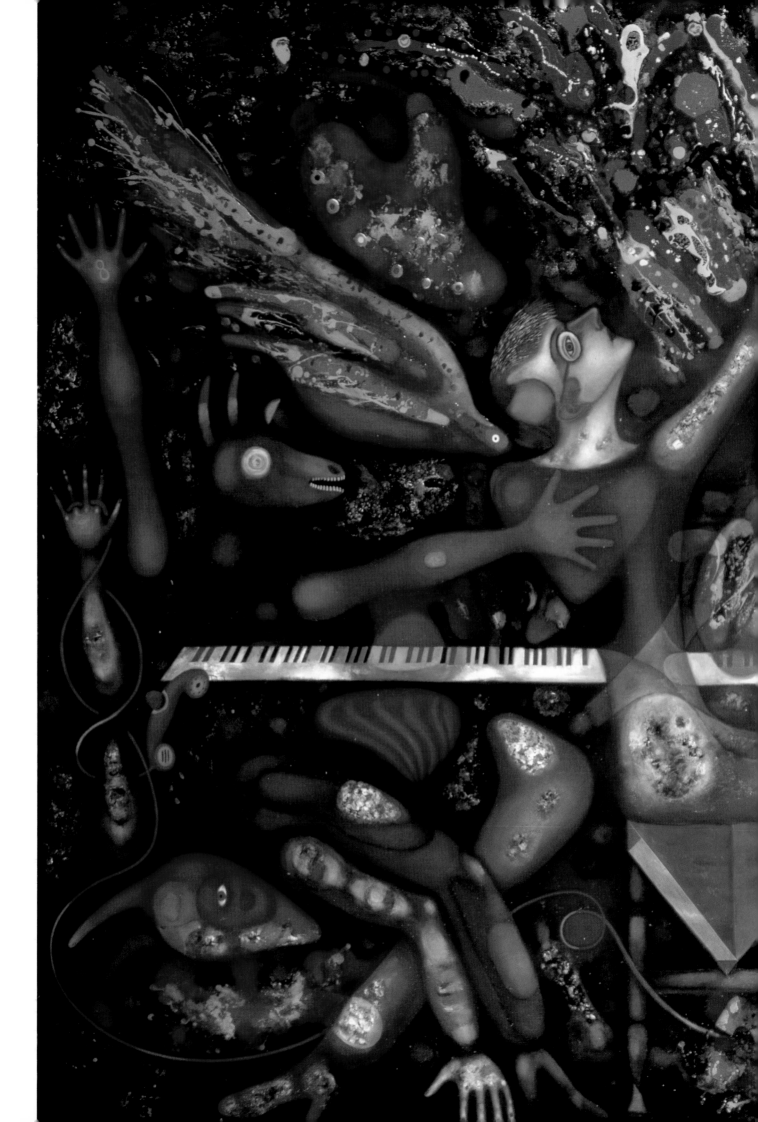

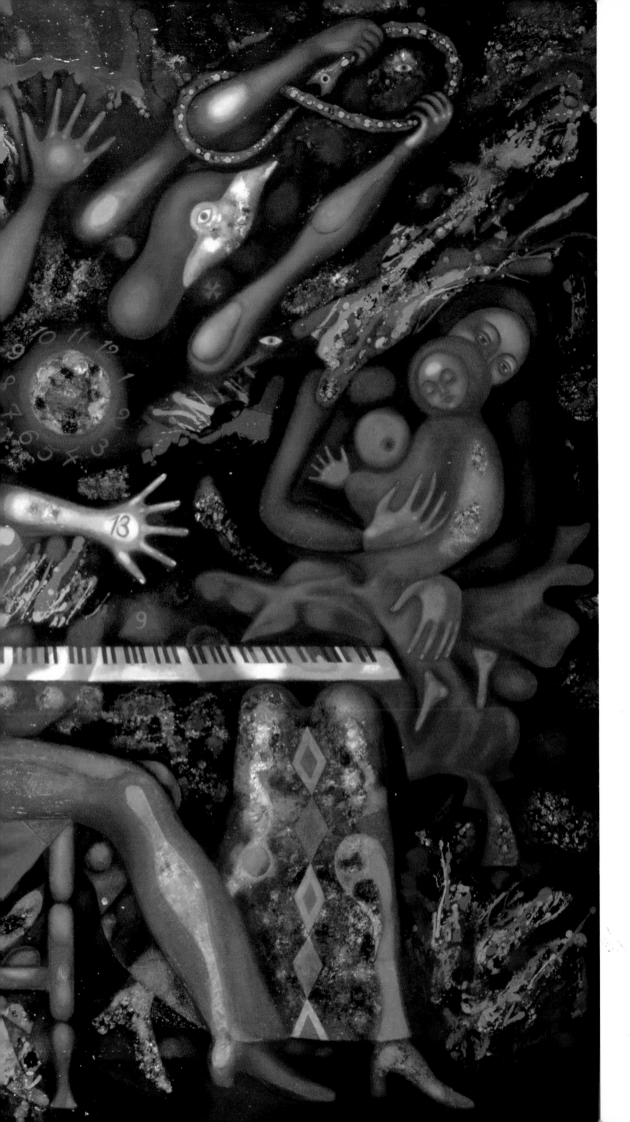

Aleksandr Sitnikov in *Concert. Memories of Shostakovich* celebrates a complex man whose music and life became powerful symbols beyond his unquestioned genius or intention. His 7th Symphony (the *Leningrad*) and the 8th were seized upon internationally to express resistance to the German invasions, while the 13th, invoking Yevtushenko's memorial poem to the 1943 massacre of Jews at Babi Yar, was banned. Deeply concerned about the victims of inhumanity, Shostakovich believed that art could destroy silence. This painting perhaps confirms his wish that younger people "would be free of the bitterness that has colored my life gray" (1985, cat. 227).

sculpture. For all their individualism, such writers and artists presented a concerted challenge to the pillars of the cultural establishment, symbolized by the famous polemic between Neizvestny and Khrushchev at the exhibition *Thirty Years of Moscow Art* at the Manège Exhibition Hall in 1962. Even though the immediate consequence of Khrushchev's indignant dismissal of "modern" art was a reinforcement of the socialist realist method, and the non-conformist movement continued to be condemned, increased exposure to western fashions such as pop art, a freer flow of information, a slow but sure rediscovery of the brave traditions of the avant-garde, and a more urgent questioning of the exclusivity of socialist realism—all these elements stimulated ever greater change in the composition of contemporary Soviet culture. Still, the Soviet Union did not have flower children or rock concerts in the late 1950s and 1960s, and the analogies sometimes drawn between Kennedy's America and Khrushchev's Russia can be misleading. Certainly, Moscow witnessed a cultural relaxation, just as Washington, D.C. witnessed an increasing demand for greater cultural and civil liberties. But Moscow's thaw was brief, for the combined pressures of the agencies responsible for the management of Soviet culture were too

heavy to encourage or tolerate deep change in artistic policy. Even so, that first generation of Moscow dissidents soon attracted many other artists such as Erik Bulatov, Ivan Chuikov, Francisco Infante, and Vladimir Kotliarev who continued the valiant campaign to bring credence to their experimental styles of conceptual, kinetic, and body art. It is out of this highly charged atmosphere that many of today's leading Moscow artists—Tatyana Nazarenko, Natalya Nesterova, Aleksandr Sitnikov, Dmitry Zhilinsky, and others—have derived their energy; and it is thanks to this history of protest that artists and critics can now lift taboos and discuss the aboli-

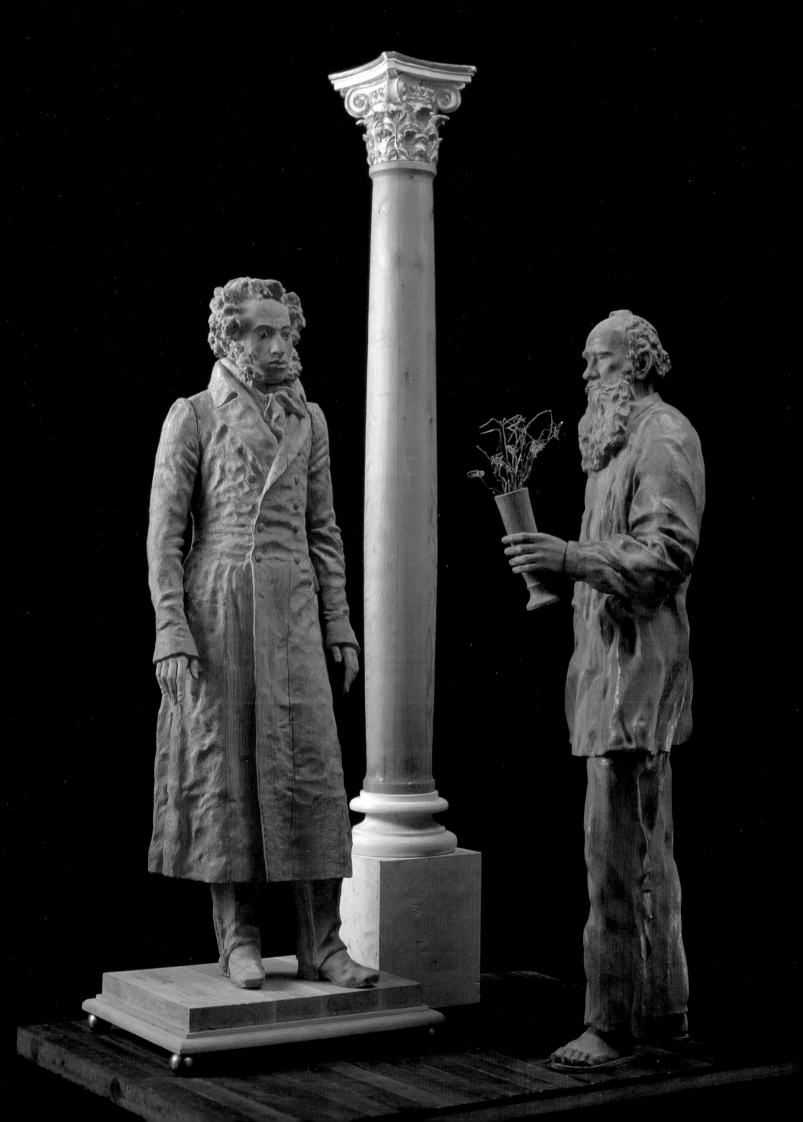

In the 1970s, Tatyana Nazarenko began to experiment with visual language, opening a dialogue with the past. The creative world of *A Studio* is populated with Lucas Cranach, Jan van Eyck, Chagall, and Pushkin—spiritual entities as tangible as the recognizable landscape seen through Nazarenko's studio window on Nezhdanova Street (1983, cat. 223).

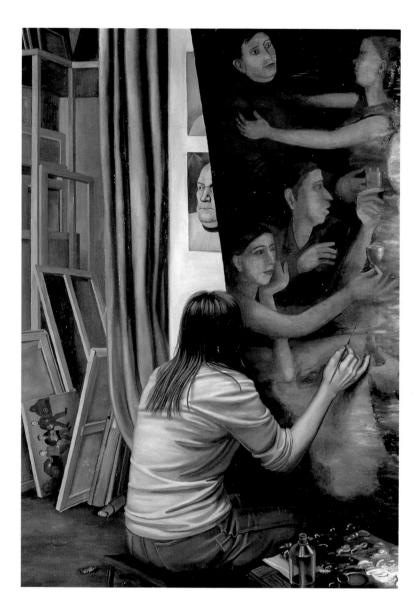

tion of socialist realism and even the disbandment of the Ministry of Culture of the USSR. Such radical proposals would have been almost unthinkable before *glasnost* and *perestroika*.

As far as art now is concerned, it is tempting to concentrate on the young and the bold and to offer the achievements of the new avant-garde artists such as Yury Albert, Arkady Petrov, Sergey Shutov, Aleksey Sundukov, and Konstantin Zvezdochetov as typical of the Moscow scene. Certainly, their productions are exciting, entirely contemporary, and can easily be accommodated by the international style of postmodernism. When we confront the rich and varied art scene of Moscow today, our eternal quest for the novel, the instantaneous, and the shocking may well be gratified by the new avant-garde. But to exaggerate its primacy would be to

repeat the same misconception regarding the assumed hegemony of the avant-garde just before and after 1917. We should not forget that, as then, so now, realism is alive and well, and that many Moscow artists, young and old—from Vladimir Braynin and Gely Korzhev to Leonid Baranov and Ivan Nikolaev—continue to paint themes from everyday life in a straightforward, accessible manner. Most Muscovites still find the meticulous and clear rendering of a landscape, a social ritual, or a human face to be more significant and more uplifting than a black square on a white background. Ultimately, perhaps even Malevich reached that conclusion.

Bowlt is Professor of Art History and Slavic Languages and Literatures at the University of Southern California, Los Angeles.

NOTES

1. For information on the Jack of Diamonds see G. Pospelov, "O 'valetakh' bub-novykh i valetakh chervonnykh," in *Panorama iskusstv '77* (Moscow, 1978), pp. 127-42, and "M. F. Larionov," in *Sovetskoe iskusstvosnanie '79* (Moscow, 1980), No. 2, pp. 238-67. For general information on the avant-garde period in Russian art see C. Gray, *The Great Experiment: Russian Art 1863-1922* (London: Thames and Hudson, 1962, and later reprintings).

2. For the "everythingness" manifesto and other information see M. Ledantiu, "Zhivopis vsekov," in *Minuvshee* (Paris, 1988), No. 5, pp. 183-202.

3. For information on the Morozov and Shchukin collections see B. Kean, *All the Empty Palaces* (London: Barrie and Jenkins, 1983).

4. B. Livshits, *The One and a Half-Eyed Archer*, J. Bowlt, trans. (Newtonville, Mass.: Oriental Research Partners, 1976), p. 82. Original edition: *Polutoragizyi strelets* (Leningrad: Izdatelstvo pisatelei, 1933).

5. N. Ya-o, "Vystavka 1915 goda," in *Miechnyi put* (Moscow, 1915), No. 4, p. 63.

6. Opening lines of Maiakovsky's poem, *A vse-taki [And Yet]* (1914), trans. in V. Markov and M. Sparks, *Modern Russian Poetry* (London: MacGibbon, 1966), p. 529.

7. From the manifesto *Poshchechina obshchestvennomu vkusu [A Slap in the Face of Public Taste]* (Moscow, 1912), trans. in V. Markov, *Russian Futurism* (Berkeley: University of California Press, 1968), p. 46.

8. Livshits, op. cit., p. 81.

9. P. Ettinger, "Vystavka Obshchestva 'Bubnovyi valet,'" in *Russkaia khudo-zhestvennaia letopis* (St. Petersburg, 1912), No. 5, March, p. 9.

10. A. Lentulov, "Avtobiografiia," in *Sovetskie khudozhniki* (Moscow: Iskusstvo, 1937), Vol. 1, p. 162.

11. K. Malevich, *O novykh sistemakh v iskusstve* (Vitebsk: Unovis, 1919 [= 1920]), p. 10.

12. V. Ulianov [Lenin], "Dekret Soveta narodnykh komissarov o sniatii pamiat-nikov, vozdvinutykh v chest tsarei i ikh slug, i vyrabotke proektov pamiatnikov Rossiiskoi sotsialisticheskoi revoliutsii" (April 12, 1918). First published on April 15, 1918, and since republished in numerous sources, e.g. V. Kuchina, comp., *Iz istorii stroitelstva sovetskoi kultury 1917 Moskva 1918* (Moscow: Iskusstvo, 1964), pp. 25-26.

13. N. Punin, "O pamiatnikakh," in *Iskusstvo kommuny* (Petrograd, 1919), No. 14, pp. 2-3.

14. The occasion for this was the exhibition *5x5 = 25* to which these artists con-tributed five works each. As they made clear from the catalogue statements, they regarded their careers as studio artists finished and looked forward to entering the world of technology and industrial design.

15. "Deklaratsiia Assotsiatsii khudozhnikov revoliutsionnoi Rossi" (1922), trans. in J. Bowlt, ed., *Russian Art of the Avant-Garde* (London: Thames and Hudson, 1988), p. 266.

16. From the First Section of the Charter of the Union of Soviet Writers of the USSR, in *Pervyi Vsesoiuznyi sezd sovetskikh pisatelei 1934. Stenograficheskii otchet* (Moscow, 1934). Trans. in Bowlt, op. cit., p. 296.

17. According to Punin's daughter, Irina Nikolaevna Punina, in conversation with the author, Leningrad, July 5, 1989.

RULERS OF RUSSIA
SINCE 1462

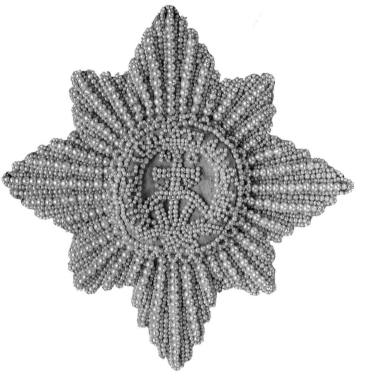

To honor women, Peter the Great chose the name saint of his wife in founding the Order of St. Catherine. Its star features the broken wheel (symbol of St. Catherine's martyrdom), a cross, and the motto "For Love and Country," worked here in pearls (cat 90).

	Born	Ruled[1]
Ivan III	1440	1462-1505
Vasily III	1479	1505-1533
Ivan IV (the Terrible)	1530	1533-1584
Fedor I	1557	1584-1598
Boris Godunov	ca. 1551	1598-1605
Fedor II	1589	1605-1605
Dmitry I[2]	?	1605-1606
Vasily IV (Shuiski)	?	1606-1610[3]
"Time of Troubles"	—	1610-1613
Mikhail Romanov	1596	1613-1645
Aleksey Mikhailovich	1629	1645-1676
Fedor III	1656	1676-1682
Ivan V[4]	1666	1682-1689[5]
Peter I (the Great)[4]	1672	1682-1725
Catherine I	ca. 1684	1725-1727
Peter II	1715	1727-1730
Anna	1693	1730-1740
Ivan VI	1740	1740-1741[6]
Elizabeth	1709	1741-1761
Peter III	1728	1761-1762
Catherine II (the Great)	1729	1762-1796
Paul I	1754	1796-1801
Alexander I	1777	1801-1825
Nicholas I	1796	1825-1855
Alexander II	1818	1855-1881
Alexander III	1845	1881-1894
Nicholas II	1868	1894-1917[7]

PROVISIONAL GOVERNMENT (PREMIERS)

Prince Georgi Lvov	1861	1917-1917
Alexander Kerensky	1881	1917-1917

POLITICAL LEADERS

N. Lenin	1870	1917-1924
Aleksei Rykov	1881	1924-1930
Vyacheslav Molotov	1890	1930-1941
Joseph Stalin[8]	1879	1941-1953
Georgi M. Malenkov	1902	1953-1955
Nikolai A. Bulganin	1895	1955-1958
Nikita S. Khrushchev	1894	1958-1964
Leonid I. Breznev	1906	1964-1982
Yuri V. Andropov	1914	1982-1984
Konstantin U. Chernenko	1912	1984-1985
Mikhail S. Gorbachev	1931	1985-

[1] For tsars through Nicholas II, the year of the end of rule is also that of death, unless otherwise noted. [2] Also known as False Dmitry. [3] Died 1612. [4] Ruled jointly until 1689, when Ivan was deposed. [5] Died 1696. [6] Died 1764. [7] Killed. [8] General Secretary of Communist Party, 1924-53.

ACKNOWLEDGMENTS

Moscow: Treasures and Traditions brings to the American public a 500-year legacy of art and culture from one of the world's great capital cities. Opening at a time when USA-USSR relations are especially strong, the exhibition encourages Americans to deepen and enrich their still newfound knowledge of Moscow's history and artistic traditions. Commensurate with the magnitude of an exhibition that strengthens not only peoples' visual knowledge, but also their appreciation of others who at times have seemed remote, *Moscow: Treasures and Traditions* involved the time and talents of hundreds of individuals.

The spirit of international cooperation characteristic of *Moscow: Treasures and Traditions* is nowhere better represented than among the cultural and museum officials who have worked on this project. Two years ago, Genrikh P. Popov, Chief of the Department of Fine Arts of the USSR Ministry of Culture, and Tom L. Freudenheim, Assistant Secretary for Museums of the Smithsonian Institution, initiated the collaboration by signing an official protocol. Since that time, Zelfira I. Tregulova, Senior Art Historian of the Department of Exhibitions at the Ministry, coordinated activities among the twenty participating Soviet museums and collections with unlimited dedication, intelligence, and perseverance. Her counterpart in the United States, Donald McClelland, Exhibition Coordinator and curator at the Smithsonian Institution Traveling Exhibition Service, directed activities on the American side. Every facet of *Moscow: Treasures and Traditions* came under his supervision, and the efforts of all involved were made stronger by his guidance. At every stage Mr. McClelland benefited from the administrative talents of Gregory Naranjo and Katherine Hudgens, who handled myriad exhibition details with great skill and dedication.

In shaping the exhibition's interpretive character, Mr. McClelland worked closely with Sally Hoffmann, an educator whose intimate knowledge of and affection for Moscow enriched the catalogue and exhibition script beyond measure. She brought extraordinary insight and diligence to her curatorial labors, creating a special lens through which to understand Moscow and its people.

Soviet Minister of Culture Nikolai N. Gubenko, Andrei L. Anikeev, Chief of the Exhibition Section of the Department of Fine Arts, and their staffs dedicated their efforts to this international collaboration. Within the Ministry, SITES worked most closely with the All-Union Artistic Association named after E. Vuchetich: Alexander Z. Olinov, General Director; Valentin L. Rivkind, Deputy Director; Tatyana S. Abalova, Chief of the Department of Information and Propaganda; and Svetlana G. Dzhafarova, Chief of the Department of Exhibitions.

The Soviet working group for *Moscow: Treasures and Traditions* consisted of: Elizaveta V. Shakurova, Tatyana V. Tolstaya, Alexey K. Levykin, Irina F. Krasnikova, Natalya N. Skornyakova, Nadezhda F. Trutneva, Olga G. Gordeeva, Galina G. Smorodinova, Emma D. Zhuravskaya, Tatyana A. Mozzhukhina, Lydia N. Solovyova, and Zelfira I. Tregulova.

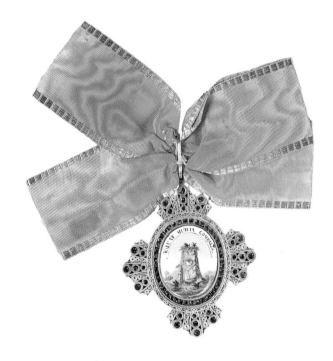

Cross and ribbon of the Order of St. Catherine (cat. 89, obverse).

Our colleagues from the lending museums deserve appreciation in equal measure. Each of these people is a scholar and a teacher, who has made all of us richer by their knowledge and the enthusiasm with which they share it. From the State Museums of the Moscow Kremlin: Irina A. Rodimtseva, Director; Nonna S. Vladimirskaya, Deputy Director of Scientific Work; Victor B. Smorodsky, Deputy Director; Elizaveta V. Shakurova, Chief of the "Armory Chamber" Department; Elena A. Marshakova, Chief of the Section of Russian Metalwork. From the State Tretyakov Gallery: Yuri K. Korolev, General Director; Lydia I. Iovleva, Deputy Director of Scientific Work; Lydia I. Romashkova, Deputy Director and Chief Conservator; Irina F. Krasnikova, Chief of the Depository of Pre-Revolutionary Art; Tatyana P. Gubanova, Senior Expert of Foreign Department. From the State History Museum: Konstantin G. Levykin, Director; Nina A. Asharina, Deputy Director of Scientific Work; Tamara G. Igumnova, Scientific Secretary; Nadezhda F. Trutneva, Chief of the "Novodevichy Convent" Department; Natalaya N. Skornyakova, Senior Scientific Worker of the Department of Fine Arts; Natalaya A. Perevezentseva, Senior Scientific Worker of the Department of Fine Arts. From the State Ceramics Museum at Kuskovo: Elena S. Yeritsyan, Director; Emma D. Zhuravskaya, Deputy Director of Scientific Work; Tatyana A. Mozzhukhina, Chief of the Department of Russian and Foreign Ceramics; Larisa G. Karogodina, Chief of the Department of Soviet Ceramics and Glass; Natalya G. Presnova, Senior Scientific Worker of the "Country Estate" Department. From the State Russian Museum: Vladimir A. Gusev, Director; Yevgeniya N. Petrova, Deputy Director of Scientific Work. And from the Museum of the History of Moscow: Lydia N. Solovyova, Director.

Ostankino Palace-Museum, Moscow; Museum of Fine Arts, Kazan; State Art Museum of Belorussia, Minsk; State Art Museum named after A. Radishchev, Saratov; Museum Apartment of I. Brodsky, Leningrad; Museum of State Porcelain Factory, Dulevo; Regional Museum of Art and History, Serpukhov, graciously lent works of art from their collections. In addition, the private collections of Marianna A. Lentulova, Leonid M. Baranov, Alexander G. Sitnikov, Arkady I. Petrov, Vladimir E. Brainin, and Ivan V. Nikolayev were made available through the generosity of these artists and their families.

Curatorial research proceeded smoothly and unencumbered in part because representatives of the diplomatic corps in both Moscow and Washington, D.C., assisted with myriad details. At the American Embassy in Moscow, Ambassador Jack Matlock and his wife, Rebecca, as well as Cultural Attache Rosemary DiCarlo were particularly helpful. At the Soviet Embassy in Washington, Ambassador Yuriy V. Dubinin and his wife, Liana, as well as Minister-Counselor Yevgeniy G. Kutovoy and Counselor of Cultural Affairs Aleksandr P. Potemkin gave generously of their time throughout the planning stages.

Moscow: Treasures and Traditions represents an enormous achievement in international cooperation and in cultural creativity. Yet the degree to which those goals may be accomplished depends to a significant extent on financial support. The Boeing Company enabled the idea of *Moscow: Treasures and Traditions* to become a reality. Its sponsorship has extended far beyond the exhibition itself, encompassing scholarly symposia about Moscow past and present, direct involvement on the part of Soviet curators in exhibition-related programs, and the creation of posters and teacher materials for schools. The corporate leadership of Frank Shrontz, Chairman and Chief Executive Officer; Harold Carr, Vice President, Public Relations and Advertising; Fred L. Kelley, Manager, Corporate Communications; and David Jenks, Creative Director, Corporate Communication Design, has brought extraordinary commitment to this project.

The same positive spirit that has characterized Boeing's involvement is reflected in the Seattle Organizing Committee of the 1990 Goodwill Games, which together with SITES presents *Moscow: Treasures and Traditions* to the American public. The 1990 Goodwill Games mirror the exhibition as a symbol of international cooperation and as an acknowledgment of the riches that nations may bequeath to one another in times of peace. These ideals have served as guideposts for the SOC, and it has been a pleasure to work with Seattle Organizing Committee on the planning of landmark events in sports and culture: Rev. William J. Sullivan, Chairman of the Board; Bob Walsh, President; Kathy Scanlan, Executive Vice President; Jim Lowe, Vice President, General Counsel; Jarlath Hume, Vice President, Community Relations; and Mary Lui, Finance Officer. SITES worked most closely with the Seattle exhibition staff: C. David Hughbanks, Director; Nancy Tonkin, Assistant to the Managing Director; Kelly Brandon, Exhibition Design Architect; Michael Whittle, Operations Manager; Nan Hall, Media Relations; Evelyn Klebanoff, Registrar; Janine LaVoie, Group Sales Manager; and Jeri McDonald, Public Relations Consultant. The Goodwill Arts Festival staff was also involved with planning and presentation: Norm Langhill, Executive Producer; Paul Schell, Co-Chair; Jane Carlson Williams, Co-Chair; Roberta Katz, Legal Advi-

sor; and Anne Focke, Arts Advisor. James Ellis, Chairman of the Board, Washington State Convention and Trade Center, and his staff assisted with the logistics of installing the exhibition in Seattle.

The University of Washington Press was an early partner in the publication of this book, which provides a cultural and historical context for the artworks in the exhibition. The commitment of Donald R. Ellegood, Director, and his staff to broad distribution of this book helped shape its presentation. The willingness of our eight Soviet and four American authors to share their academic expertise is testimony to their dedication to the subject areas of Russian history and art history they know best.

Moscow: Treasures and Traditions was shown in Seattle under the auspices of the Seattle Art Museum in June 1990 and at the Smithsonian Institution in November 1990. Both institutions share a tradition of excellence in bringing to museum visitors of all ages and backgrounds insights and information about world cultures. Yet many aspects of museum exhibitions involve work that public audiences in fact never see. It therefore is a special pleasure to close by acknowledging the contributions of many individuals from both institutions whose work has been fundamental to the presentation of *Moscow: Treasures and Traditions*. From the Seattle Art Museum: Jay Gates, Director; Patterson Sims, Associate Director for Art and Exhibitions and Curator of Modern Art; Julie Emerson, Associ-

ate Curator of Decorative Arts; Michael McCafferty, Exhibitions Designer; Gail Joice, Museum Registrar and Associate Director for Museum Services; Jacci Thompson-Dodd, Public Affairs Officer; Scott Charles, Associate Director for Finance and Development; and Jill Rulkoetter, Head of Education.

From the Smithsonian Institution, the directors and staffs of: the Office of Exhibits Central, Office of Procurement and Property Management, Office of Plant Services, Security Office, Smithsonian National Associate Program, Resident Associate Program, Special Events, and Visitor Information and Associates' Reception Center. And at SITES itself: Assistant Director for Administration Linda Bell and Administrative Manager Allegra Wright, Head Registrar Lee Williams and her staff, Public Relations Director Liz Hill, and Executive Assistant Diane Stewart.

SITES is gratified and deeply honored to participate in an international exchange that highlights not only a nation's artistic treasures but also shares in the fullness of a people's cultural heritage.

Anna R. Cohn
Director
Smithsonian Institution
Traveling Exhibition Service

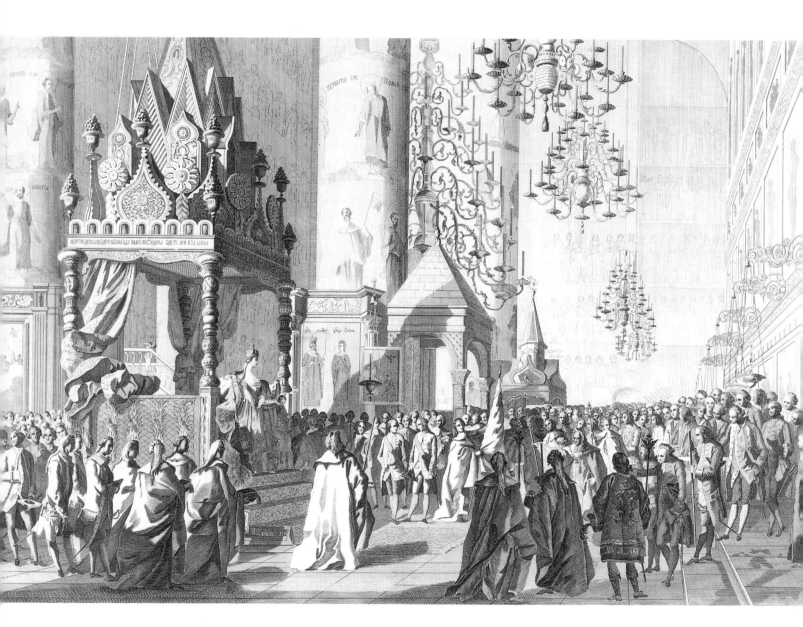

***T**he Scene in Assumption Cathedral. Catherine II After the Coronation Ceremony Before the Departure to Archangel Cathedral.* Although the court and capital had moved to St. Petersburg, the most important state ceremonies were still solemnized in the Kremlin. In 1762 Catherine II, in the presence of the church hierarchy, the aristocracy, and deputies, placed the imperial regalia upon herself—the crown, the purple mantle, and the Order of St. Andrew. With scepter and orb in hand, she prepares to pray at the tombs of the grand dukes and tsars of Russia (cat. 150).

CATALOGUE
OF THE EXHIBITION

Measurements are given in centimeters unless indicated otherwise; height precedes width precedes depth. The abbreviations *h* (height), *w* (width), *d* (diameter), and *l* (length) have also been used where appropriate.

An asterisk (*) preceding entry text indicates that this is the first publication of the material.

For the benefit of the general reader, a slightly modified Board of Geographical Names transliteration system has been employed throughout the catalogue, except for names already well known in English. In the last name "Alekseev," for example, a *y* has been inserted (Alekseyev) to ensure proper pronunciation.

In this checklist, the names of museums that lent works to the exhibition have been abbreviated as follows. The object's inventory number, assigned according to each museum's cataloguing system, appears after the abbreviation.

AMB	State Art Museum of Belorussia in Minsk
DFM	Dulevo Factory Museum named for the newspaper *Pravda*
HM	State Historical Museum
MAB	Apartment-Museum of I.I. Brodsky in Leningrad
MC	USSR Ministry of Culture
MCK	State Museum of Ceramics and 18th-Century Estate of Kuskovo
MFAK	Museum of Graphic Arts of the Tatar People in Kazan
MHM	Museum of the History of Moscow
MMK	State Museum of the Moscow Kremlin
OPM	Ostankino Palace-Museum
RAMV	Regional Art Museum, Ulyanovsk
RM	State Russian Museum
SAM	Saratov State Art Museum named after Radishchev
TG	State Tretyakov Gallery

Material in these entries is based upon information provided by scholars at the following institutions in the Soviet Union. Their generosity with their research is greatly appreciated.

All-Union Artistic Association named after E. Vuchetich: S.G. Dzhafarova, Z.I. Tregulova; Museum of the History of Moscow: Z.I. Bakhtina, I.M. Katsman; Ostankino Palace-Museum: V.A. Rakina; State Historical Museum: T.S. Aleshina, O.G. Gordeeva, I.L. Kyzlasova, N.A. Perevezentseva, L.Yu. Rudneva, S.Yu. Samonin, N.N. Skornyakova, G.G. Smorodinova, N.F. Trutneva; State Museum of Ceramics and 18th-Century Estate of Kuskovo: L.G. Karogodina, T.A. Mozjukhina, N.G. Presnova; State Museum of the Moscow Kremlin: I.A. Bobrovnitskaya, I.D. Kostina, A.K. Levykin, N.D. Markina, E.A. Marshakova, M.V. Martynova, V.A. Menyailo, V.M. Nikitina, E.Ya. Ostapenko, E.V. Shakurova, I.I. Vishnevskaya; State Russian Museum: V.P. Knyazeva, G.K. Krechina, A.B. Lyubimova, O.N. Shikhireva, E.I. Stolbova; State Tretyakov Gallery: I.F. Krasnikova, G.V. Sidorenko; L. Andreeva, author

1. The Miracle of St. George and the Dragon

Novgorod, late 15th-early 16th century
Wood, gesso, tempera
82 x 63
TG; No. 12036
Acquired from I.S. Ostroukhov Museum of Icons and Paintings in 1929
Illustrated p. 66

Among the tales of St. George's miracles is his struggle with the dragon, a symbolic image of the triumph of good over evil. In ancient Russia, he was considered the patron saint of the prince and his consorts. During the reign of Grand Prince Ivan III in the mid-1400s, the image of St. George on horseback defeating the dragon became the coat of arms of the prince, and subsequently of the Moscow state.

2. The Virgin of Vladimir

Moscow, late 15th-early 16th century
Wood, gesso, tempera
40 x 33
MMK; No. Zh-1421
Originally found in side chapel dedicated to St. Nicholas the Miracle-worker, Cathedral of the Annunciation, Moscow Kremlin
Illustrated p. 73

*Distinguishing this icon from its revered prototype—the Virgin of Vladimir icon of the late 11th to early 12th century—is the placement of the hands, the tilt of the head, and the direction of Mary's gaze. This particular composition first appeared in a group of works by Andrey Rublev after Grand Prince Vasily Dmitrievich brought the original icon to Moscow in 1395.

3. The Life of St. Sergius of Radonezh

Moscow, 2d quarter of 16th century
Wood, *pavoloka,* gesso, tempera
157.8 x 114.5
TG; No. 20879
Originally found in Old Believers' Chapel on Tokmakov Lane, Moscow
Acquired from I.E. Grabar Central State Studios for Restorational Work in 1934
Illustrated p. 69

St. Sergius of Radonezh (1319-92), born Bartholomew, was one of the highest spiritual authorities of ancient Russia and founder of the Troitsky Monastery (later the Troitse-Sergiev Monastery) near Moscow. Largely thought of as the saint of the Moscow lands, St. Sergius was often portrayed against the background of the Moscow Kremlin as well as the Troitsky Monastery.

4. The Crucifixion with Mourners

*Moscow, 16th century
Wood, gesso, tempera
82 x 67
HM; No. 1090/1264
Illustrated p. 74

5. The Church Militant (The Blessed Army of the Heavenly King)

Moscow, 2d half of 16th century
Wood, *pavoloka,* gesso
41 x 65
MMK; No. Zh-1065
Originally found in burial vault of Grand Prince Sergey Aleksandrovich in Chudov Monastery
Illustrated p. 76

Seen in the right circular panel is "the heavenly city of Jerusalem," which provides a background for this depiction of the Virgin with the Christ Child. At the head of the middle row rides the Archangel Michael. The young horseman behind him has been identified as Ivan IV. The city being consumed by flames may be Kazan, which he had defeated in 1551. Thus, the composition resembles the triumphant military campaign of the first Russian tsar.

6-14. The Entry into Jerusalem

Moscow, 1560s
Wood, gesso, tempera
Mount: silver; filigree, chasing, gilding
Originally found in Deesis and Feast Day rows of iconostasis in side chapel of Annunciation Cathedral, Moscow Kremlin
Illustrated frontis 2

During the 1560s, small side chapels were built and consecrated in the Annunciation Cathedral to commemorate the military campaigns of Ivan the Terrible. Their interiors were decorated with iconostases, such as this one from the Entry into Jerusalem side chapel. Typical of works produced by Moscow court artists during Ivan IV's reign, these two-part icons (no. 10 is a three-part icon) display techniques and styles commonly associated with master painters from Novgorod.

6. The Nativity/Basil the Great

133.4 x 33.8
MMK; No. Zh-1487/1-2

**7. The Presentation at the Temple/
The Apostle Peter**

133.5 x 34
MMK; No. Zh-1488/1-2

In the right-hand section, Simeon the
elder kneels upon an altar with the
Christ Child in his arms; the prophetess
Anna is behind him. The Virgin and
Joseph, who holds sacrificial doves,
appear before him.

8. The Baptism/Archangel Michael

134 x 36.9
MMK; No. Zh-1489/1-2

**9. The Resurrection of Lazarus/
The Virgin**

134 x 34.4
MMK; No. Zh-1490/1-2

**10. The Entry into Jerusalem/The
Savior in Glory/The Transfiguration**

133 x 66.7
MMK; No. Zh-1491/1-2

11. The Crucifixion/John the Baptist

134 x 34
MMK; No. Zh-1492/1-2

Here, the eight-tipped cross with the
crucified Christ is set against a back-
ground of Jerusalem's pink, two-tiered
walls.

**12. The Descent into Hell/
Archangel Gabriel**

134 x 37.2
MMK; No. Zh-1493/1-2

Standing in an aureole at the gates of
Hell, Christ takes Adam by the hand.
The prophets Solomon, David, Daniel,
and John the Baptist appear above. To
the right, the forefathers, led by Moses
and Abel, are seen behind the kneeling
Eve.

13. The Ascension/The Apostle Paul

134.5 x 34.3
MMK; No. Zh-1494/1-2

**14. The Descent of the Holy Spirit
on the Apostles/John Chrysostom**

134.5 x 34.3
MMK; No. Zh-1495/1-2

**15. The Life of St. Dmitry
of Thessalonica**

Moscow, 1586
Icon: wood, gesso, tempera
Mount: silver; pearl, precious stones;
 chasing, niello, enameling
162 x 88
HM; No. 75304/ok 9106
Originally found in Ipatevsky Monastery
 in Kostroma
Acquired from Kostroma Regional
 Museum in 1933
Illustrated p. 79

Scenes from the life of the saint, who is
portrayed in a full-length pose, are
divided into 16 panels. The icon was

ordered by the boyar Dmitry Ivanovich
Godunov, uncle of Tsar Boris Godunov.
Upon his death in 1606, D.I. Godunov
was buried in the family vault in the
Ipatevsky Monastery.

**16. The Deposition of Christ's Robe
in the Cathedral of the Assumption in
the Moscow Kremlin**

Moscow, ca. 1627
Icon: wood, gesso, tempera
Mount: silver; chasing, niello, gilding
38 x 32
MMK; No. Zh-280/1-2
Originally found in Assumption
 Cathedral, Moscow Kremlin
Illustrated p. 80

On February 1, 1625, a piece of ancient
cloth considered to be part of Christ's
robe was presented by envoys of the Per-
sian Shah Abbas to Tsar Mikhail
Fedorovich Romanov (1613-45) and to
Patriarch Filaret (born Fedor Nikitich
Romanov and first cousin to Tsar Fedor
I). After Russian and Greek authorities
testified to the holy relic's "authenticity,"
it was placed in a bronze reliquary in
the "Lord's Tomb." This icon, whose
painting style is linked to the so-called
Stroganov school, may be one of the
earliest depictions of the scene.

17. The Nativity

Sergey Vasilevich Rozhkov (?-1688),
 Moscow, 1686
Wood, gesso, tempera
40 x 30
HM; No. 514/627

Acquired from Feast Day row of iconostasis in Sophia side chapel, Smolensk Cathedral, New Maiden Convent
Illustrated p. 84

Features of the icon's composition resemble the iconography of the adoration of the Magi. Along the lower panel is inscribed "7194 Sergey of Kostroma painted this." Rozhkov, an icon painter from Kostroma, was a salaried master of the Armory Chamber. He executed imperial commissions, painted and restored icons, created monumental frescoes, and illustrated books.

18. The Intercession of the Virgin

Vasily Ivanov Pakhomov, Moscow, 1690
Wood, gesso, tempera
12 x 70
HM; No. 6452/1492
Acquired from Gate Church of the
 Intercession, Novodevichy Convent
Illustrated p. 85

The inscription "Icon painter Vasily Ivanov, son of Reklo Pakhomov, painted this icon" appears along the lower edge of this baroque-influenced work.

19. The Nativity

Moscow, 1690
Wood, gesso, tempera
112 x 70
HM; No. 6760/1621
Acquired from Local Saints and Patrons
 row of iconostasis in Gate Church of
 the Intercession, Novodevichy
 Convent
Illustrated p. 85

*In technique, this icon resembles works by Kirill Ivanovich Ulanov (?-1731), an icon painter who participated in creating the church's iconostasis. As a salaried master of the Armory Chamber, Ulanov produced icons for the tsar's chambers as well as for cathedrals in the Kremlin and throughout Moscow.

20. The Presentation at the Temple

Moscow, late 17th century
Wood, gesso, tempera
80.5 x 70
MMK; No. Zh-700
Originally found in Feast Day row of
 iconostasis in Ascension Cathedral,
 Ascension Monastery, Moscow
 Kremlin
Illustrated p. 83

*The apocryphal Gospel of St. James, which was written between A.D. 150 and 200, was disseminated throughout Russia before the Mongol invasion and was widely used as a subject by icon painters. Closely adhering to the text, this icon shows Joachim and Anna giving their daughter Mary to the temple under a vow. It is painted in a style then typical of the masters of the Armory Chamber: the body proportions are elongated, the whitewash has a yellowish tint, and the robes are generously gilded. Other elements of the scene were derived from an engraving in the Piscator Bible, published in Amsterdam in 1650.

21. The Washing of the Feet

Moscow, late 17th century
Wood, gesso, tempera
60.5 x 48
MMK; No. Zh-732

Originally found in Passion row of
 iconostasis in Assumption Cathedral,
 Assumption Monastery, Moscow
 Kremlin

*In the late 1600s, master artists of the Armory Chamber often referred to compositions by western European painters and engravers, as was done with this icon based on an engraving from the Piscator Bible of 1650. Instead of conveying the commotion among the apostles in the background, as in the original, the Russian artists portrayed the disciples deep in thought.

22. Christ Before Caiaphus

Moscow, late 17th century
Wood, gesso, tempera
60 x 47
MMK; No. Zh-737
Originally found in Passion row of iconostasis in Assumption Cathedral, Assumption Monastery, Moscow Kremlin

*This work was also based upon an engraving from the Piscator Bible. Its painter, however, significantly modified the composition by placing Christ prominently in the foreground and decorating garments with a leafy design. The soldier holding a sword at the far left was derived from the engraving *Peter's Renunciation*, which further attests to the artist's ingenuity.

METALWORK

23. The Fedorov Virgin

Kirill Ivanovich Ulanov (?-1731),
 Moscow, 1708
Icon: wood, gesso, tempera
Mount: silver; engraving, niello, gilding
23 x 13
HM; No. 1333/347, SA 677
Illustrated p. 87

*According to writing on the reverse of
the middle section, this folding triptych
belonged to the aristocrat M.I. Zasetsky.
Ulanov, to whom this subtle but elegant
icon is attributed, participated in creat-
ing the iconostasis of the Pokrov in Fili
Church as well as other such works. In
1710 he became a monk and received the
name Kornilius.

24. Panagia

Moscow, 1st half of 15th century
Silver, pearl, almandine; casting, chasing,
 carving, gilding, niello
15 (h); 11 (d)
MMK; No. MR-1037
Acquired from Cathedral of the
 Annunciation, Moscow Kremlin
Illustrated p. 90

From the late 1300s into the next cen-
tury, the panagia was associated with the
monastic ritual of the elevation of Our
Lady's bread. A type of traveling pana-
gia, such as this one, was then developed.
Later panagias of the higher clergy were
transformed into small pectoral icons
strewn with precious stones.

25. Censer

Moscow, late 15th century
Silver; chasing, *kanfarenie*, carving,
 gilding
27.5 (h)
MMK; No. MR-1027
Acquired from Cathedral of the Annun-
 ciation, Moscow Kremlin, in 1935
Illustrated p. 30

Russian censers were usually topped by a
cylindrical drum with a rounded head
and a cross, which recalled the appear-
ance of Russian cathedrals. The master
who created this rare piece seems instead
to have been guided by contemporary
examples of Moscow architecture. This
particular censer may have been pro-
duced especially for the Cathedral of the
Annunciation and may have served as a
model for censers made in the 16th and
17th centuries.

26. The Life of Metropolitan Peter

Northern Russia (?), 1st third of 16th
 century
Bone, silver, tin plate; carving, filigree,
 gilding
15.9 x 12.7
MMK; No. DK-132
Acquired from Tsarist Icon Chamber,
 Moscow Kremlin
Illustrated p. 71

With the move of Metropolitan Peter
from Vladimir to Moscow in 1326, Mos-
cow became the spiritual center of old
Russia. The last 7 scenes of this icon,
beginning with Peter's founding of the
Cathedral of the Assumption, focus on
his years in Moscow. Judging from
17th-century documents, this bone relief
may have been a diptych panel with a
representation of the Moscow Metropoli-

tan Aleksey on its other half. This icon
stands out as one of the best examples of
ancient Russian low relief.

27. Altar cross

Kremlin workshops, Moscow, 1562
Gold, precious stones, pearl; chasing,
 filigree, enameling
40 (h); 19 (w)
MMK; No. MR-1194
Acquired from Solovetsky Monastery in
 1922
Illustrated p. 91

An inscription on the cross indicates that
it was made on the order of Ivan IV and
donated to the powerful Solovetsky
Monastery, which was headed by Father
Superior Filipp. The cross' precise date
confirms that it is one of the earliest
extant works produced in the filigree
technique.

28. Basil the Blessed

Moscow, late 16th century
Wood, gesso, tempera, fabric, gold,
 precious stones; chasing, niello
15.3 x 11.5
MMK; No. Zh-1746
Illustrated p. 93

*Basil the Blessed, who lived in Moscow
in the mid-1500s, gained enormous pop-
ularity as an ascetic "holy fool." Even

Ivan the Terrible respected and feared him. After one of the chapels of the Pokrovsky Cathedral was erected over his grave, the church itself became known as St. Basil's Cathedral. Basil was canonized in 1588 during the reign of Tsar Fedor Ivanovich. Consequently, icons of the saint could not have appeared before that date.

29. Descent into Hell

Moscow, 1st half of 17th century
Wood, gesso, tempera, silver, emeralds, rubies, turquoise, glass; chasing, carving, *kanfarenie,* gilding
29.4 x 25
MMK; No. Zh-540/1-2
Acquired from Archangel Cathedral, Moscow Kremlin
Illustrated p. 94

*As part of the cathedral's decoration, central, wall, and pillar iconostases commemorated patron saints as well as princes and tsars of old Russia. This mounted icon complemented larger icons that adorned the burial place of tsars from the Romanov dynasty.

30. Kovsh

Kremlin workshops, Moscow, 1st half of 17th century
Silver; chasing, engraving, gilding
29 (l with handle); 21 (w); 13.5 (h with handle)
MMK; No. MR-8912
Acquired from permanent collection of Armory Chamber
Illustrated p. 105

Kovshi, used during festive banquets to serve mead, were employed as drinking vessels until the late 1600s. Demonstrating the skilled workmanship of Russian silversmiths, highly decorative kovshi were awarded for services performed in civilian and military life.

31. Bratina (toasting cup)

Kremlin workshops, Moscow, 2d quarter of 17th century
Silver; chasing, niello, filigree, *kanfarenie,* gilding
11.5 (h); 12 (d)
MMK; No. MR-4172
Acquired from Sacristy of the Patriarch in 1920
Illustrated p. 95

As early as the late 1500s, gold and silver *bratinas* were used by tsars and boyars as characteristic components of Russian tableware. Their design originated from the earthenware and wooden utensils of peasants. An inscription on this bratina reveals that it was owned by Timofey Vasilevich Izmaylov, a Moscow nobleman noted in documents from 1627 to 1640.

32. Dish

Moscow, mid-17th century
Silver; engraving, gilding
35.6 (d)
MMK; No. MR-441
Acquired from Sacristy of the Patriarch in 1920

The Kremlin court of the Moscow patriarch had its own studios that produced objects for religious ceremonies and for everyday use. According to the decorative inscription engraved in the wide rim, this dish was part of the "private" or personal tableware of Patriarch Yosif.

33. Chalice

Moscow, 1681
Silver; niello, chasing, engraving, *kanfarenie,* gilding
30 (h); 20 (d of cup)
MMK; No. MR-4428
Acquired in 1920s

34. Diskos (paten)

Moscow, 1697
Silver; niello, engraving, *kanfarenie,* gilding
11 (h); 27 (d)
MMK; No. MR-4432
Acquired from Church of the Elevation of the Cross, Moscow, in 1922
Illustrated p. 96

35. Asteriskos

Moscow, 1697
Silver; niello, engraving, *kanfarenie*,
 gilding
14.5 (h); 2.5 (w); 9.5 (d of center)
MMK; No. MR-4963
Acquired from Church of the Elevation
 of the Cross, Moscow, in 1922
Illustrated p. 96

The presentation of magnificent religious
ceremonies required a large number of
splendid liturgical objects, such as this
ensemble of chalice, diskos, and asteris-
kos. In the late 17th century, the highly
decorative ornamentation of gold and
silver objects more closely resembled nat-
ural forms. For example, the portraits of
Moscow saints Aleksey, Peter, Ivan, and
Filipp that grace the asteriskos are
framed by stems and leafy patterns,
which impart a festive spirit to the piece.
The chalice was produced under the
orders of Tsar Fedor Alekseyevich, who
offered it to the Nil Stolbensky
Monastery.

36. Kopie (knife)

Russia, late 17th century
Silver, iron; casting, *obron, kanfarenie*,
 gilding
21.3 (l)
MMK; No. MR-3779
Acquired in 1926

*Used as a knife to cut the Communion
bread, the shape of the *kopie* was
intended to recall the lance that pierced
Christ's side. The deep engraving tech-
nique of *obron* heightens the light-dark
contrast between gilding and niello, and
brings the leafy designs into slight relief.

37. Plate

Yuri Frobos (?), Kremlin workshops,
 Moscow, 1694
Gold, rubies, emeralds; chasing,
 engraving, enameling
15.2 (d)
MMK; No. MR-3365
Acquired from permanent collection
 of Armory Chamber
Illustrated p. 88

An inscription confirms that this plate
was given by Tsaritsa Natalya Kirillovna,
mother of Peter I, to her four-year-old
grandson Aleksey. Its design closely
resembles a gold plate produced by Yuri
Frobos for Tsar Aleksey Mikhailovich in
1675. During his reign the Russian
ruler's coat of arms was formalized, with
a two-headed eagle clutching an orb and
scepter appearing beneath three crowns.
The coat of arms of Siberia, Astrakhan,
Novgorod, Pskov, Tver, Smolensk, and
Kazan, which at various times were
joined to Moscow, adorn the plate's rim.

38. Bowl

Moscow, late 17th century
Silver; gilding, chasing, filigree,
 enameling
16 (d)
MMK; No. MR-1079
Acquired in 1924
Illustrated p. 100

Inside this bowl are enameled scenes
from the Old Testament story of the
unwise king Rehoboam, son of Solomon.

An unusual subject for 17th-century
Russian art, this painting may have
alluded to political events in 1698, when
a revolt threatened the rule of Fedor
Yurevich Romodanovsky, viceroy for
Peter the Great. That this piece belonged
to Romodanovsky is evidenced by the
coat of arms of the Romanov-Starodub
princes on the bottom of the bowl.

39. Bratina (toasting cup)

Moscow, 2d half of 17th century
Silver, coconut shell; enameling
10.5 x 6.9 x 6.9
MHM; No. 16/ok 1074
Acquired from collection of P.I.
 Shchukin

Depictions of Biblical scenes, parables,
and allegories, such as the engraved
scenes of Adam and Eve, the story of the
rich man and Lazarus, and the judgment
of Solomon, characterized Muscovite
woodcarving in the late 1600s.

40. Beaker

Moscow, 1696-97
Silver; niello
19.2 (h)
MHM; No. 82417/ok 13996
Illustrated p. 97

Even though traditional floral patterns
were here replaced by birds, animals,
and clusters of fruit, the disproportion
between miniature beasts and gigantic
flowers lends a fairy-tale quality to the
decoration.

41. Charka (drinking cup)

Petr Ivanov (active 1686–c. 1708),
 Moscow, 1704
Silver; casting, carving, niello, gilding
2.9 (h); 7.2 (d)
MMK; No. MR-5178
Acquired in 1924

Although a decree issued in 1613
ordered objects made of precious metals
to be stamped, the earliest known marks
date to 1651-52. Marks attributed to spe-
cific masters appeared in 1700, while a
double-headed eagle mark, signifying
Moscow, came into use by 1740.

42. Kovsh

Moscow, 1712
Silver; chasing, casting, engraving, niello,
 gilding
12 x 40 x 23.5
MMK; No. MR-1826
Acquired from collection of N.N.
 Boborykin
Illustrated p. 105

On the order of Peter the Great, this
kovsh was granted to the merchant Fedor
Malakhnevsky in appreciation of his ser-
vice. Such gift items were awarded to
merchants for collecting customs duties
and fees, and for thus increasing the sov-
ereign's income. This piece retains the
boat shape of kovshi of the previous
century.

43. Writing set

Petr Ivanov (active 1686–c. 1708),
 Moscow, late 17th-early 18th century
Silver; niello
Inkwell: 9 (h), 5.5 (d); quill pen: 20.9 (l)
HM; No. 18397/ok 650
Acquired from collection of P.I.
 Shchukin

Writing sets similar to this one created
by Petr Ivanov, a salaried master crafts-
man of the silver chamber, could be fas-
tened to a belt and taken on journeys.

44. Gospel

Text: Moscow, 1753
Cover: Ivan Grigorev, workshop of
 Vasily Kunkin (active before 1751–61),
 Moscow, 1755
Silver, velvet, paper; chasing, casting,
 gilding, seal, engraving on copper
47.8 x 30.6
MMK; No. KN-52/1
Acquired from Solovetsky Monastery
 in 1922
Illustrated p. 101

The subjects on the cover of this Gospel
are untraditional and doubtless reflect
the wishes of Archimandrite Gennady,
head of the Solovetsky Monastery, who
commissioned the book. Handwritten
notes attributed to Gennady explain that
the book was purchased in Moscow for 4
roubles and 60 kopecks, and that the
cover was made from contributed mon-
astery silver.

45. Kovsh

Moscow, 1774
Silver
29.5 x 40 x 18.5
MHM; No. 57356/ok 3794
Acquired from collection of Yusupov
 Princes
Illustrated p. 106

Shaped like a *ladya* (an old Russian boat),
this ornate piece was presented in the
Empress' name to the merchant Abram
Vasilev Zubkov for urging the purchase
of drinking houses and "for encouraging
others to engage in commerce."

46. Samovar

Aleksey Ratkov (?-1821), Moscow, 1782
Silver, wood
37.3 (h)
HM; No. 51415/ok 3937
Gift of A.A. Bobrinsky in 1918
Illustrated p. 98

The widespread consumption of tea and
coffee in the 1700s led to the creation of
a whole range of silver tableware, from
samovars and teapots to tea canisters and
sugar bowls.

47. Tureen

Aleksey Kosyrev (active 1747-91),
 Moscow, 1783
Silver; chasing, gilding
19.5 x 23
HM; No. 51256/ok 5445
Gift of A.A. Bobrinsky in 1918
Illustrated p. 99

Peter the Great's reforms affected not only political and economic but also culinary life in Russia. The introduction of new foods and beverages required appropriate tableware. Peter decreed the production of the first table service in 1711; by mid-century the quantity of articles manufactured reached into the thousands.

48. Chalice

E.V. Iskornikov (active 1773-95),
 Moscow, 1795
Silver; enameling
40 (h); 15.3 (d)
HM; No. 77169/ok 9859
Acquired from Donskoy Monastery
 in 1935
Illustrated p. 102

In the late 1700s, the complexity of the baroque style was replaced by the simple shapes and ornamentation of classical art. The influence of ancient models is apparent here in the caryatid figures, bands of acanthus leaves, and palm branches.

49. Flagon

Stepan Dmitrievich Kalashnikov
 (?-ca. 1795), Moscow, 1795
Silver; niello
29.3 (h); 11.1 (d)
HM; No. 347sh/ok 51
Acquired from collection of P.I.
 Shchukin

The open-work of Moscow filigree tracery was largely achieved not through soldering but by being overlaid on smooth metal, such as silver or gold. Tracery with a filigree meshwork of four-petaled rosettes was especially typical in the second half of the 18th century.

50. The Virgin in Search of Sinners Astray

Mount: Matvey Borisovich Kostrov
 (active 1805-09), Moscow, 1805
Wood, tempera, silver; niello
13 x 9.5
HM; No. 80091/ok 11833
Acquired from Museum of Architecture
 in 1939
Illustrated p. 103

A favorite motif for filigree articles in ancient Russia—undulating stems and offshoots—was used in the early 1800s by master artists such as Kostrov, who headed the silversmith's workshop. Colorful foils of gold, green, and red often underlay the open-work ornamentation.

51. Jewelry box

Andrey Vilgelmovich Vekman (active
 1869-80), Moscow, 1869
Silver
12 x 13 x 9
HM; No. 102433/ok 18207
Acquired from State Fund in 1972
Illustrated p. 112

The stylistic development of Russian jewelry combined a revival of forms and ornamental motifs with new subjects derived from the life and customs of the common people. Jewelry and money boxes thus assumed the shape of peasant huts and small houses.

52. Saltcellar

Workshop of Fedor Grigorevich
 Gorbunov (active 1892-1908),
 Moscow, 1892
Silver
13.2 x 12 x 6.5
HM; No. 107220/ok 23216
Acquired from State Fund in 1987

Decorative saltcellars in the shape of high-back stools, modeled on the traditional wooden saltcellars used by peasants, gained popularity in the mid-1800s. An inscription on the top reads, "A meal is not complete without the salt and bread."

53. Pitcher on tray

Factory of Gustav Gustavovich Klingert
 (active 1865-1917), Moscow, 1880-90
Silver, mother-of-pearl; enameling
Pitcher: 17 x 17.7; tray: 26.3 (d)
HM; No. 103173/ok 18367, 18368
Acquired from State Fund in 1974
Illustrated p. 113

Crucial to the development of an indigenous art industry in Russia was the organization and participation of leading firms in national and international exhibitions. Klingert's firm received awards for enameled silverware at world's fairs held in Paris (1889) and Chicago (1893).

54. Icon lamp

Workshop of Ivan Alekseyevich
 Alekseyev (active 1876-1917), Moscow,
 1895
Silver; enameling
9.2 (h); 15.3 (d)
HM; No. 100425/ok 16652
Acquired from State Fund in 1967
Illustrated p. 9

Containing holy oil, icon lamps burned
during church services or while worship-
pers prayed before the icon. They could
be hung or placed on a table or the floor.
Christian symbols, such as doves, boats,
crowns, and crosses, often decorated
ancient icon lamps.

55. Our Lady of Kazan

Mount: Workshop of Aleksandra
 Makhalova, Moscow, 1896
Tempera on panel, fabric, silver, gold,
 enamel, pearls, precious stones
31.5 x 26.8
MHM; No. 105074/ok 22865
Acquired from State Fund in 1980
Illustrated p. 115

The practice of adorning icons with gold
and silver mounts dates to the 1100s. Ini-
tially, mounts covered only the back-
ground and margins of icons, but with
time the increasingly elaborate ornamen-
tation concealed almost the entire
painting.

56. Bratina (toasting cup)

Firm of Pavel Ovchinnikov (1830-88),
 Moscow, 1896
Silver; enameling
17.5 (h)
MHM; No. 78814/ok 11178
Acquired from State Fund in 1937
Illustrated p. 109

Born a serf, Ovchinnikov and his brother
founded a gold- and silverware factory
that prospered from 1853 to 1917. In
1865, his firm, which was internationally
renowned for its applied arts, became the
supplier to the Russian court.

57. Cup and salver

Firm of Pavel Ochinnikov (1830-88),
 Moscow, 1887-90
Silver; enameling
Cup: 12 (h); salver: 14.8 (d)
MHM; No. 105087/ok 22863

The engraved inscription on the salver's
plain medallion indicates that the cup
was awarded as a prize by a Moscow
hunting club.

58. Easter egg

Firm of Ivan Petrovich Khlebnikov
 (active 1870-1917), Moscow, 1899-1908
Silver; enameling
8.5 (h); 5.5 (circum)
HM; No. 78795/ok 11220
Acquired from State Fund in 1937
Illustrated p. 114

Giving richly ornamented Easter eggs
made of stone, ceramic, porcelain, crys-
tal, wood, or precious metals stemmed
from the ancient tradition of distributing
red eggs at Easter time.

59a-h. Wine service

Workshop of Mikhail Yakovlevich
 Tarasov (active 1905-17), Moscow,
 1908-17
Silver
Bucket: 22 (h); ladle: 21.5 (l);
 cups: 7.5 (h each), 5.5 (d each)
MHM; No. 104001/ok 22642-49
Acquired from State Fund in 1977
Illustrated p. 119

Shaped in imitation of a peasant's house-
hold utensils, each of these objects bears
a representation of two Russian warriors
in chain-mail shirts, with helmets,
swords, shields, and maces. A stone for-
tress is silhouetted in the background.
Inspired by Russian ballads, this motif in
a neo-Russian style commonly decorated
silver saltcellars, cigar cases, and wine
services.

60. Beaker

Workshop of Mikhail Goloshchapov
 (active 1883-1917), Moscow, 1912
Silver
13.6 (h); 8.1 (d)
HM; No. 53054/ok 4738
Acquired from collection of P.I.
 Shchukin
Illustrated p. 118

Inscriptions on the beaker attest that it was presented to "the industrial-commercial association of P.M. Ryabushinsky and Sons" by the artel workers. The Ryabushinsky family was famed as entrepreneurs who owned textile factories, a printing press, and a bank in Moscow.

61. Sugar bowl

Factory of Maria Semenova, Moscow,
 1908-17
Silver; enameling
5.4 (h); 10.2 (d)
MHM; No. 107080/ok 23160
Acquired from collection of A.
 Ostrovsky in 1987
Illustrated p. 117

Maria Semenova owned a silverware factory that had been founded by her father, Vasily Semenov, in 1852. Under her direction, the factory became famous for its brilliantly enameled articles.

62. Kovsh

Sixth Moscow Jewelers' Artel, Moscow,
 1908-17
Silver; enameling
5.5 x 10.5
HM; No. 104909/ok 22790
Acquired from State Fund in 1974
Illustrated p. 107

In Moscow, jewelers' artels, as well as factories and studios, produced numerous pieces in enamels. These artels emerged in the late 1800s, and particularly after the 1905 Revolution.

63. Kovsh

Sergey Ivanovich Shaposhnikov,
 Moscow, 1899-1908
Silver; enameling
HM; No. 83590/ok 14149
Acquired from Moscow Mint in 1952
Illustrated p. 107

Active between 1897 and 1908, Shaposhnikov was a jewelry merchant and a master in the Kremlin silversmith's workshop.

64. Vase

Workshop of Evgeny Andreyevich
 Roshet (active 1897-1908), Moscow,
 early 20th century
Silver; enameling
5.3 x 5.3
HM; No. 107614/ok 23314
Acquired from State Fund in 1988

In their quest for national forms, master jewelers in the late 19th and early 20th centuries turned to the legacy of pre-Petrine Russia and adopted its enamel filigree and painting designs. The flowers on this vase are reminiscent of the painted enamels produced in the town of Usole during the late 1600s.

65. Miter

Olovyanishnikov Firm (active
 1766-1917), Moscow, 1908-17
Silver, semi-precious stones, pearls,
 mother-of-pearl, velvet, fabric;
 enameling
19.5 (h)
MHM; No. 75692/ok 8788
Illustrated p. 116

Cloisonné, one of the most ancient and complicated techniques of enamelwork, entered Kievan Russia from Byzantium. After it fell into disuse during the Tatar invasions, cloisonné experienced a revival in the 19th century among workshops and firms that produced jewelry and ecclesiastical items.

66. Box

Fabergé Firm (active 1842-1917),
 Moscow, 1908-17
Silver; enameling
5.5 x 2.5 x 2
MHM; No. 107257/ok 23224
Illustrated p. 121

The hinged lid of this octagonal silver box bears an image of a boyarin, or nobleman. The box may have been produced in the workshop of Fedor Ruckert, an associate of Charles Fabergé, whose father founded the famous jewelry-making firm in 1842.

67. Cigar case

Fabergé Firm (active 1842-1917),
 Moscow, 1906
Silver, diamonds, sapphires
18.9 x 13 x 4.1
MHM; No. 96515/ok 15421
Illustrated p. 120

A relief of snow-covered fir trees, an old man, and a sleeping girl, all part of the Russian folktale "Morozko" ("Father Frost"), decorates the diamond-studded lid.

68. Box

Fabergé Firm (active 1842-1917),
 Moscow, early 20th century
Silver; enameling
7.9 x 5 x 2.6
MHM; No. 598-CY
Acquired in 1984
Illustrated p. 197

Coinciding with a reevaluation of
ancient Russia's cultural legacy was artis-
tic interest in fairy tales. Even the lead-
ing jewelry firm of Fabergé turned to
Russian folklore in the search for a
national style. A painted miniature based
on *The Tsarevich Ivan on the Grey Wolf*
(1889) by V.M. Vasnetsov adorns the
box's center.

69. Saccos

Kremlin workshops, Moscow, 1589-1605
Brocade, velvet, silver, pearls; weaving,
 embroidery, chasing, braiding, gilding
133 (l)
MMK; No. TK-2254
Acquired from Patriarch's Treasury
 in 1920
Illustrated p. 144

*This bishop's vestment belonged to
Patriarch Job, who was enthroned in
1589. Medallions on the yoke contain
images of Church Fathers and signify
the Byzantine origins of Russian
Orthodoxy. Those portraying Russian
saints testify to the sovereignty and
power of the church.

70. Stole

Embroidery: Moscow, 2d half of 17th
 century
Fabric: western Europe, 17th century
Velvet, satin, gilt thread, spangles, pearls,
 precious stones, silver; weaving,
 embroidery
111 x 33.5
MMK; No. TK-2722
Acquired from Monastery of St. Simon,
 Moscow, in 1918
Illustrated p. 146

*Worn by the Orthodox clergy under
the cope or over the cassock, this red
velvet stole typifies Muscovite hand-
crafts of the late 1600s. Dense patterns
of flowers, leaves, and stems are out-
lined with pearls, while the background
is filled with spangles. Precious stones
incorporated into the embroidery, and
gold and pearl tassels heighten the
impression of festivity.

71. Palitsa (thigh shield)

Embroidery: Kremlin workshops,
 Moscow, 1st half of 17th century
Fabric: western Europe, 17th century
Satin, gold and silver thread, pearls,
 silver; weaving, embroidery
41 x 40
MMK; No. TK-2524
Acquired from Patriarch's Treasury
 in 1920
Illustrated p. 143

*Thirteen half-length figures of saints,
the ensemble of the New Testament
Trinity, and a framed depiction of
Christ's resurrection appear in the cen-
ter of this thigh shield. At each corner
are embroidered symbols of the Evan-
gelists: lion, eagle, ox, and angel.

72. Pair of ecclesiastical cuffs

Embroidery: Kremlin workshops,
 Moscow, 2d half of 17th century
Fabric: western Europe, 17th century
Velvet, satin, pearls, gilt thread, spangles,
 silver; weaving, embroidery
24.2 x 19.2 each
MMK; No. TK-107/1-2
Acquired from Patriarch's Treasury
 in 1920
Illustrated p. 148

*The striking combination of red velvet,
solid seed-pearl embroidery, and gold
spangles, each topped by a small pearl,
is typical of decorative needlework then
produced in the Kremlin workshops.

ARMS AND ARMOR

73. Caftan

Kremlin workshops, Moscow, 1655
Velvet: Italy, 1st half of 17th century
Velvet, satin, glazed canvas, damask,
 cord; weaving
150 (l); 167 (w at hem)
MMK; No. TK-2244
Acquired from Patriarch's Treasury
 in 1920
Illustrated p. 145

Among the few examples of Old Russian
clothing that exist today is this caftan
owned by Patriarch Nikon, a major
religious and political figure in the
mid-1600s. Such loosely cut robes were
worn at home by all levels of society.

74. Shroud

Embroidery: Transfiguration Monastery
 workshop, Moscow Kremlin, early
 20th century
Damask: V.G. Sapozhnikov Textile
 Plant, Moscow, early 20th century
Damask, silk and gold thread, precious
 stones, pearls; weaving, embroidery
316 x 194
MMK; No. TK-3129
Acquired in 1918
Illustrated p. 196

Donation veils, representing a spiritual
appeal to God, are an ancient tradition in
the Russian Orthodox church. Most
common are memorial veils, such as this
shroud for Grand Duke Sergey Aleksan-
drovich, Moscow's governor-general who
was assassinated in 1905. Artist V.M.
Vasnetsov may have designed it.

75. Helmet

Moscow, 1557
Steel; forging, chasing, gold incising
18.3 (d)
MMK; No. OR-9.4681 ochr
Illustrated p. 122

Once property of the three-year-old
Tsarevich Ivan Ivanovich, this helmet is
a rare example of traditional armor
worn in the 10th to 16th centuries. The
slender, decorative top identified the
warrior on the battlefield, while the
apertures along the rim held a soft lining
as well as the nose guard and the
barmitsa, a mail protection worn over
the face, neck, and shoulders.

76. Pantsyr (shirt of chain mail)

Moscow, 17th century
Iron; forging
79 (l)
MMK; No. OR-4749
Illustrated p. 127

Pantsyr derives from Greek for "iron."
It came into use in the 15th century to
distinguish it from the heavier *kolchuga.*
The flat rings of the chain-mail pantsyr
were held together with integral pins,
while the interlinked rings of the
kolchuga were fastened by nails.

77. Musket

Armory workshops, Moscow, early 17th
 century
Damask steel, iron, wood, mother-
 of-pearl; forging, engraving, chasing,

inlaid work
161 (total l); 125.4 (barrel)
MMK; No. OR-414/1-2
Illustrated p. 127

Highly valued in the 1600s were damask
steel barrels forged in Turkey, such as
this one. (The breech of the barrel bears
three medallions with "Made by Akh-
mat" engraved in Arabic.) Pervusha
Isaev, an outstanding gunmaker known
for his efficient flintlocks, may have
made this lock for the tsar's sporting
gun.

78a-b. Saddle pistols

Armory workshops, Moscow, late 17th
 century
Iron, steel, silver, wood; forging,
 engraving, wood and metal carving,
 gilding, enameling
63 (each total l); 44.4 (each barrel); 11 m
 caliber
MMK; No. OR-2834/1 2

Firearms became an integral part of a
horseman's military or hunting equip-
ment in the 1600s. The rich ornamenta-
tion of griffins and double-headed eagles
suggests that these pistols belonged to a
member of the Romanov dynasty and
perhaps to the tsar himself.

79. Cuirass

Nikita Davydov (active 1613-64),
 Armory workshops, Moscow,
 mid-17th century
Steel, copper; forging, chasing, etching,
 engraving
40 (h)
MMK; No. OR-127/1-2
Illustrated p. 124

According to a 1687 inventory of the
royal depository of arms, this coat of
armor was made by Nikita Davydov.
The highly proficient craftsman was
summoned to Moscow in 1613 and
worked in the Kremlin's armory work-
shops for over fifty years.

80. Saber with scabbard and belt

Armory workshops, Moscow, 17th
 century
Steel, silver, leather, pearls, tape; forging,
 engraving, gilding, niello
98.5 (total l); 87.5 (blade); 92.3 (scabbard)
MMK; No. OR-141/1-3
Illustrated p. 125

The saber evolved from a weapon com-
monly owned by nomadic peoples on the
borders of Old Russia to the principal
weapon used by Russian soldiers in
hand-to-hand combat. Sabers with dam-
ask steel blades, whether imported or
forged with steel from Oriental coun-
tries, were highly valued for their
resiliency.

81. Ambassador's axe

Armory workshops, Moscow, mid-17th
 century
Gold, silver, damask steel, turquoise;
 forging, chasing, gold incising, gilding
126 (total l)
MMK; No. OR-2241
Illustrated p. 128

Although they resembled the principal
weapon of the Russian warrior, ambassa-
dor's axes held ceremonial rather than
military importance. During the 1500s
and 1600s, the tsar's honor guard, the
rynda, carried them during receptions
of foreign dignitaries and similar state
occasions.

82a-c. Saadak

Armory workshops, Moscow, 1675
Leather, silver, gold, gold and silver
 thread, satin, gems; embroidery,
 carving, casting, gilding, enameling
70.4 (bow case l); 42 (quiver l)
MMK; No. OR-147/1-3
Illustrated p. 126

The *saadak* originally consisted of a long
bow, bow case, arrows, and quiver, but
the term now refers only to the bow case
and quiver. This ceremonial saadak was
presented to Tsarevich Fedor Alekse-
yevich (1661-82) during Easter week, a
time when gifts of arms and armor were
traditionally offered to members of the
royal family.

83. Chervonets (gold coins)

Moscow, 1687-89
Gold; chasing
20 mm (d)
MMK; No. H-4318
Illustrated p. 134

In the late 17th century, Kremlin work-
shops and the mint produced thousands
of gold pieces, such as these awarded to
all who had participated in the Russian
army's campaigns against the Crimean
khanate in 1687 and 1689.

84. Medal "In Memory of the Seizure of Schlisselburg"

Fedor Alekseyev, Moscow, early 18th
 century
Silver; chasing
70 mm (d)
MMK; No. OM-66
Illustrated p. 134

*Based on a print by the Dutch engraver
Adrian Schonebeck (1661-1709?), this
medal commemorates the Russian
army's success in recovering territories
from Sweden. It also documents works
by the first generation of Russian
medalmakers. A portrait of young Tsar
Peter I appears on the obverse.

85. Medallion

Grigory Mussikisky (1670/71?-1737),
 Russia, early 18th century
Gold, copper; painting on enamel
35 x 30 mm
MMK; No. MR-9062
Acquired from Moscow Archives of
 Foreign Office in 1853
Illustrated p. 25

This badge, with a certificate of merit dated May 23, 1722, was granted by Peter the Great to Vasily Frolov, the ataman (chieftain) of a Cossack army. Upon Frolov's death in 1723, the medallion, minus its expensive mounting, was returned to the Foreign Office.

86. Cross and ribbon of the Order of St. Andrew the First-Called

Russia; cross: 1st quarter of 18th
 century; ribbon: mid-19th century
Gold, casting, chasing, engraving,
 enameling; moiré ribbon, weaving
Cross: 71 x 49 mm; ribbon: 100 x
 1240 mm
MMK; Nos. OM-1256, OM-2422
Illustrated p. 43

Since the earliest Christian princes of Kiev, St. Andrew was claimed as Russia's apostle. This cross, according to tradition, belonged to the founder of the Order of St. Andrew, the emperor Peter the Great.

87. Star of the Order of St. Andrew the First-Called

Russia, 18th century
Silver, gold and silver thread, silk, paper;
 embroidery
120 mm (d)
MMK; No. OM-2390
Illustrated p. 135

In the 1700s to the mid-1800s, those awarded the Order of St. Andrew

received embroidered stars such as this. Forged silver or gold stars with enamel decoration were presented after July 1854. The order's motto, "For Faith and Fidelity," is inscribed along the medallion's frame.

88. Chain of the Order of St. Andrew the First-Called

Russia, late 18th century
Gold; stamping, engraving, enameling
1435 mm (l)
MMK; No. OM-2407
Acquired from Department of Imperial
 Orders
Illustrated p. 135

This chain consists of twenty-three links of three alternating kinds: a double-headed eagle, a cartouche with Peter I's monogram, and a rosette with a saltire cross. It belonged to Empress Maria Fedorovna (1759-1828), wife of Emperor Paul I.

89. Cross of the Order of St. Catherine of the First Class, and bow

Russia, 2d half of 19th century
Gold, silver, diamonds, stamping,
 painting on enamel; moiré ribbon,
 weaving
Cross: 107 x 70 mm; ribbon: 45 mm (w)
MMK; No. OM-1261/1-2
Acquired from Department of Imperial
 Orders
Illustrated p. 136, obverse p. 239

Between the arms of the painted cross are the letters *DSFR,* which stand for the Latin phrase "God save the King." An inscription on the obverse reads *Aequant*

munia comparis, "In her labors equal to her husband," in reference to Empress Catherine I, wife of Peter the Great.

90. Star of the Order of St. Catherine of the First Class

Russia, 2d half of 18th century
Pearls, silk, paper; embroidery
98 mm (d)
MMK; No. OM-2219
Illustrated p. 237

*The star, whose medallion is inscribed with the order's motto of "For Love and Country," belonged to Empress Catherine II (1729-96).

91. Cross and ribbon of the Order of St. Alexander Nevsky

St. Petersburg, late 18th-early 19th
 century
Gold, silver, glass, stamping, painting on
 enamel; moiré ribbon, weaving
Cross: 196 x 71 mm; ribbon: 98 x 1660
 mm
MMK; Nos. OM-2311, OM-2312
Acquired from Department of Imperial
 Orders
Illustrated p. 132

*A painted image of Alexander Nevsky on horseback adorns the center. The obverse bears the saint's monogram beneath a princely crown. These insignia belonged to Empress Elizaveta Alekseyevna (1779-1826), wife of Alexander I.

92. Star of the Order of St. Alexander Nevsky

Russia, 1st quarter of 19th century
Gold, silver, metal; forging, gilding, enameling, guilloché
104 mm (d)
MMK; No. OM-2326
Acquired from Department of Imperial Orders
Illustrated p. 137

*"For Labors and Homeland," the motto of the Order of St. Alexander Nevsky, runs along the medallion's enameled border. Emperor Alexander I (1777-1825) owned this star.

93. Cross and ribbon of the Order of St. George of the First Class

St. Petersburg, 1st quarter of 19th century
Gold, stamping, enameling, painting on enamel; moiré ribbon, weaving
Cross: 93 x 68 mm; ribbon: 85 x 1680 mm
MMK; No. OM-2226/1-2
Acquired from Department of Imperial Orders
Illustrated p. 138

*Once belonging to Emperor Alexander I, the center medallion shows St. George on horseback killing the dragon. The cross also bears the mark of St. Petersburg—two crossing anchors and a scepter.

94. Star of the Order of St. George of the First Class

Russia, 2d half of 18th century
Gold; engraving, enameling, *kanfarenie*
82 mm (d)
MMK; No. OM-2225
Illustrated p. 168

*Founded by Empress Catherine II, the Order of St. George had the motto "For Service and Valor." The saint's monogram appears in the medallion's center.

95. Cross of the Order of St. Vladimir of the First Class

Russia, 2d half of 18th century
Gold; stamping, enameling
81 x 61 mm
MMK; No. OM-2240
Illustrated p. 140

*Prince Vladimir (972-1015) was the grandson of Princess Olga and, from 980, ruled as the Grand Prince of Kiev. He was baptized in 988 and introduced Christianity as Russia's official religion, which contributed to the consolidation of the state. The cross belonged to the founder of the order, Catherine II.

96. Star of the Order of St. Vladimir of the First Class

Russia, 2d half of 18th century
Gold, silver; forging, enameling
75 mm (d)
MMK; No. OM-2261

*The center black medallion bears a gold cross with one of the four Cyrillic letters *CPKB* between each pair of arms. The abbreviation stands for the saint's

full title, "Saint Apostolic Prince Vladimir." The order's motto, "Utility, Honor, and Glory," encircles the medallion.

97. Cross of the Order of St. Anne of the First Class, with crown and sword

V. Keibel, St. Petersburg, 1855-74
Gold; stamping, engraving, enameling, guilloché
80 x 50 mm
MMK; No. OM-1276
Acquired from Department of Imperial Orders
Illustrated p. 140

*A painted image of St. Anne in a landscape appears within the central medallion. On the reverse is the Latin abbreviation *AIPF*, which stands for "Anne, the Emperor Peter's Daughter."

98. Star of the Order of St. Anne of the First Class, with crown

V. Keibel, St. Petersburg, mid-19th century
Gold, silver; forging, gilding, engraving, enameling
91 mm (d)
MMK; No. OM-2291
Acquired from Department of Imperial Orders

*Encircling the red cross in the medallion is the motto of the Order of St. Anne: *Amantibus . Justitiam . Pietatem . Fidem* (To Those Who Love Justice, Piety, and Faith).

99a-e. Order of St. George the Victorious service

Gardner Factory, 1778
Designed by G. Kozlov
Porcelain; overglazed, gilding
Acquired from State Hermitage
 Museum (except 99d)
Illustrated p. 169

Catherine the Great ordered three ser-
vices for the palace banquets that were
held for the knights of the orders of St.
George, St. Andrew, and St. Alexander
Nevsky. This service was first used in
1778 on the feast day of St. George to
commemorate the ninth anniversary of
the order's founding.

All the pieces shown here are marked
in an underglazed blue with a G in
honor of St. George. The star of the
order, as well as its ribbon and badge
interwoven with laurel garlands, appears
on each piece.

a. Oval basket
 9.2 (h); 29.8 x 20.8 (top)
 MCK; No. F-R 3926

b. Leaf-dish
 25.3 x 25.8
 MCK; No. F-R 6485

c. Small leaf-dish
 18.8 x 7.4
 MCK; No. F-R 4044

d. Soup plate
 24 (d)
 MCK; No. F-R 2110
 Acquired from former Central
 Stroganov Artistic-Industrial School,
 Moscow, in 1922

e. Custard cup with cover
 11.3 (h); 6.2 (d)
 MCK; No. F-R 6487

100. Double saltcellar

Gardner Factory, 1790-1800
Porcelain; overglazed
15.9 (h); 15.7 x 9.4 (base)
MCK; No. F-R 3120
Acquired from collection of A.V.
 Morozov in 1918

The form of this double saltcellar
derived from the Meissen Factory in the
1760s. While this is identical to its Ger-
man model, such pieces were altered
slightly for the Russian market. Instead
of a figure in German dress, a Russian
man in clothing characteristic of a mer-
chant appears here.

101. Cup and saucer with portrait of M.I. Kutuzov

Gardner Factory, 1815-25
Porcelain; overglazed, gilded
Cup: 11.4 (h), 7.2 (d); saucer: 13.7 (d)
MCK; No. F-R 11103
Acquired from collection of A.V.
 Morozov in 1918
Illustrated p. 139

Painted in an oval medallion on the cup
is the profile of Mikhail Illarionovich
Kutuzov (1745-1813), the general field
marshal who defeated Napoleon in
October 1812.

102. Cup and saucer with military scene

Gardner Factory, 1820s
Porcelain; underglazed covering,
 overglazed design, gilding, *tsirovka*
Cup: 9.7 (h); saucer: 14.3 (d)
MCK; No. F-R 7280
Acquired from State Museum Fund
 in 1925
Illustrated p. 170

A rectangular medallion on the cup
illustrates a fight between a Russian hus-
sar and a French uhlan. Empire-style
ornamentation enlivens the cobalt blue
background.

103a. Sugar bowl

Gardner Factory, late 1820s
Porcelain; overglazed, relief, gilding
18.6 (h); 12.1 (inside d)
MCK; No. F-R 10412
Acquired from collection of A.V.
 Morozov in 1918
Illustrated p. 167

103b. Cup and saucer

Gardner Factory, late 1820s
Porcelain; underglazed, relief, gilding,
tsirovka
Cup: 7.8 (h); saucer: 13 (d)
MCK; No. F-R 8269
Acquired from collection of A.V.
 Morozov in 1918
Illustrated p. 186

Scenes of rural life, such as a country
round dance and children playing with a
kite, decorate this sugar bowl and cup
and saucer. The Gardner Factory,
founded in 1766 by the English mer-
chant Francis Gardner, was purchased by
M.S. Kuznetsov in 1891 and is now
called the Dmitrov Porcelain Factory.

103c. Cup and saucer with portrait of a messenger

Gardner Factory, 2d half of 1820s
Porcelain; overglazed, *krytie,* gilding,
tsirovka
Cup: 11.5 (h); saucer: 18.3 (d)
MCK; No. F-R 11052
Acquired from Art Museum of
 Rogozhsky-Simonovsky Region of
 Moscow in 1925

A uniformed messenger traveling with a
coachman and horses appears inside the
rectangular medallion. The image is
based upon a lithograph by A.O.
Orlovsky.

104-108. Figures from the Magic Lantern service

Gardner Factory, 1820s
Porcelain; overglazed, gilding
Acquired from collection of A.V.
 Morozov in 1918

This series of figures derived from
sketches in the illustrated journal "The
Magic Lantern, or Spectacle of Peters-
burg Vendors, Masterworkers, and other
Simple Tradesmen Walking, with a True
Brush to the Actual Dress and Presented
Conversing with Each Other, Corre-
sponding to Each Person and Calling."
Between 1820 and 1830, the Gardner
Factory produced these figures in differ-
ent colors and with variously decorated
bases. These particular pieces date from
the early 1820s, when the figures were
distinguished for their individuality and
accurate depiction.

104. A Dvornik (Doorkeeper)

16.8 (h); 5.7 x 5.6 (base)
MCK; No. F-R 6003
Illustrated p. 171

105. A Coachman

18.7 (h); 4.8 x 4.5 (base)
MCK; No. F-R 2591

106. A Blini Vendor

18 (h); 5.2 x 4.5 (base)
MCK; No. F-R 6340

107. A Glass Seller

18.8 (h); 6.1 (d of base)
MCK; No. F-R 5703

108. A Peasant Woman with a Basket of Berries

17 (h); 5.5 (d. of base)
MCK; No. F-R 5709

109. Inkstand with Russian cossack motif

Popov Factory, 1820s
Porcelain; overglazed, gilding, silvering
21 (h); 12.5 x 8.8 (base)
MCK; No. F-R 5532
Acquired from collection of A.V.
 Morozov in 1918

*Based upon a model from the Emper-
or's Porcelain Factory, this inkstand
consists of a drum and a Russian cos-
sack officer sitting on the base of a can-
non. Military medals from the Order of
St. George the Victorious and the War
of 1812 adorn his chest.

110a-d. Tea and coffee service

Popov Factory, 1820s
Acquired from Central Repository, State
 Museum Fund, in 1927
Illustrated p. 10

A bird motif enlivens several of the pieces in this overglazed and gilded porcelain service. An Empire-style ornamentation of gold lyres in wreaths, flowers, and bows and arrows adds to the service's elegant appearance.

a. Coffee pot
 25.5 (h); 9 (d of base)
 MCK; No. F-R 8501

b. Sugar bowl
 16.6 (h); 11 (d)
 MCK; No. F-R 9618

c. Creamer
 18.5 (h); 7.5 (d of base)
 MCK; No. F-R 10284

d. Cup and saucer
 Cup: 6.7 (h), 7.3 (d); saucer: 12.8 (d)
 MCK; No. F-R 3843

111. A Peasant Woman with a Basket of Mushrooms

Popov Factory, 1840s
Porcelain; overglazed, gilding
18.8 (h); 6.2 (d of base)
MCK; No. F-R 1767
Acquired from Bureau of Foreign
 Service in 1941
Illustrated p. 171

112. A Peasant Woman Dancing

Popov Factory, 1840s
Porcelain; overglazed paint
16.8 (h); 8.2 (d of base)
MCK; No. F-R 10161
Acquired from collection of A.V.
 Morozov in 1918

113. A Peasant with a Balalaika

Popov Factory, 1840s
Porcelain; overglazed paint, gilding
17 (h); 7.5 x 5.3 (base)
MCK; No. F-R 2616
Acquired from collection of A.V.
 Morozov in 1918

114. Vase

Popov Factory, mid-19th century
Porcelain; overglazed, *krytie,* gilding
44.5 (h); 16 (d)
MCK; No. F-R 11180
Acquired from First Proletarian
 Museum of Moscow in 1923

*The Popov Factory was purchased by A.G. Popov, a merchant, in 1811. After Popov's death in the 1850s, the factory was transferred to his children and then to several owners in the next decade. It was finally closed in 1875.

115. Covered tankard and saucer depicting Pokrovsky Church

Popov Factory, mid-19th century
Porcelain; *krytie,* overglazed design, gilding
Cup: 12.8 (h); saucer: 17 (d)
MCK; No. F-R 3851
Acquired from collection of A.V.
 Morozov in 1918

*Pokrovsky Church (now called St. Basil's Cathedral) on Red Square appears on the tankard, while multicolored bouquets of flowers enliven the saucer and lid.

116. Covered cup and saucer depicting Red Square and the Resurrection Gates

Popov Factory, mid-19th century
Porcelain; *krytie,* overglazed design, gilding
Cup: 15 (h); saucer: 15.2 (d)
MCK; No. F-R 6956
Acquired from collection of A.V.
 Morozov in 1918
Illustrated p. 183

*On the cup is a view of Red Square with the Resurrection Gates, which marked the entrance to the Kitai gorod, one of the oldest sections of Moscow. Its stone walls were built from 1535 to 1538; the gate itself was constructed in 1680. In the 1790s, a chapel was built next to the gate to house the highly revered icon of the Iverian Mother of God.

117a-c. Tea service

Safronov Factory, late 1830s-1840s
Porcelain; overglazed design, *krytie,* mastic, gilding
Acquired from State Museum Fund
 in 1923
Illustrated p. 173

The Safronov Factory was founded in 1814 by A.T. Safronov. In the 1860s, it came into the possession of S.T. Kuznetsov.

a. Teapot
 20 (h); 8.8 (inner d)
 MCK; No. F-R 8539

b. Cup and saucer
 Cup: 6.4 (h); saucer: 14 (d)
 MCK; No. F-R 4346

c. Cup and saucer
 Cup: 6 (h); saucer: 13.9 (d)
 MCK; No. F-R 8541

118. Decorative plate, 1873

Evdokin Alekseyevich Egorov (1832-91)
Porcelain; overglazed, gilding
45 (d)
MCK; No. F-R 468
Acquired from Polytechnical Museum in
 1935

*The Polytechnical Exhibition, which is
commemorated here, was organized in
Moscow in 1872 to mark the 200th
anniversary of Peter the Great's birth
and to celebrate advances in science,
technology, and agriculture.

119. Cup and saucer depicting Russian countryside

Factory of M.S. Kuznetsov, 1912
Porcelain; underglazed, gilding, stamped
Cup: 5.3 (h); saucer: 14.5 (d)
MCK; No. F-R 2847
Acquired from *Pravda* Dulevo Porcelain
 Factory in 1928
Illustrated p. 174

Scenes of a Russian village, its cottages
decorated with gingerbread woodcarv-
ings, embellish the cup.

120. Cup and saucer depicting a folk musician

Factory of M.S. Kuznetsov, 1900
Porcelain; underglazed, gilding

Cup: 5.8 (h); saucer: 14 (d)
MCK; No. F-R 2834
Acquired from *Pravda* Dulevo Porcelain
 Factory in 1928

A folk musician playing a gusli in an
evening landscape appears on one side
of the cup. On the other side and on the
saucer are landscapes with pine trees,
behind which stand the fortress walls,
cupolas, and towers of ancient Russian
towns. Founded by T.Ya. Kuznetsov in
1832, the factory that produced these
pieces is now called the *Pravda* Dulevo
Porcelain Factory.

121a. Cup and saucer, 1930s

Nikolay Mikhailovich Suetin (1897-
 1954), *Pravda* Dulevo Porcelain
 Factory
Porcelain; overglazed, stenciled
Cup: 5.5 (h); saucer: 14.5 (d)
DFM; No. 7759

121b. Cup and saucer, 1930s

Nikolay Mikhailovich Suetin (1897-
 1954), *Pravda* Dulevo Porcelain
 Factory
Porcelain; overglazed, stenciled
Cup: 5.5 (h); saucer: 14.5 (d)
MCK; No. F-R 1220
Acquired from *Pravda* Dulevo Porcelain
 Factory in 1935

*Suetin emerged as one of the founders
of suprematism when he worked for
the Lomonosov Porcelain Factory in
Leningrad beginning in the 1920s. He
also organized the Soviet pavilions at
the world's fairs held in Paris in 1937
and in New York in 1939.

122. Cup and saucer with suprematist design

Pravda Dulevo Porcelain Factory, 1920s
Porcelain; overglazed, stenciled
Cup: 5.5 (h); saucer: 14.5 (d)
DFM; No. 7759

*The suprematists, including Malevich,
chose to work on porcelain, typically an
industrial material, due to the novelty
of its artistic qualities. This particular
porcelain ware, however, existed mainly
as a model and did not progress to a
more developed level.

123. Plate with suprematist design

Pravda Dulevo Porcelain Factory, 1920s
Porcelain; underglazed, stenciled
23 (d)
DFM; No. 6170

*White porcelain provided an ideal sur-
face for the suprematists' designs,
although its plastic shape, rounded con-
tours, and smooth texture differed
greatly from painting. The sense of cos-
mic space implied in suprematist con-
structions, and the vibrancy of colors,
were further intensified by the porce-
lain's stark whiteness.

124. Cup and saucer with hammer and sickle designs

Pravda Dulevo Porcelain Factory, 1920s
Porcelain; overglazed
Cup: 6.5 (h); saucer: 18 (d)
DFM; No. 3365
Illustrated p. 176

This cup and saucer preserves the traditional forms of Moscow porcelain, with symbols of the Revolution interspersed in the colorful ornamentation.

125. **Woman with Basin on Her Lap,** Model 1925, issued 1932

Aleksandr Terentevich Matveyev
 (1878-1960)
Design by T.S. Zaidenberg
Porcelain; overglazed
15.4 (h)
TG; No. SKS-838
Acquired from Z.Ya. Matveyeva-
 Mostova in 1972

126. **Putting on Slippers,** 1923 (issued 1924)

Aleksandr Terentevich Matveyev
 (1878-1960)
Porcelain; overglazed
18.5 (h)
TG; No. 1-8711
Acquired from the artist in 1926

Matveyev, a sculptor of monumental statues as well as small figures, received a gold medal at the International Exhibition of Decorative Arts in Paris in 1925.

127. **The Thorn,** 1923

Aleksandr Terentevich Matveyev
 (1878-1960)
Porcelain; overglazed
17 (h)

TG; No. SKS-839
Acquired from Z.Ya. Matveyeva-
 Mostova in 1972

Matveyev once remarked that "one has to have a large attitude towards small things." Consequently, his smaller porcelain sculptures retained their singular importance and were not considered accessories to his more monumental compositions.

128a-c. **For the Soviet Metro service,** 1935

Aleksandra Alekseyevna Chekulina
 (b. 1906), Dmitrov Porcelain Factory
Porcelain; overglazed, gilded, stenciled
Acquired through Association of
 Porcelain-Faience Industries, Dmitrov
 Porcelain Factory, in 1936
Illustrated p. 175

*Chekulina entered the Dmitrov Factory as an apprentice at the age of ten, and then worked there for the next 45 years. Known for her delicate ornamental graphics, she won a gold medal at the world's fair in Paris in 1937. This service bears construction scenes of the Moscow subway system, one of the capital city's greatest building projects in the 1930s.

a. Vase
 14.4 (h); 14 (d of base)
 MCK; No. F-R 1070

b. Creamer
 8.5 (h); 6.7 (d of base)
 MCK; No. F-R 4292

c. Cup and saucer
 Cup: 5.5 (h); saucer: 14 (d)
 MCK; No. F-R 8877/ab

129a-c. **The Moscow Woman service,** 1937

Petr Vasilevich Leonov (1910-82),
 Pravda Dulevo Porcelain Factory
Porcelain; overglazed, stenciled
Acquired from artist's studio

*Before becoming the chief artist of the *Pravda* Dulevo Porcelain Factory in 1950, Leonov assimilated into his work the rich tradition of Russian folk art. His vibrant, decorative motifs are reminiscent of Russian fabrics.

a. Teapot with cover
 13.8 (h); 7 (d of base)
 MCK; No. F-R 1607/ab

b. Plate
 18.9 (d)
 MCK; No. F-R 1555

c. Cup and saucer
 Cup: 5.9 (h); saucer: 15.5 (d)
 MCK; No. F-R 737/ab

130a-f. **Tea service depicting "The Tale of the Fisherman and the Fish"**

Petr Vasilevich Leonov (1910-82), *Pravda*
 Dulevo Porcelain Factory, 1935
Porcelain; overglazed, stenciled
Illustrated p. 177

Preparations for the 1937 world's fair in Paris became a major event at the Dulevo Factory and mobilized all of its

creative forces. Leonov combined his artistic talent with his love for Russian folklore to produce this tea service based on "The Tale of the Fisherman and the Fish."

a. Teapot with lid
23 (h); 6.2 x 6.8 (base)
DFM; No. 1498

b. Creamer
11.7 (h); 4.5 x 5 (base)
DFM; No. 1498

c. Tray
33.2 x 44
DFM; No. 5307

d. Sugar bowl
9.5 (h); 5.5 x 6.5 (base)
DFM; No. 5284

e. Cup and saucer
Cup: 8 (h); saucer: 14.5 (d)
DFM; Nos. 1499, 1500

f. Cup and saucer
Cup: 8 (h); saucer: 14.5 (d)
DFM; No. 5306

131a-b. **30th Anniversary of October service**, 1947

E.P. Smirnov (1915-80), Dmitrevsky
 Porcelain Factory
Porcelain; overglazed, gilding
Acquired from Museum of Decorative
 Porcelain in 1952

a. Teapot with cover
13.6 (h); 8.3 (d of base)
MCK; No. FR-11661a, b

*A depiction of the Soviet Army Theater (built 1934-40) fills one side of the teapot. The other side bears the inscription "30th Anniversary of October" written in overglaze.

b. Sugar bowl with lid
12.7 (h); 7.8 (d of base)
MCK; FR-11585a, b

*Illustrations of the Northern Station, built in 1937, and a sickle and hammer with the dates 1917-1947 adorn the bowl.

132a-d. **Woman's festival dress**

Moscow Province, end of 18th century
Illustrated p. 152

*This ensemble of *sarafan,* blouse, and *dushegreya* (jacket) was commonly worn throughout Russia in the 1700s, particularly by those who were not affected by Peter the Great's dress reforms. On holidays, accessories such as this necklace further enlivened the women's costumes.

a. Sarafan
Brocade, gold thread, ribbon
113 (l); 336 (w at hem)
HM; No. 55219 B-412
Acquired from private donor in 1916

b. Blouse
Cotton
37 (l); 66 (l of sleeve)
HM; No. 81922/2 B-3297
Acquired in 1935

c. Jacket
Brocade, gold fringe
62 (l); 68 (l of sleeve)
HM; No. 102108/7 B-3297
Acquired in 1976

d. Necklace
Canvas, mother-of-pearl, glass, silk
 ribbon
25 (l); 17 (w)
HM; No. 77649 B-112
Acquired from private donor in 1935

133. **Kokoshnik (woman's headdress)**

Moscow Province, late 18th-early 19th
 century
Velvet, gold and silver thread, spangles,
 galloon lace, silk ribbon
17 (front h); 7.5 (back h); 28 x 23 (crown)

HM; No. 70488 E-637
Acquired in 1936
Illustrated p. 153

In keeping with ancient customs, married women covered their hair with a scarf or, on festive occasions, with a bright *kokoshnik*. The steep oval shape, red velvet material, and gold embroidery design are typical of kokoshniks worn in Moscow.

134. Head kerchief

*Kolomna, Moscow Province, 1790s
Brocade
106 x 101
HM; No. 84835 D-941
Acquired in 1939

135. Head kerchief

Kolomna, Moscow Province, 1st quarter
 of 19th century
Silk, gold fringe
116 x 115
HM; No. 106494/I D-1540
Acquired in 1984
Illustrated p. 150

*Head kerchiefs with brocaded foliate designs composed of brightly colored leaves, bouquets of flowers, and highlights of gold threads became so popular that large factories specialized in their production. This piece may have been made in the Levin textile factory in Kolomna.

136a-e. Woman's costume

Early in the 19th century, women's fashions adopted a slender and more classical silhouette. Dresses and fans were made of light, semi-transparent fabrics, such as tulle, gauze, and chiffon. In keeping with classical designs, women wore flat slippers with ribbon ties that criss-crossed around the ankle and up the shin. Hair styles, which also mirrored those of ancient Greece and Rome, were adorned with combs.

a. Dress
 Russia, 1810s
 Batiste, silk, cotton thread, lace
 116 (l in front)
 HM; No. 70488 B-394
 Acquired in 1921
 Illustrated p. 156

b. Slippers
 Russia, 1820s-30s
 Silk, gold thread, embroidery, leather
 24 (l); 4 (h)
 HM; No. 71840 Zh-103 a,b
 Acquired in 1931
 Illustrated p. 158

c. *Comb
 Tula, 1st half of 19th century
 Steel; filigree, chasing, engraving
 14 x 20
 HM; No. GMS-6696 shch K-31
 Gift of P.I. Shchukin in 1905-11
 Illustrated p. 158

d. Shawl
 Western Europe, 1st quarter of 19th
 century
 Wool, silk
 14 x 272
 HM; No. 106479 D-1543
 Acquired in 1984

e. *Folding fan
 Russia, early 19th century
 Bone, gauze, spangles, embroidery
 16.5 (l)
 HM; No. 54097 O-62
 Acquired in 1922
 Illustrated p. 158

137. Shawl

Workshop of Nadezhda Merlin (active
 1806-ca. 1850), Riazan Province,
 1830s-40s
Wool
139 x 137
HM; No. 55753 D-46
Acquired in 1921
Illustrated p. 159

The refinement of the weavers' abilities and the designers' artistic conceptions resulted in innumerable variations on the flower motif, including this display of lilac, chrysanthemums, roses, and wild flowers.

138a-f. General's uniform, Life Guard Hussar Regiment

From their first appearance in Hungary in the mid-1400s, Hussars were distinguished by their peculiar uniforms. The Hussars were organized and disbanded several times between 1634 and 1751, when the first regular regiment was formed. After fighting in several major conflicts, including battles in Austerlitz and Wolfsdorf and the War of 1812, the regiment was disbanded in 1918.

a. Doloman jacket
Broadcloth, gold galloon, cord,
 buttons
55 (l in front)
HM; No. 84077/220 T-316
Acquired in 1953
Illustrated p. 160

b. Pelisse
Broadcloth, gold galloon, cord,
 buttons, fur trim
58 (l in front)
HM; No. 84077/104 T-313
Acquired in 1953
Illustrated p. 160

c. *Chakchiry* (breeches)
Broadcloth, gold galloon
142 (l)
HM; No. 84077/198 T-352
Acquired in 1953

d. Boots
Patent leather, gilt buckle
50.5 (h); 26 (l)
HM; No. 68257/3237 T-655 a,b
Acquired in 1925

e. *Shako* (cap)
Third Elizavetgrad Grand Duchess
 Olga Nikolaevna Hussar Regi-
 ment, 1843
Leather, broadcloth, metal, silver cord
37 (h)
HM; No. SHM 68257/1082 T 15a

f. Pompon
Wool, silver gilt
HM; No. SHM 68257/1082 T 15b
Acquired from Military Museum
 Elizavetgrad Hussar Regimental
 Collection in 1930

139a-c. Man's costume

At home, men wore robes in the morn-
ing and occasionally throughout the day.
This custom, practiced since the early
1700s, was enhanced when "exotic"
clothing became fashionable a century
later. In the 1830s and 1840s, robes
inspired by Oriental costumes were usu-
ally worn with pantaloons, slippers or
unstructured boots, and a fez.

a. *Robe
Russia, mid-19th century
Silk, cotton
153 (l)
HM; No. 70488 B-661
Acquired from "Life in the 1840s"
 Museum in 1921

b. *Boots
Torzhok, Tver Province, 1830s-40s
Velvet, gold thread
27 (l); 33 (h)
HM; No. 42567/b Zh-19
Gift of A.P. Bakhrushin in 1905
Illustrated p. 163

c. At-home cap
Crimea (?), 1840s
Silk
20 (h)
HM; No. 58673 E 66
Gift of private donor in 1927

140a-c. Woman's festive costume

Verey district, Moscow Province,
 mid-19th century
Illustrated p. 165

Certain groups of peasants in the Verey
district were renowned for their dialect
and their dress, which combined ele-
ments of northern and southern Russian

traditions. The red cloth insets in the
blouse, for example, derived from north-
ern designs, while the use of vivid geo-
metric trim can be traced to the south.

a. Sarafan
Cotton, cord, silk ribbon, galloons,
 braid
102 (l); 282 (w at hem)
HM; No. 58431 B-474a
Acquired in 1921

b. Blouse
Cotton, silver cord, spangles, ribbon
39 (l); 99 (sleeve l)
HM; No. 58451 B-474b
Acquired in 1921

c. Apron
Wool, cashmere, spangles, gold
 fringe, ribbon
76 (l); 63 (w at hem)
HM; No. 98596 B-2664
Acquired in 1964

141a-e. Woman's costume

Russia, mid-19th century

*Echoing European fashions in the 1840s
and 1850s, this pink taffeta dress with
batiste undersleeves and white lace
parasol was produced by highly skilled
but anonymous craftswomen, who
either worked as serfs on a nobleman's
estate or as professional seamstresses in
fine sewing establishments. These
exceptional pieces exhibit not only the
finest quality and variety of embroidery

GRAPHICS

techniques but also the highest standard of artistic taste.

a. Dress
Taffeta
Bodice: 59 (l); skirt: 104 (l), 377 (w at hem)
HM; No. 20884 shch B-57
Gift of P.I. Shchukin in 1906-11
Illustrated p. 162

b. Bodice inset
Batiste, cotton thread
82 x 54
HM; No. 58338 S-110
Acquired in 1926
Illustrated p. 162

c. Undersleeves
Batiste, cotton thread, lace
41 (l of each)
HM; No. 53138 S-75a,b
Acquired in 1922

d. Parasol
Brussels lace, silk, ivory, turquoise, rubies, metal; enameling
62.5 (l)
HM; No. 56423 L-2
Acquired in 1922

e. Dancebook cover
Moroccan leather; gold embossing, embroidery
15.5 x 10.5
HM; No. 87706 B-2374
Acquired in 1956

142. City Plan of Moscow in the 1520s

Sigismund Herberstein (1486-1566)
Engraving, etching, hand-painted watercolor
40 x 54
HM; No. 70156/sheet 1
Acquired from the Museum of the History of Moscow in 1930
From G. Braun's atlas *The Most Famous Cities of the World, Book Two,* Cologne, 1577
Illustrated p. 22

This is the first known city map of Moscow. It appeared in the second edition of Herberstein's book *Rerum Moscovitarum* (Basel, 1556). Particularly popular was the retouched engraving from Braun's atlas, which was first published in 1575 and engraved by Franz Hohenberg and Simon Novelanus. The map bears the inscription, "Moscow, the capital city of the identically named country, is twice as large as Prague, in Bohemia."

Herberstein, a diplomat and member of the Royal Council of the Holy Roman Empire, was sent to Russia as an ambassador in 1517 and 1526. Although he composed this slightly fantastic map from memory 30 years later, he did include the Kremlin, the Dormition Cathedral, the bell tower of Ivan the Great, and the Tsar's Palace.

143. "Sigismund" City Plan of Moscow, 1610

Lucas Kilian (1579-1637)
Engraving, etching
53 x 72
HM; No. 70156/sheet 43
Acquired from the Museum of the History of Moscow in 1930
Illustrated p. 180

A rare depiction of Moscow during the Middle Ages, this map was produced and published in Augsburg by John Philipp Abeline Gottfried "according to a patent from the King of Poland, Sigismund III," for whom it was named. Based on the "Godunov draft," a plan of Moscow drawn up in the early 1600s by order of Tsarevich Fedor Godunov, this map offers a fairly accurate depiction of Moscow's historic center.

144. "Kremlenograd": Map of the Kremlin and Red Square in the early 17th century

Anonymous engraver, 2d half of 17th century
Engraving, etching
41 x 56
HM; No. 42949/sheet 18
Acquired from collection of A.P. Bakhrushin in 1905
Illustrated p. 26

By this time, the Kremlin was a secured fortress surrounded by stone walls with towers. In addition to the tsar's palace complex and two monasteries, the Kremlin contained Execution Hill (*Lobnoe mesto*), Merchants' Rows, and the Resurrection Gate of Kitai gorod, with an arched bridge spanning the Neglinnaya River.

145. Portrait of Peter I, ca. 1698

Peter Gunst (1659-1724) after Gottfried
 Kneller (1646-1723)
Engraving
56.7 x 41.5
HM; No. 48858/I 111-48980
Acquired from collection of N.I.
 Vasilchikov in 1914
Illustrated p. 39

This is one of the first bona fide portraits
of the young ruler, Peter I. It was drawn
from life by Kneller in Utrecht in Sep-
tember 1697 for King William III of
England, when the Russian leader was
touring western Europe incognito.
Graphic artists such as Gunst made
reproductions after Kneller's portrait to
feed public interest in the Russian
monarch.

**146a-d. Panorama of Moscow as Seen
from Zamoskvoreche at the Stone
Bridge**, 1707-08

Peter Picart (1668/69-1737)
Engraving, etching on four sheets
50 x 67.5 each
HM; No. 53408/sheets 889a, b, c, d
Acquired from Moscow Stock
 Commission in 1922

Picart's engraving accurately relates the
appearance of Moscow at the beginning
of Peter I's reign. The Dutch artist paid
particular attention to the Kremlin and
its picturesque domes and cupolas as
seen from the tiered tower that topped
the arched gateway to the Stone Bridge.

**147. The Triumphant Entry of the
Russian Troops into Moscow in
December 1709, After the Victory at
Poltava**, 1710-11

Peter Picart (1668/69-1737)
Engraving, etching
65 x 83.5
HM; No. 26208/51680 ZhSh
Acquired from collection of D.D.
 Chetverikov in 1918
Illustrated p. 130

With the city of Moscow serving merely
as a backdrop, this scene records the
lengthy victory celebration over the
Swedish troops of Charles XII. The fes-
tivities' main event was the entry of the
Russian army into the city through seven
triumphal arches. Peter himself headed
the Preobrazhensky Guards Regiment,
which brings up the rear of the parade.

**148a-b. Panoramic View of the German
Suburb in Moscow and the Country
Estate of F.A. Golovin in Lefortovo**, 1705

Adrian Schonebeck (1661-1705)
Engraving, etching on two sheets
50 x 122 each
HM; No. 99497/I 111-42863
Illustrated p. 37

By the end of the 1600s, activity in Mos-
cow had moved from the Kremlin to the
northeast, near the emperor's residence.
Late in the century the distinguished
official F.A. Golovin (1650?-1706) built a
palatial home and parks on the left bank
of the Yauza River. Across from that was
the German Suburb, which had long
been settled by foreigners who came to
serve in Russia.

**149. Ivanov Square of the Moscow
Kremlin During the Reading of the
Manifesto of the Coronation Ceremony
of Catherine II**, 1857

Aleksandr Kirprianovich Melnikov
 (1803-after 1855)
Engraving
57.5 x 78.5
HM; No. 56406/I 111-26045/3
Acquired from collection of N.S.
 Shcherbatov in 1925

Pictured here is the public announce-
ment of the time of Catherine II's coro-
nation in September 1762. Three months
earlier Catherine II (the Great) had come
to power through a palace coup.
Melnikov based his engraving on draw-
ings made jointly by Jean-Louis de Velly
(ca. 1730-1804) and Mikhail Ivanovich
Makhaev (1717-70) in the previous
century.

**150. The Scene in Assumption
Cathedral. Catherine II After the
Coronation Ceremony Before the
Departure to Archangel
Cathedral**, 1857

Vasily Lebedev (active mid-19th century)
Engraving
57.5 x 77.8
HM; No. 56406/I 111-26045/8
Acquired from collection of N.S.
 Shcherbatov in 1925
Illustrated p. 242

The main coronation ceremony of Catherine II was held on September 22, 1762, in the Kremlin's Assumption Cathedral. Built by Italian architect Aristotle Fioravanti in 1475-79, the cathedral, with its height, lightness, and sense of space, greatly influenced the development of Russian architecture. This engraving was also based on an original version by de Velly and Makhaev.

151a-j. Panorama of the Kremlin and the Zamoskvoreche as Seen from the Taynitsky Tower, 1850s

F. and Obren Benois after Dmitry
　Stepanovich Indeytsev (1813-?)
Lithograph with watercolors on ten
　sheets
35 x 46 each
MHM; No. OF-9587/1-10
Acquired from USSR Ministry of
　Culture in 1956
Illustrated p. 44

In the 1700s and 1800s, circular panoramas of the capital, as seen from Borovitsky Hill, were frequently produced. Based on drawings by Indeytsev, this landscape looks from inside the Kremlin south towards the Moscow River and the merchants' quarter of Zamoskvoreche. The panorama unfurls clockwise from the left, from Nicholas Place and Ivanov Square, towards the Spassky Gate, and on to Cathedral Square.

152. Portrait of Tsar Fedor Ioannovich

Armory Chamber, Moscow, 2d half
　of 17th century
Wood, gesso, tempera
42.1 x 32.2
HM; No. 29173/I USh 3800
Acquired from Archangel Cathedral,
　Moscow Kremlin, in 1894
Illustrated p. 35

Ill equipped to handle government affairs, Fedor Ioannovich (1557-98), the last tsar of the Ryurik dynasty and son of Ivan IV, let his brother-in-law, the boyar Boris Godunov, rule the country. In the 18th and 19th centuries, this portrait of the sickly tsar hung over his tomb in the burial vault of Moscow princes and tsars in the Archangel Cathedral. Although this painting may have been produced for another purpose, it does represent an early example of portraiture in Russia.

153. Portrait of Tsar Aleksey Mikhailovich, 1670s

Anonymous
Oil on canvas
117 x 94
HM; No. I1-3462
Acquired from the Tretyakov Gallery
　in 1924
Illustrated p. 40

Aleksey Mikhailovich (1629-76), the second Romanov tsar, was a defender of the Orthodox church, a supporter of autocratism, and the father of Peter the Great. Shown here in imperial regalia, the tsar wears a *barmy,* a richly embroidered collar copied from Byzantine emperors. The painting's brushwork suggests that the portrait was produced by two or more artists.

154. Still Life with a Parrot, 1737

Grigory Nicolaevich Teplov (1716-79)
Oil on canvas
88 x 70
MCK; No. 246
Acquired from the collection of
　Sheremetev in 1918

Teplov's personal interests in art, music, philosophy, and the natural sciences are reflected in these diverse objects, which not only were here given allegorical meaning but were also associated with the growing number of well-educated people in Russia. The trompe l'oeil style favored in northern Europe did not become popular in Russia, and examples such as this are rare.

155. Portrait of Elizaveta Frantsevna Buturlina, 1763

Aleksey Petrovich Antropov (1716-95)
Oil on canvas
61 x 48
HM; No. I1-1925
Acquired from the Tretyakov Gallery
　in 1929

Elizaveta Buturlina (1739-1810), née Countess Santi, belonged to a family of rich landlords from Moscow Province. Antropov also completed a portrait of her husband, Mikhail Dmitrievich Buturlin, a brigadier of the Semionov regiment, and his parents.

156. Portrait of Count Petr Borisovich Sheremetev, 1760

Ivan Petrovich Argunov (1739-1802)
Oil on canvas
92 x 73.5
OPM; No. Zh-108
Illustrated p. 43

Count Sheremetev (1713-87) was the son of Count Boris Petrovich Sheremetev, a fieldmarshal to Peter I. He was a cavalier of the orders of St. Alexander Nevsky, the White Eagle, and St. Andrew the First-Called, as well as the owner of the Kuskovo estate.

157. Portrait of an Unknown Woman in a Blue Dress with Yellow Trim, 1760s

Fedor Stepanovich Rokotov (1735?-1808)
Oil on canvas
58.3 x 45.7
TG; No. 21180
Acquired from State Museum Fund in
 1923
Illustrated p. 178

Dynamic brush strokes, such as those seen forming the sitter's bows, ruches, and flowerets, became a hallmark of Rokotov's paintings in the 1760s. Central to this image of an unknown woman, however, is her sense of femininity and the significance of human existence, which in Rokotov's later works develops into an attempt to unravel the mystery of the soul.

158. Portrait of a Young Man, 1770s

Anonymous, 2d half of 17th century
Oil on canvas
110 x 80
OPM; No. J-203
Acquired from estate museum of
 Astafyevo, former country estate of
 Vyazemsky family, in 1931

159. View of Moscow from the Balcony of the Kremlin Palace on the Stone Bridge Side, 1798

Gerard de la Barthe (mid-1700s-early
 1800s)
Oil on canvas
74 x 142
RM; No. Zh-4688
Acquired from Alexandrov Palace
 in 1931
Illustrated p. 155

This panorama of Moscow, as well as its other half, which was executed from the side facing the Moskvoretsky Bridge, depicts an elevated view from the Kremlin grounds. Part of the Kremlin wall and its towers, as well as the Stone Bridge, are seen. The Vorobev (Sparrow) Hills appear in the distance.

160. Ice Slides on Neglinnaya Street in Moscow During the Week Before Lent, 1795

Gerard de la Barthe (mid-1700s-early
 1800s)
Oil on canvas
75 x 141
RM; No. Zh-4682
Acquired from Alexandrov Palace in
 1931
Illustrated p. 16

As part of the traditional festivals held before Lent, iced slides were constructed on the riverbank for the public's amusement. On the right is the Kremlin wall, with the Uglovy and Sredny Arsenalny (Corner and Mid-Arsenal) towers facing the Neglinnaya River.

161. Portrait of Praskovya Ivanovna Kovaleva-Zhemchugova in a Red Shawl, 1801-02

Nikolay Ivanovich Argunov (1771-after
 1829)
Oil on canvas
134 x 98
MCK; No. Zh-103
Acquired from collection of Sheremetev
 in 1918
Illustrated p. 157

Born a serf in the Yaroslavl Province, P.I. Kovaleva-Zhemchugova (1768-1803) became a leading singer and actress in the serf theater of the counts Sheremetev. Argunov was also associated with the Sheremetev family as its serf artist. Two years after his emancipation in 1816, Argunov was honored with the title of Academician of Arts.

162. View of the Moscow Kremlin and the Stone Bridge, 1815

Fedor Yakovlevich Alekseyev
 (1753/54-1824)
Oil on canvas
80 x 106
HM; No. 70156/K-260
Acquired from the Museum of Old
 Moscow in 1930
Illustrated p. 181

When interest in the history and architecture of Moscow grew in the 19th century, Alekseyev (on order of the emperor) produced over 100 watercolors of the city. He later translated these into paintings, such as this urban landscape of the Kremlin, the Borovitsky Gate and Hill, the Stone Bridge, and life along the river Moscow.

163. View of Moscow's Red Square,
1830s

Anonymous
Oil on canvas
71 x 106
MHM; No. 1229
Acquired from an art gallery in 1936
Illustrated p. 182

Built in the late 15th century under Grand Prince Ivan III, Red Square has witnessed many of the great events in Russia's history. It has been called Great Market Square, Fire Square, and since the 1600s, Red Square, with "red" (*krasnaya*) in old Russian meaning "beautiful" or "main."

The square is here being reconstructed after the Kremlin's destruction during the Napoleonic invasion of 1812. In the background, the Church of Our Protection on the Moat (commonly known as St. Basil's Cathedral) commemorates

Ivan IV's victory over the khans. On the site now occupied by the GUM department store stands the colonnaded building of the Trade Arcades.

164. At the Spassky Gate of the Kremlin, 1838

Edward Gartner (1801-77)
Oil on canvas
70 x 100
MHM; No. 0-26988
Acquired from S.V. Makedonsky in 1984
Illustrated p. 161

*In 1839, Gartner, a German landscapist and lithographer, published an album of 12 views of Moscow that he had produced while in Russia (1837-39). Shown here are a part of the Kremlin that borders with the Spassky Tower, the former Voznesensky Nunnery, the church of St. Catherine, and the 16th-century belfry and church of Mikhail Malein.

165. Ivanov Square in the Moscow Kremlin, 1839

Edward Gartner (1801-77)
Oil on canvas
86 x 77
HM; No. 70156/K-40
Acquired from the Museum of the
 History of Moscow in 1930
Illustrated p. 21

A master of urban landscape, Gartner depicted well-known buildings in Moscow, including the Ivan the Great belfry,

Uspensky Cathedral, and the distant cupola of Verkhopassky Tower. A group portrait of the Olsufevs, a noble family distinguished under Peter I, fills the foreground. The artist inserted himself as no. 18.

166. A Sleigh Race on the Petersburg Highway at the Main Entrance of Petrovsky Palace, 1848

A.A. Golitsyn (active mid-1800s)
Oil on canvas
50 x 68
HM; No. 42567/K-258
Acquired from collection of A.P.
 Bakhrushin in 1905
Illustrated p. 188

A common feature of everyday life in the 1800s was the famous Russian troika sleigh races, held here before Catherine II's country residence. By the end of the 19th century, the theater and the concert and dancing hall of Petrovsky Park had also become favorite gathering places for Muscovites.

167. Portrait of Ekaterina Alexandrovna Sisalina, 1846

Vasily Andreyevich Tropinin (1780-1857)
Oil on canvas
75.2 x 60.8
TG; No. 9277
Acquired from Tsvetkovskaya Gallery in
 1927
Illustrated p. 184

The portraitist was known for achieving a striking resemblance, but then subordi-

nating the sitter to his own "Tropinin ideal." According to Sisalina (1822-1907), née Lukhmanova, he painted her face and neck from life; the accessories and landscape derived from his imagination. That Sisalina's face and inner state of being seem to be in harmony was, as one contemporary commented, typical of a Muscovite.

168. Portrait of the Writer Yuri Fedorovich Samarin, 1846

Vasily Andreyevich Tropinin (1776-1857)
Oil on canvas
101 x 81.2
TG; No. 9375
Acquired from State Museum Fund
in 1927
Illustrated p. 185

Known for his inflexible conviction and staunch moral character, Samarin (1819-76) was often outspoken in his criticism of the tsarist government. Tropinin seems to have projected the writer's stormy personality onto the background of this portrait.

169. Kuskovo. View of the Country Estate from the Pond, 1839

Nikolay Ivanovich Podklyuchnikov
(1813-77)
Oil on canvas
67 x 158
HM; No. 70156/K-142
Acquired from the Museum of the
History of Moscow in 1930

The architectural landscapist Podklyuchnikov often painted views of two estates owned by Count Sheremetev: Ostankino, where the artist lived as a

serf until he was freed in 1839, and Kuskovo, "the Versailles of Moscow." The palatial estate of Kuskovo, with its planned gardens, ornamental park, pavilions, and pond, took over 40 years to complete and was renowned for its firework displays and state receptions.

170. View of the Ostankino Estate, no earlier than 1856

Nikolay Ivanovich Podklyuchnikov
(1813-77)
Oil on canvas
96 x 134
OPM; No. Zh-279
Acquired from collection of Yu.A.
Bakhrushin in 1927

The artist returned to the countryside to document Alexander II's visit to Ostankino in 1856, where the monarch stayed for a week before his coronation. The presence of royalty is evident by the imperial standard on the palace's belvedere, the guard station, and the regal bathing hut by the pond. Among the figures populating the landscape is Podklyuchnikov himself, shown sketching in the foreground right.

171. Podklyuchnikov's Gallery of Art, no later than 1860

Nikolay Ivanovich Podklyuchnikov
(1813-77)
Oil on canvas
96 x 143
HM; No. 42572/I1-2176
Acquired from A.P. Podklyuchnikova
in 1905
Illustrated p. 187

Showing the interior of the painter's Moscow apartment, this group portrait depicts the artist friends and family of Podklyuchnikov. In the background are some of the 200 artworks in his collection of Russian and western European paintings.

172. Second-Hand Market in Moscow, 1868

Petr Petrovich Vereshchagin (1834-86)
Oil on canvas
64 x 84
HM; No. 70156/K-43
Acquired from the Museum of the
History of Moscow in 1930
Illustrated p. 170

In the mid-1800s, genre painting grew in popularity, with scenes of bustling markets becoming a speciality in Russian art. The colorful crowds of shoppers that gathered on Novaya Square in the heart of Moscow allowed artists to explore the character and peculiarities of Russia's diverse society.

173. Tea-Drinking in Mytishchi, near Moscow, 1862

Vasily Grigorevich Perov (1834-82)
Oil on canvas
43.5 x 47.3
TG; No. 5249
Acquired from Rumyantsev Museum
in 1925
Illustrated p. 190

An invalid soldier and his young guide stop in Mytishchi on their pilgrimage from Moscow. Even though the soldier wears the Cross of St. George, Russia's highest award for valor, the priest offers no charity. In this way, Perov criticized

both the state and society for their ingratitude toward military heroes.

174. View of the Kremlin in Rainy Weather, 1851

Aleksey Kondratevich Savrasov (1830-97)
Oil on canvas
67 x 90.5
TG; No. 28328
Acquired from M.Ya. Liberman in 1947
Illustrated p. 200

Although Savrasov typically produced realistic landscapes, traces of the romantic tradition in Russian art are evident in the artist's depiction of a turbulent moment before a storm.

175. Elk Island in Sokolniki, 1869

Aleksey Kondratevich Savrasov (1830-97)
Oil on canvas
62 x 88
TG; No. 825
Acquired by P.M. Tretyakov from the artist in 1870

Savrasov won first prize at the 1870 competition of the Moscow Society of Art Lovers for this lyrical and yet emotionally charged painting.

176. In the Doctor's Waiting Room, 1870

Vladimir Egorovich Makovsky
 (1846-1920)
Oil on canvas
69.4 x 85.3
TG; No. 594

Acquired by P.M. Tretyakov from
 the artist
Illustrated p. 49

Makovsky concentrated on city scenes and events in everyday life in his paintings. Early works, such as this humorous and sympathetic portrayal of patients in a doctor's waiting room, are confined to ordinary narration and lack the sharp social commentary of his later canvases.

177. The Doss House, 1889

Vladimir Egorovich Makovsky
 (1846-1920)
Oil on canvas
94 x 143
RM; No. Zh-4224
Acquired from the artist's collection
 in 1925
Illustrated p. 50

Makovsky belonged to the powerful Association for Traveling Art Exhibits, whose members, called *Peredvizhniks,* took a socially critical stance in their paintings toward the plight of many of their fellow Russians. Here, empty-handed people await shelter for the night. The expressive face of the old man holding a portfolio was based on the famed landscapist A.K. Savrasov.

178. In the Artist's Studio, 1890

Illarion Mikhailovich Pryanishnikov
 (1840-94)
Oil on canvas
49 x 42.2
TG; No. 569
Acquired by P.M. Tretyakov
Illustrated p. 199

Although he was a prominent artist, Pryanishnikov constantly lived in poverty, and this work may well be a self-portrait. Through this scene, the painter decries the contradiction between the social significance placed on art in Russia and the low social status of the artist.

179. Savvino-Storozhevsky Monastery, ca. 1875

Lev Lvovich Kamenev (1833-86)
Oil on canvas
49 x 84.5
TG; No. Zh-15
Acquired from Khokhlova in 1962

Along with his teacher Savrasov, Kamenev is considered the founder of realist landscape painting in Russia. While landscapes including architecture are rare among his works, the peaceful monastery near Zveni gorod was special to the artist, for he spent his last years there.

180. A Sick Woman, 1886

Vasily Dmitrievich Polenov (1844-1927)
Oil on canvas
41.7 x 59.5
TG; No. 11134
Acquired from I.S. Ostroukhov's
 Museum in 1929

Moved by the recent deaths of friends and family, Polenov conceived of this image in 1879 in a sketch now held by the State Russian Museum. The subsequent deaths of his twin sister and his eldest son led the artist to this final version seven years later.

181. The Three Princesses of the Underground Kingdom, 1884

Viktor Mikhailovich Vasnetsov
 (1848-1926)
Oil on canvas
85 x 134
AMB; No. RZh-690
Acquired from S.K. Pkhakadze,
 Moscow, in 1957
Illustrated p. 110

In 1879, Savva Ivanovich Mamontov commissioned the artist to produce a series of paintings for the main office of the Donetsk railroad system. This one was based on a popular fairy tale of the riches within the earth. Five years later Vasnetsov returned to the theme to tell of a boy's journey underground and his discovery of the kingdom's princesses and their gold, iron, and precious stones.

182. Evening on the Volga, 1887-88

Isaak Ilich Levitan (1860-1900)
Oil on canvas
50 x 81
TG; No. 1474
Acquired by P.M. Tretyakov from the
 artist in 1888
Illustrated p. 203

In his efforts to convey the national character of the Russian countryside, Levitan focused on one of the greatest symbols of his nation, the Volga River. This, the first of Levitan's paintings of the river, expresses the emotional connotations of beauty, freedom, power, and wealth that many Russians associate with the Volga.

183. Moonlit Night. The Big Road, ca. 1890

Isaak Ilich Levitan (1860-1900)
Oil on canvas
83 x 87
TG; No. Zh-234
Acquired from S.A. Elperin in 1961
Illustrated p. 15

During the last years of his life, Levitan became dissatisfied with his work. He sought new artistic forms in the decorative and abstract elements of the color wheel. Scenes of nature at twilight or nighttime also entered his oeuvre at this time.

184. In the Sun (Portrait of Nadezhda Ilinichna Repina), 1900

Ilya Efimovich Repin (1844-1930)
Oil on canvas
94.3 x 67
TG; No. 11152
Acquired from I.S. Ostroukhov's
 Museum in 1929
Illustrated p. 55

Nadezhda Ilinichna Repina (1874-1931), the artist's daughter, is shown here in her mid-twenties. While working as a nurse, she contracted typhus in the 1910s and spent the rest of her years on her father's estate. Repin's sunlit painting is among his numerous outstanding portraits of women.

185. Portrait of the Writer Leonid Nikolaevich Andreyev, 1904

Ilya Efimovich Repin (1844-1930)
Oil on canvas
76 x 66.5
TG; No. 15109

Acquired in 1933
Illustrated p. 192

Andreyev (1871-1919) was a remarkable Russian author of novels, short stories, and dramas, including *The Abyss* and *The Life of Father Vasily Fiveysky.* Repin freely painted his friend's portrait during what was perhaps the writer's most productive period.

186. The Visit of the Tsarevna to the Convent, 1912

Vasily Ivanovich Surikov (1848-1916)
Oil on canvas
144 x 202
TG; No. Zh-158
Acquired from A.K. Kraytor in 1958
Illustrated p. 28

Following the tradition that the daughters of tsars became nuns, a tsarevna, aware of her fate, visits a convent. The surrounding nuns and lay sisters contrast with her youth and faithful sincerity as they watch her with envy, curiosity, suspicion, and indifference.

Surikov was highly regarded as a history painter, and this was his last finished canvas. He based this scene on I. Zabelin's book, *Family Life of Russian Tsarinas,* which examined daily life of royal women before the 18th century. The artist's granddaughter sat for the tsarevna's image, engulfed in a brocade dress taken from a theater wardrobe. The dress had been designed by the artist Konstantin Korovin for the performance of Minkus' ballet *The Golden Fish* in the Bolshoi Theater.

187. Motherland, 1886

Apollinary Mikhailovich Vasnetsov
 (1856-1933)
Oil on canvas
49 x 73
TG; No. 967
Acquired by P.M. Tretyakov from
 the artist in 1886

Here, Vasnetsov produced a generalized image of his homeland of Ryabovo, with its river, high hills, and sharply sloping forests. At this point in his career, the landscapist was strongly influenced by members of the Abramtsevo Artists Circle, in particular Polenov.

188. The Prose of Life, 1892-93

Vasily Nikolaevich Baksheyev
 (1862-1958)
Oil on canvas
68 x 73
TG; No. 1437
Acquired from the artist in 1893; gift
 of P.M. Tretyakov in 1894
Illustrated p. 53

In the late 1800s, genre painters turned from sharp social criticism to depict scenes of everyday events and family life. Baksheyev presented a conflict of generations in this aftermath of a squabble between an elderly father and his young daughter.

189. Portrait of Prince Vladimir Mikhailovich Golitsyn, 1906

Valentin Aleksandrovich Serov
 (1865-1911)
Oil on canvas
114 x 94
HM; No. 72304/I1-2114

Acquired by Moscow city duma in 1931
Illustrated p. 195

Serov was commissioned by the Moscow city duma to paint a portrait of Prince Golitsyn (1847-1932), even though the two became archenemies through their work on the Soviet of the City Art Gallery. Golitsyn, an art collector and author as well as governor and later head of the city of Moscow, possessed an aristocratic title and stature, yet he held no royal authority.

190. Portrait of Ivan Abramovich Morozov, 1903

Konstantin Alekseyevich Korovin
 (1861-1939)
Oil on canvas
90.4 x 78.7
TG; No. 10873
Acquired from the State Museum of the
 New Western Art (collection of I.A.
 Morozov) in 1928

Produced from just a single sitting, this image of the textile manufacturer and art collector Morozov (1871-1921) testifies to Korovin's exceptional talent as a portraitist, who often concentrated on decoration and outer appearance rather than the inner psyche.

191. Moskvoretsky Bridge, 1914

Konstantin Alekseyevich Korovin
 (1861-1939)
Oil on canvas
104 x 134
HM; No. 70156/K-322
Acquired from the Museum of the
 History of Moscow in 1930
Illustrated p. 206

Although he conveyed with particular exuberance Moscow's urban landscape, Korovin produced few such works. Instead, the painter and theater designer chose to express his affinity for his native city in the short stories and essays he wrote in the 1930s after he emigrated to Paris.

192. Silence, 1903

Mikhail Vasilevich Nesterov (1862-1942)
Oil on canvas
71.2 x 116
TG; No. 5831
Acquired from collection of P.I. and
 V.A. Kharitonenko in 1924
Illustrated p. 105

In the early 1900s, Nesterov visited Solovetsky Monastery, where he was greatly impressed by the monks' purity, calm lives, and harmony with nature. His belief that only retreat from the vain world could bring peace is convincingly reflected in this painting.

193. The Arrival of Foreigners. Seventeenth Century, 1901

Sergey Vasilevich Ivanov (1864-1910)
Oil on canvas
151.5 x 232
TG; No. 1442
Acquired by the Gallery Council from
 the artist in 1901
Illustrated p. 33

Known for his melding of history and genre paintings, Ivanov recreated the 1600s, when the Moscow state was being formed, to examine different responses of typical Russians encountering foreign ambassadors.

194. **Portrait of the Artist Igor Emmanuilovich Grabar**, 1895

Filipp Andreyevich Malyavin (1869-1940)
Oil on canvas
131.5 x 63
RM; No. Zh-7482
Acquired from M.M. Grabar in 1961
Illustrated p. 207

After his education at the St. Petersburg Academy of Arts, Malyavin became a portraitist known for his accurate portrayal of character, confident brush stroke, and freely executed painting style. Later, he achieved fame for his vivid peasant themes and genre scenes based on folklore traditions.

195. **The March Sun**, 1915

Konstantin Fedorovich Yuon (1875-1958)
Oil on canvas
107 x 142
TG; No. 3823
Acquired by the Gallery Council from the artist in 1916
Illustrated p. 204

Lyrical landscape paintings that expressed the artist's emotions dominated Russian art, and in the 1910s the term "Yuon's landscapes" became associated with the joyous and energetic depiction of nature.

196. **The Easter Table**, 1903

Stanislav Yulianovich Zhukovsky (1873-1944)
Oil on canvas
87.5 x 133
TG; No. Zh-762
Acquired from T.V. Shadr in 1974
Illustrated frontis 3

Characteristic of Zhukovsky's style is a heightened emotional perception of the world. The Easter table, laden with festive foods, occupies the entire canvas and is pushed forward for the viewer to admire.

197. **Moscow Tavern**, 1916

Boris Mikhailovich Kustodiev (1878-1927)
Oil on canvas
99.3 x 129.3
TG; No. 25452
Acquired from I.F. Fedoseyev in 1930
Illustrated p. 214

Kustodiev carefully studied everyday life in Moscow when he composed this scene of cabmen warming themselves and drinking scalding hot tea with great pleasure. He felt he succeeded in capturing the reverence of an icon in the brilliant highlights and red tonalities of the genre scene.

198. **Carnival Booths**, 1917

Boris Mikhailovich Kustodiev (1878-1927)
Oil on canvas
80 x 93
RM; No. Zh-4357
Acquired from collection of Ya.I. Savich in 1917

The artist's reputation rests with his colorful and slightly ironic depictions of festivals, sideshows, and bazaars. Here, common people celebrate their favorite holiday of Shrovetide. Kustodiev also conveyed the bitter frost and bright sky of a Russian winter day.

199. **Shrovetide**, 1919

Boris Mikhailovich Kustodiev (1878-1927)
Oil on canvas
71 x 89
MAB; No. Zh-58
Acquired from collection of I.I. Brodsky in 1939
Illustrated cover

The optimism and gaiety of Shrovetide, which marks the passing of winter, are expressed here by Kustodiev. Celebrated the week before Lent, Shrovetide was a joyful time for Muscovites. Entertainments as diverse as wrestling, ice skating, dancing bears, and magic shows were held for the public's amusement.

200. **A New Tavern**, 1909

Nikolay Petrovich Krymov (1884-1958)
Oil on canvas
62.2 x 96.4
TG; No. Zh-702
Acquired from L.I. Ivanova in 1970
Illustrated p. 212

The search for ways to express a new understanding of the landscape and the desire to escape traditional artistic forms led Krymov and other artists to practice a primitive style based on folk painting and popular art.

201. **Moscow Winter**, 1910s

Natalya Sergeyevna Goncharova (1881-1962)
Oil on canvas
100 x 105
RAMV; No. 589
Acquired from State Museum Fund in 1924

Goncharova portrayed Moscow as a comfortable city, with sleighs, snowdrifts, and clouds of smoke drifting over rooftops. In this way she communicated the feeling of the unhurried pace of the quiet Moscow neighborhoods.

202. **The Round Dance**, 1900-10s

Natalya Sergeyevna Goncharova
 (1881-1962)
Oil on canvas
133 x 100
Museum of Art and History, Serpukhov;
 No. Zh-225

203. **Tavern Tableware**, 1909

Vasily Vasilevich Rozhdestvensky
 (1884-1963)
Oil on canvas
97.5 x 85.4
MFAK; No. Zh-699

Still life dominated Russian art in the 1910s. Many of the artists who produced such works, including Rozhdestvensky, belonged to the Jack of Diamonds group. They assimilated their interest in primitive art with new styles emerging from Europe, particularly the work of Paul Cézanne.

204. **Urban Landscape in Winter**, ca. 1914

Ilya Ivanovich Mashkov (1881-1944)
Oil on canvas
89 x 86
RM; No. ZhB-1718
Acquired from Museum of Artistic
 Culture in 1926

A leader of the Jack of Diamonds group, Mashkov focused on enlarged shapes, colorful decoration and texture, and abstract images in his paintings, as seen in this view of the Sukharev Tower and the Red Gates of Moscow.

205. **Victory Battle (Military Panel)**, 1914

Aristarkh Vasilevich Lentulov
 (1882-1943)
Oil on canvas, bronze, silver
137.5 x 183
Collection of M.A. Lentulova, Moscow
Illustrated p. 210

During World War I, Lentulov painted military scenes in which he isolated elements—a faceless cavalier, a war ribbon, exploding shells—to underscore the shifting dynamics of a battle. The victor is surrounded by a pink aura, a device borrowed from icon paintings that shows Lentulov's ability to combine primitive and traditional art with contemporary aesthetics.

206. **View of the New Jerusalem Church**, 1917

Aristarkh Vasilevich Lentulov
 (1882-1943)
Oil on canvas
102 x 101
SAM; No. Zh-1021
Acquired from State Museum Fund in
 1929
Illustrated p. 216

Lentulov explored the intricate architecture of Moscow's cathedrals in a series of abstract "portraits" that were intended to symbolize Russian spirituality. The artist

lived near the New Jerusalem Monastery in the suburbs of Moscow during the summer of 1917.

207. **Improvisation #34**, 1913

Vasily Vasilevich Kandinsky (1866-1944)
Oil on canvas
120 x 139
MFAK; No. Zh-771
Acquired from the Tretyakov Gallery in
 1962
Illustrated p. 59

As a prominent pioneer of abstract art in the early 20th century, Kandinsky explored nonobjective painting by focusing on the interrelationship of color and form. One result of his efforts is that he is often credited with producing the first purely abstract art.

208. **Moscow. Red Square**, 1916

Vasily Vasilevich Kandinsky (1866-1944)
Oil on canvas
51.5 x 49.5
TG; No. P.47113
Gift of G.D. Costakis in 1977
Illustrated p. 219

Kandinsky admitted that he created this painting in an attempt to unify "the complex and the simple in a single sound." The colorful whirlwind of Kremlin cupolas, tsar's bell, and figures of saints makes this canvas a link between the artist's studies of nature and his improvisational works.

209. **Suprematism #56**, 1916

Kazimir Severinovich Malevich
 (1878-1935)
Oil on canvas
79 x 71
RM; No. ZhB-1421
Acquired from Department of Fine
 Arts, People's Commissariat of
 Education, Moscow, in 1920
Illustrated p. 209

Malevich came to the forefront of the
Russian avant-garde with his develop-
ment of suprematism. He believed a
painting could be totally subjectless and
thus exist independently and uncon-
nected with nature. By freeing art from
the framework of earthly understanding,
he hoped to move it toward universal
thought and the unconscious.

210. **The Reaper**, ca. 1928

Kazimir Severinovich Malevich
 (1878-1935)
Oil on plywood
72.4 x 72
RM; No. Zh-9487
Illustrated p. 223

211. **Still Life with Coffee Pot**, 1919

Petr Petrovich Konchalovsky (1876-1956)
Oil on canvas
105 x 108
RM; No. ZhB-1187
Acquired from the artist in 1931

After a decade of involvement with the
Jack of Diamonds group and interest in
works by van Gogh, Cézanne, and
Matisse, the artist turned to producing
still lifes in the 1910s. In an effort to
avoid naturalism in his paintings, Kon-

chalovsky instead focused on purely
chromatic relationships on his canvases.

212. **Still Life with China Figurines**,
1922

Ilya Ivanovich Mashkov (1881-1944)
Oil on canvas
99 x 114
TG; No. ZhS-2328
Acquired from V.Iu. Kubasov in 1983
Illustrated p. 56

In the early 1920s, Mashkov created still
lifes in which he freely combined
antiques with modern objects. These
works are characterized by their peculiar
reddish coloring, the lighter application
of paint, and the artist's concentration on
the objects' material attributes and deco-
rative qualities.

213. **The Strastnoy (Holy) Boulevard**,
1926

Nisson Abramovich Shifrin (1892-1961)
Oil on canvas
89 x 65
TG; No. ZhS-1875
Acquired from A.N. Shifrina in 1981
Illustrated p. 12

In a series of works that depicted the
everyday life and work of the Soviet peo-
ple, Shifrin combined foreshortening, a
flat treatment of shapes, and a loose
arrangement of objects to accentuate the
dynamism of the scene.

214. **The First Locomotive on the
Turksib Railway**, 1929

Aleksandr Arkadevich Labas (1900-83)
Oil on canvas
89.5 x 120
TG; No. Zh-716
Acquired from the artist in 1931
Illustrated p. 60

Technical developments in the Soviet
Union and the country's faster pace of
life fascinated Labas. He produced this
painting after traveling on the
Turkestan-Siberian (Turksib) Railway
and speeding across a desert that shortly
before had been traversed only by camel.

215. **Teacher Training**, 1929

Efim Mikhailovich Cheptsov (1875-1950)
Oil on canvas
60 x 90
TG; No. 10635
Acquired from the artist in 1930
Illustrated p. 224

This group portrait of teachers getting
ready for a new school year was based
upon members of the artist's village of
Medvanka, in the Kursk region.

216. **Outskirts of Moscow**, 1941

Aleksandr Aleksandrovich Deyneka
 (1899-1969)
Oil on canvas
92 x 142
TG; No. 27655
Acquired from the Moscow Purchase
 Commission in 1946
Illustrated p. 227

Painted during the first year of World
War II (the Great Patriotic War), the
scene's gloomy emptiness and feeling of
foreboding reflect the Muscovites' deter-
mination to resist invasion.

217. Self-Portrait in a Yellow Shirt, 1943

Petr Petrovich Konchalovsky (1876-1956)
Oil on canvas
122 x 103
TG; No. 27908
Acquired from the Moscow Purchase
 Commission in 1945

The artist's face mirrors the strain of
life during World War II. A feeling of
uneasiness pervades, despite the paint-
ing's bright, expressive colors.

218. The Morning of Industrial Moscow,
1949

Konstantin Fedorovich Yuon (1875-1958)
Oil on canvas
134 x 180
TG; No. 28005
Acquired from the artist in 1949
Illustrated p. 18

Yuon offers his own artistic vision of the
city, just as he did with his earlier lyrical
landscapes. Here, factory chimneys and
church cupolas merge, as if signifying
their equal right to exist in the urban
landscape.

219. Poor Grades Again, 1952

Fedor Pavlovich Reshetnikov (1906-88)
Oil on canvas
101 x 93
TG; No. ZhS-16
Acquired from Management of
 Exhibitions and Panoramas in 1957
Illustrated p. 228

In the postwar period, when life was
returning to normal, an interest in genre
painting reappeared. The simple theme
of this work echoed everyday concerns
and made it one of Reshetnikov's most
popular paintings.

220. Shatov Mountain Village, 1964

Vladimir Fedorovich Stozharov
 (1926-73)
Oil on canvas
115 x 127
TG; No. ZhS-683
Acquired from USSR Ministry
 of Culture in 1968
Illustrated p. 229

Taking advantage of the "thaw" experi-
enced under Khrushchev, artists entered
a period of renewed creativity in which
many painters, including Stozharov,
depicted the countryside of the northern
provinces. Instead of presenting a
detailed account of village life, as earlier
artists had done, Stozharov conveyed the
remarkable beauty of nature at twilight.

221. Family of the Artist Chernyshev,
1969

Dmitry Dmitrievich Zhilinsky (b. 1927)
Wood strips, gesso, poly-vinyl-acetate
 tempera
80 x 100
RM; No. 9193
Acquired from USSR Ministry
 of Culture in 1976

In his creative quest, Zhilinsky studied
traditional classic artists, such as Giotto
and Cranach, as well as Surikov and the
icon painter Aleksandr Ivanov. To
achieve his accurate outlines and highly
detailed background, the artist applied
tempera paint onto a wooden board that
had been overlaid with gesso.

222. Seasons of the Year, 1974

Dmitry Dmitrievich Zhilinsky (b. 1927)
Wood strips, gesso, tempera
172 x 135
TG; No. P-60110
Acquired from USSR Ministry
 of Culture in 1989
Illustrated p. 232

By referring to classical art and themes,
such as these allegories of the seasons,
Zhilinsky hopes to give contemporary
mankind access to a humanistic percep-
tion and to a universal culture and
history.

223. A Studio, 1983

Tatyana Grigorevna Nazarenko (b. 1944)
Oil on canvas
Triptych: 140 x 100 (left); 140 x 180
 (middle); 140 x 100 (right)
TG; Nos. 2317, 2318, 2319
Acquired from USSR Ministry of
 Culture in 1985
Illustrated p. 234

In an unusual blending of past and pres-
ent, Nazarenko chose a triptych format
in which to depict the contemporary sur-
roundings of her studio. The artist
included herself at work in the left sec-
tion, and then introduced her world of
beloved objects, art reproductions, and
friends in the remaining two panels.
Through the studio window is seen an
urban landscape of central Moscow,
which makes the framed view look like
a painting within a painting.

224. The Wedding, 1987

Ivan Valentinovich Nikolaev (b. 1940)
"Orgalit," gesso, oil-casein tempera
175 x 234
Collection of the artist
Illustrated p. 65

Nikolaev recorded key events in a person's life in a triptych, of which this is the central panel. (The other two sections are entitled *The Pregnancy* and *The Funeral*.) Here, he surrealistically presented the common occurrence of newlyweds visiting the Tomb of the Unknown Soldier.

225. The House of Pushkin on Arbat, 1987

Natalya Igorevna Nesterova (b. 1944)
Oil on canvas
100 x 170
MC; No. Zh-5213
Acquired from the artist in 1988
Illustrated p. 62

Time and again Nesterova returned to the oldest street in Moscow when creating the numerous works in her Arbat series. Two parallel but isolated planes of images exist in each: the old architecture that safeguards the past, and the emotionless, impersonal people on the street. The house where Pushkin spent his first months of marriage in 1831 occupies the center of this painting.

226. Alla Pugacheva, 1981

Arkady Ivanovich Petrov (b. 1940)
Oil on canvas
160 x 130
Collection of the artist

This painting portrays Alla Pugacheva, an extremely popular folk singer among the Soviet masses, surrounded by references to mass-produced kitsch art. Petrov was among those artists in the 1970s who explored artistic culture and experimented with folk and naive painting.

227. Concert. Memories of Shostakovich, 1985

Aleksandr Grigorevich Sitnikov (b. 1945)
Oil on canvas
142 x 172
Collection of the artist
Illustrated p. 230

Sitnikov dedicated a series of his paintings to Dmitry Shostakovich, an outstanding Russian composer of the 20th century. To the artist, Shostakovich symbolized the creative person who both absorbs and reflects the complex conflicts of the contemporary world.

228. Morning, 1988

Vladimir Efimovich Braynin (b. 1951)
Oil on canvas
150 x 115
Collection of the artist

Braynin repeatedly paints scenes of his hometown of Moscow, but not from a quaint or ideal point of view. Instead, his memory and imagination produce unexpected transformations of the city's streets and architecture, as if his fragile world stands on the verge of destruction.

229. Spring, 1899-1900

Mikhail Aleksandrovich Vrubel
 (1856-1910)
Majolica with blue glaze
32 (h)
TG; No. SK-264
Acquired from P.P. Plotnikova in 1971
Illustrated p. 198

This image of spring was inspired by Rimsky-Korsakov's opera *The Snow Maiden*. Vrubel produced about 150 ceramic replicas of this piece in S.I. Mamontov's pottery studio in Abramtsevo. Created with sharp, graphic contours, these colorful objects were designed to be viewed frontally on shelves and in cabinets.

230. The Mordovinian Woman with Four Sheafs, 1914-16

Nikolay Andreyevich Andreyev
 (1873-1932)
Ceramic, engobe, glaze, paint
49 (h)
TG; No. 18520
Acquired from the artist's studio in 1934

Andreyev visited the villages of Mordovia, located between the Volga and Kama rivers, in the early 1910s. He later created massive majolica sculptures based on children's toy designs and the traditions of folk and primitive art he had seen there.

231. Portrait of Savva Timofeyevich Morozov, 1902

Anna Semenovna Golubkina (1864-1927)
Bronze
58 (h)
TG; No. SK-12
Acquired from the A.S. Golubkina
 Museum in 1952
Illustrated p. 220

Morozov (1861-1905), a wealthy industrialist, actively supported revolutionary movements and even subsidized Lenin's newspaper. During the construction of the Moscow Art Theater, he suggested Golubkina create a work to be placed over its entrance. She in turn captured his complex character in this bronze sculpture.

232. **Lenin Writing**, 1920

Nikolay Andreyevich Andreyev
 (1873-1932)
Bronze
30 (h)
TG; No. SKS-349
Acquired from the Woodworking
 Factory in 1964

After the October Revolution, Andreyev actively participated in Lenin's plan to create monumental art that would depict the people's struggle for liberation. His bronze of Lenin, which was based on life drawings and sculptures done in May 1920, became an extremely popular portrait of the famed Soviet leader.

233. **October**, 1929

Aleksey Evgenevich Zelensky (1903-74)
Bronze
50 (h)
TG; No. SKS-742
Acquired from the E.V. Vuchetich
 VKhPO in 1982
Illustrated p. 225

Zelensky referred to the propaganda art employed in the first years of the Revolution to create this symbolic representation of the triumph of the October uprising.

234. **Tsita Volina**, 1928

Sarra Dmitrievna Lebedeva (1892-1967)
Bronze
50 (h); 9 (base h)
TG; No. 29588
Acquired from Department of Fine
 Arts, People's Commissariat of
 Education, Moscow, 1930
Illustrated p. 220

An outstanding feature of model Tsita Volina was her wide, straight eyebrows. Lebedeva further emphasized the eyebrows by leaving them as openings, which are somewhat reminiscent of the empty eye sockets used by sculptors in antiquity.

235. **Portrait of Valery Pavlovich Chkalov**, 1936

Sarra Dmitrievna Lebedeva (1892-1967)
Head: bronze, 37 (h); base: labradorite,
 17 (h)
TG; No. 27398
Acquired from Management of Artistic
 Exhibitions and Panoramas in 1948
Illustrated p. 221

Chkalov (1904-38) was a famous Soviet aviator and hero who completed nonstop flights from Moscow to the Udd Islands (1936) and from Moscow to Vancouver (1937). This portrait, considered to be one of Lebedeva's best works, remained unfinished after the pilot's sudden death on a test flight.

236. **The Industrial Worker and the Collective Farmer**, 1936

Vera Ignatevna Mukhina (1889-1953)
Bronze
160 (h)
TG; No. P.58338
Acquired from the E.V. Vuchetich
 VKhPO in 1987
Illustrated p. 222

This work served as the model for the sculpture that topped the Soviet Pavilion at the 1937 world's fair in Paris. Executed from chrome-nickel steel and standing 24.5 meters tall, that sculpture was moved to the Exhibition of Soviet Economic Achievements in Moscow the following year.

237. **The Partisan**, 1942

Vera Ignatevna Mukhina (1889-1953)
Bronze
46 (h)
TG; No. 30673
Acquired from Experimental Art Studio
 of USSR Artistic Fund's Sculpture
 Section in 1951
Illustrated p. 221

During World War II, Mukhina felt it was her task to produce highly individualized figures as well as more abstract images of those who fought for the Soviet Union. Consequently, her monumental sculptures convey a sense of spiritual beauty, undying courage, and patriotic heroism.

238. **Pushkin and Tolstoy**, 1989

Leonid Mikhailovich Baranov (b. 1943)
Wood, plaster, bronze paint
200 x 127 x 93
Collection of the artist
Illustrated p. 233

This unrealistic meeting of writers who lived at different periods of the 19th century becomes a convincing mis-en-scène due to the artist's depiction of Pushkin and Tolstoy as inwardly dynamic but not heroic figures. For Baranov, the choice of wood for the sculpture also reflects a deeply rooted nationalism.